William Morris and the Aesthetic Constitution of Politics

William Morris
and the Aesthetic Constitution
of Politics

Bradley J. Macdonald

LEXINGTON BOOKS
Lanham • Boulder • New York • Oxford

LEXINGTON BOOKS

Published in the United States of America
by Lexington Books
4720 Boston Way, Lanham, Maryland 20706

12 Hid's Copse Road
Cumnor Hill, Oxford OX2 9JJ, England

Copyright © 1999 by Lexington Books

All rights reserved. No part of this publication may be reproduced,
stored in a retrieval system, or transmitted in any form or by any
means, electronic, mechanical, photocopying, recording, or otherwise,
without the prior permission of the publisher.

British Library Cataloguing in Publication Information Available

Library of Congress Cataloging-in-Publication Data
Macdonald, Bradley J.
 William Morris and the aesthetic constitution of politics / Bradley
J. Macdonald.
 p. cm.
 Includes bibliographical references and index.
 ISBN 0-7391-0055-6 (cloth : alk. paper)
 1. Morris, William, 1834-1896—Political and social views.
2. Aesthetics—Political aspects—Great Britain—History—19th
century. 3. Politics and literature—Great Britain—History—19th
century. 4. Art—Political aspects—Great Britain—History—19th
century. 5. Great Britain—Politics and government—1837-1901.
6. Aesthetics, British—19th century. I. Title.
PR5087.P6M33 1999
821'.8—dc21
 99-11559
 CIP

Printed in the United States of America

∞™ The paper used in this publication meets the minimum requirements of American
National Standard for Information Sciences—Permanence of Paper for Printed Library
Materials, ANSI Z39.48–1992.

*In loving memory of my father, James B. Macdonald,
whose theoretical spirit animates my own*

Contents

Acknowledgments		ix
Introduction		xi
Chapter One	The Question of Cultural Politics	1
Chapter Two	The Great Exhibition and the Class Politics of Art	25
Chapter Three	Towards a Political Economy of Art: John Ruskin and the Representation of Labor in Aesthetic Theory	43
Chapter Four	Constituting the Aesthetic Self: Medievalism, Pre-Raphaelitism, and Morris's Early Aesthetic Education	75
Chapter Five	Aesthetic Theory and Political Subjectivities: Morris's Lectures on Art.	101
Chapter Six	The Political Theory of William Morris: Revolutionary Socialism, Utopian Practicalities, and the Beauty of Life	123
Conclusion	Morris and Western Marxism	151
Bibliography		159
Index		169
About the Author		175

Acknowledgments

Of course, all scholarly works have multiple origins and diverse, though convergent, genealogies. My work on Morris is no exception. First, I began my interest in Morris's theory under the tutelage of my dissertation advisor at UCLA, Richard Ashcraft, whose unerring historical sense forced me into the archives and led me to view the way in which theory is always a living practice tied to historical actors. His "new historicist" position is clearly evident in the foregoing study, though I am sure if he were alive today he would probably disagree with the way I have enacted his metatheoretical position. With the further help of Albion Urdank and Victor Wolfenstein at UCLA, I was able to put the finishing touches to my dissertation on Morris. Second, in attempting to turn that dissertation into a more polished and consistent scholarly work, I was helped immensely by an initial reading from Craig Calhoun, who forced me to begin to think more clearly about issues outside of my discipline and the way in which Morris potentially lives in the contemporary theoretical world. More recently, kind support and prodding from Chip Rhodes led me to give my work another substantial rewrite.

Equally, I want to thank Robin Adler at Lexington Books for her initial interest and Kelli Kobor for her present support. Lynn Weber and Karen Johnson at Lexington Books were also extremely helpful in getting the manuscript in shape for publication. More generally, but just as importantly, I would like to thank the support, intellectual camaraderie, and helpful comments from a number of individuals: Clyde Barrow, Terrell Carver, Manfred Enssle, Peter McLaren, Karl Schleunes, and Paul Trembath.

My sister, Jamie Macdonald Furches, and my mother, Susan Macdonald Hyman, have continued to provide intellectual and emotional sustenance, and without them I would not be where I am now.

Moreover, I want to thank Kevin Foskin for his intellectual companionship and insightful critiques. Last but not least, I want to thank Susanne for her patience and love throughout the months of working on this manuscript.

Sections of Chapter One, with slight changes, were originally published in "Political Theory and Cultural Criticism: Towards a Theory of Cultural Politics," *History of Political Thought* XI, no. 3 (Autumn 1990), in particular, 509, 514-524. Reprinted with permission of the publisher, Imprint Academic. I want to thank Princeton University Press for granting permission to reprint selections from Norman Kelvin, ed. *The Collected Letters of William Morris*, Vols. I & II. (Princeton, NJ: Princeton University Press, 1984 and 1987).

Introduction

> Morris was twenty-two before I was born; and I am now eighteen years older than he was when he died. I who am very much his junior now write as almost equally his senior. And with such wisdom as my years have left me I note that as he has drawn further and further away from the hurlyburly of our personal contacts into the impersonal perspective of history he towers greater and greater above the horizon beneath which his best advertised contemporaries have disappeared.
> —G. B. Shaw[1]

The life of William Morris (1834-1896) spanned one of the most dynamic periods in England's history, a time that is characterized by a number of diverse, though interconnected, developments: the first sustained flourishing of capitalist industrialization, the Chartist uprisings and the socialist revival of the 1880s, and the cultural practices associated with late romanticism and the arts and crafts movement. Morris's stature within this period of English life is monumental, if not unique. He began his adult life as a celebrated poet associated with Pre-Raphaelitism and aestheticism, became a designer and craftsman who helped to spawn a whole revival in decorative art in England and the United States, struggled against the avid razing of ancient architecture, during which he delivered lectures that forcefully elucidated the relationship of art to society, and then, in the waning years of his life, linked up with the burgeoning socialist movement in the 1880s, becoming one of the most influential individuals in that political struggle.

Given the diversity of Morris's talents and achievements, scholars have striven to uncover an underlying ethos that unites the seemingly disparate facets of his life. For instance, E. P. Thompson has argued that what is most important in establishing Morris's stature in history is the quality of "moral realism" that pervades all aspects of his life and work: "it is the practical moral example of his life which wins admiration, the profound moral insight of his political and artistic writings which gives them life."[2] This quality of which Thompson speaks was not lost on Morris's contemporaries. Edward Carpenter, a fellow artist who turned to socialism in the 1880s, saw clearly the importance of Morris's life as a moral example:

> It is not so much perhaps in his work that his greatness will lie, as (what is more) in the man himself. For, after all, Life is greater than art; and the greatest of all artworks is the genuine expression of his own true heart which a man

finds and forges for himself out of the materials of the time into which he is born. Morris stood up from the first against the current of ugly, dirty commercialism in which his lot was cast—like a man in the midst of a stream fighting against the stream, like a captain in the rout of his men withstanding the torrent of their flight and turning them back to battle.

He hated with a good loyal hatred all insincerity; but most he hated, and with his very soul, the ugliness and meanness of modern life. I believe that was the great inspiring hatred of his life.[3]

Whether as an "idle singer of an empty day" (a phrase he used to define his early aesthetic self) or a troubadour for the socialist cause, Morris maintained his hatred toward "the ugliness and meanness of modern life." What Carpenter has presciently uncovered is the implicit political dimension that undergirds Morris's life. Morris's moral outrage toward Victorian life was built upon his earlier aesthetic education, and continued to surface in his various activities, either indirectly in his aestheticist poetic practices or directly in his activism for Anti-Scrape and socialism. Moreover, such an underlying ethos helped to engender important conceptual insights, connections and relays that would ultimately make Morris an important innovator within the tradition of Western Marxism.

When Morris retraced his development as a socialist he clearly discerned this underlying political dimension to his life. In "How I Became a Socialist" (1894), Morris inquires how he came to form an ideal which would ultimately be consummated in practical socialism. "Apart from the desire to produce beautiful things," Morris noted, "the leading passion of my life has been and is hatred of modern civilization."[4] Yet, this should not lead one to think that making "beautiful things" and professing "hatred of modern civilization" are separate processes for Morris, for his "study of history and the love and practice of art forced [him] into [this] hatred of civilization."[5] Moreover, if one thinks that as a practical socialist Morris would now shun the ideals that brought him to his own political conclusions, they could not be more mistaken. Morris ended his reflections on his political development with a interesting claim for the role of art in the struggle of the working class: "It is the province of art to set the true ideal of a full and reasonable life before him, a life to which the perception and creation of beauty . . . shall be felt to be as necessary to man as his daily bread."[6] This is more than an aside by a lifelong artist on his burning passion for beauty; rather, it is a telling representation of Morris's own sense of the role of his earlier aesthetic life on his later socialist activism.

Because of Morris's centrality as a cultural and political figure in the nineteenth century, a veritable publishing industry has arisen around his life and work.[7] Yet, while many books and articles have been published on Morris, there are relatively few that have advanced Morris scholarship in new directions, especially in relation to clarifying the relation of Morris's aesthetic life to his political activism. The two most important works in this respect are now classics—Mackail's *The Life of William Morris* (1924) was the first full narrative of Morris's life, drawing upon many original sources; and, Thompson's *William Mor-*

ris: Romantic to Revolutionary (1976, revised edition) was the first to make a detailed case for a more intimate relationship between Morris's romanticism and his revolutionary politics, in the process uncovering a multitude of original sources that Mackail overlooked, and elucidating the history of the socialist movement in which Morris was an important leader. Since 1976, works devoted to Morris's theoretical reflections of art and politics, let alone on the relationship between the two in his own life, have been sparse. The most important recent works in this respect are those collected in *William Morris Today*;[8] a very interesting article by William Casement on Morris's articulation of the link between labor and pleasure;[9] a good overview of Morris's "utopian communism" that attempts to show its influence on later socialist thought;[10] a book by Peter Stansky that uncovers the rich history of various organizations associated with the arts and crafts revival in England, a movement in which Morris was both a participant and an inspiration;[11] a collection of essays that, in provocative and diverse ways, explore Morris's socialist literary discourses and works;[12] and, a much heralded new biography by Fiona MacCarthy that uncovers new information on Morris's personal life, and makes an important argument for Morris's concern for women's issues.[13]

This work will not construct another biographical narrative of Morris, in which all of the events of his life and the intricate aspects of his personality will be displayed and enacted for the reader. Its purpose is at once more wide-ranging and more circumscribed. It is a theoretical and historical engagement with Morris, with the intention of elucidating the important ways in which historical actors in general were becoming political subjects through their practice and interrogation of aesthetic discourses. In this respect, I see this work as a study of the *cultural politics* of a particular period in English history.[14] What then concerns this work in relation to Morris is how he made the transition from artist to revolutionary: What were the social, cultural and political conditions of Morris's development? What were the concepts he developed as an artist that would be instrumental in constituting his political subjectivity? How did he work these concepts and ideals out in his writings? Given the genealogy of his theory, in what way does Morris initiate important conceptual developments and insights for particular intellectual traditions, specifically Western Marxism?

In engaging in such a task, I have had to take issue with Thompson's particular portrayal of Morris's movement from romanticism to socialism as well as renegotiate what Morris offers to contemporary participants of the Marxist tradition. Thompson's claim that there is a relationship between Morris's aesthetic life and his revolutionary socialism is not new. What is important about Thompson is that he is one of the only scholars to attempt to articulate this connection in some detail. My contention is that he did not interrogate this relationship well enough, in the process losing sight of some very important aspects to Morris's development as a socialist, not to mention the particular way in which cultural politics were being articulated during this period in English history. This oversight is not a consequence of Thompson's scholarship per se—his work, as he noted, is a veritable "quarry of information"[15]—rather it has to do with the par-

ticular problematic within which he was working, as well as the particular audience to which he was writing.

As Perry Anderson has noted, Thompson's intentions were to show Morris to be an important example of the "Marxist past in England," as well as an original theorist whose Romantic moral vision provides a needed corrective to the excesses of the orthodox Marxist tradition.[16] To make Morris an important heir to the British Marxist tradition, and yet to show the originality and importance of Morris's romanticism for Marxism is no easy task. From within this problematic, Thompson has done an admirable job. What I would claim is that the way in which Thompson has negotiated this context has engendered his selective portrayal of the influence of Morris's romanticism. In Thompson's narrative, Morris's earlier aesthetic life is split between opposition and acquiescence to Victorian life, the former exhibited in Morris's earliest poetry while the latter is seen in his later aestheticist stance. The problem with this characterization is twofold: first, historically neither Morris nor his contemporaries saw such a distinction; and, second, to deny a more positive role for Morris's aestheticism closes one's eyes to the important role that an ethical notion of beauty had for his political development, and continued to have when he was a socialist. As we noted before, even at the end of his life Morris still claimed that art represented the "true ideal of a full and reasonable life." This does not deny that Morris's hope for social change—"the river of fire," as Thompson calls it[17]—was not also premised upon his increasing political activism. But it is to assert the necessity of taking Morris's romanticism in its totality (its realism *and* escapism), if we are to understand his later revolutionary socialist position not to mention the theoretical innovations he initiates within Marxist tradition itself.

We can surmise that part of the reason for Thompson's oversight here is that he was writing to a Leftist audience that had never seen Morris as anything other than sentimental and utopian.[18] To assert the importance of *part* of Morris's romantic heritage, without at the same time falling prey to a glorification of what Marxists had seen as "decadent" and "utopian" in art, would be a very strategic way of convincing his audience of the importance and originality of Morris's thought in the socialist tradition. Whatever the particular polemical reasons, the task is now to continue the important work that Thompson has begun. To continue such a task, though, demands that we extricate ourselves from the particular issues that concerned Thompson and accept the radically different theoretical and political context we find ourselves in. Only then can we fully enter into a dialogue with Morris's work and make him relevant for our own culture.

Of course, I am also working from within a particular theoretical and political context, one that intimately informs my discussion of Morris. First, as any experienced educator knows, the current situation within the university is one characterized by a movement away from traditional boundaries of knowledge. Of course, disciplinary boundaries have always been artificial, and have been constantly in flux. But, as one commentator on the institutional context of knowledge has noted, today there is an unprecedented movement toward inter-

disciplinary studies.[19] This trend has been greatly reinforced by the growth of institutional spaces (e.g., journals and degree programs) devoted to interdisciplinary analysis. For the discipline of politics at least (a discipline that constitutes my own academic identity), this interdisciplinary trend is evidenced in the avid borrowing of tools and notions from the natural sciences, philosophy, sociology, economics and history.[20] While our discipline has been compelled to expand its sense of the terrain of politics through its engagement with other social and natural sciences, it has generally not been as ready to draw impetus from the humanities, in particular, those disciplines associated with the study of art and literature. Yet, on the historical level in which actors engage in political action and come to terms with their political world one cannot so easily ignore the role and influence of art and literature. The study of the life and thought of William Morris provides an important avenue for analyzing the way in which aesthetic practices and discourses are constitutive of political subjectivities and actions. Thus, this study is guided by the perceived need to engender an interdisciplinary framework for the study of cultural politics.

Second, the political and theoretical developments of the late twentieth century have radically shaken the assurances and character of the Marxist tradition. The fall of so-called "communist" regimes, the virulence and entrenchment of post-Fordist global capitalism, and the development of new social movements whose character and aims are not reducible to issues related to production have all provided ample fodder for radically questioning the relevance of Marxism today. Moreover, the currency of postmodern forms of thought—and of antifoundationalist theory in general—has seemingly relegated Marx's thought to the dustbin of history (a dustbin presently filled with such "irrelevant" thinkers as Plato and St. Thomas Aquinas). While undoubtedly such developments have led many to abandon the Marxist tradition, it has also engendered a creative rethinking of the tradition itself. Indeed, such a context has led to avid attempts to make Marxism a *living tradition*, one that directly accepts and negotiates these new political and theoretical developments.[21] In this respect, with the tradition of Marxism increasingly freed from its conventional moorings we no longer have to be concerned about bowing to orthodoxy, if we ever were. From within this contemporary context, Morris's cultural and political theory appears as an important precursor to creative attempts at renegotiating Marxism today, raising issues and concerns related to ecology and the politics of desire that are increasingly our own.

In Chapter One, I begin a conceptual discussion of cultural politics by showing its current linkages to important policy debates and theoretical developments, thereby eliciting why an analysis of cultural politics is an important contemporary issue. I then more specifically look at the way that some theorists have attempted to articulate the role of art in social and political practices. Drawing sustenance from Marxist and postmodern theoretical currents, I lay out three positions that have advanced our conceptual understandings in this respect—art as ideology; art as critical consciousness; and, art as politicizing practice. These latter two positions—what I collectively call the "aestheticist"

position—have advanced our understanding of cultural politics by making the argument that art, irrespective of the ideological context of its production, is an important way of gaining political knowledge and/or engaging in political action. I take issue with their transcendental and transhistorical claims for cultural politics, and instead claim the necessity of historicizing these claims to not only allow for a wider range of aesthetic phenomena, but also to link it up with significant historical actors.

If the first chapter provides the *raison d'être* for proceeding within the context of our present theoretical and conceptual concerns, Chapter Two uncovers a first layer upon which Morris's own development is given historical meaning and significance. In this chapter, I engage in a critical genealogy of the cultural politics of Victorian England by examining the discourses and events that surrounded the Great Exhibition of 1851. It is evident from this discussion that on a larger historical level social and political concerns were becoming intertwined with aesthetic and cultural practices, engendering on the level of ideology and class discourses an acute awareness of the linking of art to politics. From this vantage point, one is given an empirical grounding for cultural politics during this period, one that not only signals Morris's later aesthetic and political concerns, but also clarifies what will be the significance of Morris for the tradition of nineteenth-century cultural and political thought. When Morris claimed in 1888 that "it is impossible to exclude socio-political questions from the considerations of aesthetics," he was clearly recognizing the existence of this form of political engagement in Victorian life. It is his insightful theoretical engagement of these issues that points to one of his most important contributions to the tradition of Western Marxism itself.

Morris's reflections on cultural politics were influenced by one of that century's most important cultural theorists, John Ruskin. Chapter Three turns to the thought of Ruskin not only to lay the groundwork for understanding Morris's considerations on art, but also to elucidate how ideological tensions were reverberating within aesthetic theory, tracing out new connections and considerations hitherto ignored in this ideological domain. Ruskin drew upon the politically contested category of labor to make his prescient analyses of the beauty of Gothic art. What is important is that Ruskin's ideal of joyful labor had a clear homology to the political discourses of the working classes, to such an extent that it led him into becoming an avid, though paternalistic, champion of their cause. Ruskin's theory is a clear example of the important way in which political claims were appropriated by cultural discourses, in turn affecting the political understandings of particular individuals.

Morris read Ruskin early on in his education at Oxford, and he was immediately struck by the moral denunciations of Victorian society that poured from Ruskin's pen. Yet, Morris's engagement with Ruskin's thought at this point was not as a fellow social critic, but rather as a devoted artist attempting to plumb the nature of beauty. In Chapter Four, Morris's early aesthetic education is discussed with the intention of elucidating the development of important aesthetic notions that lay the groundwork for his movement toward socialist principles.

Between the 1850s and the 1870s, Morris began to initiate those aesthetic practices that would make his fame, becoming both an important designer for the decorative arts and an important figure in the Aesthetic Movement of poetry. It is in my interpretation of the importance of the latter dimension to Morris's aesthetic life that I take issue with Thompson. Morris's attachment to a notion of beauty that was separate from Victorian society provided an important way to retain an ideal of life that was antagonistic to Victorian life. My interpretation of this political dimension to Morris's aestheticist claim is supported by looking at the way in which other artists associated with the Aesthetic Movement, as well as working class activists involved in political struggle, were utilizing a similar notion of beauty.

Driven by his attachment to a notion of beauty that was both critical and ideal, Morris began to theoretically interrogate the history and nature of arts in the late 1870s. Chapter Five explores the way in which Morris's theoretical articulation of the nature and character of beauty began to explicitly lead him into the direction of socialism. This is an important task—and one that has not been explored before—for it clarifies how aesthetic thinking can lead to political concerns. His guide in this respect is Ruskin, who he had encountered earlier and was now drawing more clearly upon in his thinking. Importantly, his lectures show a gradual realization that the hope for the rebirth of beauty within Victorian life was intimately related to the political project of the working classes, and ultimately to the complete transformation of capitalist society.

From 1881, the character of Morris's revolutionary socialism was already in place. In 1883, Morris joined the Democratic Federation and became an important activist within the socialist revival of the 1880s. Chapter Six explores this important period in Morris's life, with the intention of showing the relationship of Morris's particular aestheticist ideals to the tactics and ideals of his revolutionary socialism. As Morris had noted, he became a socialist before he knew anything about the history of socialism. In the process of establishing these linkages between his aesthetic theory and socialist theory, the claim is made that the best way to characterize Morris's socialism is as "constructive." This implies two important aspects to his conception of socialism: that there is an emphasis on the imaginative portrayal of the future world that socialism represents, as well as a realization that this "utopian" dimension is intimately involved in the necessity of political action. Moreover, Morris's aestheticist background ensured that his conception of the socialist life-world would entail pleasure, hope, and natural beauty, and in turn the regeneration of art for which he so longed.

In the Conclusion, I approach the general issue of Morris's stature in the tradition of Western Marxism. After some general metatheoretical considerations of what it means to work within a living tradition, I point out three substantive areas that Morris initiates in this tradition that will become important focal points for later Marxists: his materialist aestheticist position on cultural politics; his focus on pleasure and desire as defining features of socialist life; and, his articulation of an eco-Marxist/eco-socialist position.

In this portrayal of the cultural politics of Victorian England, and in particular of Morris's life and work, I have undoubtedly covered some ground that has been dealt with before by Morris scholars. This is inevitable in a quarry that has been well mined, and where the biographical features of the terrain are the same. In those cases where I am covering ground that is the preserve of particular authors, I have made sure to deal with them either in the text or in footnotes. Otherwise, my articulation of these issues is drawn from my own reading of original sources and my own interpretation of social and historical reality.

Yet, in the process of this discussion of the cultural politics of Victorian England, I hope to bring about a needed reevaluation of Morris's political development and theoretical stature. If the first battle in Morris scholarship revolved around the tension between Morris the artist and Morris the socialist, and the second battle around the character of Morris's socialism, the next battle is pitched on the terrain of showing the interconnections between his unabashed devotion to beauty and his revolutionary socialism. At the very least, what I hope to have done is to present, without qualms and hesitation, how Morris could be both an artist *and* a revolutionary. From within this hermeneutic horizon, it becomes possible to enact and perform Morris in ways that are relevant to both his, and our own, historicity.

Notes

1. G. B. Shaw, "William Morris As I Knew Him," in *William Morris: Artist, Writer, Socialist*, Vol. II, May Morris, ed. (Oxford: Basil Blackwell, 1936), xxxix-xl.
2. Thompson, *William Morris: Romantic to Revolutionary*, 717.
3. Edward Carpenter, "William Morris," *Freedom* X, no. 111 (December 1896).
4. Morris, "How I Became a Socialist," *Justice* (June 16, 1894): 6.
5. Morris, "How I Became a Socialist," 6.
6. Morris, "How I Became a Socialist," 6.
7. For a listing of works on Morris from 1896 to 1985, consult Gary Aho, *William Morris: A Reference Guide* (Boston: G. K. Hall & Co., 1985).
8. *William Morris Today* (London: Institute For Contemporary Art, 1984) is a collection of articles by various authors to commemorate the ICA's exhibition of Morris's life and work.
9. William Casement, "Morris on Labour and Pleasure," *Social Theory and Practice* 12, no. 3 (Fall 1986): 351-382.
10. Florence and William Boos, "The Utopian Communism of William Morris," *History of Political Thought* VII, no. 3 (Winter 1986): 489-510.
11. Peter Stansky, *Redesigning The World: William Morris, the 1880s, and the Arts and Crafts* (Princeton: Princeton University Press, 1985).
12. Florence Boos and Carole Silver (eds), *Socialism and the Literary Artistry of William Morris* (Columbia, MO: University of Missouri Press, 1990).
13. *William Morris: A Life of Our Time* (New York: Alfred A. Knopf, 1995).

14. By "cultural politics" I mean the way in which culture (in particular, aesthetic discourses) are intimately related to the political claims of particular historical actors and/or are instrumental in the constitution of political subjects.

15. Thompson, *William Morris: Romantic to Revolutionary*, 768.

16. Perry Anderson, *Arguments Within English Marxism* (London: Verso, 1980), 158-159. In this particular attempt to rescue Morris for contemporary socialists, Thompson clarified that it was the moral vision associated with Morris's romanticism that was the most defining characteristic of his socialism, and indeed represented the aspect of Morris's thought that still stands unheeded by Marxism. For a discussion of these issues, see Thompson, "Postscript: 1976," *in William Morris: Romantic to Revolutionary*, in particular, 778-779.

17. Thompson, *William Morris: Romantic to Revolutionary*, 243-274.

18. This is implied in Thompson's discussion of his "piety towards politics-as-text and timidity before the term, 'utopian'," in "Postscript: 1976," 792-793.

19. See Jean-Francois Lyotard, *The Postmodern Condition: A Report on Knowledge* (Minneapolis: University of Minnesota Press, 1984), 52.

20. For a discussion of the problems this raises for the subfield of political theory, see John G. Gunnell, *Between Philosophy and Politics: The Alienation of Political Theory* (Amherst: University of Massachusetts Press, 1986).

21. For an important attempt at making Marxism a living tradition in this way see Ernesto Laclau and Chantal Mouffe, *Hegemony and Socialist Strategy: Towards a Radical Democratic Politics* (London: Verso, 1985).

Chapter One

The Question of Cultural Politics

> It is not possible to dissociate art from morality [and] politics . . . Truth in these great matters of principle is of one, and it is only in formal treatises that it can be split up diversely.
>
> —William Morris, "The Art of the People" (1879)[1]

To write a book on the relation of art to politics, more particularly, on the constitutive role of aesthetic discourses in engendering political judgement and political action in our social world, is to at once raise the commonplace and the exotic. Anyone remotely aware of the National Endowment for the Arts (NEA) funding debates in the United States begun during the Reagan/Bush era will not be shocked to hear the story of the political force of art. The Neo-conservative attack on the NEA funding of works like Andres Serrano's seemingly sacrilegious "Piss Christ" and Robert Mapplethorpe's homoerotic photography was done with striking similarity to very classic arguments well known by students of the Western tradition of political thought. While some conservatives made arguments under the banner of "democratic responsibility"—that we should not be spending tax monies on practices deemed "offensive" by certain members of our society—others focussed on the moral harm such works create in our troubling times.

In terms of the latter argument, we need only remember the arguments of Plato in *The Republic* to get an earlier intimation of today's issues surrounding the politics of art. In discussing the education of the Guardians, Plato argues for the censorship of particular aesthetic practices on the grounds that certain works instill incorrect moral virtues (e.g., by portraying the Gods in morally ambiguous ways), and that certain forms of art actually excite emotions deemed destructive to the ruling function the Guardians must perform. What is implied in Plato's argument is that art has a peculiar force that must be regulated, especially if the desired ideal of the political community (for Plato, a "just" system is one in which all are performing their naturally suited tasks, and not meddling in the affairs of others) is at stake. Thus, art is not a neutral cultural practice, but an important human endeavor that has demonstrable effects on human character, and in turn, has significant political resonances.

In contemporary America, of course, the neo-conservative ideal against which art has been judged is not that of "justice," but a notion of moral decency and moral life particularly important to the Christian right. Yet, the implications are the same: implied in the public discourse surrounding the funding of art is a notion that *art has such an important moral and political force—it can actually transform people's consciousness about the world, and, in the process, affect their moral, social and political actions.* Indeed, both sides to this policy issue seem to recognize the importance of art in human affairs: those supportive of unrestricted NEA funding of art proclaim the importance of art for human and social development, while those who wish to restrict, or even eradicate, NEA funding decry the moral and political destabilizing effects that such art promotes. While this issue is seemingly caught in a polemic of binary oppositions, there is an implicit agreement, albeit in most cases unconscious, on the existence of cultural politics.

Perhaps more exotically, the understanding of the aesthetic nature of politics is becoming increasingly important in contemporary theory, particularly in that intellectual trajectory we might collectively label as "postmodern theory."[2] As Alan Megill has perspicaciously argued, one can trace an "aestheticist" orientation—that is, "an attempt to expand the aesthetic to the whole of reality"[3]— from Romanticism to the thought of Nietzsche, Heidegger, Foucault and Derrida. As Megill further notes, what we are seeing in recent avant garde thought is "a tendency to see 'art' or 'language' or 'discourse' or 'text' as constituting the primary realm of human experience."[4] For Megill, this allows us to understand, among other things, the importance that postmodern thinkers have placed on the constructivist foundation of knowledge, a position that initially arises out of the thought of Nietzsche and which is rendered most famously in Derrida's claim that "there is nothing outside of the text." If all human reality and experience is a text—a constructed artifact—then aesthetic practices that are most clearly textual are indicative of other human practices, including politics. Indeed, as one recent proponent of this position has argued, literature is by its very nature a "politicizing practice."[5] In self-referentially elucidating the fact that all human reality is textual, literature can engender both political knowledge and political action: its exhibition of univocal meanings elicits the presence of power relations, while the foregrounding of textual play that is intimately involved in aesthetic practices can also, in certain formal modes at least, provoke "antagonistic imagery that provides sites for resistance to [that] power."[6]

While we will closely explore such conceptions of cultural politics later within this chapter, we should at least reflect on how its implication as a recurring structural feature in postmodern theory raises the stakes of our discussion. The way in which we understand the connection between art and politics may have important bearings on how we should situate ourselves in these present theoretical controversies. Indeed, Megill argues that postmodern thought provides a more recent variation of the Romantic defense of the aesthetic against the dominance of the instrumental and scientific rationality associated with the

Enlightenment. Earlier, Romantics assumed that the autonomy of art represented its distance and difference from other forms of human life, in the process evoking a better way in which to arrive at human understanding and human values important to emancipatory political action. As a later incarnation of this tradition, postmodern thought takes the assumption of the primacy of the aesthetic to mean not only its superiority, but, more importantly, its ontological priority in terms of other modes of human experience. Breaking free from the supposed Kantian temptation to separate human life into the scientific, moral and aesthetic (a separation that Megill rightly notes is not as secure as one might at first think in the thought of Kant),[7] postmodern thought sees the aesthetic as delimiting the possibilities and limitations to the scientific and moral, not to mention the political.

A good, though not necessarily obvious, example of the issues this extreme aestheticist position within postmodern thought raises can be seen in the work of Jean-Francois Lyotard. Leaving aside his particular analyses of art works and artists (in which he seems to locate liberatory possibilities in the aesthetic articulation of the sublime—the ineffable and "unpresentable" present in all good works of art),[8] Lyotard's argument that the potentialities for justice lie in the recognition and acceptance of the multiple and competing prescriptive language-games of "the just"—its possibility arising upon a discursive rift he later names the "differend"[9]—implies the discursive/linguistic negotiation of justice without the "terrorism" of any particular regulatory ideal that can decide between their competing claims.[10] In *Just Gaming*, Lyotard actually raises the problems that he sees associated with an "aesthetic politics," a politics built upon aesthetic judgement, claiming that such a position actually leaves itself open to "injustice":

> It is not true that one can do an aesthetic politics. It is not true that the search for intensities or things of that type can ground politics, because there is the problem of injustice . . . Aesthetic judgement allows the discrimination of that which pleases from that which does not please. With justice, we have to do, of necessity, with the regulation of something else.[11]

While I think that Lyotard's emphasis on separate quality of discourses related to art and politics is necessary—if not for the very reason that it helps us to overcome some of the simplistic claims that art is by its very nature political—it is clear that he has rendered the aesthetic realm devoid of anything other than its ability to evoke sensations, desires and feelings. In this sense, he has sequestered the "aesthetic" into an essentialist, ahistorical corner, reducing it to a monadic discursive practice devoid of cognitive, let alone relevantly political, characteristics. Pace Lyotard, there can be diverse historical "language-games" appropriate to the issue of cultural politics. This does not mean that a discourse on cultural politics can adjudicate disputes between other language-games, but it may mean that one can render issues in which it becomes understandable how agents use aesthetic notions in ways that relate to political life.

Yet, even in claiming to promote the radical separateness of language-games related to art and justice, Lyotard's overall position is indebted to an "aestheticist" rendering of the nature of justice itself. Indeed, for those on the left who argue for the necessity of grounding justice in universalist and/or realist terms, Lyotard's admonishments to accept the multiplicity of notions of justice steers very close to accepting what different groups find to be "pleasing" (a political catharsis?), ignoring the necessity of establishing criteria for justice that transcend self-interest for the sake of the community at large.[12] As if to signal a return of the repressed within his own position, Lyotard's claim that we should respect the limits of the aesthetic in terms of pleasurable sensations is built upon a deeper "aestheticist" conception of the discursive construal of social reality. This means that, paradoxically, Lyotard denies the sense in which the experiential realms of art and politics are radically separate (for on this deeper level they are both aesthetic construals). To understand more deeply the connection between the aesthetic and the political we must paradoxically accept their discursive and historical separation, not only in terms of the way in which they appeal to different facets of our existence, but also in the differing way in which they render criteria for judgement in those realms. Yet, we are not implying here a return to a form of Lyotardian essentialism—we are instead intending to accept the historically contingent way in which art intersects with other social practices within its specificity. Indeed, it is because art has different ways of rendering and engaging political practices in their specificity—not only eliciting the fissures of political conflict, but also articulating ideals of social life that transcend pathways of relations of power—that it can provide an impetus to social and political change.

Ultimately, the question of the nature of cultural politics—its mode of historical articulation and the social and political practices it engages—is an historical one. In saying this, I am not trying to shy away from a more generalized theoretical consideration of the issue. If anything, this work is a *theoretically* informed historical examination of cultural politics, and it will be helpful to examine those theoretical surfaces already in existence in order to get a sense of the limitations and possibilities surrounding its present conceptual articulation. Yet in raising the importance of the historicity of cultural politics (i.e., its historically contingent articulation), I am attempting to avoid the tendency to take an historically located practice and turn it into an ontological claim about the nature of art. While, as we will see, such a theoretical move may immediately allow one to accept cultural politics—like a *coup d'théâtre* it creates an illusion of solidity for the theoretical play at hand—it also may close off one's understanding of the potentially multifarious ways in which art may intersect with politics.

Chapter One

Politics *Arte Magistra*: Towards a Conceptualization of Cultural Politics

To draw upon a familiar image in Plato's *Republic*, political scientists and political theorists have generally barred the poet from their ideal society of political action and political knowledge. Yet, unlike Plato's scenario, the censorship of art from their academic republic is not done out of reverence for its damaging political and pedagogical effects; indeed this is precisely the problem.[13] Instead, this interdiction is primarily a consequence of the way in which the academic discourse of politics has defined the domain of "politics," i.e., proposed which institutions, values, forms of knowledge, etc., are to be considered relevantly "political." This disciplinary attitude could be understood as a consequence of what one political theorist calls the "alienation of political theory": its estrangement, as a form of academic discourse, "through philosophical myths about theory, tradition, science, and politics, not only from the particularities of politics but from substantial theoretical analysis of the nature of political phenomena."[14] Thus, while Plato, and even Aristotle, may beckon to us from within the "tradition" of political thought to take art seriously, and the historical "particularities of politics" offer us many examples of the way aesthetic works and discourses sustain, transform, or even constitute the political,[15] the epistemological and ontological presuppositions that underlie the methodological practices of students of politics seem to have averted their gaze from these important signs.[16]

If the issue of cultural politics is sidelined within the disciplines of political science and political theory, there are many other voices within contemporary theory, particularly as articulated within the humanities, that are attempting to break this silence. Traditionally, studies within the humanities have tended to underplay or ignore the relation of art to larger social and political processes. As Janet Wolff has argued, cultural criticism still clings to "mystical" notions about art as the creation of individual "'genius,' transcending existence, society and time."[17] This understanding of the separation of art from social and political practices within the humanities has only reinforced the absence of significant analyses of cultural politics within the social sciences. However, within the last twenty years at least there has been a growing articulation of the material, social and political practices of art, to such an extent that one cannot pick up a journal without seeing the saliency of the "political" question of art. This centrality of the question of cultural politics is clearly noted by Fredric Jameson when he argues that within cultural texts one will see "nothing which is not social and historical—indeed, that everything is 'in the last analysis' political."[18] Leaving aside the issue of whether his particular position on this topic is valid, Jameson is one of the most important recent thinkers within a long tradition of Marxist cultural criticism that has provided much impetus for discussing the connection between politics and art.[19]

Given the importance the Marxist tradition, and certain currents within postmodern theory, have laid upon the politics of art, a closer look at the differ-

ent positions within these diverse traditions will provide an important theoretical context in which to begin to conceptualize the practices of cultural politics. While not laying claim to exhaustiveness by any means, I will lay out three distinct positions that have gone a long way in linking aesthetic practices to political discourses. Importantly, as we will see, we will be moving from the initial insight of the way that politics structures aesthetic practices to the more tantalizing conception of how aesthetic discourses can constitute politics itself. While recognizing the embeddedness of art within ideological practices—and thus representing a step toward a viable conception of cultural politics—I argue that the first position does not allow for one to see the way in which art can articulate discursive transformations that have some independent affect on political action. That is, to draw upon language common to the social sciences, it recognizes the "structural" dimensions to aesthetic production, but not its potential "agential" properties. I will then look at what could be termed "neo-Romantic" approach that arose within Western Marxism in which the centrality of aesthetic agency is discussed. From there, we will then look to the way in which cultural politics has been articulated by those inspired by postmodern theory. While these latter two conceptualizations—which we can collectively label as the "aestheticist" position—clearly argue that art is an important and necessary site for political knowledge and/or political action they do so within a transcendental and essentialist framework, and thereby ultimately short-circuit an analysis of the diverse ways in which cultural politics manifests itself within history.

Art as Ideological Practice

While those traditions of cultural theory inspired by Marxism have engendered a sensitivity toward uncovering the embeddedness of culture within social and economic structures, what has not been so readily articulated in this tradition is the constitutive role that aesthetic discourse may have in bringing about ideological conceptions of the political world, and by that very process constituting political action. In particular, classical Marxist cultural criticism has consistently focussed on the political character of art by following Marx's lead in looking at the relation of art to the economic mode of production, particularly the classes which are struggling for power within that realm. In this respect, Marx and his followers have been instrumental in articulating the relation of *art to ideology*. Within this conception, art is political in its reflection and reiteration of ideological discourses constituted in the economic field. Thus, in the classical Marxist position, art is essentially twice removed from the realm of relevant political action, the later being defined strictly as class struggles in the economic realm. This does not mean that classes do not "fight it out" in cultural spheres (as Marx noted in his famous "Preface" of 1859),[20] but rather that culture is always a reflection of deeper economic motives. More importantly, as implied in some of Marx's writings and replicated by many Marxists critics later on, art reflects these more primary struggles, ultimately becoming a mere social hieroglyph of more fundamental economic fissures within the social body.

Now, I obviously realize that in laying out this particular model to represent the classical Marxist position I am entering into a field of dispute that has consumed many academic careers in the last 30 years—to wit, the issue of how Marx actually conceived of the character of "ideology."[21] Without entering into the thicket of this important issue, it is clear that Marx's comments on the placement of culture within the domain of the "ideological superstructure" has spawned cultural analysis that ultimately sees culture as a mirror of economic struggles, or as a part of the general reproduction of the capitalist mode of production in general.[22]

From Marx's notion of the relation of culture to ideology arose the whole modern tradition of sociology of art, in which art is seen as not just conditioned by economic forces, but also "social conditions" conceived more widely. A representative example of this sociological position is the work of Arnold Hauser.[23] Hauser clearly recognizes the importance of Marx's understanding of "art as ideology" but articulates the relationship in a more general way.[24] Yet, importantly, what the sociological tradition has been discursively limited by is an implicit adherence to a overly reflectionist and objectivist notion that while the artwork or cultural practice may be more or less a complex manifestation of conflicting social forces (that is, it is not a unitary object that reflects only one aspect to that social body), its agency as a cultural practice is lacking. As within other social sciences, it sees art not as a living force that can actually affect the judgement, ideas, even practices of historical actors, but as a dead artifact that merely tells the prescient observer about the character of social forces outside the cultural artifact, as the epitaph on a tombstone cryptically attempts to reflect the remains of a life buried beneath.

Undoubtedly, one reason for this conceptual blind spot in the classical Marxist/sociological perspective is related to the fact that Marx's theory was derived in opposition to Idealism, a philosophical position that did explicitly focus on the agency of spiritual and cultural factors as motive forces in human history. As Marx claimed in the *Theses on Feuerbach*:

> The chief defect of all hitherto existing materialism—that of Feuerbach included—is that the thing, reality, sensuousness, is conceived only in the form of the object or of *contemplation*, but not *as human sensuous activity, practice*, not subjectively. Hence it happened that the *active* side, in contradistinction to materialism, was developed by idealism—but only abstractly, since, of course, idealism does not know real, sensuous activity as such.[25]

When one looks to the more complex and interesting formulations within this tradition that are in the work of Pierre Bourdieu and those inspired by the work of Louis Althusser, one begins to see openings for looking at the way that art has more than a mere reflective role in social and political processes. Bourdieu's attempt to overcome the dualisms of object/subject and structure/agency in sociological theory by articulating the interconnections between what he terms a "field" (representing the structural "positions" of the actor within grids

of power and capital) and "habitus" (the embodied, socially structured, yet subjective, "dispositions" of the actor) has promising possibilities for seeing the efficacy of culture in political discourses.[26] Yet, as is seen in his work on artistic taste, *Distinctions*, Bourdieu is highly suspicious of notions that assume the autonomous efficacy of art (what he sees to be associated with "aestheticism") outside of an understanding of the complex way in which art is produced within particular aesthetic fields that have particular relationships to other social fields, and ultimately, to relations of power and dominance.[27]

Undoubtedly, Bourdieu's argument here is with particular theoretical tendencies and aesthetic self-conceptions that assume a radical potential to art by its very distance from social relationships, ignoring not only that such art arises within particular social fields (and is thus not autonomous) but also that its radical reception is ultimately a preserve of particular positions within structures of power and dominance. In this sense, Bourdieu wishes us to recognize that aesthetic production is not by its very nature "radical" or "political" in eliciting changes toward emancipation and freedom, but is socially produced by the "dominated fraction of the dominant class,"[28] which given a particular historical juncture may provide impetus for resistance and struggle against power and domination.

Cultural criticism influenced by Althusser has probably engendered the most interesting analyses of aesthetic texts as they relate to ideological practices. As befits the theoretical innovations proffered by Althusser (e.g., structural causality, overdetermination, and ideological state apparatuses),[29] aesthetic practices are seen as intimately associated with ideology while at the same time as fundamentally autonomous in their specific productivity. That is, ideology is never simply reflected within aesthetic texts; rather it is always worked on, transformed, produced by the "materiality of the [aesthetic] text" itself.[30] This raises important issues concerning the potential politics of aesthetic texts. Within the aesthetic text, ideology is then not reflected, but *displayed* phenomenologically: the spectator and/or reader experiences and lives ideology through the text, but in a way that allows for distantiation (and thus the experiencing of the "limits"[31] of ideology) and in turn a political understanding of ideology's "nature, purview, and provenance."[32]

In terms of our topic, two particular criticisms of the Althusserian position have arisen that are relevant (though not necessarily conclusive). First, while recognizing the specificity of aesthetic practices as a form of political knowledge, the autonomy of aesthetic practices is seemingly elided by the a priori insistence on determination of the economy "in the last instance."[33] In a related way, as Pierre Macherey and Etienne Balibar argue, ultimately "the aesthetic effect of literature" is always intimately associated with the "ideological domination-effect."[34] Thus, within this position at least, aesthetic texts seem limited in their agential potentials, not only in terms of their autonomous effect on political practices but also in terms constituting practices associated with resistance and contestation to hegemonic power relations. Second, when the agential efficacy of aesthetic texts are raised within this tradition, they are seen as an invari-

ant transhistorical aspect of the text itself.[35] That is, according to some critics at least, there is a relative inattentiveness to the historically contingent factors that engender cultural politics.

Art, Autonomy and Critical Consciousness

According to Perry Anderson, the tradition of Western Marxism has been defined by a resilient distance to the actual workings of radical socialist politics in the twentieth century and a concomitant focus on philosophy and culture.[36] While undoubtedly a bit overzealous in his general indictment, the work of the Frankfurt School is an exemplary model of the dilemmas that Anderson argues are associated with this tradition. Within their writings (particularly those of Theodor Adorno and Herbert Marcuse), one finds a pessimistic appraisal of the possibility of socialist political action with a neo-Romantic emphasis on the political potentialities of art and culture. More specifically, they argue that, given the shrinking of the political possibilities of proletarian revolution and concomitant growth of one-dimensional society, one must begin to look to more individual spheres for the possibility of critique. Art becomes construed as intimately political by the fact that it harbors the possibility of a critical consciousness necessary for political change. In this conception, the artist's connection to larger political forces, let alone to particular ideological discourses, is not a necessary condition for designating aesthetic works as political. No matter what the "politics" behind its production, art will have identifiable, or at least, understandable, political effects.

Central to their claims about the political potential of art is that in its very autonomy from society and traditional politics (whether "traditional" Marxist or liberal politics), art is most "political," indeed even revolutionary. To understand this seemingly contradictory claim, we need to take into consideration their assumption that late capitalist society is either "one-dimensional" (Marcuse) or "administered" (Adorno): the growth of the technological and productive apparatus of advanced capitalism have all but eradicated the possibility of radical praxis, let alone critical thinking. As Adorno has argued: "what the philosophers once knew as life has become the sphere of private existence and now of mere consumption, dragged along as an appendage of the process of material production, without autonomy or substance of their own."[37]

For both Adorno and Marcuse, the capitalist commodification of human life has been enhanced by the very extent of its penetration into the subject: the individual's own instinctual drives—forces that potentially contest their domination and evoke a new life of freedom and happiness—have been repressively desublimated under the aegis of "technological rationality."[38] With the further integration of the critical subject into the apparatus of commodity production in late capitalism, the chance for liberation rests in what at first sight seems the most distant and nonpolitical of spheres—the aesthetic work. In his more optimistic gestures, Marcuse still perceives political potentialities in those marginal groups not yet sequestered by the dominant technological rationality (students, margi-

nalized cultures), and thus still conceives of a more conventional "politics" of liberation. Adorno, on the other hand, forever dismayed by real political alternatives, sees only the possibility of real political action in those "waste products and blind spots" that have "outwitted the historical dynamic"[39]: critical philosophy and the aesthetic work.

In this characterization of cultural politics, we can perceive that Adorno and Marcuse both perceive a *displacement* or *sublimation* of politics from the sphere of history and social action into the realm of art. Moreover, because of their pessimistic appraisal of the recuperative process of advanced capitalist society—where the possibility of "non-identity," individuality and Eros have dwindled—agential properties inhere in the least "committed" (in the political sense) aesthetic work. The political hope evinced by art arises from its ability to estrange the reified senses of the individual, thus "opening the horizon of change (liberation)."[40] In Marcuse's polemic against traditional Marxist aesthetics this position is clearly stated:

> Literature is not revolutionary because it is written for the working class or for "the revolution." Literature is revolutionary in a meaningful sense only with reference to itself, as content having become form. The political potential to art lies only in its own aesthetic dimension . . . The more immediately political the work of art, the more it reduces the power of estrangement and the radical, transcendent goals of change. In this sense, there may be more subversive potential in the poetry of Baudelaire and Rimbaud than in the didactic plays of Brecht.[41]

As the above quotation suggests, the political character of art resides in its own ability to transform a given social content (which is expressive of actual or historical conditions of the reified social whole) into aesthetic form. It is "political" by the very fact that it has become the self-contained whole of a play, poem, novel, etc. In so doing, Marcuse avers, the work of art assumes a certain significance and "truth" of its own. It not only reflects the "truth" of societal domination in its very autonomy (a position that Adorno also argued), but it necessarily reshapes "language, perception, and understanding so that they reveal the essence of reality in its appearance: the repressed potentialities of man and nature. The work of art thus re-presents reality while accusing it."[42]

In Marcuse's theory, art's ability to rupture the individual's normalized senses and perceptions, and thereby "defy the rationality and sensibility incorporated in the dominant social institutions,"[43] lays the initial foundation for liberating political action. It at least reopens the possibility of "remembrance," an experience denied by the administered world, and thus "spurs the drive for the conquest of suffering and permanence of joy."[44] Similarly, Adorno sees the political and radical potential of the art work in its unwillingness to be "part of the system of practical activities and practical human beings" thereby denouncing the "the narrow-mindedness and untruth of practical life."[45] Yet, such autonomy, while a necessary prerequisite for its critical posture toward society, inevitably bars it from the real political processes of change. As Adorno further notes: "the

impact that works of art have operates at the level of remembrance; impact has nothing to do with translating their latent praxis into manifest praxis, the growth of autonomy having gone too far to permit any kind of immediate correspondence."[46]

For both Marcuse and Adorno, art has agential potentialities given the perceived closure of political space. Political knowledge is essentially defined as the cognitive apperception of "real" and transcendental human interests: freedom, happiness, joy. Given that the normal everyday life-world has been reified under advanced capitalism, this political knowledge can only arise from the experience appropriate to the aesthetic work. At the same time, neither of these thinkers is willing to make the further claim that aesthetic works are viable political acts. In this hesitancy to move politics completely into the aesthetic realm, we are no doubt encountering the Marxist heritage in their thought: to play upon Marx's eleventh Thesis on Feuerbach, while art may be necessary for gaining political knowledge of our repressed needs, the real point is to change the world in accordance with that insight. All art can do, in its own distant praxiological way, is to start this political process of change by eliciting pictures, images and experiences of a future liberated life.

What is then very clear is that in both of their theories there is still some sense of the difference between politics and art. This is partly due to the fact that significant political action is conceived as an all-embracing, totalizing act: it must inevitably overthrow the whole system of commodity production under advanced capitalism for it to be relevantly "political." There is thus always a self-conscious sense of the limits of their aestheticist position—while art is necessarily the contemporary terrain of politics, it really can never replace the "lost" political realm of social change (even proletarian revolution). As Adorno so perspicaciously revealed about his own theorizing: "In the face of the totalitarian unison with which the eradication of difference is proclaimed as a purpose in itself, even part of the social force of liberation may have temporarily withdrawn to the individual sphere. If critical theory lingers there, it is not only with a bad conscience."[47]

Aesthetic Text as Politicizing Practice

When we move our sights to more recent articulations of the aestheticist position inspired by structuralist and poststructuralist theory we are struck with the way in which the conceptual and political hesitation of the Frankfurt School has been overcome. As we noted earlier, postmodern theory gives the aesthetic realm conceptual priority. Thus, while we could still talk about the "aesthetic dimension" to politics in Adorno and Marcuse, in which art is "political" because of the deferral of real political action in society, we are now confronted with what may be more properly called the "political dimension" of aesthetics, in which politics is really possible only because of the literary and figurative nature of human reality.

One of the more important interventions in this way of understanding the politics of art is the work of Michael Shapiro. In his article, "Literary Production as a Politicizing Practice," Shapiro outlines well the way in which poststructuralist reading of cultural politics might look like. In the process of critically explicating his position, we can perceive the underlying assumptions that have consistently been part of the aestheticist orientation of postmodern thought.

Following the claims of Heidegger and Foucault, Shapiro argues that we can overcome the epistemological impasse implicit in Enlightenment thought by assuming that the subject is historically, socially and linguistically embedded. What this implies is that both the subject and object are mutually constituted in textual production. If political and social events are seen as "texts," as a product of prior literary figurations that utilize metaphors, tropes, etc., then we can no longer talk about an independent world of political "objects" (the poststructuralist argument being that all political objects within social theory are constituted by the particular narratives with which the social scientist comes to the political world, narratives that are part of the life-world of the knowing subject).

The poststructuralist notion of "textuality" thus provides Shapiro with two important elements toward understanding the nature of cultural politics. First, the assumption that the "text" is the primary site in which subjects and objects are constituted points to the possible permutations of power. Accepting the Sausserian notion that meaning derives from the relationships between signifiers, not from their quality of representing a referent or object in the world, Shapiro argues that "textualism denies epistemic privilege to both the object or referent of a statement to the subject/author of the statement. What replaces the referent and the intentional consciousness of the subject is the text."[48] This implies that the "text" is potentially constituted in a plurality of ways, related to the many possible combinations of signifiers. What then accounts for the sedimentation of "myths" and "fetishes"—and in this respect, the production of a particular subject of knowledge and of a certain object or referent in our experience—are the relations of power and the value systems ensconced in the text. In this sense, when the "text" exhibits a certain univocal meaning, it is reflecting underlying power constellations or political relationships. Moreover, in using methods predicated on the attempt to grasp objective facts or universal truths, interpreters are unknowingly supporting these immanent grids of "domination."

Second, the notion of textuality opens up the possibility of perceiving the important resisting dimension to art. In this sense, Shapiro locates both a cognitive and agential property to literary production. If texts are potentially open, not bounded by a particular meaning or object in the world, then when there is a reification of meaning we are directly experiencing relations of power or domination. Literature, according to Shapiro, as a discursive practice based upon figuration, provides an important site for understanding or "experiencing" the way in which discourses in general constitute "the world of objects and subjects" given that it presents itself as a "fiction." Moreover, because it does exhibit its textual quality, literary production elucidates the possibility of the "openness" of texts, which simultaneously points to new creative and political potentialities

while criticizing the prevalence of political closure associated with "myths" and "fetishes."[49]

But, more importantly, Shapiro sees literary production as a way to directly confront relations of power imminent in discourses. If power is manifested in the congealing of meanings and "things" in our discursive practices, then literature's ability to create new metaphors, new "things," new subjects, etc., in it figural production contests the political realm; that is, literature, conceived as "text," becomes for Shapiro the very site for political action. After a fairly detailed examination of the political discourses of Mann and Beckett, Shapiro delineates this dual political quality of literary production:

> Literary discourse, particularly in its modernist guise, is hyperpoliticizing. By producing alternative forms of thought in language, it makes a political point. By virtue of its departure from linguistic normality, it points to the way that institutions hold individuals within a linguistic web. But it goes beyond this demonstration. It deforms images to show how accepted models of the real are productions of grammatical and rhetorical constructions, and it forms antagonistic imagery that provides sites for resistance to domination. A failure to exercise a literary self-consciousness, then, amounts to the adoption of a depoliticizing posture, the acceptance of institutional imperatives.[50]

As in the neo-Marxist perspective on cultural politics, literary discourse has the ability to break through reified, habituated forms of thought, to deform images; moreover, it engenders "sites for resistance to domination." In a similar vein, Lyotard has argued that cultural politics resides in those attempts by the artist to "deconstruct" the ordered, "the formed, the most directly plastic aspect of painting, photography, or the film," so as to "show that this 'order' conceals something else, that it represses."[51] It is thus in the literary or formal deconstruction of signs—whether written, painted, or photographed—where the poststructuralist finds a basis for political action.

How this position differs from the Frankfurt School version is that it essentially reinscribes the idea of political action as one internal to the aesthetic work or text. Because of our embeddedness in signification systems, the ability to contest power imminent in the reification of signs implies a "political" act. If Adorno and Marcuse saw the art work as a site of political knowledge necessary for the *possibility* of critical political action, but not synonymous with real political change, poststructuralism understands the very act of figural and literary production as political "resistance." That is, if we were to draw upon a conception of Foucault's, aesthetic production for the poststructuralist represents a "local, specific struggle" against relations of power.[52]

It is in these notions of "resistance" and "local, specific struggle" that one finds a conception of the limits of viable political action: for the poststructuralist, it is impossible for there to be a totalizing political act like revolution for all such acts not only assume that there is a specific center to societal domination that can be attacked (which ignores, especially for Foucault, that power is widely and intimately dispersed throughout society), but also that it is possible

to somehow liberate ourselves from relations of power (which eschews the fact that historically all "liberation" has really only been a manifestation of the "positivity" of power).[53] Given this construal of the pervasiveness of power, poststructuralism has claimed that the only possible political strategy is to resist it in local ways. In this respect, certain forms of aesthetic production, like other local strategies, are significant political acts.

Learning from the Aestheticist Position: Pitfalls and Potentials

What is theoretically significant about the aestheticist position seen in both its neo-Marxist and postmodern guises is that it focuses our attention on the ways aesthetic works and discourses are intimately involved in the process of social and political change. In so doing, it proposes ways in which to conceive of political knowledge and political action in terms of the specificity of the art work or text, and not in terms of an already defined, exterior realm of politics. Thus, whether we understand art as either "aesthetic form" or "textuality," this position at least challenges us to get beyond the reductionism of certain forms of Marxist cultural analysis and take up seriously the question of cultural politics.

Yet, while these theoretical positions do provide impetus toward an analysis of art, they also exhibit a number of constraints and problems. First, as we saw within the Frankfurt School version, aesthetic works become "political" by their very distance from political and social practices. In so doing, aesthetic works provide a basis for knowledge about universal human values that then can contest the reified social world. The pessimism and "melancholy" implied in this characterization need no clarification here.[54] Rather, what is most striking for our purposes is that it replicates a general philosophical disposition towards the politics of art, only now claiming that along with critical philosophy, genuine works of art *qua* works of art generate significant truths about humans that provide a basis for enlightened and liberating political action. For Marcuse, these aesthetic truths are necessarily transhistorical, for it is in their emancipation "from the given universe of discourse and behavior" that they elicit "a reality which is suppressed and distorted in the given reality."[55] While Marcuse, and sometimes even Adorno, view realist art as subversive in this sense, it is primarily within the most anti-realist, dissonant art works that they locate such a critical cognitive dimension. In a similar vein, the poststructuralist version lauds the most modernist and postmodernist texts as those which provide a site for understanding the figurative nature of reality and a platform for engaging in political resistance. While this latter perspective indeed wishes to avoid any notion of transcendental truths, it is the very essentialist claim of *différance* (to use Derrida's term), or of the constant deferral of meaning within any symbolic system, that becomes the transcendental horizon for premising the political character of these texts.[56]

While the aestheticist rightly focuses on the specificity of the art work's cognitive dimension to find its inherent political quality, it does so by positing these specific truths or experiences within a transhistorical and transcendental

framework. In valorizing those art works and texts that are radically dissociated from the repressive discourses of advanced capitalist society (whether viewed as one-dimensional or power-laden) as those most prone to eliciting critical knowledge, it feels compelled to locate art's political claims in a limited and particular formal realm. In so doing, they constrain our understanding of the ways in which other "aesthetic ideologies," to borrow Terry Eagleton's term, may provide a basis for political knowledge.[57] Indeed, even under the social conditions assumed by the aestheticist it is not clear such aesthetic forms would represent critical forces. It has been argued by Fredric Jameson that the poststructuralist's emphasis on the political potentialities of the polyvalent or "schizophrenic" text really only replicates the fragmentation and reification that is symptomatic of our domination under late capitalism.[58] Thus, to push even further the "break up" of linguistic "myths" through literary production may really only reinforce these practices of power. In a similar vein, Gerald Graff has claimed that "the politics of anti-realism," which he sees proposed in the writings of Marcuse and the poststructuralists (though we could easily add Adorno to this group), helps to reaffirm the political impotency generated by consumer society: it further marginalizes the political potentialities of art (by further exacerbating the spiral of artistic alienation) and works against the terms of political discourse necessary for radical change (in that in attacking shared linguistic practices as ideological or power-laden *tout court*, it removes the basis for political demystification, one that would ultimately rest "on an appeal to a real world of things, relations, and processes outside language").[59] All art works—whether autonomous or politically committed, whether realist or anti-realist, whether in the form of literature or architecture—may provide, under specific social and historical conditions, a space for grasping, or actually constituting, political knowledge.

Second, we uncovered within the poststructuralist version an attempt to portray literary production as a political act in itself. This conceptualization stemmed not only from their underlying assumption about the presence of power within any discourse with stable and reified meanings (and thus certain forms of aesthetic production, in breaking up meanings and constituting new ones, is a political act), but also from the understanding that political action must of necessity (given the pervasiveness of power) be a local and specific activity. While this conception of politics does help to break through some of the more atavistic notions of politics in the discipline of politics by focussing on the multifarious realms in which power and politics circulate, it also expands the notion of politics beyond any meaningful sense. As a provisional definition, we may say that aesthetic production can only be a political act if it is somehow linked up with the political claims and actions of significant historical actors. The key is then to try and locate the many ways in which aesthetic production mediates, intersects, and constitutes these larger political processes.

A first step in overcoming some of these problems with the aestheticist position is to historicize our notions of political knowledge and political action. Within the discipline of political theory at least, this methodological move has clearly surfaced within the work of J. G. A. Pocock, Quentin Skinner, and Rich-

ard Ashcraft.[60] This "new historicist" approach within political theory explicitly attempts to break with philosophical approaches to the history of political thought by arguing that all political theory is part of the political and ideological discourses in which the theorist wrote and acted. Thus, for instance, Ashcraft has argued that political theory "is both a form of social consciousness that, as Hegel put it, allows individuals to feel at home in the world they have created, and at the same time, it supplies the criteria according to which the social actions appropriate for changing that world are rendered meaningful."[61] Importantly, once political knowledge and political theory are viewed as integral aspects of the social life-world of the particular historical period under examination, political theory no longer resides within formal philosophical treatises; it germinates within diverse and varied "paradigmatic structures,"[62] which implies not only that political language is fundamentally a polyvalent and overdetermined discursive act, but also that it is constituted in various media of which aesthetic works and discourses may represent a significant form.

Thus, political theory may be understood not only as those texts which systematically discuss "justice" or "political constitutions," but also as any cultural artifact or discourse that is part of the ideological process by which historical actors constitute their political interests and develop their political subjectivities. Along these lines, Ashcraft argues that if political theory is the symbolic process by which certain individuals and social groups rationalize and organize their interests, and indeed make sense of their social life-world, then one should look not just to the conventional canon of philosophical texts (the "tradition" normally conceived), but also to "newspapers, pamphlets, broadsides, and various literary forms (plays, novels, poetry). Political theory as a social language flows through all these media."[63] We might add that if political theory engages these literary media, it is also constituted by the symbolic languages of the visual, plastic and decorative arts. Thus, painting, sculpture, and architecture also become a terrain for political conflict and the constitution of political subjects. If we were to begin with a conception of political theory and political knowledge as an active and variable form of discourse linked to the political claims and practices of historical actors, we would be able to accept aesthetic works as an important facet of this dimension of human endeavor.

In being an aspect of political discourses in this way, it can be shown that aesthetic works are involved in what Skinner calls "normative vocabularies," discourses that invariably constrain the possible pathways of political action.[64] It is in this respect that we can begin to talk about a relation between art and political action. At the same time, aesthetic works and texts may also be involved in constituting the possibility of alternative political practices for the historical actor. This is indeed the important insight gained from the aestheticist trajectory. But this potentiality for elaborating alternative political strategies is not a priori present within aesthetic works or texts; it does not rest, as the aestheticist argues, within a transcendental realm of aesthetic truths or experiences but rather within the specific historical conditions that engender a convergence and/or contestation between aesthetic and political discourses.

What is then necessary is a theory of cultural politics that *historically* locates the multiple ways in which aesthetic works and discourses constitute political knowledge and political action. The important lesson from the aestheticist position, and one that indeed overcomes some of the more simplistic analyses in the discipline of politics, is that art has peculiar formal and discursive properties that make it potentially political. It has its own specificity, and because of that, it has a peculiar "political" dimension. Moreover, the aestheticist position also warns us against the persistent temptation to conceive of the aesthetic realm as *merely* an emanation of some underlying and originary realm of social and political struggle. Instead, it asks us to recognize the specificity of the aesthetic realm, articulating its relation to political conditions as more mediate, less direct. As already noted, if anything has plagued the Marxist and sociological traditions up to very recently it has been this very tendency to conceive of all cultural phenomena as simply a *reflection* of social conditions.[65] Thus, it is important that we continually take care not to efface the particular and unique efficacy that the aesthetic realm has in this relationship.

Yet, if it has brought us to a heightened sense of the specificity of the aesthetic realm in cultural politics, it has done so by effacing the importance and conditions of the political realm. Thus, while overcoming the reductionism that inheres in more traditional analyses of cultural politics, it initiates its own theoretical terrorism by articulating politics completely in terms of a transcendentally inscribed "aesthetic work" or "text." What the new historicist teaches us is that to understand whether the specific dimensions to art are really political, not just potentially so, requires us to step outside the formal boundaries of the "aesthetic work" or "text" and focus on its interrelationship to social and political struggles. Not only would these historical studies provide a vantage point from which to analyze the various ways and means by which aesthetic works and discourses engage the political realm, but it would also establish a conduit for drawing upon that body of work within the social sciences that already analyzes political movements and political change.

I wish to argue that this type of analysis generates a necessary interdisciplinary dialectic: it helps to fertilize the sometimes barren treatises in cultural criticism that talk about politics, but cannot seem to get beyond the formal properties of the art work. In this respect, "politics" would gain the substantive and historical weight it deserves. On the other hand, it also opens the disciplines of political science and political theory to a fuller sense of the historical "particularities of politics" in which the regional ontology of politics seems to shift into different spheres of life, areas that at first glance seem distantly related to one's original concern. Importantly, if political theory is to engage the practical and historical dimensions of politics, it must at times become cultural criticism. To play upon a statement by Adorno quoted earlier, one can only hope that it will be done with a *good conscience*.

Morris, Cultural Politics, and a Materialist Aestheticist Position

When William Morris claims that it is not "possible to dissociate art from morality and politics," he was writing as an artist who had come to realize that truly living art was only possible given radical transformations in the working conditions of Englishmen. Later, as a revolutionary socialist, Morris's concern for instituting beauty would be completely transposed onto the plight and possibilities of the working class. What could the words of an aesthetic reformer turned revolutionary of late nineteenth-century England have for our understanding of cultural politics, let alone the viability of postmodern conceptions as Lyotard's? If anything, Morris's premonitory discussions bring us to the degree zero of cultural politics, the initial crossroads of aestheticism with revolutionary politics. Ultimately, the originality of Morris's conception of cultural politics is easily overlooked by the very facility in which it can be discerned in his biographical details: an apolitical artist turned revolutionary socialist who could not help but discuss beauty in his conception of socialism. Nothing could, on the surface at least, so easily portray the interrelationship of the aesthetic and the political. More importantly, Morris was painfully aware of the dissociation between those spheres of life that he would claim were similar in great "matters of principle." And, indeed, it is in this very sense of ontological distance that Morris's conception of cultural politics provides such an important corrective to the willingness to forsake the political (in all of its non-discursive weight) for the aesthetic. What I hope will become apparent is that Morris will provide a much needed reassessment to the viability of the current form of aestheticist politics, articulating a position that ultimately realizes both the limitations and connections between art and politics.

What Morris presents to us is a *materialist aestheticist position* that clearly accepts the importance that "beauty" and other aesthetic criteria can have in engendering political action, but which is willing to see that politics demands a different logic and set of institutions, that it involves collective struggle and institutional power. To so realize, I would argue, is "materialist" in two intimately related ways: first, it does not conflate the institution of art with political institutions, thereby avoiding the pitfalls of assuming that renderings within art can be immediately translated into political transformations. While the aestheticist position within cultural theory have brought the importance of art to the forefront, it has not understood them within a larger political rendering of the importance of collective action. Second, it is materialist because it resolutely lodges the discussion of art within the structural dimensions of the social and economic lifeworld.

With these conceptual considerations in mind, the next chapter begins the historical excavation of nineteenth-century England by looking to a particular cultural event that clearly represents a symbol of England's cultural, political and economic development during the Victorian period. The Great Exhibition of 1851 provides a tantalizing entry point for our discussion of Morris: it is a spectacle that at once gives us a window into the social conditions that define this

period, while at the same time showing the peculiar way in which political aspirations and cultural practices were being mutually articulated.

Notes

1. Morris, "The Art of the People," in *Collected Works of William Morris*, May Morris, ed. (London: Longman and Green and Co., 1914), hereafter referred to as *CW*, Vol. XXII, 47.
2. For a concise and critical discussion of key figures in this tradition, see Stephen Best and Douglas Kellner, *Postmodern Theory: Critical Interrogations* (New York: Guilford Press, 1992). I use this term as a shorthand to articulate "family resemblances," knowing full well the theoretical and political differences that exist between those theorists generally placed under its rubric.
3. Allan Megill, *Prophets of Extremity: Nietzsche, Heidegger, Foucault, Derrida* (Berkeley: University of California Press, 1985), 2. Recently, Jonathan Loesberg, in *Aestheticism and Deconstruction: Pater, Derrida, and De Man* (Princeton: Princeton University Press, 1991), has made a similar argument concerning the connection between aestheticism and postmodern thought, only arguing, pace Megill, that aestheticism (and thus deconstruction) has an inherent historical and political dimension.
4. Megill, *Prophets of Extremity*, 2.
5. Michael Shapiro, "Literary Production as a Politicizing Practice," *Political Theory* 12, no. 3 (August 1984).
6. Shapiro, "Literary Production," 410.
7. Megill, *Prophets of Extremity*, 9-13.
8. See Lyotard, "Answering the Question: What is Postmodernism?" in *The Postmodern Condition*, 78. In his earlier work, Lyotard seems to side with Adorno in his claim that the liberatory nature of art lies in it ability to pry open the ordered and formal qualities of its presentation. See, "On Theory: An Interview," in *Driftworks* (New York: Semiotext(e), 1984), 28-29. See also those essays that deal with contemporary art in Andrew Benjamin, ed. *The Lyotard Reader* (Cambridge: Basil Blackwell, 1989).
9. Lyotard, *The Differend: Phrases in Dispute*, Georges Van Den Abbeele, trans. (Minneapolis: University of Minnesota Press, 1988).
10. See Lyotard and Thebaud, *Just Gaming* (Minneapolis: University of Minnesota Press, 1985), 100.
11. Lyotard and Thebaud, *Just Gaming*, 90. In *Logics of Disintegration: Post-Structuralist Thought and the Claims of Critical Theory* (London: Verso Press, 1987), 138-143, Peter Dews argues that this comment is actually a self-criticism of his earlier expousal of a politics of desire and intensities most clearly argued in *The Libidinal Economy*, I. Hamilton Grant, trans. (Bloomington: Indiana University Press, 1993).
12. See Best and Kellner, *Postmodern Theory*, 160-179, for a critique of his later work.
13. Given the institution of poetry as a moral and political discourse in Greece prior to Socrates, I tend to agree with Hans-Georg Gadamer that the "quarrel with the poets" is based on moral, pedagogical and political reasons. See "Plato and the Poets," in *Dialogue and Dialectic: Eight Hermeneutical Studies on Plato*, P. Christopher Smith trans. (New Haven: Yale University Press, 1980).
14. Gunnell, *Between Philosophy and Politics*, 41.

15. A general overview of the importance of aesthetic works and discourses in the tradition of social radicalism in Western Europe can be found in Donald Drew Egbert, *Social Radicalism and the Arts: Western Europe* (New York: Alfred A. Knopf, 1970). The interrelation between culture, art and politics has recently become an important topic in intellectual history. For instance, a provocative attempt at understanding the importance of aesthetic and cultural practices (rhetoric, sculpture, dress, and the visual arts) in constituting the political process of the French Revolution can be found in Lynn Hunt, *Politics, Culture, and Class in the French Revolution* (Berkeley: University of California Press, 1984). See also Alice Yaeger Kaplan, *Reproductions of Banality: Fascism, Literature and French Intellectual Life* (Minneapolis: University of Minnesota Press, 1986), for an interesting discussion of the role of literature (e.g., Celine) in the rise of Fascism in France.

16. For a critical discussion of these limitations within the disciplines of political science and political theory, see Bradley J. Macdonald, "Political Theory and Cultural Criticism: Towards a Theory of Cultural Politics," *History of Political Thought* XI, no. 3, (Autumn 1990): 510-514.

17. Janet Wolff, *The Social Production of Art* (New York: New York University Press, 1984), 1. For a discussion of the resilience of this methodological assumption within American literary studies, see Frank Lentricchia, *After the New Criticism* (Chicago: University of Chicago Press, 1980).

18. Fredric Jameson, *The Political Unconscious: Narrative as a Socially Symbolic Act* (Ithaca, NY: Cornell University Press, 1981), 20.

19. Of course, Jameson has had a lot to do with revitalizing this tradition and bringing it forward to contemporary scholars. See his magisterial, *Marxism and Form: Twentieth-century Dialectical Theories of Literature* (Princeton: Princeton University Press, 1971). For more general sampling of the many positions within this tradition, see Maynard Solomon, ed., *Marxism and Art: Essays Classic and Contemporary* (Detroit: Wayne State University Press, 1979); Berel Lang and Forrest Williams, eds., *Marxism and Art: Writings in Aesthetics and Criticism* (New York: David McKay Co., 1972); and, Chris Bullock and David Peck, *Guide to Marxist Literary Criticism* (Bloomington: Indiana University Press, 1980). Also, we cannot leave out the work of Terry Eagleton, particularly his critical overview of the Marxist tradition of cultural criticism, *Marxism and Literary Criticism* (Berkeley: University of California Press, 1976).

20. Marx, "'Preface' to a Contribution to the Critique of Political Economy," in T. Carver, ed. *Marx: Later Political Writings* (Cambridge: Cambridge University Press, 1996), 160.

21. For a representative discussion on this issue, and a view of the different positions, consult, Franz Jakubowski, *Ideology and Superstructure* (London: Allison Busby, 1976); Louis Althusser, "Ideology and Ideological State Apparatuses," in *Lenin and Philosophy* (New York: Monthly Review Press, 1971), 127-186; John Mepham, "The Theory of Ideology in *Capital*," in *Issues in Marxist Philosophy, Volume III: Epistemology, Science, Ideology*, John Mepham and David Hillel Ruben, eds. (London: Harverster Press, 1979), 141-173; Stuart Hall, "The Problem of Ideology—Marxism Without Guarentees," *Journal of Communication Inquiry*, 10:2, (Summer 1986): 28-60; and, Michele Barrett, *The Politics of Truth: From Marx to Foucault* (Stanford: Stanford University Press, 1991).

22. Wolff, *The Social Production of Art*, 80-86.

23. Arnold Hauser, *The Social History of Art* (4 Vols.) (New York: Vintage Books, 1951), and *The Philosophy of Art History* (Evanston: Northwestern University Press, 1985) for representative analyses by Hauser. See also the work of Raymond Williams, especially *The Sociology of Culture* (New York: Schocken Books, 1981).

24. As Hauser notes in "Ideology in the History of Arts," in *The Philosophy of Art History*: ". . .we frequently get a situation in which the spiritual tendencies are much more tangled, more pervaded by deep-seated oppositions than the economic; in which, as for example in the age of the enlightenment, the ruling class was already spiritually divided into two hostile camps while economically it still maintained an appearance of unity" (33).

25. Marx, *Theses on Feuerbach*, in R. Tucker, ed. *The Marx-Engels Reader* (New York: W. W. Norton, 1978), 143.

26. For a recent discussion of Bourdieu's notions of the "field" and "habitus," see Pierre Bourdieu and Loic J. D. Wacquant, "The Purpose of Reflexive Sociology (The Chicago Workshop)," in *An Invitation to Reflexive Sociology* (Chicago: University of Chicago Press, 1992), 94-140.

27. Bourdieu, *Distinctions: A Social Critique of the Judgements of Taste* (Cambridge, Mass.: Harvard University Press, 1984), especially, 44-50.

28. Bourdieu, "The Purpose of Reflexive Sociology (The Chicago Workshop)," 104-105.

29. For a recent collection of essays that in various ways explores the importance of Althusser's theoretical innovations for engaging current theoretical and political issues, see D. Ruccio and A. Callari, eds. *Postmodern Materialism and the Future of Marxist Theory: Essays in the Althusserian Tradition* (Hanover: Wesleyan University Press, 1996).

30. Pierre Macherey and Etienne Balibar, "Literature as an Ideological Practice: Some Marxist Propositions," in *Praxis: A Journal of Cultural Criticism*, no. 5 (1981): 50.

31. Macherey and Balibar, "Literature as an Ideological Practice," 50.

32. Michael Sprinker, *Imaginary Relations: Aesthetics and Ideology in the Theory of Historical Materialism* (London: Verso Press, 1987), 282.

33. Wolffe, *Social Production of Art*, 80-86.

34. Macherey and Balibar, "Literature as an Ideological Practice," 54-58.

35. See Tony Bennett, *Formalism and Marxism* (London: Routledge, 1979), 127-142.

36. Perry Anderson, *Considerations on Western Marxism* (London: Verso, 1976).

37. Adorno, *Minima Moralia: Reflections from Damaged Life*, E. F. N. Jephcott, trans. (London: Verso, 1974), 15. For a similar, though more elaborate, discussion of the bases of the liquidation of individuality and radical potential, see Marcuse, *One-Dimensional Man: Studies in the Ideology of Advanced Industrial Society* (Boston: Beacon Press, 1964).

38. Marcuse, *One-Dimensional Man*, 78.

39. Adorno, *Minima Moralia*, 151.

40. Marcuse, *The Aesthetic Dimension: Towards a Critique of Marxist Aesthetics* (Boston: Beacon Press, 1977), xi.

41. Marcuse, *The Aesthetic Dimension*, xxi-xxii. A similar, though less ecstatic, praise of the political reserve of autonomous art can be found in Adorno's essay, "Commitment," in *The Essential Frankfurt School Reader*, Andrew Arato and Eike Gebhardt, eds. (New York: Urizen Books, 1978), 300-318. For a more elaborate

discussion of this issue, see Adorno's posthumously published treatise on aesthetics, *Aesthetic Theory*, C. Lendhardt, trans. (London: Routledge and Kegan Paul, 1986), in particular, Chapter 12, "Society," 320-369.

42. Marcuse, *The Aesthetic Dimension*, 8.
43. Marcuse, *The Aesthetic Dimension*, 7.
44. Marcuse, *The Aesthetic Dimension*, 73.
45. Adorno, *Aesthetic Theory*, 342-343.
46. Adorno, *Aesthetic Theory*, 343.
47. Adorno, *Minima Moralia*, 18.
48. Shapiro, "Literary Production," 388.
49. Shapiro, "Literary Production," 394-396. Following Roland Barthes, Shapiro sees "myths" as those universal and common sense meanings that are part of the ideological practices of dominant groups. See "Myth Today," in *Mythologies*, Annette Lover, trans. (New York: Hill and Wang, 1985), 109-159. Loosely following Marx, Shapiro characterizes "fetishes" as objects that have taken on a life of their own (as if they existed outside of human intervention), hiding the fact that they are actually human constructions.
50. Shapiro, "Literary Production," 410.
51. Lyotard, "On Theory," in *Driftworks*, 28-29.
52. See Foucault, "Truth and Power," in *Power/Knowledge: Selected Interviews and Other Writings, 1972-1977*, Colin Gordon, trans. (New York: Pantheon Books, 1980), 130. See also "Intellectuals and Power," in *Language, Counter-Memory, Practice: Selected Essays and Interviews*, Donald Bouchard and Sherry Simon, trans. (Ithaca, NY: Cornell University Press, 1977) where Foucault argues that the primary function of the intellectual is to struggle within his particular domain against "forms of power that transform him into its object and instrument" (208).
53. See also Foucault's discussion of power in *History of Sexuality, Volume One: An Introduction*, Robert Hurley, trans. (New York: Vintage Books, 1980), 123-143.
54. See Gillian Rose, *The Melancholy Science: An Introduction to the Thought of Theodor Adorno* (New York: Columbia University Press, 1978) for a discussion of this tendency in Adorno.
55. Marcuse, *The Aesthetic Dimension*, 6.
56. For a discussion of this transcendental horizon within Derrida's thought, see Dews, *Logics of Disintegration*, 1-44.
57. Eagleton, *Criticism and Ideology* (London: New Left Books, 1976), 44-101.
58. Jameson, *The Political Unconscious*, 42.
59. Gerald Graff, *Literature Against Itself: Literary Ideas in Modern Society* (Chicago: University of Chicago Press, 1979), 90.
60. One of the important characteristics of this methodological move—what we may call "new historicism" in the field of political theory—is its reengagement with political and ideological history to interpret political theory, integrated with analyses based on new developments in the study of language. These latter developments stem from new concerns in analytic philosophy (e.g., Searle's speech act theory), sociological theory or structuralist/poststructuralist insights. All three of the theorists mentioned engage in one way or another in this methodological move. For representative discussions of their approaches, consult Quentin Skinner, "Preface," in *The Foundations of Modern Political Thought, Volume One: The Renaissance* (Cambridge: Cambridge University Press, 1978), x-xv; J. G. A. Pocock, "Introduction: The State of the Art" in

Virtue, Commerce, and History: Essays on Political Thought and History, Chiefly in the Eighteenth Century (Cambridge: Cambridge University Press, 1985), 1-34; and Richard Ashcraft, "Introduction" in *Revolutionary Politics and Locke's Two Treatises on Government* (Princeton: Princeton University Press, 1986), 3-16.

61. Ashcraft, *Revolutionary Politics*, 5.
62. Pocock, *Virtue, Commerce, and History*, 8.
63. Ashcraft, *Revolutionary Politics*, 7.
64. Skinner, *The Foundations of Modern Political Thought*, xiii.
65. For an insightful discussion of this issue as it relates to the Marxist tradition, see Raymond Williams, "Base and Superstructure in Marxist Cultural Theory," in *Problems in Materialism and Culture* (London: Verso Press, 1980), 31-49. In this respect, the greatest strength of the Althusserian tradition is its insistence on the productive specificity of the aesthetic text.

Chapter Two

The Great Exhibition and the Class Politics of Art

The Great Exhibition of 1851 may seem a distant event from which to begin a work on William Morris. It took place seven years before Morris published his first set of poems, *The Defense of Guenevere*, ten years before his commercial venture into the decorative arts, and over thirty years before his socialist activism. Thus, the constellation of practices associated with the "great fact of 1851" seem to lie squarely outside the boundaries of Morris's adult life as a poet, decorative artist, and political theorist. Yet, the economic, political, and cultural processes that were clearly present in this spectacle—practices that were beginning to take particular forms and definitions—were the very same that provoked Morris into his activities as an aesthetic reformer and a socialist revolutionary. These included, on the economic plane, the further entrenchment of capitalism, and the continued plight of the working classes; in the political arena, the growth of reformist liberalism in all its manifestations; and, in the realm of art and culture, the proliferation of mass produced art goods—what one organizer of this event, Henry Cole, had called "art manufactures."[1] Importantly, as an event of cultural politics the Great Exhibition elucidates the movement of capitalism into the sphere of culture, and as a consequence, the politicization of these very cultural practices. Within this spectacle, the architectural site and the decorative arts on display became symbolic acts for class identification and the constitution of political subjectivities. Indeed, as a grandiose forum for displaying the wonders of the world's industrial manufactures, the Great Exhibition raised dramatically the issue of the relation of these manufactured art goods to the interests and well-being of the working classes, an issue never raised to such a public level before, and one that would become important in Morris's thinking.

Morris visited the Great Exhibition at the Crystal Palace, and while he was moved by the splendor of this spectacle, he remarked that it was "wonderfully ugly."[2] What is interesting is that this phrase has a certain historical truth to it: it hints at the underlying political conflict that the event tried to transcend, but which could not help but inform its supposed grandeur. For while the Great Exhibition was a "wonderful" display of architectural ingenuity and industrial supremacy on the part of Britain, it also exhibited the rather hideous and ostentatious state of the industrial and fine arts of this period, a condition that had

inscribed within its decorative superfluity the economic and political practices that could be, and indeed were, deemed as "ugly" from the perspective of working class radicals and socialists.

Class Conflict and the Discourse on Labor: The Great Exhibition in Context

As many commentators and historians have noted, 1851 represented a year of intense optimism for Victorian England. It ushered in a period of relative prosperity and "equipoise" that would last for the next fifteen to twenty years. Indeed, until 1879, the year that saw the beginning of that century's Great Depression, there was consistent and rapid economic growth, with only two "crises" coming in the years 1857 and 1866.[3] Great Britain found herself incomparably the richest nation on earth, the world's foremost banker, shipper, supplier of manufactured goods. The material indicators of general economic prosperity were abundant: the market value of British exports quadrupled between 1842 and 1870; the tonnage of ships entering and leaving British ports tripled between 1853 and 1873; in the same period, the gross national income doubled, and the real wages of workers rose nearly thirty percent.[4]

While these positive statistics are generally known, and are featured in the many writings concerning Victorian England, there was an additional side to this prosperity that clearly helps us to understand the widespread nature of this well-documented self-confidence: this period witnessed the ascendancy of the bourgeoisie. This was the era in which their interests were secured on the economic front with the growth of the "Age of Capital" as a world drama, and their political power, while not finally ensured by any means, was at least beginning to be formally instituted, a process starting nineteen years earlier with the First Reform Bill of 1832.[5] While the bourgeoisie may not have garnered many parliamentary seats at this time, a move that would ultimately have to wait until the Second Reform Bill of 1867, what the bourgeoisie did grasp was economic hegemony: given there was no viable alternative to capitalism as a system of economic development, there was the continual implementation of the economic and institutional program of this class, as well as the growing importance of its position in the state apparatus.[6]

Along with the growing importance of this class on the political and economic fronts, and indeed intimately related to the surging confidence of these years, was the subsidence of working class agitations that had racked England from the Jacobin agitations of the late eighteenth century to the various uprisings and movements associated with Chartism. The transformations associated with industrial development helped to unsettle the social, economic, and cultural conditions of the working classes during the sixty-year span between 1790-1850, creating new social relationships which simultaneously stimulated a greater sense of working class consciousness and a multitude of popular uprisings.[7] We find an incredible array of working class agitation from the early teens to the late forties of the nineteenth century—between 1811 and 1813, the Luddite crisis; in

1817, the Pentridge Rising; in 1819, Peterloo, followed in the next decade by the proliferation of trade union activity, Owenite propaganda, Radical journalism, the Ten Hours Movement, agitations in support of the First Reform Bill, and the multitude of movements that made up Chartism. With the veritable dissolution of the Chartist movements after 1848, working class agitation seemed to take a less "revolutionary" route, moving either into quiet apathy due to the bettering of economic conditions, or into the more "reformist" or "practical" actions associated with trade union activity and the Cooperative Movement. This political "silence" of the working classes was to be broken during the 1880s and 1890s, a rupture that coincided with a prolonged economic depression, and expressed itself in the "revival of Socialism," New Unionist activity, and the many strikes that erupted throughout England.

Connected to this growing bourgeois hegemony, one perceives during the period from the late eighteenth century to the 1850s the emergence of the language of class in periodicals and journals. As Asa Briggs has argued, the use of the term "middle class" became not only a critical tool for expressing a sense of class unity among the manufacturers of England, but it also was tied to a larger cultural discourse that promoted this class as the important "strategic and 'progressive' group" in the nineteenth century.[8] The "middle class" was increasingly seen as that body of citizens who represented the most stable, informed, and enlightened in England. This political use of the term was heightened to a large extent by the Anti-Corn Law agitations in the late 1820s and 1830s, a prolonged conflict that clearly pitted, in the words of one of its organizers, "representatives from all the great sections of our manufacturing and commercial population" against landed interests.[9] Such use of language, especially after these agitations, became important not only in engendering a sense of unity and importance in relation to other classes within English society, but also in proclaiming the larger political and economic goals of the bourgeoisie. The linking of these ideals to language of class can be seen in Richard Cobden's comment to Peel after the repeal of the Corn Laws:

> Do you shrink from the post of governing through the bona fide representatives of the middle class? Look at the facts, and can the country be otherwise ruled at all? There must be the end of the juggle of parties, the mere representatives of tradition, and some men must of necessity rule the state through its governing class. The Reform Bill decreed it; the passing of the Corn Bill has realized it.[10]

These words, coming as they did in the late 1840s, portray the extent to which the bourgeoisie did not as of yet grasp clear power within a political realm still dominated by "mere representatives of tradition." What could not be denied, and what the bourgeoisie increasingly began to feel, was the historic mission that was now placed in their hands: the repeal of the Corn Law and other "facts" exhibited the necessity of their eventual hegemony within the political realm, especially in an era in which their interests represented the economic interests of the nation under industrial capitalism.

This growing sense of class importance and consolidation also surfaced within some the more well-known cultural values associated with this period in history. One of the most important of these values that clings to the "Victorian frame of mind" was that of "work" or "labor."[11] We find Carlyle exclaiming what was a generally held belief in the dignity and necessity of "Work":

> there is a perennial nobleness, and even sacredness, in Work. Were he never so benighted, forgetful of his high calling, there is always hope in a man that actually and earnestly works: in idleness alone is there perpetual despair. Work, never so mammonish, mean, *is* in communication with nature; the real desire to get Work done will itself lead one more and more to truth . . .[12]

Such a value concerning the nobility of work or labor is not only a manifestation of the Puritan religious tradition in the middle class; it is also clearly related to the secular necessities of a burgeoning commercial society—it was only through hard work that the engines of capitalism could keep turning. But its political value should also be recognized: it represented an implicit critique of the "nonworking" aristocrat who would rather, in the cryptic words of Carlyle, "have no task laid on him, except that of eating his cooked victuals, and not flinging himself out of the window."[13] In this way, the Gospel of Work represented an important cultural discourse of political initiation and challenge; it engendered a sense of importance to that class who was working within the commercial centers for their money and status, while at the same time it lashed out at the landed aristocracy, whose money rested in the work of some distant ancestor or in the "unproductive" rent of land.

At the same time, discourses articulating the "working class" began gradually to take shape in opposition to both the landed aristocracy and bourgeoisie. From the beginning of the nineteenth century to the Chartist uprisings, working class journals and pamphlets began to clearly express the burgeoning sense of working class unity that was reflected in the many episodes of political resistance and rebellion noted above. One of the more important concepts that surfaced within this political process was that of the right of the working classes to "the fruits of their labour."[14] In 1833, Bronterre O'Brien wrote in the pages of the *Poor Man's Guardian* that

> a spirit of combination had grown up among the working classes, of which there has been no example in former times . . . The object of it is the sublimest that can be conceived, namely—to establish for the productive classes a complete dominion over the fruits of their own industry . . . Reports show that an entire change in society—a change amounting to a complete subversion of the existing 'order of the world'—is contemplated by the working classes. They aspire to be at the top instead of at the bottom of society—or rather that there should be no bottom or top at all.[15]

Their self-definition as the "productive classes" who should thus have "a complete dominion over the fruits of their own industry" is an important discur-

sive manifestation of the differentiation of their interests from those of the bourgeoisie and the landed aristocracy, a conceptualization that developed out of their unique economic and political experiences. Of course, the middle classes had also stressed their importance in terms of their productiveness and propensity to "work." Indeed, as Briggs notes, there had been many attempts during the Anti-Corn Law agitations to rhetorically attach the interests of the working classes (as exploited brethren at the hands of the "unproductive aristocracy") to the political and economic project of the bourgeoisie,[16] a symbolic gesture that came up against this counter-hegemonic reinscription of the Gospel of Work as a value that inheres strictly within the working classes.

Although the discourse on the dignity of labor provided such a rich cultural weapon for both the working class and the middle class, it was articulated differently by each of them. Working class radicals began to define their class as the sole productive class, which conferred upon them the rights to "the fruits of their industry." The middle class also saw itself as productive, though in the more general sense of earning money through work. Moreover, for working class radicals "dignity of labor" meant a condition in which there was no degradation of the laborer and when all would have rights to their produce—that is, when there was a condition of social life beyond capitalism. The middle class discourse was one in which, no matter what the condition of labor, there was always dignity. As Carlyle so eloquently put it:

> Consider how, even in the meanest sorts of Labour, the whole soul of a man is composed into a kind of real harmony, the instant he sets himself to work! Doubt, Desire, Sorrow, Remorse, Indignation, Despair itself, all these like hell-dogs lie beleaguering the soul of the poor dayworker, as of every man: but he bends himself with free valour against his task, and all these are stilled, all these shrink murmuring far off into their caves. The man is now a man.[17]

This discourse on labor provided a rich cultural reservoir upon which different classes could appeal for self-assurance in the face of rapid economic and social change, and from which they could develop different political self-understandings about the necessity of their social status or the prospects of a better world.

In the midst of these developments—the rise and consolidation of the bourgeoisie on the economic and political fronts, working class agitations, and the growth of class discourses for both of these classes—came the Great Exhibition of 1851. As a cultural spectacle, it played upon all of these developments, addressing the cultural matrix of class self-understandings and the cauldron of class conflict in different ways.

The Great Exhibition, I: Bourgeois Dreams and Technological Utopias

The Great Exhibition of 1851 was the world's first international exhibition of "the Works of Industry of all Nations." It was a spectacular success. It had over 6 million visitors, from all classes, from England and abroad. The exhibit itself was housed in Joseph Paxton's iron and glass mansion within Hyde Park, aptly called the "Crystal Palace." This architectural monument—its design, its materials, and its mode of construction—simultaneously generated a sense of grandeur for the occasion and the feeling of industrial and technological potentiality. The Crystal Palace was 1,848 feet long, 408 feet wide, and 66 feet high, with transepts 108 feet high so constructed as to contain indoors some of the finest elms in Hyde Park. Within the Crystal Palace were displayed the works of close to fifteen thousand exhibitors, one half of the total area being occupied by Great Britain and the colonies, and the other half by foreign states. The actual objects on display at the exhibition fell into one of four groups—raw materials, machinery, manufactures, and fine arts (the last of these were restricted to sculpture and plastic arts, given that these were the least individualized of the art forms and had already come under the sway of the new manufacturing processes).

Yet more important than the sheer size of this exhibition and the volume of objects on display were the clear moral and political meanings the event was intended to symbolize. Five years after the repeal of the Corn Laws, two years after the end of the Navigation Acts, the exhibit was clearly intended as a celebration of the fruits of free trade and of the capitalist economic processes that emanated from England and were quickly spreading throughout the world. In a celebrated speech given in London to herald the upcoming exhibition, Prince Albert, the chief organizer behind this spectacle, claimed that in a new period where

> the products of all quarters of the globe are placed at our disposal, and we have only to choose which is the best and cheapest for our purposes, and the powers of production are intrusted to the stimulus of competition and capital . . . [t]he Exhibition of 1851 is to give us a true test and a living picture of the point of development at which the whole of mankind has arrived . . . and a new starting point from which all nations will be able to direct their future exertions.[18]

Implied in these celebratory words by the Prince Consort is the faith that mankind can better itself through an untrammeled system of "competition and capital," a project that this very exhibition was to help promote. Indeed, in all of the writings of the principal organizers, there is an awareness of the symbolic importance of this event for ushering in a period of unfettered commercial development, economic prosperity, and even international peace. In the writings of Henry Cole, for instance, a sense of the utopian political consequences of free trade and capitalist development most clearly emerges. Given these ideals, it is

no wonder that Cole set about to organize an International Peace Conference at the Exhibition.[19] Moreover, if the Great Exhibition was to be a monument to "competition and capital," it would also be a monument to England's leading role in these political economic developments. In his Preface to the Catalogue of the Exhibition of 1851, Cole observes:

> The activity of the present day chiefly develops itself in commercial activity, and it is in accordance with the spirit of the age, that the nations of the world have now collected together their choicest productions. It may be said without presumption, that an event like this Exhibition, could not have taken place at any earlier period, and perhaps not among any other people than ourselves. The friendly confidence reposed by other nations in our constitution; the perfect security for property; the commercial freedom, and the facility of transport, which England preeminently possesses, may all be brought forward as causes which have operated in establishing the Exhibition in London.[20]

For its organizers the Great Exhibition was to be a beacon to the world about the progressive nature of England, both economically and politically. It would exhibit the fruits of its manufacturing centers, the importance of free trade for prosperity and peace, and the stability of its constitutional arrangement. Unlike the continent, England was spared the tumultuous political upheavals of 1848, a fact generally attributed to its constitutional arrangement that allowed for reform and incremental social change. Thus, the Great Exhibition was to be a nationalist spectacle that would underscore and reinforce England's economic prosperity (fueled by free trade, and symbolized by the grandiosity of the Crystal Palace and the superiority of English commodities on display) and demonstrate the rectitude of its political structure (a fact that would be confirmed by the easy commingling of England's "Two Nations" at the spectacle).

It needs to be emphasized that 1851 was still very close to the period of working class agitations associated with Chartism. While this diverse movement did not topple the government as peasant and artisan movements had done on the continent, it did shake the tranquility of ruling class life. It showed the ruling classes the potential tenacity and strength of working class demands. Indeed, it has been argued that the initial idea for the Great Exhibition developed out of a need to find an antidote to Chartism.[21] As we will see, the organizers set about to tie the interests of the working classes to the spectacle—to make it not just a festival for the capitalist, but also an homage to the working man. If these were the ideals that the organizers wished to promulgate to the world, they could not have found a more interesting symbol than the very structure that housed the Exhibition. It is in the relation of economic and political ideals to the architectural monument itself that one can find an initial entry point for encountering the cultural politics experienced by those who visited there.

As a work of architecture, the Crystal Palace embodied the sheer optimism of the burgeoning means of production that England preeminently controlled. What is fascinating to the contemporary observer is that the immensity and inventiveness of Paxton's Crystal Palace—its use of prefabricated iron and glass,

its symmetrical box-like structure, and its towering uniformity—point toward the Modernist edifices that in the twentieth century would tower in almost every major city. As Nikolaus Pevsner has argued, the Crystal Palace was a clear example of the wedding of what had until then been primarily separate and distinct professions: civil engineering and architectural design. Such a combination of discourses represented an important foundation for the Modernist projects of Walter Gropius and the Bauhaus movement in the twentieth century.[22] As with this latter movement, the materials used, as well as the method of construction, circumscribed the very design of the structure itself, demonstrating the insinuation of technological and manufacturing concerns into the intricacies of aesthetic form. Indeed, the amount of materials used drew amazement from contemporaries: 23,000 cast iron girders, 3300 iron columns, 30 miles of guttering tube, 202 miles of sash bars and 900,000 panes of glass in panes a twelfth of an inch thick. The fact that it had to be erected within one year demanded a great deal of technological ingenuity on the part of the builders. As one commentator in *The Times* noted:

> The Great feature of its erection is that no stone or mortar will be necessary. All sections of the building, girders, columns, and gutters are interchangeable. The roofing and upright sashes will be made by machinery and fitted together and glazed with rapidity, most of them being finished previously to be taken to the place, so that little else will be required on the spot than to finish and fit together the materials.[23]

While the novel structure demanded a great deal of technological ingenuity to raise its skeleton of iron girders and sash bars, it also demanded the hard work of the laboring classes. As the building began to form, laborers and artisans from all over England journeyed to lend a hand with the result that in December 1850 over 2,000 men were employed. The only labor dispute that took place was a short strike by the glaziers in late November 1850, an action quelled by the presence of the police and by the hiring of other workers.[24] What seems clear is that the laboring classes were drawn to Hyde Park not only to receive employment, but also to be participants in the raising of this monumental icon to a new, and hopefully better, age.

In this architectural monument we find then the encroaching sway of manufacturing ingenuity over aesthetic form. The intermixing of these two elements were clearly formulated in a speech by Samuel Laing, chairman of the Crystal Palace Company, when he exclaimed that "an entirely novel order of architecture, producing by means of unrivalled mechanical ingenuity, the most marvelous and beautiful effects, sprung into existence to provide a building."[25] It should be noted that Paxton's idea for the Crystal Palace did not entirely stem from a visionary assessment about what form of architecture would best express that sense of economic and technological progress these Victorians were experiencing. As has been fully documented elsewhere, Paxton drew upon his experience as the head gardener for the Duke of Devonshire at Chatsworth, where he began experimenting with cast-iron sash bars and large panes of glass for his

construction of the *Victoria Regia* Lily House in 1828.[26] What was "novel," of course, was the use of prefabricated iron and glass on such a large scale. Such an example of standardized production—all materials (girders, columns, gutters, sash-bars, glass panes) were of identical size, and thus interchangeable—would have been unheard of at the beginning of the nineteenth century.[27] These novel technological factors make it understandable why most observers of this architectural "wonder" were drawn not merely to its aesthetic splendor (which was debated), but to the "mechanical ingenuity" that could produce such a pleasing site; that is, to an art form wedded to the new system of technological production.

In a tantalizing way, Walter Benjamin has discussed the contradictory political meanings that such nineteenth-century constructs generate: the very use of iron and glass for arcades and exhibition halls generated a sense of the utopian possibilities of the burgeoning capitalist means of production for overcoming social deficiencies, even class conflict. A multiplicity of political meanings ultimately arise, at least for Benjamin, from the realization of the social fruits of the "new" and the social loss of the "old" that intermingle in the experiential space between observer and architectural monument:

> Corresponding in the collective unconscious to the forms of the new means of production [as exhibited in the use of iron and glass], which at first were still dominated by the old (Marx), are images in which the new is intermingled with the old. These images are wishful fantasies, and in them the collective seeks both to preserve and to transfigure the inchoateness of the social product and the deficiencies in the social system of production . . . These tendencies direct the visual imagination, which has been activated by the new, back to the primeval past. In the dream in which, before the eyes of each epoch, that which is to follow appears in images, the latter appears wedded to elements from prehistory, that is, of classless society. Intimation of this, deposited in the unconscious of the collective, mingle with the new to produce the utopia that has left its traces in thousands of configurations of life, from permanent buildings to fleeting fashions.[28]

As a utopian image, the Crystal Palace represents a political space in which a lived ideology is experienced: it masks the real contradictions and deficiencies that mar the "new" (exploitation, etc.) by the very utopian and progressive sense it exudes, while at the same time these very deficiencies of the new are experienced by the very specter of the past that calls forth images of a better past (what Benjamin sees as "classless society"). Importantly, the dialectical tension between the "old" and the "new" that clings to this architectural site implies, at least on the historical level, that there cannot be one clear political meaning that it engenders, and that it is thus also an arena for political agonistics. For the bourgeoisie, the Crystal Palace reflected its sense of class importance and a positive image of its utopian mission as the guardians of future economic development. This indeed seems to be the dominant image that surfaces in writings during this period. On the other hand, John Ruskin and Augustus Pugin—two

important proponents of the Gothic art at this time—drew upon the "primeval past" of feudalism (which, unlike the past of "classless society" to which Benjamin refers, was a society of aristocratic privilege and hierarchy) to uncover the encroaching social destruction of communal ideals and Christian morality in the refracted light of that monumental iron and glass construct in Hyde Park.[29] The working class experienced this site not only as an icon of its own prowess (it was they who actually built it), but also as a citadel of their "continued prostration" at the hands of "a horde of usurpers, idlers, and Sybarites," testifying to the latter's "conservation and extension of their unholy supremacy" over the working classes.[30]

While the Crystal Palace was intended to foster an aesthetic space of wonder for all—a space in which all classes and all countries could celebrate the bourgeois dreams and technological ingenuity of capitalism—it was also an arena of political contestation, in which different social groups acquired their own separate political identities and definitions in contradistinction to each other.

If the Crystal Palace itself exuded at the same time the potentialities and deficiencies of those technological forces that were being brought to life by the capitalist system, the actual objects displayed within its iron and glass edifice were a curious mixture of the old and the new. Next to sewing machines from the United States and cotton machines from Oldham there was the fine black silk from Barcelona. Yet, as accounts from the period verify, most visitors were drawn to the new machines in the Machinery Court, and marveled over the decorative art that had been created by new manufacturing processes. Any glance at this decorative art leaves one with a sense of seeing superfluous luxuriousness—most objects had the typical High Victorian characteristics of having generous curves, with outlines blurred or broken, and with a general tendency toward top-heaviness. Also one perceives the propensity in such design to use all available surfaces for decoration, with much of that ornamentation prone to the telling of narrative stories.[31] As one present-day observer has claimed, such artifacts were "the productions of an epoch in which design in art tended entirely to obliterate functional value by the addition of superfluous, allusive or meaningless decoration," and represented the perfect aesthetic correlate to a profit-seeking, "machine-minded" class.[32]

It is important to emphasize the intricate relationship between such decorative excess and the larger social practices germinating in England; such machine-made exuberance was the outcome of a century of capitalist expansion, and, as Pevsner has argued, "appealed to" an ascendant "self-confident class."[33] But these artifacts did not only reflect these class characteristics; they also were part of the wider cultural process of creating a sense of "class" for these individuals. The importance of cultural artifacts for generating and constituting class identities has been pointed out before, most notably in the study of the political processes of the French Revolution by Lynn Hunt.[34] In a more theoretical vein, Jean Baudrillard has argued that cultural objects are always "the locus of the conservation of an effort, of an uninterrupted performance, of a *stress for*

achievement, aiming always at providing the continual and tangible proof of social value."[35] Seen in this light, the decorative excess at the Great Exhibition may be seen to have had at least two ideological functions: for the middle classes, it solidified a sense of class importance (especially in relation to the aristocracy) and economic wealth, while for the working classes, who do not in reality possess such an economic position, it allowed them to experience in the realm of the art the possibilities of a better existence—even the illusion of class mobility—that could await them in the present economic order.

Yet, another important political meaning emerges, one that will be of primary importance in Morris's aesthetic. Behind the ornamental excess of these machine-made artifacts lay the enslaving of human labor to those very machines. The relation of beauty and ornament to the conditions of human labor had already been raised by Ruskin two years before the opening of the Great Exhibition, when he argued that "the only question to ask respecting all ornament, is simply this: Was it done with enjoyment?—was the carver happy while he was about it?"[36] As we will see, it would be Morris who would draw the full social significance from Ruskin's words, clearly seeing the destitution of the worker behind such hideous ornamentation as was on exhibit there.

The Great Exhibition, II: Bourgeois Hegemony and Working Class Struggles

> But what to me are these inspiring changes,
> that gorgeous show, that spectacle sublime?
> My labour, leagued with poverty, estranges
> Me from this mental marvel of our time.
> I cannot share the triumph and the pageant,
> I, a poor tailor at a whirling wheel,
> The slave, not servant of a ponderous engine
> with bounding steam-pulse and arms of steel.
>
> —Thomas Hood[37]

While we have already shown how the Great Exhibition represented a material embodiment of bourgeois dreams fueled by capitalist development and technological ingenuity, we have only intimated the extent to which it also represented an arena of political contestation. It is clear that the issue concerning the relation of the working classes to the Exhibition generated much anxiety among the organizers of the event. The potential appearance of workers in such mass at the Crystal Palace brought back fears associated with the days of Chartism, and raised the specter of a social disturbance that could disrupt the spectacle of economic harmony and constitutional order that the organizers wished to promote.[38] The workers also could signify, by their apathetic absence, the hypocrisy of their proposed celebration. Driven by these concerns, the organizers set about to arrest the possibility of the alienation of the working classes from this spectacle by

instituting the Working Classes Central Committee for the purpose of communicating with that class about the Great Exhibition. On this committee sat the Bishop of Oxford (chairman), Charles Dickens, William Thackerey, Chartists William Lovett, Francis Place and Henry Vincent, among others. While this committee signaled an earnest attempt to bring the working classes into consultation, it disbanded after only three months due to the Royal Commission's unwillingness to have it officially affiliated with their body.[39] Reasons for this decision by the Commission seem to have rested in the fear of providing official sanction to a body on which prominent Chartists sat. Yet, the necessity of such a hegemonic institutional site was evident to one member of the Commission: "It is very desirable that some new machinery with the same objects in view be formulated as the labouring classes must not be allowed to think . . . that there is any indifference on the part of HRH to their interests."[40] While such "machinery" never materialized again, the Royal Commission did attempt to draw working class audiences to the event through a number of practical incentives: cheaper rail tickets; cheaper entrance fees for certain weeks; and, probably the most famous consequence of these concerns, the building of the Mechanics Home near Hyde Park to provide inexpensive housing for the artisans and operatives who visited the Great Exhibition.

These concerns also filtered into a more generalized discourse, surfacing in many speeches and writings during this period, that symbolically and rhetorically transformed this celebration of the industrialist and his commodities into a celebration of the laborer himself. At the prompting of the Prince Consort, The Bishop of Oxford delivered his "Dignity of Labour" speech, claiming that the Great Exhibition, "as promoting the industry of nations, is a great and noble event. It calls attention to the dignity of labour—it sets forth in its true light the dignity of the working classes—and it tends to make other people feel the dignity which attaches to the producer of those things."[41] These notions were echoed by one commentator in *The Eclectic Review*: "Honour to the Working Man, this is the message of the Exhibition. It is to the makers of these things that the great show leads the mind."[42] This same theme also surfaced in the widely popular poem, *Honour to Labour*, by Lady Emmeline Stuart Wortley. All in all, there were a multitude of voices extolling the importance of this spectacle for honoring the working classes.

What is important about this cultural development is that in the attempt to portray the importance of the Great Exhibition for the working classes, it also raised the issue that England might have a society that was riven with class distinctions, even antagonisms, a perception that had been felt by England's rulers since the days of Chartism, but which had never been given such a public space before. Thus, in the very process of galvanizing the interests of the working classes to the ideals of the Exhibition, it also questioned the very economic structure that it was supposed to celebrate. For some of its supporters, the Exhibition even offered the chance of fostering a reconciliation between capitalist and worker. In an attempt to gain working class interest for the spectacle, Mr. Abbott of the Lansdowne Association asserted that the working classes should

favor this event given that it would "show the capitalist the importance of the mechanic and the artisan,"[43] the implication being that there was at this time not such an understanding.

But such a discourse did not stop after the preparation stages for the Great Exhibition; it circulated throughout the yearlong spectacle. One of the more interesting symbolic expressions of this situation of power rested in the very message that was inscribed on the prize medals given to the exhibitors. *Pulcher et ille labor palma decorare laborem*—"in such a festival not only the captains of industry but also the manual laborers had to be remembered."[44] In its own way, the ritual behind, and language upon, these medals elucidate the hollowness of the whole discourse on the "dignity of labour": they were presented not to the workers who actually produced such objects, but to the entrepreneurs themselves. Also, written in a language that could only be read and understood by an educated economic elite, these medals, by the very form in which the message was inscribed, portray how this message spoke more to their own interests as a class than to the experiences of the manual laborer.

The hollowness of this message that we see inscribed on the prize medals was not missed by some of this spectacle's more perspicacious observers. What was missing from the event, a commentator in *Punch* notes, was the display of the "industrious" at work. Yet,

> as needlewomen cannot be starved, nor tailors 'sweated,' nor miners blown up, amongst a multitude of people, with any degree of safety, it is suggested that paintings of our various artisans labouring in their usual vocations, should accompany the display of substances and fabrics which we owe to the labours or ingenuity of respective classes . . . Should we ostentatiously show off all manner of articles of comfort and luxury and be ashamed to disclose the condition of those whom we have to thank for them?[45]

What is implied in this observation is again the limitations of the whole discourse on the nobility of labor. While such a discourse claims that the Great Exhibition celebrates the honest labor of the working man, it wishes only to do so for the purpose of hiding the real conditions in which that labor is performed within capitalism. In a way, this is a necessary discursive absence if such a notion is to also reaffirm the bourgeois ideals of the Great Exhibition. In relation to this issue, we might agree with Walter Benjamin when he observed: "The world exhibitions glorify the exchange value of commodities. They create a framework in which commodities' intrinsic value is eclipsed."[46] It is clear that if labor was honored at the Exhibition, it was in the form of the commodity—literally, it was the object of labor that was honored. And if the celebration of labor meant more than the product he or she created, it was an image of a working class happy in capitalism, a phantasmagoria without "intrinsic value," a cultural "exchange value" distantly related to the real needs and suffering of that class under this period of capitalism.

The most radical working class portrait of the Great Exhibition came from G. Julian Harney, a former Chartist turned socialist. He saw the emptiness be-

hind the official proclamations of the Great Exhibition as a "Festival of Labour": "The works of art and industry exhibited in the building may be looked upon as so much plunder, wrung from the people of all lands, by their conquerors, the men of blood, privilege, and capital."[47] As may seem apparent, Harney focussed on the ideological character of such a discourse: the talk of the "dignity of labour" was a way of cloaking the real exploitation on display there. But what is also important for our purposes is the way in which Harney perceives the ideals of the Exhibition to be a worthy goal, but ultimately one that points beyond the present political and social arrangements. "I can imagine a *fete* worthy of an Industrial Exhibition," Harney ponders,

> in which the people at large should participate. I can imagine artists and artisans, workers from the field, and the factory, the mine, and ship summoned to take their part in a Federation of Labour,—combining Industry, Art, and Science . . . I can imagine a rich array of material wealth, which would testify to the enjoyment, as well as skill and industry of the workers; of which the profit and the glory would be theirs, untouched by useless distribution and *exploiting* capitalists. Lastly, I can imagine that such a *fete*—such an Exhibition—will be only when the working classes shall first have . . . substituted for the rule of masters, and royalty of a degenerated monarchy,—'the Supremacy of Labour, and the Sovereignty of the Nation.'[48]

Harney's vision points to a number of important issues: first, in this vision we perceive the use of the discourse on the "dignity of labour" for developing a sense of political identity and purpose antithetical to the bourgeois ideology underlying the Exhibition (indeed, it might be better to say that we see a rearticulation of this "language of class" for the interests of the working class). Even though these notions, at this time, functioned as a way to hide the class nature of this celebration, and to ignore the real conditions of the working classes, they become for Harney important tools for generating a critique of class domination. Second, and related to the first issue, the purpose and ideals of the Great Exhibition generate a vision of a true, "worthy" fete. That is, the utopian image that the Great Exhibition elicits as a cultural spectacle elucidates not only the deficiencies of the present exhibition, and the capitalist exploitation that undergirds its pomp and ostentatiousness, but also a vision of its possible transformation—"the Supremacy of Labour, and the Sovereignty of the Nation."

The last two issues related to Harney's observations provide an opening for our later discussion of Morris's aesthetic theory. First, Harney sees that the objects on display in his future exhibition would not only reflect the "skill and industry" of the working classes, but also their "enjoyment" in labor. This concept of "pleasurable labour" (the concept is actually Morris's) provides an important critical concept against the organization of labor under capitalism—while under capitalism there could be "skill and industry," there could not be, in the minds of working class radicals, "enjoyment" as a "slave" to "a ponderous machine" (to quote Thomas Hood). Second, Harney touches upon the relationship of beauty

to pleasurable labor—in his mind's eye, a true exhibition would display a "rich array of material wealth" founded upon "enjoyment" in labor.

The Great Exhibition and Cultural Politics

The cultural and political discourses that emerge out of the Great Exhibition present us with two important insights: first, as a spectacle intended to promote the virtues of commercial development, it elucidates in an instructive way the intermingling of culture—architecture, decorative art—with the dictates of capitalist production. In so doing, it also shows the sense in which culture can have clear political effects and characteristics. If art becomes the captive of economic processes that are themselves contested in the realm of political action, then art will acquire important political resonances. What I have portrayed, though, was the way in which this "captivity" is never absolute—that the Crystal Palace as an architectural monument, and the machine-made decorative art on exhibit within that edifice, can engender quite different, even antagonistic, political identities, irrespective of the initial intentions behind their production.

Second, the Great Exhibition raised the whole issue of the relation of the interests of the working classes to the arts. This emerges from the discourse surrounding the "dignity of labour." What seems evident in this cultural process is a symbolic and rhetorical attempt to link the working class to the ideals of the event. While such a discourse was indeed tied to the interests of the bourgeoisie, it also allowed the possibility of its use as a means of furthering a sense of class consciousness among the working class; as we saw with Harney, it provides a basis for a critique of the Exhibition, and for perceiving the art works of display, as so much "plunder." The relation of art to labor is thus valorized in this political process.

What is important to note is that the linking of art to labor is an important foundational principle for a "working class aesthetics," in that it allows for an analysis of aesthetic production, a theory of aesthetic value, and is intimately tied to a tradition of the "language of class" that began at the turn of the century within working class culture. Yet, it should not be surprising that activists in the working class movement did not spend much time in elaborating this aesthetic: they were involved in the nuts and bolts of political and economic reform. The development of such an aesthetic would have to be left to individuals deeply involved in the arts. Indeed, as we will see in the next chapter, the "labour theory of art" will first make its appearance within the aesthetic theory of the radical conservative, John Ruskin. While Ruskin was drawn into working class reform because of his aesthetic theory, he avoided the more radical direction implicit in this conception. It is with the thought of William Morris that one finds the intersection of such aesthetic concerns with the political and social vision of the working classes.

Notes

1. See "Southeby's Art Manufactures," in *Fifty Years of Public Work* (London: George Bell and Sons, 1884), Vol. II.
2. Noted in Asa Briggs, *Victorian People: A Reassessment of Persons and Themes, 1851-67* (New York: Harper and Row Publishers, 1963), Chapter 1, "The Crystal Palace and the Men of 1851," 40.
3. G. D. H. Cole and Richard Postgate, *The British Common People: 1746-1946* (London: Metheun and Co., 1961), 348-349.
4. For a detailed discussion of the general economic trends in this period, consult Francois Crouzet, *The Victorian Economy* (New York: Columbia University Press, 1982). Also, David Thomson, *England in the Nineteenth Century* (Middlesex: Penguin Books, 1985), 99-168; E. J. Hobsbawm, *The Age of Capital: 1848-1875* (New York: New American Library, 1975), 27-47; Cole and Postgate, *The British Common People*, 328-366; and Richard Altick, *Victorian People and Ideas* (New York: W. W. Norton, 1972), 73-106.
5. Altick, *Victorian People and Ideas*, 88, rightly notes that the First Reform Bill in no way affected the vote of the working class, and only really enfranchised about half the middle class: "The old claim that the First Reform Bill put the middle class in power is now universally discredited. What happened in 1832 was that the commercial, 'town' interest *began* to play an effective role in politics, breaking the monopoly hitherto enjoyed by the great landowner." See also, J. R. Dinwiddy, *From Luddism to the First Reform Bill: Reform in England, 1810-1832* (London: Basil Blackwell, 1986), 55-56, where he concludes that while through the Reform Bill "[t]he landed interest retained, and in someways strengthened, its hold over the greater part of the electoral process," it did offer the bourgeoisie an "appropriate status within the political system and security against more democratic schemes."
6. Hobsbawm, *The Age of Capital*, 275.
7. See E. P. Thompson, *The Making of the English Working Class* (New York: Vintage Books, 1966). See also, R. J. Morris, *Class and Class Consciousness in the Industrial Revolution, 1780-1850* (London: Macmillan Publishers, 1979) for a critical appraisal of the issues concerning this topic.
8. Asa Briggs, "The Language of 'Class' in Early Nineteenth-Century England," in *History and Class: Essential Readings in Theory and Interpretation*, R. S. Neal, ed. (Oxford: Oxford University Press, 1983), 12.
9. Quoted in Thomson, *England in the Nineteenth Century*, 80.
10. Quoted in Briggs, "The Language of 'Class'," 16.
11. See Walter E. Houghton, *The Victorian Frame of Mind, 1830-1870* (New Haven: Yale University Press, 1957), 242-262, for a discussion of the importance of this concept for the Victorian.
12. Carlyle, *Past and Present* (New York: New York University Press, 1965), 196.
13. Carlyle, *Past and Present*, 180.
14. Briggs, "The Language of 'Class'," 22. As may seem apparent, such a conception drew sustenance from a critical reappropriation of Locke's labor theory of property rights.
15. Quoted in Briggs, "The Language of 'Class'," 24-25.
16. Briggs, "The Language of 'Class'," 17.
17. Carlyle, *Past and Present*, 196.

18. Quoted in Cole, *Fifty Years of Public Work*, Vol. II, 212-213.
19. See Cole's essay, "On the International Results of the Exhibition of 1851," in *Fifty Years of Public Work*, Vol. II, 233-256.
20. Extracted in *Fifty Years of Public Work*, Vol. II, 208.
21. See Egbert, *Social Radicalism and the Arts*, 407, where he notes that the "idea for a Great Exhibition in London had first been expressed by a Scottish Sergeant in 1848 as an anecdote to Chartism."
22. See Nikolaus Pevsner, *Pioneers of Modern Design: From William Morris to Walter Gropius* (London: Penguin Books, 1960), especially Chapter 5, "Engineering and Architecture in the Nineteenth Century," 118-147.
23. *The Times* (August 2, 1850): 5.
24. Audrey Short, "The Great Exhibition of 1851" (Doctoral Dissertation in History, University of Cincinnati, 1968), 113.
25. *The Times* (June 12th, 1851).
26. See Yvonne Ffrench, *The Great Exhibition: 1851* (London: The Harvill Press, 1950), especially Part II, "The Crystal Palace," 89-93; and C. R. Fay, *Palace of Industry, 1851: A Study of the Great Exhibition and its Fruits* (Cambridge: Cambridge University Press, 1951), 26-31.
27. Fay, *Palace of Industry, 1851*, 16.
28. Benjamin, "Paris, Capital of the Nineteenth Century," in *Reflections*, Edmund Jemphcott, trans. (New York: Harcourt Brace Jovanovich, 1978), 148.
29. Pugin's disdain for the Crystal Palace was based on his notion of the moralizing effects of architecture, of which the Gothic style provided the most Christian form. Ruskin's dislike also rested in his analysis of Gothic forms, seeing the "savagery" and individuality of the latter as expressions of joyful labor—the use of iron could not produce beautiful effects for it never reflected the creativity of the labourer. See Chapter Three for a discussion of Ruskin's ideas.
30. G. Julian Harney, *The Friend of the People*, no. 22 (May 10, 1851): 189. Next to Ernest Jone's *People's Paper* and O'Connor's *Northern Star*, Harney's journal was one of the only surviving Chartist organs in 1851. What is clear is that Harney was pushed further to the left after 1848, seeing the importance of social change, not just political reform, for the betterment of the conditions of the working classes. For a discussion of these developments, see John Saville's "Introduction" to the reprint of *The Red Republican & The Friend of the People* (London: Merlin Press, 1966), i-xv.
31. For the most discerning discussion of the design at the Great Exhibition, see Nikolaus Pevsner, "High Victorian Design," in *Studies in Art, Architecture and Design: Victorian and After* (Princeton: Princeton University Press, 1968), 38-96. See also, Ffrench, *The Great Exhibition*, Chapter XIII, 211-256.
32. Ffrench, *The Great Exhibition*, 231.
33. Pevsner, "High Victorian Design," 52-54, 79.
34. Hunt, *Politics, Culture and Class in the French Revolution*.
35. Baudrillard, "Sign Function and Class Logic," in *For a Critique of the Political Economy of the Sign* (St. Louis: Telos Press, 1981), 33. Baudrillard calls this process of consumption, "social prestation." We might even say that the Great Exhibition provided a spectacle in which all could consume in the wonders of capitalism.
36. Ruskin, *The Seven Lamps of Architecture* (New York: Farrar, Straus and Giroux, 1986), 165.
37. Quoted in Fay, *Palace of Industry, 1851*, 42.

38. See Cole's discussion in *Fifty Years of Public Work*, Vol. I, 188. A lot of the fears related to the influx of foreign revolutionaries. See Short, *The Great Exhibition of 1851*, 86, 101-110 for a discussion of these issues.

39. See the account of this committee in Cole, *Fifty Years of Public Work*, Vol. I, 188-193. In his autobiography, *Life and Struggles of William Lovett* (London: Macmillan & Kee, 1967), 304, Lovett notes cryptically about the reason for the refusal: "It would seem. . .that there was some aristocratic prejudice on the part of some of the General Commission."

40. Colonel Grey to Cole, June 7, 1850, quoted in Short, *The Great Exhibition of 1851*, 82.

41. Quoted in Short, *The Great Exhibition of 1851*, 82.

42. *Eclectic Review* I (1851): 739.

43. *Daily News* (November 7, 1850): 4.

44. See Briggs, *Victorian People*, 41. Briggs notes that next to the "gospel of peace," the Exhibition wished to honor the working man.

45. *Punch* XX (January-June, 1851): 42.

46. Benjamin, "Paris, Capital of the Nineteenth Century," 152.

47. Harney, *The Friend of the People*, no. 22 (May 10, 1851): 189. As an interesting historical note, the first English translation of Marx and Engels' *The Manifesto of the Communist Party* appeared in Harney's earlier journal, *The Red Republican* in 1849-50.

48. Harney, *The Friend of the People*, no. 22 (May 10, 1851): 189-190.

Chapter Three

Towards a Political Economy of Art: John Ruskin and the Representation of Labor in Aesthetic Theory

Three years after the spectacle of the Great Exhibition, John Ruskin delivered a scathing attack on those who praised the Crystal Palace as a novel and progressive form of architecture.[1] After hundreds of years of contemplating the rich forms of Europe's architecture, Ruskin claimed,

> we suppose ourselves to have invented a new style of architecture, when we have magnified a conservatory!
> It is to this then, that our Doric and Palladian pride is at last reduced! We have vaunted the divinity of the Greek ideal—we have plumed ourselves on the purity of our Italian taste—we have cast our whole souls into the proportion of pillars and the relations of orders—and behold the end! Our taste, thus exalted and disciplined, is dazzled by the lustre of a few rows of panes of glass; and the first principles of architectural sublimity, so far sought, are found all the while to have consisted merely in sparkling and in space.[2]

Within this essay, Ruskin touches upon the reasons behind his distaste for this modern form of architecture and its hold over the nineteenth-century mind: the underlying technological developments that have made this monument a reality have created a fetish for "mechanical ingenuity." While, for Ruskin, this awe at the Promethean prowess of industrial capitalism is well-placed when we look to "a screw frigate, or a tubular bridge," it cannot be the "*essence* either of painting or architecture"; moreover, as so well exhibited in the Crystal Palace, "largeness of design does not necessarily involve nobleness of design."[3] Aesthetic worth can never be a product simply of technological or mechanical ingenuity; it must also be the expression of man's pleasure in his work, and, in general, an emanation of the "vital energy" of human beings as the expression of God's will. Indeed, for Ruskin technological or mechanical ingenuity, especially in the form of the industrial machine, is antithetical to the life of true art.[4]

Within the short space of this particular essay, Ruskin does not fill out the underlying assumptions of his distaste—assumptions more clearly developed in *The Seven Lamps of Architecture* (1849) and *The Stones of Venice* (1851, 1853)—but rather moves immediately to a discussion of the practical, indeed political, effects of this fetish for "mechanical ingenuity." Not only does such

praise for the Crystal Palace distract one's attention from the insipid destruction of Europe's greatest art, especially its "true and noble Christian architecture,"[5] but the very mechanistic discourse that is implied in this attitude of awe helps to divert even the best of antiquarian aims. Present attempts at restoring past architectural monuments with "mathematical exactitude"

> are, nevertheless, more fatal to the monuments they intended to preserve, than fire, war, or revolution. For they are undertaken, in the plurality of instances, under an impression, which the efforts of all true antiquaries have as of yet been unable to remove, that it is possible to reproduce the mutilated sculpture of past ages in its original beauty.[6]

Ruskin's exhortation against mechanically reproducing, in the name of restoration, past architectural monuments is clearly related to a general critique of instrumental rationality he shared with other Romantic writers. Such wide-ranging mechanistic practices associated with industrial capitalism—what Heidegger meant by *Ge-stell*,[7] and the Frankfort School referred to as technological rationality[8]—are, for Ruskin, clearly destructive processes in the production of a living art, and are reflected not only in the architectural uses of prefabricated iron and glass, but also in the very characteristic engagement one has with past forms of beauty. Importantly, working conditions are so radically different under industrial capitalism that reproduction becomes a vain attempt: noble design produced under the radically different social conditions of past ages can never be replicated without those same social conditions.

The thought of John Ruskin provides an important stepping stone from the cultural and political spectacle of the Great Exhibition to the cultural and political theory of William Morris. It is well-known that Morris recognized the importance of Ruskin on the development of his own thought. Ruskin's chapter on "The Nature of Gothic" in *The Stones of Venice* provided Morris with an initial critical insight into the social foundations of aesthetic production, and a sense of what conditions can actually bring about the flowering of true art (that is, as Morris claimed, art that is "a help and solace to the daily life of all men").[9] Indeed, Morris's continued sense of indebtedness to Ruskin is seen in his publication of "The Nature of Gothic" as the first book from his Kelmscott Press (1890-91). Importantly, Ruskin provided theoretical nourishment that gave "form" to Morris's own political and aesthetic intuitions, especially prior to his practical and intellectual immersion into the socialist movement in the 1880s. Reflecting upon his own theoretical and political genealogy, Morris notes that next to contented middle class men,

> there were a few who were in open rebellion against the said Whiggery—a few, say two, Carlyle and Ruskin. The latter, before my days of practical socialism, was my master towards the ideal aforesaid, and, looking backward, I cannot help saying, by the way, how deadly dull the world would have been twenty years ago but for Ruskin! It was through him that I learned to give form to my discontent, which I must say was not by any means vague.[10]

While Morris is here referring strictly to the development of his later political self-understandings, his statement also points toward a more general issue during this period of English culture: cultural criticism began to become an arena for the articulation and inculcation of political knowledge and political theory. Thus, Ruskin represents not only an important bridge to the political theory of William Morris because of the latter's indebtedness to Ruskin's aesthetic insights, but also because he elucidates the very interesting way in which aesthetic issues were binding with those of politics, a coupling that we saw clearly on the historical level within the cultural spectacle of the Great Exhibition.

The purpose of this chapter is twofold: first, as a chapter in intellectual history it will elucidate the specific characteristics of Ruskin's conception of the relation between art and labor. This, as we noted earlier, is important given that it will allow us to later understand the particular issues and dilemmas that Morris was to face in his theory. Second, I argue that larger social dynamics—particular forms of class languages and discourses—were being represented and articulated in Ruskin's particular theoretical insights, allowing us to make sense of why we should find Ruskin discussing the connection between art and labor. In following through some of the implications of this argument, I will uncover what I think has been overlooked by previous scholars in their discussion of Ruskin; namely, that there is a clear aporia within his theory between the political logic of his particular conception of art and labor, and his explicit political and social ideals. With these two aims in mind, I will first lay out the general transformations and developments within English cultural criticism from the eighteenth century to Ruskin's time.

Situating Ruskin, I: The Changing Politics of Cultural Criticism

The importance of Ruskin's cultural criticism can be more clearly grasped if we look to the prior role and function of cultural criticism in England. In one of the more provocative and insightful works on these developments, entitled, *The Function of Criticism: From The Spectator to Post-Structuralism*, Terry Eagleton argues that prior to the nineteenth century cultural criticism represented one strategy of "struggle against the absolutist state" in which the bourgeoisie fashioned "a distinct discursive space, one of rational judgement and enlightened critique rather than of the brutal ukases of an authoritarian politics."[11] Such a development related directly to the political project of the rising bourgeoisie in that it provided a cultural space in which this class could constitute a sense of importance and political efficacy in relation to the previous hegemonic class. As Eagleton notes: "a polite, informed public opinion pits itself against the arbitrary diktates of aristocracy; within the translucent space of the public sphere it is supposedly no longer social power, privilege and tradition which confer upon individuals the title to speak and judge, but the degree to which they are constituted as discoursing subjects by sharing in a consensus of universal reason."[12] Through clubs, coffee shops, periodicals and journals—and in terms of the lat-

ter, Steele's *Tatler* and Addison's *Spectator* are exemplary—the bourgeoisie could promote the discussion of important public issues, generating from this interplay of ideas a general public opinion. This "public sphere" of opinion was deeply attached to the needs of the rising bourgeoisie; it allowed for the production and consolidation of this class's own cultural space, which in turn allowed for the elaboration and dissemination of its political and economic goals. Yet, at the same time, as reflected in the real political and strategic exigencies of this period, it was not a sphere closed to the aristocracy. Rather, Eagleton argues that it provided a catalyst "in the creation of a new ruling bloc in English society, cultivating the mercantile class and uplifting the profligate aristocracy."[13]

For Eagleton, it is in the nineteenth century that this classical bourgeois public sphere begins to disintegrate. Cultural criticism in the eighteenth century distinguished itself not only in its invocation of universal reason as a regulating principle of cultural exchange, but also in its lack of political vituperation. It was a sphere that did not wish to alienate, but consolidate. Its peculiar goal was consensus, though one favorable to the goals of the bourgeoisie. During the nineteenth century, cultural criticism became much more clearly "political." Underlying this transformation in the content and character of cultural discourse were the political, social and economic transformations associated with the development of capitalist industrialization. While these developments may have signaled the growth in stature and power of the bourgeoisie, they also engendered the rise of the working class as a political force. This implied on the cultural level the institution of a number of counter-hegemonic discourses. As Eagleton notes, clearly following the seminal work of E. P. Thompson in *The Making of the English Working Class*, "in the Corresponding Societies, the radical press, Owenism, William Cobbett's *Political Register* and Thomas Paine's *Rights of Man*, feminism and the dissenting churches, a whole oppositional network of journals, clubs, debates and institutions invades the dominant concerns, threatening to fragment it from within."[14]

In such a climate, as Eagleton argues, "criticism . . . becomes a locus of political contention rather than a terrain of cultural consensus."[15] In saying this, Eagleton is clearly not claiming that cultural criticism was earlier immune to politics, but that its politics had previously been exhibited in the lack of decisive political debates. Class conflict and contestation in the early nineteenth century brought out the ideological divisions within the ruling bloc, generating a cacophony of political topics, debates, attacks and counter-attacks among ruling bloc journals and periodicals. What is interesting to note is that Eagleton sees the proliferation of *political* topics to be the clearest result of the wider political struggles of the period.[16] While he argues that these journals may have translated working class political claims into a splintering of defensive political stances (repression or liberality), he does not assume that these counter-hegemonic claims were insinuating themselves into more clearly aesthetic language; that is, transforming specific conceptions about literature, art and beauty.

This seeming blindness on Eagleton's part to the diverse representations of politics within aesthetic and cultural language stems from a somewhat reduc-

tionist view in which he overemphasizes the strictly bourgeois nature of cultural criticism. The history of cultural criticism has been a history of a ruling bloc discourse, albeit one not completely closed to other political voices. This is especially the case in the nineteenth century. It is true that discussions of high culture were generally confined to those classes who were educated (which was indeed tied to property and leisure); indeed, even among self-educated artisans and workers strictly aesthetic issues were ultimately delegated little discursive space given the urgency of more "germane" political and social topics. Yet, this is not to say that the working classes eschewed literature or other forms of high culture. Working class journals not only frequently published poetry, but also certain literary works provided important tools for developing working class self-understandings.[17] Moreover, the very way in which art was conceived in this cultural sphere was being transformed by the wider cultural ramifications of working class demands. As we had already noted, for Eagleton the social claims of the working classes were most readily reflected in the proliferation of political topics within ruling bloc journals. He rightly notes that certain political claims associated with working class struggles could not be directly incorporated within this cultural sphere; they had to be refracted through the political interests of the ruling bloc (as issues and ideals to be contended with defensively). But, working class ideals were not just tied to notions of democracy, and thus were not necessarily contestable on the conscious political level, but were also related to particular conceptions about labor and consequent economic rights. Indeed, working class activists frequently borrowed from a wide range of sources (Benthamite utilitarianism, Lockean liberalism, Owenite socialism, Romanticism and Marxian communism, to name a few) for the elaboration of their ideals, fusing them into a theoretical melange that "was meaningful from the standpoint of practical action, of mobilizing individuals to secure their rights and benefits."[18] While the cultural value of labor was shared among classes, it was incorporated into their respective political projects in different ways. We encountered these varying political articulations surrounding the spectacle of the Great Exhibition. If working class activists argued that the working class had a "natural right" to the "fruits of their labour,"[19] a right impeded by the monopoly established by the capitalist, they also were drawn to promoting an ideal of "enjoyment" in labor, to quote Harney. This latter concept, as a more general conception of a way of life, represented just as much of a critical political notion as the other concepts that were part of working class political discourses.

In Raymond Williams's history of the concept of culture we find a more subtle rendering of English cultural criticism that focuses on its polyvalent political nature. As he notes in the conclusion to his magisterial work, *Culture and Society: 1750-1950*:

> The body of intellectual and imaginative work which each generation receives as its traditional culture is always, and necessarily, something more than the product of a single class . . . [E]ven within a society in which a particular class is dominant, it is evidently possible both for members of other classes to con-

tribute to the common stock, and for such contributions to be unaffected by or in opposition to the ideas and values of the dominant class. The area of culture, it would seem, is usually proportionate to the area of a language rather than to the area of a class.[20]

For Williams, the characteristics of English cultural criticism over the same period are more open to the "languages" and discourses of other classes. While Eagleton sees the politics of criticism as bounded by the supposed class affiliation of the discourse (and thus its politics is inevitably one of hegemony and reaction), Williams is more willing to grant a sense of autonomy—or more precisely *heteronomy*—to these cultural discourses. This allows Williams to recognize, as Eagleton does not, the singular importance of Ruskin.[21] Beginning with the thought of Pugin and Ruskin, Williams correctly sees there is a shift in problematic concerning the rendering of art, one which was to come to its logical conclusion in the thought of Morris. Indeed, what is apparent is that Ruskin discussed aesthetic issues from a sociological and political viewpoint hitherto unknown in the tradition of that discourse.[22] For Williams, Ruskin's emphasis on the relation of art to the material practices of society was a response to the onslaught of industrial capitalism that engendered the concept of culture in which the "art of a period is closely and necessarily related to the general prevalent 'way of life,' and further that, in consequence, aesthetic, moral and social judgements are closely interrelated."[23] While the novelty of Ruskin's approach is broached by Williams, it is clear that he sees it as an extension of the tradition of criticism which began with the work of Edmund Burke, a tradition that disseminated a notion of culture antagonistic to the all-consuming disruptions of industrial capitalism.

While Eagleton errs by reducing discussions of culture to the hegemonic interests of the ruling classes, Williams's analysis seems at times painfully abstract from the political discourses of the period in which each theorist acted and wrote.[24] As noted above, the important emphasis for Williams is on the development of culture as a concept in direct conflict with the social developments of industrial capitalism. But—and this is somewhat curious given Williams's sociological intent—such a discursive development is never placed within the social and political dynamics of particular social classes or groups. That is, we never get a sense of whether such a concept was intimately involved with important social actors in their attempts to understand their life-world and act within it. The real focus in Williams's study is then not conceptions of culture in *social use*, or even as representations of conflicting social meanings, but culture as a critical concept in relation to a "whole way of life" (one seemingly devoid of conflicting languages and meanings). Because we never get a sense of the political mediations that would constitute various transmutations and developments in the concept of culture, these ideological developments seem the inexorable unfolding of a concept, rather than the product of political struggle and an arena of social contestation. The implications of this characterization is that we never really encounter an explanation of why a conception of art that is inti-

mately related to society, and specifically to laboring conditions, should appear at this point in history.

Situating Ruskin, II: The Concept of Pleasurable Labor in Working Class Political Discourses

As a first step toward such an explanation, I would argue that Ruskin's cultural criticism took the form it did because of the larger political and cultural struggles transpiring during this period. Ruskin drew upon the political contested category of labor because of its wide social and political currency; as we have seen, it was a concept in social use by different classes in the nineteenth century. Moreover, it was becoming clearer to lovers of art that capitalist development was radically changing the conditions of art and the possibilities of beauty. In this respect, art could no longer be conceived as a realm with timeless characteristics immune to societal and economic transformations. What we find in Ruskin's observations on art and society is the first representation of an alternative conception of art that works against what Eagleton argues are the successive attempts by the bourgeoisie to reconstitute the classical public sphere. The particular way he linked art to labor is the most critical political component in his cultural criticism, articulating in aesthetic language the counter-hegemonic discourses of the working classes.

As discussed in the last chapter, the utilization of the general concept of labor was widespread within the cultural and political landscape of Victorian England. It had currency within the oftentimes conflicting political and social discourses of both the bourgeoisie and working classes. While retaining a core meaning (which was a shared antipathy to "idleness"), the concept was articulated in different ways by spokesmen of these classes, offering specifically useful ways in which to constitute and differentiate their interests vis-à-vis other classes as well as providing a ground for the elaboration of diverse social and political ideals. It provided a rich and potentially open cultural language from which were constituted diverse subject positions within the political terrain of Victorian England. Moreover, these more strictly political uses of the concept were reinforced by its presence in various religious traditions that proclaimed, in the words of Cardinal Newman, "[that] everyone who breathes, high and low, educated and ignorant, young and old, man and woman, has a mission, has a work."[25] Indeed, Carlyle, one of the most vociferous and influential spokesmen for the value of labor or work (and who Ruskin considered after J. W. Turner to be his most important mentor), had claimed that "all true Work is religion."[26] Yet, if it was a fundamentally religious activity, being an expression of God's will on earth, it did not necessarily have to be a pleasurable one; whether toilsome or menial, labor provided a way toward spiritual and moral salvation. "Who art thou that complainest of thy life of toil?," Carlyle queried. "Complain not. Look up my wearied brother; see thy fellow workmen there, in God's eternity; surviving there, they alone surviving: Sacred Band of the Immortals, celestial Bodyguard of the Empire of Mankind."[27] Highly influenced by the impas-

sioned words of Carlyle, the Christian socialism of F. D. Maurice, J. M. Ludlow and Charles Kingsley also proclaimed the religious character of work, a declaration that after the movement's inception in 1848 moved the founders toward various reformist and educational schemes in alleviating the plight of the working classes, the most famous being the institution of the Working Men's College in 1854.[28] All of these discourses on labor were wonderfully represented in Ford Madox Brown's "Work" (1864), a painting that foregrounds workers heartily engaged in their activity, surrounded by various specimens of the idle poor and idle rich, being watched from the sidelines by the caring and loving eyes of Thomas Carlyle and F. D. Maurice.[29]

What is indeed less salient within the multitude of voices proclaiming the dignity and religious character of labor and work was the ideal that such activity should be happy or pleasurable. While it was a necessary activity that may lead to happiness, either later in this earthly life or in heaven, it may of necessity be arduous, toilsome, "unpleasurable." Samuel Smiles, who may be considered the most influential and popular proponent of the "Gospel of Work" after mid-century, had correctly summarized the general relationship between happiness and labor that was acknowledged by most Victorians: "Honourable industry travels the same road with duty; and Providence has closely linked both with happiness. The gods, says the poet, have placed *labour and toil* on the way leading to the Elysian fields [author's emphasis]."[30] To have recognized that happiness must be an integral quality of that providential activity would only call into question the very economic processes that were already providing an earthly "Elysian Fields," at least in the lives of the aristocracy and bourgeoisie.

It is within this general matrix of voices extolling the virtues of labor as toil that we can see the significance of Ruskin's ideal of enjoyable labor, an ideal that, as we will shortly see, developed out of his social excavations of the foundations of beauty in medieval art forms. Moreover, there seems to be an interesting homology between this particular emphasis on enjoyment or pleasure in labor and wider political discourses associated with the working class movement. If Ruskin found in his considerations of art the concept of pleasure, activists within the working class movement were keenly aware of the degradation of their constituency in the laboring processes associated with capitalism. Indeed, as we saw in the discourses of labor surrounding the Great Exhibition, Harney explicitly uses the concept of enjoyment when talking about the goals of labor associated with a worthy industrial exhibition. Given the prevailing conditions of labor, most activists within the movement could not help but discuss the dehumanization associated with machinery and the factory system, and, in so doing, either explicitly or implicitly elaborate a goal of labor free from toil. The division of labor associated with the factory system ensured that what was in earlier periods a many-sided activity (physically and intellectually) in the production of a good or commodity would be replaced by the repetition of menial tasks and the atrophying of potentialities. Writing in 1867, and drawing extensively on official accounts and reports, Marx had perspicaciously portrayed the

particular conditions of work that prevailed in the burgeoning factory system in England:

> Factory work exhausts the nervous system to the uttermost; at the same time it does away with the many-sided play of the muscles, and confiscates every atom of freedom, both in bodily and in intellectual activity . . . Owing to its conversion into an automaton, the instruments of labour confronts the worker during the labour process in the shape of capital, dead labour, which dominates and soaks up living labour-power. The separation of the intellectual faculties of the production process from manual labour . . . is, as we have finally shown, finally completed by large-scale industry erected on the foundation of machinery. The special skill of each individual machine-operator, who has now been deprived of all significance, vanishes as an infinitesimal quality in the fact of science, the gigantic natural forces, and the mass of social labour embodied in the system of machinery, which . . . constitutes the power of the master.[31]

Marx's analysis of the factory system and machinery incisively illuminates their role in the intensified dehumanization and exploitation of the worker at the behest of capital. The harsh life of the worker in the factory was further exacerbated by the lengthening of the working day brought on by machinery, the unsanitary conditions, low wages and the prison-like discipline that was instituted in order to ensure the unhampered (unnatural?) automatic processes of the mechanized production process.[32] All in all, this picture of the working classes was one shared by all people who were keenly concerned with their condition, whether informed in their analyses by a theory of surplus value or by their own experiences. As one working class activist in the pages of *The Red Republican* asked:

> What aspect, regarding labour, does the prevailing system of social arrangements present? Broadcloth and silk are woven by pale, half-naked, squalid artisans, crouching fourteen and sixteen hours a day over his loom for a pittance barely sufficient to keep him from actual starvation. Houses like palaces, are built by the denizens of damp, filthy cellars, unfit for human habitation. Rich fields of golden grain are sown and reaped by the labourer who gets scarcely enough of the coursest food to satisfy his hunger, who lives in a hovel like a pigstye, and whose only recourse is the workhouse when crippled by old age, or by the fever and rheumatism brought on by privations and hardships to which he is incessantly exposed.[33]

As we can see from the above quotation, in working class discourses the value of pleasurable labour was ultimately linked to larger economic and social issues. Thus, while this political goal surfaced within articles and manifestos in working class periodicals, it was always implicated in more pertinent issues about economic control, the division of labor and just wages, issues that related directly to, as one commentator in *Reynold's Political Instructor* claimed, a "better constitution of things."[34] It was only through providing "justice to the labourer"—which meant a "just and equitable division of labour," as well as remuneration

proportional to the "value of that labour" and to the "necessities of their different modes of life"[35]—that the worker's labor would become an activity intrinsically meaningful to his life. Once the division of labor is constituted such as to alleviate the most menial and degrading work, or, as argued by one proponent of co-operative schemes, there is at least a rotation of work so that no worker is doomed forever to toil at menial tasks,[36] the true skill of the laborer shines forth, allowing for the production of works of good quality, works that may even exhibit beautiful characteristics. As the commentator in *Reynold's* continues:

> What, for instance, would be the difference between two pieces of work in any of the absolutely real or ornate trades, if one man, driven by competition to despair, undertook it at a nominal price, and the other at good workman's wages? The one would do it as a task imposed upon him . . . the other regards it as a labour of love, . . . and he throws into it all the resources of his art and genius. The one thrusts the *proletaire* still lower in the mire; and the other elevates his art, his class, and enriches his employer.[37]

What is important to note is that the development of laboring processes that are intrinsically meaningful to the worker (i.e., "a labour of love") demands in the eyes of working class radicals and socialists some form of economic equality, just remuneration for labor as well as the diminution of the harshest consequences of the division of labor (consequences that, in the words of one working class activist, presently condemn the worker "to manual labour, . . . render him like those machines they have now raised up as his rival").[38] What is also fascinating to note here, in anticipation of our discussion of Ruskin, is that this commentator has attempted to link the quality of the commodity produced with the quality of labor used in its production.

In his Preface to Ruskin's "The Nature of Gothic," Morris notes that while Ruskin was not the only one to "put forward the urgent necessity that men should take pleasure in labour," he was the sole voice that saw this issue as intrinsically tied to the essence of aesthetic production:

> For Robert Owen showed how by companionship and goodwill labour might be made at least endurable; and in France Charles Fourier dealt with the subject at great length, and the whole of his elaborate system for the reconstruction of society is founded on the certain hope of gaining pleasure in labour. But in their times neither Owen nor Fourier could possibly have found the key to the problem with which Ruskin was provided. Fourier depends, not on art for the motive power of the realization of pleasure in labour, but on incitements, which, though they would not be lacking in any decent state of society, are rather incidental than essential parts of pleasurable work; and on reasonable arrangements, which would certainly lighten the burden of labour, but would not procure for it the element of sensuous pleasure, which is the essence of all true art. Nevertheless, it must be said that Fourier and Ruskin were touched by the same instinct, and it is instructive and hopeful to note how they arrived at the same point by such very different roads.[39]

As Morris claimed, Owenite socialism rested to some extent upon the goal of creating laboring conditions that were pleasurable, as did the socialism of Fourier. What Morris finds lacking in these schemes for the betterment of the working class is that they did not see that degradation rested not only in the lack of "incitements" that constituted and guided laboring activity (as Morris claims, "they would not be lacking in any decent state of society"), but also in the very process of labor itself. Thus, to give workers their just wages, yet at the same time continue toilsome and menial labor, would not be a viable goal for Morris. This focus on the constitution of "the element of sensuous pleasure," as Morris calls the ideal inherent in all human labour associated with the creation of art, represents what one commentator considers Morris's most important contribution to socialist thought.[40] But what is more important for our purposes here is that Morris has drawn an implicit parallel between Ruskin's own concept of "pleasurable labour" and similar notions developed within socialist doctrines of the working class movement.[41] Yet, to claim that Ruskin's conception of labor was a *direct* reflection of these political discourses would be misleading and reductionist. Ruskin's conception of pleasurable labor surfaced gradually, and at first hesitantly, from his painstaking analyses of Gothic architecture.

From Art to Political Economy: Towards a Labor Theory of Art

> In these books of mine their distinctive character as essays on art is their bringing everything to a root in human passion and human hope. Every principle of painting which I have stated is traced to some vital or spiritual fact: and in my works on architecture, the preferences accorded finally to one school over another is founded on a comparison of their influence on the life of the workman,—a question by all other writers on the subject of architecture wholly forgotten or despised.
>
> —Ruskin, *Modern Painters*[42]

In the tradition of Ruskin scholarship there has been a general attempt to portray the organic nature of Ruskin's oeuvre; in particular, to show the formal similarities between his earlier aesthetic characterizations and his later political ideals. Thus we find J. A. Hobson in *John Ruskin: Social Reformer* noting that it is "true that throughout his studies of nature, art and history, he had been sowing the seeds which, deeply buried for many years, were destined by necessary process of thought and feeling to grow and ripen into the ideals of his social teaching."[43] This particular insight is echoed by Williams when he argues that "Ruskin's social criticism would not have taken the same form if it had not arisen, as it did inevitably, from his kind of thinking about the purposes of art."[44] Both of these characterizations point to the seemingly clear relation between Ruskin's conception of "Vital Beauty" in which beauty is defined as the "felicitous fulfillment of function in living things, more especially of the joyful and right exertion of perfect life in man,"[45] and his later conception of an ideal society in

which all humans had particular functions that were ultimately related to a general design. In this ideal, Ruskin left no room for equality and liberty, given that there was to be a strict hierarchy of classes that would ensure the proper functioning of the system as a whole. As Ruskin averred concerning these political demands of the working classes: "No liberty, but instant obedience to known law, and appointed persons; no equality, but recognition of every betterness, and reprobation of every worseness."[46] Hobson succinctly characterizes the centrality of the organic metaphor in Ruskin's thought that bears on his distaste of democratic ideals:

> The organic conception everywhere illuminates his theory and his practical constructive policy; it gives order to his conception of the different industrial classes and to relations of individual members of each class; it releases him from the mechanical atomic notion of equality, and compels him to develop an orderly system of interdependence sustained by authority and obedience . . .[47]

It is thus in Ruskin's particular conception of "Vital Beauty" that recent scholars have found the roots of Ruskin's conservatism. Yet, while there are close parallels between Ruskin's conceptions of art and beauty and his later political and social ideals, there are also certain tensions that come to the forefront with a closer reading. Even in his earliest work, *Modern Painters*, it is possible to uncover a parallel though distinct conception of art and beauty that, though linked to the notion of "felicitous fulfillment of function," actually works against Ruskin's conservatism. This is the conception we had mentioned earlier concerning beauty and the conditions of the worker. Ruskin was drawn by his experience of the political turmoil of his period to the importance of the working conditions of the laboring classes. This political insight provided him with the necessary impetus to elaborate a conception of beauty that related to labor and work, a notion which would ultimately provide a basis from which to attack the bastions of orthodox laissez-faire political economy. But its "political logic," if we may use that term, was one that actually militated against notions of class hierarchy. We thus have in Ruskin two seemingly contradictory political moments: one that ultimately would seem to move him to support the political causes of the working classes in their struggle for equality and liberty, while the other drawing sustenance from those conservative traditions that assume the necessity of their obedience to the ruling classes. As we know, it is the latter that ultimately wins in Ruskin.

Painting Morals: *Modern Painters* and Ruskin's Earlier Formulations

To fully understand Ruskin's conception of the relation of labor to beauty we must start with his monumental early work *Modern Painters*. This work was written over a thirteen-year period beginning in 1843 with Volume I; Volume II was published in 1846, and Volumes III and IV came out in 1856. Between the

publication of Volume II and III, Ruskin was driven into his first analyses c. nature of architecture (with *Seven Lamps of Architecture*), and particularly the critical meaning of the Gothic form (with *The Stones of Venice*). While these works on architecture clearly portray Ruskin's interest in the social conditions that underlie the production of art, it is in *Modern Painters* that we encounter the first tentative steps in this direction.

In general, the purpose of *Modern Painters* is to show the superior truth of the modern English School (e. g., Turner) to the landscape painters of the seventeenth century. In this narrative, Ruskin is attacking in particular the Grand Style proffered at the Royal Academy by Joshua Reynolds, a style Ruskin argues is prone to generalization and ignores the finer details of natural form. It is the attempt to educate men to the "truth" in these natural forms that provides the impetus for much of the writing in these volumes, and indeed explains the fact that Ruskin actually deals more with nature itself than with painting. For Ruskin, the ability to fully perceive nature is not a gift that can be left to the intellect alone, but is intimately expressive of man's moral nature. Thus, *Modern Painters* is as much an education in morals, as it is in the principles of beauty in art. As he argues:

> With this kind of bodily sensibility to colour and form is intimately connected that higher sensibility which we revere as one of the chief attributes of noble minds, and as the chief spring of real poetry. I believe this kind of sensibility may be entirely resolved into the acuteness of bodily sense of which I have been speaking, associated with love, love I mean in its infinite and holy functions, as it embraces divine and human and brutal intelligences, and hallows the physical perception of external objects by association, gratitude, veneration and other pure feelings of our moral nature. And although the discovery of truth is in itself altogether intellectual . . . yet these instruments (perception and judgement) are so sharpened and brightened, and so far more swiftly and effectively used, when they have the energy and passion of our moral nature to bring them into action . . .[48]

The ability to observe nature is only possible once the "moral nature" of the spectator has been developed. This moral nature is a necessary and sufficient condition of perceiving beauty; indeed, one's moral nature actually motivates the perception of these truths. As Ruskin further claims, bringing the connection between morality and natural truth into a succinct formulation: ". . . a man of deadened moral sensation is always dull in his perception of truth."[49]

As has been pointed out by many other commentators, when Ruskin refers to "moral nature" he is not referring to right and wrong actions per se, but to general conduct and character. The latter is not individually constituted, but stems from wider cultural and social conditions of the age. In turn, Ruskin enters the study of art with the conviction that the "sensation of beauty is not sensual on the one hand, nor is it intellectual on the other, but is dependent on a pure, right, and open state of the heart, both for its truth and its intensity."[50] Thus, the particular human faculty associated with grasping beauty is not what has tradi-

tionally been termed "aesthetic," for such a term signifies for Ruskin "mere sensual perception of the outward qualities and necessary effects of bodies."[51] Rather, that human faculty appropriate to elucidating the moral underpinnings of beauty can be better described as "Theoretic." Ultimately, the Theoretic Faculty is a venerative and religious tool: it does not at all seek, as Ruskin clarifies,

> what the Epicurean sought, but finds its food and objects of its love everywhere, in what is harsh and fearful, . . . even in all that seems course and commonplace; . . . hating only what is self-sighted and insolent of men's work, despising all that is not of God, unless reminding it of God, yet able to find evidence of him still, where all seems forgetful of him . . .[52]

Those qualities which are identical in all things "whether it occur in a stone, flower, beast, or in man," and which "may be shown to be in some respect typical of Divine attributes," Ruskin calls "Typical Beauty."[53] In this way, the Theoretic Faculty discerns general characteristics—exhibitions of God's work and design—in all inorganic and organic objects. Yet, there is a further character of beauty of which the Theoretic Faculty takes hold, namely, "Vital Beauty." If "Typical Beauty" is that external quality of objects that uniformly delight the eye, "Vital Beauty" arises from the "appearance of felicitous fulfillment of function in living things."[54] At once this statement seems to imply that "Vital Beauty" refers solely to the contemplation of the general design or telos inherent in each object in the natural and human world, that is, the role they play in the grand design ordained by God's will. As pointed out earlier in the chapter, this has been the traditional interpretation of this notion. Yet, while Vital Beauty is expressive of the fulfillment of an object's assigned function, it is not just a particular role in the larger scheme of things that is implied by "function," but also a certain quality of life. Vital Beauty arises "in the keenness of the sympathy which we feel in the happiness . . . of all organic beings, and which . . . invariably prompts us, from the joy we have in it, to look upon those as most lovely which are most happy."[55] It is here that we find, albeit submerged under the catechisms of Ruskin's religiosity, a parallel conception of beauty that relates to the "instinctive delight in the appearances of. . .enjoyment."[56] This state of "happiness" and "enjoyment" is intimately related to the presence of "vital energy" in the object. In discussing the presence of Vital Beauty in plants, Ruskin notes: ". . . in a rose-bush, setting aside all of the considerations of graduated flushing of color and fair folding of line, which it shares with the cloud or the snow-wreath [and which exemplifies Typical Beauty], we find in and through all this, certain signs pleasant and acceptable as signs of life and enjoyment in the particular individual plant itself."[57] These signs are necessarily more particular to the specific object under study. At this point, Ruskin's text exhibits a particularly interesting aporia. What had seemed at first sight a strictly functionalist argument concerning beauty has been somewhat elided by a parallel, more elusive, consideration of the quality of life as it relates to beauty. That is, the criteria of "life and enjoyment" do not necessarily imply a particular function in a

greater design. It could just as logically imply diversity and uniqueness, indeed an unwillingness to partake in a preordained schema. One might even ask how could "vital energy," in any significant sense of the term, be other than antagonistic to an overarching design. Indeed, in Ruskin's later architectural writings beauty becomes intimately related to the creativity and freedom of the work that went into its production, a situation in direct antithesis to preordained designs.

While this aporia first surfaces within *Modern Painters* in his discussion of Vital Beauty, tempting the reader briefly with an alternative conception of beauty, it is ultimately sutured by Ruskin's religious temperament. The closing of this political moment is achieved by logical circularity. As Ruskin continues concerning the rose-bush: "Every leaf and stalk is seen to have a function, to be constantly exercising that function, and as it seems *solely* for the good and enjoyment of the plant . . . reflection will show us that the plant is not living for itself alone, that its life is one of benefaction, that it gives as well as receives."[58] Thus "enjoyment" is defined as a symptom of functioning well in God's design. What this aporia signifies is that those attempts to base Ruskin's conservatism in the notion of Vital Beauty are only partially correct. For within that very discussion surfaces an heterogeneous political moment. To focus on "life and enjoyment" as important criteria for beauty is to preface a multitude of political positions, not just conservatism. It could mean, as it did for working class activists, the eradication of capitalism as a system of production, and the expansion of equality and freedom for all people in society. The contradictory politics we find in Ruskin's aesthetic language may help to explain the curious mixture of stances in his later conscious political thought. It makes it understandable why Ruskin would in one breath side with the political discourses of the working class in their admonitions against the degrading practices of capitalist production on the life of the operative, while at the same time claiming that the solution to their predicament lay within proper obedience to a morally enlightened ruling class, a class whose existence stemmed from those exploitative economic processes.

**The Critical Light of Architecture: Ornamental Beauty
and the Enjoyment Criteria of Aesthetic Worth**

Ruskin had always been fascinated by architecture. Yet, it was not until after the publication of Volume II of *Modern Painters* that he ventured into his first sustained treatment of the character of this art form. If in *Modern Painters* we encounter a clear connection between moral nature and beauty in art, in Ruskin's writings on architecture we find a clearer rendering of the social conditions that affect the artist's moral nature. As John Sherbourne has argued, for Ruskin architecture is a more communal activity than painting; it involves the concerted activities of variously talented workmen and is experienced by a wide spectrum of the public.[59] It thus not only becomes for Ruskin an important indicator of the moral character of a nation, but it also has the potentiality of deeply influencing society. That is, architecture, by the very fact that it is socially produced and is

continually experienced by individuals in their life-world, has a critical cognitive component, and a very important moralizing function as well. Thus, as Ruskin claims, it is a "distinctively political art"[60] that "so disposes and adorns the edifices raised by man for whatever uses, that the sight of them contributes to his mental health, power and pleasure."[61]

These latter comments are from Ruskin's first sustained work on architecture, *The Seven Lamps of Architecture* (1849). His intention in this work is to clarify the general principles that underlie all great architecture; each chapter focuses on a different "Lamp" or principle that should define this art form. Importantly, it is in this work that we see Ruskin reiterating the "enjoyment" criteria of beauty first encountered in his description of Vital Beauty, only now concretely articulated as pertaining to the conditions of the worker. While there are many prescient insights scattered throughout this work, the most important for our purposes are those which raise the relation of working conditions to aesthetic production and aesthetic value. Indeed, it is in this work that we begin to see the seeds of Ruskin's distinct contribution to English cultural criticism, namely, the elaboration of a labor theory of art.

At this initial point of analysis, it should be noted that the date of its publication is significant—it came out only a year after the collapse of the Chartist movement, and it marks the beginning of Ruskin's interest in the conditions of the working class. While there is no clear evidence that Ruskin was actually in touch with Chartist leaders at this point in his life, one can assume, as with all socially aware intellectuals of this period, that he had knowledge of their doctrines and aims. Ruskin's active participation in philanthropic schemes of working class education began in the early 1850s, with his connection to the Working Men's College. There is evidence that he began to interact with the working classes in this educational forum.[62]

Whatever Ruskin's actual connection to the working class movement, his attitude toward its aspirations and political aims was ambivalent at best. We have already noted his attitude toward the twin aims of equality and liberty that made up the bulk of the political doctrines of Chartists and working class socialists. Yet, Ruskin agreed wholeheartedly in his later writings with their notion that workers have the just right to the "fruits of their industry," to quote O'Brien. Indeed, all inequalities that arise from competitive commerce have their root in the exploitation of the laborer by the capitalist, in which the latter takes "all the surplus" of the former's production, leaving the worker with only enough for mere subsistence. As Ruskin continues, seeming to echo "socialist" analyses of contemporary activists,

> success (while society is guided by laws of commerce) signifies always so much victory over your neighbour as to obtain the direction of his work, and to take the profits of it. This is the real source of all great riches. No man can become largely rich by his personal toil . . . [I]t is only by the discovery of some method of taxing the labour of others that he can become opulent. Every increase of his capital enables him to extend this taxation more widely; that is, to

invest larger funds in the maintenance of labourers,—to direct, accordingly, vaster and yet vaster masses of labour, and to appropriate its profits.[63]

If Ruskin agreed with radical contemporaries about the existence of exploitation of workers by the capitalist class, he was unwilling to agree with the political activities the working class pursued in their fight against that exploitation. Generally, Ruskin argued that what was needed was the proper education of capitalist classes toward a morally just application of labor, along with a proper consumer ethic that would ensure that there was no demand for products whose shoddiness reflected the degradation of the worker. Yet, there are times when his frustration with the "system of iniquity" leads him to propose violence and revolution. For example, in *Fors Clavigera*, "Letter Eighty-Nine" (1880), we even see Ruskin calling for the workers to unite against the capitalist class and fight for "the transference of power out of the hands of the upper classes, so called, into yours—transference which has been compelled by the crimes of these upper classes, and accompanied by their follies."[64] It is this curious mixture in his political thought of a savage critique of capitalist exploitation, with an unerring deference to the necessity of a morally rejuvenated ruling class, that portrays the conflicting political discourses of the period. It is important to note that Ruskin's entry into politics only occurred after he developed a labor theory of art. Indeed, Ruskin's analyses of architecture were discursive surfaces upon which the larger political discourses were inscribed; the latter actually constituted the problematic of his work. While retaining their political logic, these political languages were rearticulated in aesthetic terms, later providing a ground for directing his keen intellect into the political and economic issues of his day.

The Seven Lamps of Architecture begins with a discussion of the "Lamp of Sacrifice." In this chapter, Ruskin begins his analysis by distinguishing between architecture and building. The former, although seemingly very similar to a building in its utility, only comes into being when there are impressed "on its form certain characters venerable or beautiful, but otherwise unnecessary."[65] Such unnecessary adornment or ornamentation shows the supreme act of Sacrifice for Ruskin; it portrays the extent to which "we should in everything do our best; and, secondly, that we should consider increase of apparent labour as an increase of beauty in the building."[66] It is thus not any type of labor that engenders beauty or aesthetic value, but labor well executed: "It is not a question of how *much* we are to do, but of how it is to be done; it is not a question of doing more, but of doing better."[67] The "Lamp of Sacrifice" is thus intimately reflected in work well done, labor expended in enough proportion to create the most beautiful effects under existing conditions.

In the second chapter, the "Lamp of Truth," Ruskin calls for the need for all architecture to correctly reflect the character and nature of its materials, as well as the quantity of labor that went into it. In this chapter, he spends most of his time attacking three prevalent architectural "Deceits": the insinuation of a mode of structure other than the true one; the painting of surfaces to signify some ma-

terial other than what it really is; and, the use of machine-made ornament of any kind. It is in the discussion of the latter Deceit—what he calls "Operative Deceit"—that Ruskin returns to the discussion of human labor as it pertains to beauty. As we noted earlier, one of the defining characteristics of all good ornament is the amount of human labor and care spent upon it. More particularly, it is the fact that it is a manifestation of our human qualities that provokes wonder in the spectator of an architectural monument:

> all our interest in the carved work, our sense of its richness, . . . results from our consciousness of its being the work of a poor, clumsy, toilsome man. Its true delightfulness depends on our discerning in it the record of thoughts, and intents, and trials, and heart-breakings—of recoveries and joyfulness of success.[68]

It is because beauty is a reflection of human work and toil, an emanation of conscious desires and intents, that Ruskin admonishes the ornamentation created by machinery: "For it is not the material, but the absence of the human labor, which makes the thing worthless; and a piece of terra cotta, of plaster of Paris, which has been wrought by human hand, is worth all the stone in Carrera, cut by machinery."[69] So far, then, Ruskin perceives the destitution of ornamentation and aesthetic value to be premised upon this "Operative Deceit," that is, the feigning of human labor through the use of machinery. But, Ruskin does not stop at the level of the artwork itself. He proceeds to reflect upon the influence this use of machinery has on the worker himself. What is distressing about such use of machines is that it forces "men to sink into machines themselves, so that even hand-work has all the character of mechanism."[70] Thus, within this particular comment we can already see the movement from art to machines, and from mechanism (as a way of life related to industrial machine production) to social concern for the working conditions of the laborer. The degradation of the worker is concomitant with the destitution of architectural ornamentation. The particular pathways that Ruskin takes in his later architectural and political writings are already implied in these brief words: in *The Stones of Venice*, Ruskin clearly relates the beauty of Gothic forms to the freedom, creativity and intelligence of the human labor used in its production. Moreover, beginning with *The Political Economy of Art* (1857) Ruskin moves into considerations more clearly associated with political and social theory, ultimately toward adumbrating ways in which to revitalize and rehumanize labor, and thus art, through state intervention.

Yet, before exploring Ruskin's mature thinking on architecture, let us follow the path of Ruskin's thought in *The Seven Lamps of Architecture*. It is in his chapter on "The Lamp of Life" that one encounters the "enjoyment criteria" of beauty mentioned previously. If Ruskin saw the destitution of machine work in ornamentation to be characterized on one level by its inhuman quality and deceit, it was also ignoble because it did not reflect the imperfection that characterizes all truly human work. In this chapter, Ruskin reworks the notion of Vital Beauty we found in *Modern Painters* to characterize these beautiful qualities

reflected in vital and imperfect handmade ornamentation. If in organic forms we see that they "are noble or ignoble in proportion to the fulness of the life which either they themselves enjoy, or of whose actions they bear the evidence, . . . this is especially true of all objects which bear upon them the impress of the highest order of creative life, that is to say, of the mind of man."[71] As Ruskin remarks concerning man made artifacts:

> they become noble or ignoble in proportion to the amount of energy of that mind which has visibly been employed upon them. But most particularly and imperatively does the rule hold with respect to the creations of Architecture, which being properly capable of no other life than this, and being not essentially of things pleasant in themselves,—as music of sweet sounds, or painting of fair colors, but of inert substances,—depend, for their dignity and pleasurableness in the utmost degree, upon the vivid expression of the intellectual life which has been concerned in their production.[72]

Ruskin is clearly asserting the necessity of human energy, intelligence and vitality to ensure the creation of a living and true architecture. Moreover, architecture becomes a clear record of the life and death of a nation as a whole, of the vitality and decay of its living members. The evolution of a nation, Ruskin notes, "is marked most clearly in the arts, and in Architecture more than in any other; for it, being especially dependent . . . on the warmth of a true life, is also peculiarly sensible of the helmlock cold of the false."[73] For Ruskin, past architecture represents a visual "memory" of the history of mankind in its struggles, successes and failures. As a spatialized remembrance of things past, all architecture is to be revered by letting it flourish or decay untouched by the hubris and technological ingenuity of modern attempts at restoration. Not only is it the property of all generations, and thus not rightly the plaything of modern man, but also the critical force in such a built structure demands its continued preservation. Indeed, the critical knowledge supplied by the most beautiful of past architecture provides an impetus for aesthetic renewal as well as the revitalization of human life.

Ruskin concretizes this notion of vitality by focussing on the question of "finish" in architectural ornamentation. If historians of art have traditionally seen the rudeness and inexactitude of some architectural ornamentation to be a sign of its lack of aesthetic worth, Ruskin conceives of such human frailties as the sign of a "living architecture." It matters not whether ornamentation is the product of bad workmanship per se, but rather whether in that work the mind and heart were actively engaged in the totality of the art work. If this latter condition were true, there would indeed be gaps and "careless bits" in the finish of the ornamentation, but they "will be in the right places, and each part will set off the other; and the effect of the whole, as compared with the same design cut by a machine or a lifeless hand [deadened by Mechanism], will be like that of poetry well read and deeply felt to that of the same verses jangled by rote."[74]

Again, what we are encountering in this formulation is a reassertion of Ruskin's earlier notion of Vital Beauty, only now seemingly defrocked of its heav-

enly robes and referring strictly to the intelligence and vitality of *human* labor. With this in mind, it is no wonder that Ruskin would a little later in his analysis assert the quality of "enjoyment" that he found to characterize Vital Beauty within organic forms in *Modern Painters*. In a famous statement, Ruskin concludes his discussion of finish with the enjoyment criteria:

> I believe the right question to ask, respecting all ornament, is simply this: Was it done with enjoyment—was the carver happy while he was about it? It may be the hardest work possible, and the harder because so much pleasure was taken in it; but it must have been happy too, or it will not be living. How much of the stone mason's toil this condition would exclude I hardly venture to consider, but the condition is absolute.[75]

In raising the condition of happiness and enjoyment as "absolute," Ruskin has squarely moved onto the terrain of the social conditions of the working classes. From this juncture onward, Ruskin will begin his odyssey into the intricacies of economic and political reform demanded by the ideal of aesthetic worth he has elaborated here. Yet, before he can with good conscience leave his initial resting place in art, he will attempt to apply these principles to a particular architectural site in order to more fully unfold the implications of this burgeoning labor theory of art: that is, he reconstructs the drama of society and politics in the various waves of architectural styles that inundated the city of Venice.

Venetian Archaeologies: Labor and the Nature of Gothic Architecture

Certainly, *The Stones of Venice* represents the pinnacle of Ruskin's aesthetic theory. In this great work, Ruskin applies to a particular architectural space the general principles he had uncovered in *The Seven Lamps of Architecture*. The rich history and diversity of architectural styles in Venice supplies Ruskin with the social archaeology to which he had alluded in his earlier work. Yet, Ruskin does not merely record the variety of architectural styles that abound in Venice; rather he seeks to uncover the social and political meanings and practices inscribed within that shifting architectural palimpsest. The human dramas Ruskin reads in these well-worn stones are multifaceted and overlapping: first, he sees a religious allegory concerning the rise and fall of true Christianity; second, he uncovers the history of the development of the most beautiful art form, the Gothic, out of the Greek and Roman styles, and he records its eventual eclipse by the Renaissance style; and third, he portrays the transformations of laboring conditions based upon freedom and creativity to one of servitude at the wheels of machines and the discourses of mechanism. These subnarratives link into two opposing camps: on the one side, Ruskin groups true Christianity, the Gothic form and free and creative labor; on the other side, ignoble Christianity, the Renaissance style and servitude in labor. Indeed, all of

these facets are interwoven in Ruskin's lengthy text, surfacing at various points in their specificity, but always intimately connected.

In his introductory chapter, "The Quarry," Ruskin begins his discussion not with a survey of its architecture, but rather with a political history of Venice. Noting that the fall of Venice as a flourishing and vital state occurred simultaneously with its transition from a Republican to an oligarchic form of government, he asks whether one can ascribe its general economic decline to that very political form. While the political theorist may find such a query worthy of consideration, Ruskin thinks that it is really expressive of a deeper malaise, namely, the decline in the lived religious experiences of the populace: " . . . the evidence which I shall be able to deduce from the arts of Venice will be both frequent and irrefragable, that the decline of her political prosperity was exactly coincident with that of domestic and individual religion."[76] For Ruskin, such "domestic and individual" religious sentiment was concomitant with a vitality and dignity of spirit that could not but inform most acts of its citizenry. It not only reflected itself in the "prosperity of the state," and in the success of its "commercial transactions," but also in the flourishing of a particular architectural form, namely, the Gothic Style.[77] Moreover, not only are politics (defined in the more traditional sense as statecraft) and art intertwined for Ruskin, but the latter is also necessarily related to the social conditions of labor.

Ruskin spends the rest of his work analyzing three architectural waves that inundated Venice in its lifetime as a state: The Christian Roman or Byzantine style, whose preponderance lasted well into the twelfth century, and that portrayed "a people struggling out of anarchy into order and power"[78]; the Gothic Style which flourished in its most perfect form from the middle of the thirteenth century to the early fifteenth century, "that is to say over the precise period which I have described as the central epoch of the life of Venice";[79] and the Renaissance Style, which, in its overturning of Christian motifs and feelings in the name of rationalism, was expressive of her decline. Ruskin prefaces these lengthy analyses with a call to remember the importance of the specifically human qualities that determine aesthetic worth:

> much of the value both of construction and decoration, in the edifices of men, depends upon our being led by the thing produced or adorned, to some contemplation of the powers of mind concerned in its creation or adornment. . .we take pleasure, or should take pleasure, in architectural construction altogether as the manifestation of an admirable human intelligence . . . And again, in decoration or beauty, it is less the actual loveliness of the thing produced, than the choice and invention concerned in the production, which are to delight us; the love and thoughts of the workman more than his work: his work must always be imperfect, but his thoughts and affections may be true and deep.[80]

Beauty resides then in a construction or adornment that clearly expresses "choice and invention" in the act of production; indeed it should directly reflect "human intelligence." Not only does Ruskin see these qualities to be dependent on a particular moral and religious temperament, but they are also necessarily

dependent upon the particular way in which the worker is organized and used, that is, on social conditions that allow for such expression. Aesthetic worth is then determined not just by formalistic and aesthetic qualities (i. e., "loveliness"), but also on their expression through certain work conditions that promote creativity and intelligence.

It is when Ruskin discusses the Gothic style that he spends more time on elaborating the connection between architectural form and working conditions. While ostensibly a discussion of a medieval art form, Ruskin's aesthetic observations are always embedded within a moral and political discourse about nineteenth-century England. In particular, in uncovering the conditions that make the Gothic form so beautiful, he is able to bring a critical light on the devastation wrought by the division of labor and industrial capitalism. These prescient critiques mainly surface within his discussion of the first two characteristics of the Gothic style—"Savageness" and "Changefulness."

Ruskin begins his chapter on "The Nature of Gothic" by examining this first characteristic of Savageness. After exploring the geographical determinants of this element (that it was imported from the harsh Northern countries), he focuses more clearly on the work relations that make it possible. In this discussion, Ruskin outlines three different relationships of power that enter into ornamentation: "Servile ornament," which is best exemplified in Greek ornament, and in which the execution of the inferior workman is subjected to the control and designing intellect of the superior workman; "Constitutional ornament," best seen in Gothic ornament, in which the inferior power is "emancipated and independent, having a will of its own, yet confessing its inferiority and rendering obedience to higher powers";[81] and, "Revolutionary ornament," exemplified in Renaissance ornament, in which there is a complete subversion of executive inferiority. It is interesting to note the "political" nature of these terms: Ruskin's distaste for revolutionary ventures (especially those fighting for equality and liberty) is reasserted in his characterization of Renaissance ornamentation. While he notes the debilitating presence of "slavery" in Greek architecture, he still seems not willing to give the worker complete control over the design and execution of ornament that is implied in Renaissance work. For, in the process of endowing the worker with the "skill and knowledge" originally possessed by the master, "his own original power is overwhelmed, and the whole building becomes a wearisome exhibition of well-educated imbecility."[82] Whether we agree with Ruskin in this or not, what is clear is that there is a real fear that such complete subversion of power would lead to the destruction of true art. Indeed, it is the precarious, tension-ridden, balance between the freedom of the worker and reverence for grander designs that constitutes Gothic forms.

More importantly, what Ruskin really implies by "rendering obedience to higher powers" is not necessarily a lack of freedom or creativity, but a ready recognition on the part of the worker of humility in design. This translates most clearly into the open readiness to use God's creation—nature itself—as the basis of ornamentation. Thus, "Naturalism" and the use of flora become important motifs in Gothic ornamentation. Moreover, "rendering obedience" is actually

defined by Ruskin in terms of allowing self-expression and independent thought in creating art. After noting how in Classical architecture the workman was a "slave," Ruskin notes the way in which the Gothic form of ornamentation transcends this condition of servitude:

> in the Medieval, or especially Christian, system of ornament, this slavery is done away with altogether; Christianity having recognized, in small things as well as great, the individual value of every soul. But it not only recognizes its value; it confesses its imperfection, in only bestowing dignity upon the acknowledgement of unworthiness...Therefore, to every spirit which Christianity summons to her service, her exhortation is: Do what you can, and confess frankly what you are unable to do . . .[83]

From these general principles of doing all that is possible to create beauty and ornament in light of our limitations, it becomes clear why Ruskin sees "imperfection"—"Savageness"—to be an important characteristic of true art: it is an "acknowledgement of unworthiness" in front of the perfect splendor of God's creations. It also shows the moral premises behind Ruskin's admonishments against machine work. For Ruskin, machine production in ornamentation strives after perfection in its designs, and it does so with a sense of hubris, as if it were possible to match the perfection of God's work. In so doing, it eradicates the distinctly human qualities (our fallen nature) that make up worthy art. Moreover, not only does this machine production destroy art, it "unhumanizes" the worker, leaving him a tool without freedom and without intelligence. As Ruskin observes:

> You must either make a tool of the creature, or a man out of him. You cannot make both. Men were not intended to work with the accuracy of tools, to be precise and perfect in all their actions. If you will have that precision out of them, and make their fingers measure degrees like cog-wheels, and their arms strike curves like compasses, you must unhumanize them . . . On the other hand, if you will make a man of the working creature, you cannot make a tool. Let him but begin to imagine, to think, to try to do anything worth doing; and the engine-turned precision is lost at once. Out come all his roughness, all his dullness, all his incapability; . . . but out comes the whole majesty of him also.[84]

What is curious to note, though, is that the freedom that Ruskin perceived in the medieval period which expressed itself in the beauty of Gothic architecture, is one that implies oppression; indeed, "men may have been beaten, chained, tormented, yoked like cattle, slaughtered like summer flies, and yet remain in one sense, and the best sense, free . . . a freedom of thought, and rank in scale of being, such as no laws, no charters, no charities can secure; but which it must be the first aim of all Europe at this day to regain for her children."[85] As exhibited in this statement, Ruskin was not naive about the problems of oppression and arbitrary rule that threatened the workman in the Medieval period. He accepted this as social fact, and then dug beneath the harsh exterior of their lives to un-

cover a freedom of expression that benefited each individual soul. In so doing, he was able to unearth an aesthetic ideal that would propel him towards critical examination of the art and social conditions of his own century. Curiously, such a willingness to accept the good with the bad in his medievalism also limited the logical extension of his political and social critique. Unlike Morris, Ruskin never took his conception of free and pleasurable labor to signify a society without class inequalities, exploitation or poverty. In attempting to explain the reason for the working class's "universal outcry against wealth," Ruskin notes:

> It is not that men are ill fed, but that they have no pleasure in the work by which they make their bread and therefore look to wealth as the only means of pleasure. It is not that men are pained by the scorn of the upper classes, but they cannot endure their own; for they feel that the kind of labor to which they are condemned is verily a degrading one, and makes them less than men.[86]

If it is essentially their experience of degradation that forces the working classes to call for equality and liberty, what accounts for that experience? At one point, Ruskin focuses on the condition of the division of labor to explain part of that degradation, an explanation that as we know was to be echoed by Karl Marx later in that century:

> We have much studied and much perfected, of late, the great civilized invention of the division of labor; only we give it a false name. It is not, truly speaking, the labor that is divided; but the men:—Divided into mere segments of men—broken into small fragments and crumbs of life; so that the little piece of intelligence that is left in a man is not enough to make a pin, or the head of a nail . . . And the great cry that rises from all our manufacturing cities, louder than their furnace blast, is all in very deed for this,—that we manufacture everything there except men; we blanch cotton, and strengthen steel; and refine sugar, and shape pottery; but to brighten, to strengthen, to refine, or to form a single living spirit, never enters into our estimate of advantages.[87]

We know what this implied for Marx: it meant a whole system of production based upon private property and the extraction of surplus value from the working class. That is, a system of production exploitative in its very internal workings. Ruskin's analyses recognize the dehumanizing aspects of machine production and the division of labor—in *Unto This Last* and his later political writings he even recognizes the role of the profit motive in exacerbating this situation—but he did not feel that these developments were necessarily linked to a particular system of production. Rather, Ruskin thought that these conditions could be reformed within the capitalist system by an enlightened upper class and a widespread consumer ethic. Such dehumanization and degradation "can be met only by a right understanding, on the part of all classes, of what kinds of labor are good for men, raising them, and making them happy: by a determined sacrifice of such convenience, or beauty, or cheapness as is to be got only by the degradation of the workman; and by equally determined demand for the

dation of the workman; and by equally determined demand for the products and results of healthy and ennobling labor."[88]

Concluding Remarks: Ruskin and the Politics of Aesthetic Theory

For Ruskin, aesthetic worth and questions of beauty were ultimately related to the condition of human labor that went into the production of the aesthetic object. As expressed in both *The Seven Lamps of Architecture* and *The Stones of Venice*, true art for Ruskin could only arise when the worker was free, thoughtful, and happy in his work. We have at various points in the proceeding discussion attempted to locate the "politics" of this novel emphasis on art and labor. On one level, Ruskin's aesthetic theory exhibits the extent to which cultural discourses are intimately tied to political struggles existing outside the realm of art. In Ruskin's case, we find an interesting homology between his emphasis on pleasurable labor as a key category in understanding art and the political discourses of the working classes. Yet, these discourses were not directly inscribed into his discussions of art. They were refracted through his medievalism. The implication of this process is that he could only take his explicit political ideals so far in the direction of working class radicals and socialists. Like the Luddites, Ruskin could find intense pleasure in destroying the machines of capitalism, but not in establishing political and economic equality. The latter was antithetical to those relations of obedience between classes that were implied in his conservative political self-understanding.

On another level, one which we will be exploring more closely in the following chapters, Ruskin also shows the way in which aesthetic discourses themselves actually constitute political knowledge and action. If politics helped to form the problematic that Ruskin was going to approach art (i. e., one in which labor would be given a central role), those studies guided by that problematic propelled him into more strictly political and social issues. What I have shown in the case of Ruskin is that this movement from the realm of art to politics is not a smooth one, with well-defined pathways and clear causal relationships. Indeed, one of the most interesting factors about Ruskin's development is the conflicting and sometimes contradictory stances that developed in his aesthetic and political ideas. I would even argue that what is most fascinating is that Ruskin's thought represents an arena of conflicting social meanings and political intentions. It is no exaggeration to say that the strains in Ruskin's thought are also the strains and conflicts that racked the social life-world of Victorian England.

Notes

1. Ruskin, "The Opening of the Crystal Palace Considered in Some of its Relations to the Prospects of Art," in *Works of John Ruskin* (London: George Allen, 1904),

Vol. XII, 417-432. The "opening" refers not to its original opening in Hyde Park in 1851, but to its reopening in Sydenham. The Crystal Palace stayed in that location until the late 1930s when it was destroyed by fire.

2. Ruskin, "The Opening of the Crystal Palace," 419.

3. Ruskin, "The Opening of the Crystal Palace," 419-420.

4. These themes are well-known to students of Ruskin, and they appear throughout his oeuvre. See Graham Hough, *The Late Romantics* (London: Methuen, 1947),1-39, and Raymond Williams, *Culture and Society: 1780-1950* (New York: Columbia University Press, 1983), 130-158, for discussions of these themes. My particular interpretation of these issues will be elaborated later in this chapter.

5. Ruskin, "The Opening of the Crystal Palace," 421.

6. Ruskin, "The Opening of the Crystal Palace," 422.

7. See "The Question Concerning Technology," in *The Question Concerning Technology and Other Essays*, William Lovitt, trans. (New York: Harper and Row, 1977), 3-35. In this essay, Heidegger sees the "essence" of technology (what he calls *Ge-Stell*) to lie in the "challenging-revealing" of nature and all works as "standing reserve," that is, as *human* products fully capable of control and calculability. Although it cannot be fully developed here, what is interesting are the parallels between Ruskin's pious denunciations of modern restoration techniques (as based upon a socially produced cultural framework) and Heidegger's injunctions against the "dangers" of *Ge-Stell*. For Heidegger, the essence of technology represents a way of being that is exhibited not only in the very technological artifacts used by mankind, but also in the very way in which we approach the world (the past, present, and future). For further elaboration on his concept of technology, see "What are Poets For," in *Poetry, Language, Thought*, Alfred Hofstadter, trans. (New York: Harper and Row, 1971), 91-142.

8. See Herbert Marcuse, *One-Dimensional Man*; Theodor Adorno and Max Horkheimer, *Dialectic of Enlightenment* (New York: Continuum Publishing, 1972); and Horkheimer, *Eclipse of Reason* (New York: Continuum Publishing, 1974) for representative discussions of this issue.

9. Morris, "Art Under Plutocracy," in *CW*, Vol. XXIII, 164.

10. Morris, "How I Became a Socialist," 6.

11. Eagleton, *The Function of Criticism: From The Spectator to Poststructuralism* (London: Verso Press, 1984), 9. In articulating this conception, Eagleton is drawing sustenance from Jürgen Habermas's early work on the bourgeois public sphere.

12. Eagleton, *The Function of Criticism*, 9

13. Eagleton, *The Function of Criticism*, 11.

14. Eagleton, *The Function of Criticism*, 36.

15. Eagleton, *The Function of Criticism*, 37.

16. Eagleton, *The Function of Criticism*, 37. For Eagleton, the real translation of working class demands came within explicitly *political* reactions within ruling bloc journals. "It is not," Eagleton claims, "that the class struggle in society at large is directly reflected in the internecine antagonism between various literary organs; these unseemly wranglings are rather a refraction of those broader conflicts into ruling-bloc class culture, divided as it is over how much political repression of the working class is tolerable without the risk of insurrection."

17. See Thompson, *The Making of the English Working Class*, 31, where we find the author noting the importance of literary texts in the early working class movement: ". . . it is above all in Bunyan that we find the slumbering Radicalism which was pre-

served through the eighteenth century and which breaks out again and again in the nineteenth. *Pilgrims Progress* is, with *Rights of Man*, one of the two foundational texts of the English working-class movement: Bunyan and Paine, with Cobbett and Owen, contributed most to the stock of ideas and attitudes which make up the raw material of the movement from 1750-1830."

Any glance at the working class journals of the nineteenth century shows the ubiquitous presence of poetry and literature as important factors in galvanizing its audience and readership into political subjectivity and action. An interesting line of inquiry, one which has not been attempted hitherto in the secondary literature, would be an analysis of this "tradition" of literature in these journals. While this is not the place to develop such a line of inquiry, we may provisionally classify the literature in terms of authors and related functions: first, there are poems and serialized novels written by current activists within the movement. Among the more well-known are Ernest Jones in *The People's Paper* (1840s and 50s) and William Morris in the *Commonweal* (1880s). Second, there are literary works from earlier activists in the movement, or activists in other countries (e. g., Freilegrath's poetry constantly appeared in Morris's *Commonweal*). Third, there are works from important literary figures of the period, who, while usually writing on topics deemed important for the movement, were themselves not a part of the movement, e. g., Shelley, Blake, Bunyan, etc. Works by activists in the movement, whether current, past, or foreign, generally dealt with narratives of specific struggles and issues immediately confronting the workers in their political projects. The use of a past activist's poetry provided a sense of the fraternity of working class struggles around the world. With the third category, a more interesting function arises. Not only did these poets deal more with general issues of human struggle (e. g., Shelley's poem on "liberty"), the use of more mainstream literature helped to lend a sense of authority and credence to the overall struggle.

18. Richard Ashcraft, "A Victorian Working Class View of Liberalism and the Moral Life," unpublished paper presented to the Conference for the Study of Political Thought, New York, April 8-10, 1988, 29. For an elaboration of the different roots of English socialism, see Stanley Pierson, *Marxism and the Origins of British Socialism: The Struggle for a New Consciousness* (Ithaca: Cornell University Press, 1973), 3-55.

19. Ashcraft, "A Victorian Working Class View of Liberalism and the Moral Life," 29.

20. Williams, *Culture and Society*, 320.

21. Indeed, Eagleton, *The Function of Criticism*, 39-40, tends to lump Ruskin with other Romantics of the early nineteenth century who promoted what he claims is the function of the "Sage," a man of letters who attempted to extricate literature and art from the vagaries of political instrumentality and place it within the realm of transcendental forms of knowledge.

Of course Eagleton does argue that the Romantic movement did articulate a critical position toward the encroaching mechanization and rationalization associated with industrial capitalism, but in a somewhat ambivalent and contradictory way. On the one hand, the intense glorification of the creative subject in the Romantic notion of imagination offers a foothold from which to critique the rationalization associated with capitalist market exchange. In the process, the poet becomes the arbiter of truth in the onslaught of Mechanism; moreover, s/he becomes the primary locus of social change. To quote Shelley: "Poets are the hierophants of an unapprehended inspiration, the mirrors of the gigantic shadows which futurity casts upon the present;. . .Poets are the unacknowledged leg-

islators of the world" [see "The Defense of Poetry," in *Shelley's Prose*, ed. by D. Clark (London: Fourth Estate, 1988), 297].

Yet, on the other hand, such a hypostatization of creative subjectivity also removes the poet's words from the vagaries of social and political life, offering an understanding of aesthetic production based solely on a *sui generis* creative genius. This is not to claim that the Romantics were apolitical; far from this, a number of them were intensely political, offering their bard's gifts in the service of a number of different political ideologies [See Crane Brinton, *The Political Ideas of the English Romanticists* (Ann Arbor: University of Michigan Press, 1966) for an incisive and extensive discussion of their varying political ideologies. For a good discussion of Shelley's political thought, see John Pollard Guinn, *Shelley's Political Thought* (The Hague: Mouton and Co., 1969).] Rather, their explicit notions of aesthetic production removed art from the world of material struggle to a realm of transcendental subjectivity, one that could provide a vantage point for criticism of the encroaching and all-consuming sway of Mechanism and capitalist production, yet one that ultimately surrendered criticism to the irrationalism of the imagination.

22. Williams, *Culture and Society*, 130. As Williams notes: "As an idea, the relation between periods of art and periods of society is to be found earlier in Europe,...but the decisive emphasis in England begins in the 1830s, and it is an emphasis that was at once novel and welcome." See also Kenneth Clark, *The Gothic Revival: An Essay in the History of Taste* (London: John Murray, 1962), 139, where the author notes: "Standard writers of art criticism—Aristotle, Longinus and Horace—all described art as something imposed, so to speak, from without. The idea of style as something organically connected with society, something that springs inevitably from a way of life, does not occur, as far as I know, in the eighteenth century."

23. Williams, *Culture and Society*, 130.

24. This point concerning the "problem of politics" in *Culture and Society* is forcefully brought out by questions from the editorial board of *New Left Review* in their collection of interviews with Williams. See *Politics and Letters* (London: Verso, 1979), 97-132.

25. Quoted in Houghton, *The Victorian Frame of Mind*, 244.

26. Carlyle, *Past and Present*, 201. As is well known, Ruskin had by 1855 declared publicly that he owed more to Carlyle than any other living author for the direction he was taking in his political thinking. For an insightful discussion of the relationship of Ruskin to Carlyle, see Jeffrey L. Spear, *Dreams of an English Eden: Ruskin and his Tradition in Social Criticism* (New York: Columbia University Press, 1984), 86-125.

27. Carlyle, *Past and Present*, 202. Although this is the dominant image in Carlyle's thought, it should be noted that he does at times note that true labour would be that which is not toilsome and menial. See *Sartor Resartus* (New York: The Odyssey Press, 1930), 284-291, where Carlyle seems to be offering a critique of "Drudgery" as alienated and toilsome labour.

28. For a brief discussion of Christian Socialism, consult Max Beer, *A History of English Socialism* (New York: Humanities Press, 1948), Vol. II, 180-187. It should be noted that the Christian Socialists disagreed concerning what means were necessary to, in the words of Beer, "Christianize socialism and socialize Christianity." The founder, J. N. Ludlow, was clearly more radical in his political and social ideas, hoping, through experiments in working class economic association, to alter the existing institutions in human society closer to the Christian ideal. Maurice, on the other hand, had no use for such radical measures. For a discussion of these differences, see P. R. Allen, "F. D. Maurice

and J. N. Ludlow: A Reassessment of the Leaders of Christian Socialism," *Victorian Studies* XI (June, 1968): 461-482.

29. For an interesting and insightful reading of this painting as "an allegorical representation organized around the problems of work in Victorian society," see Albert Boime, "Ford Madox Brown, Thomas Carlyle, and Karl Marx: Meaning and Mystification of Work in the Nineteenth Century," *Arts Magazine* 56, no. 1 (September, 1981): 166-175.

30. Quoted in Briggs, *Victorian People*, 116.

31. Karl Marx, *Capital, Vol. I*, Ben Fowkes, trans. (New York: Random House, 1977), 548-549.

32. Marx, *Capital*, 549-553. See also the detailed analysis of the conditions of the working classes under factory production in Friedrich Engels, *The Condition of the Working-Class in England* (Moscow: Progress Publishers, 1973), 172-224. In E. J. Hobsbawm, *Industry and Empire* (London: Penguin Books, 1968), 85-86, the author notes how the mechanized factory institutes ". . .a mechanized *regularity* of work which conflicts not only with tradition, but with all inclinations of a humanity as yet unconditioned to it. And since men did not take spontaneously to these new ways, they had to be forced—by work disciplining and fines. . ., and by wages so low that only unremitting and uninterrupted toil would earn them enough money to keep alive."

33. Howard Morton, "Middleclass-Dodges and Proletarian-Gullibility in 1850," *The Red Republican* I, no. 7 (August 3, 1850): 51.

34. A Proletarian, "The Organization of Labour," *Reynold's Political Instructor* (March 16, 1850): 151.

35. A Proletarian, "The Organization of Labour," 151.

36. "The Co-operative System," *Reynold's Political Instructor* (March 2, 1850): 132.

37. A Proletarian, "The Organization of Labour," 151.

38. "The Rich and the Poor," *Reynold's Political Instructor* (November 17, 1849): 12.

39. Morris, "Preface to The Nature of Gothic by John Ruskin" (1892), in *William Morris: Artist, Writer, Socialist*, 293.

40. In Casement, "Morris on Labour and Pleasure," 351-382, the author notes how Morris found pre-existing socialist doctrines on labor to be lacking in this respect. Indeed, Casement rightly notes that Morris's addition of this notion of intrinsically pleasurable labor stems from Ruskin, and, I would add, from the enhancement of that concept through his practice and study of medieval art forms.

41. In "Art and Socialism" (1884), in *Political Writings of William Morris*, A. L. Morton, ed. (New York: International Publishers, 1973), 119-120, Morris explicitly talks how the working classes understand the notion of "the claim of labour to pleasure in the work itself," and have thus been always positively disposed toward Ruskin's ideas.

42. Quoted in J. A. Hobson, *John Ruskin: Social Reformer* (Boston: Dana Estes and Co., 1898), 43.

43. Hobson, *John Ruskin*, 33.

44. Williams, *Culture and Society*, 135.

45. Ruskin, *Modern Painters*, Vol. II, (New York: John Wiley and Sons, 1872), 27-28.

46. Ruskin, *Fors Clavigera* (London: George Allen, 1896), Letter V, Vol. I, 101-102.

47. Hobson, *John Ruskin*, 94.
48. Ruskin, *Modern Painters*, Vol. I, in *The Genius of John Ruskin*, ed. by John D. Rosenberg (London: Routledge and Kegan Paul, 1979), 25.
49. Ruskin, *Modern Painters*, Vol. I, 25.
50. Ruskin, *Modern Painters*, Vol. I, 25.
51. Ruskin, *Modern Painters*, Vol. I, 11.
52. Ruskin, *Modern Painters*, Vol. I, 17.
53. Ruskin, *Modern Painters*, Vol. I, 27.
54. Ruskin, *Modern Painters*, Vol. I, 27.
55. Ruskin, *Modern Painters*, Vol. I, 88-89.
56. Ruskin, *Modern Painters*, Vol. I, 91.
57. Ruskin, *Modern Painters*, Vol. I, 91.
58. Ruskin, *Modern Painters*, Vol. I, 91.
59. John Clark Sherbourne, *John Ruskin, or the Ambiguities of Abundance: A Study in Social and Economic Criticism* (Cambridge: Harvard University Press, 1972), 33.
60. Ruskin, *Seven Lamps of Architecture*, 10.
61. Ruskin, *Seven Lamps of Architecture*, 15.
62. Ruskin's interaction with the working class is discussed in Hobson, *John Ruskin*, 51.
63. Ruskin, *Essay on Political Economy*, later published as *Munera Pulveris* (1872), in *The Political Economy of Art, Unto This Last, and Essay on Political Economy* (New York: J. M. Dent and Sons, Ltd., 1968), 288-290.
64. Ruskin, *Fors Clavigera*, Vol. IV, 361.
65. Ruskin, *The Seven Lamps of Architecture*, 16.
66. Ruskin, *The Seven Lamps of Architecture*, 27.
67. Ruskin, *The Seven Lamps of Architecture*, 28.
68. Ruskin, *The Seven Lamps of Architecture*, 56.
69. Ruskin, *The Seven Lamps of Architecture*, 57.
70. Ruskin, *The Seven Lamps of Architecture*, 57-58.
71. Ruskin, *The Seven Lamps of Architecture*, 142.
72. Ruskin, *The Seven Lamps of Architecture*, 142.
73. Ruskin, *The Seven Lamps of Architecture*, 144.
74. Ruskin, *The Seven Lamps of Architecture*, 162.
75. Ruskin, *The Seven Lamps of Architecture*, 165.
76. Ruskin, *The Stones of Venice*, 2 Vols. (Boston: The Colonial Press, 1912), Vol. I, 19-20.
77. Ruskin, *The Stones of Venice*, Vol. I, 22.
78. Ruskin, *The Stones of Venice*, Vol. I, 17.
79. Ruskin, *The Stones of Venice*, Vol. I, 36.
80. Ruskin, *The Stones of Venice*, Vol. I, 51.
81. Ruskin, *The Stones of Venice*, Vol. II, 159.
82. Ruskin, *The Stones of Venice*, Vol. II, 160.
83. Ruskin, *The Stones of Venice*, Vol. II, 160.
84. Ruskin, *The Stones of Venice*, Vol. II, 162.
85. Ruskin, *The Stones of Venice*, Vol. II, 163.
86. Ruskin, *The Stones of Venice*, Vol. II, 164.
87. Ruskin, *The Stones of Venice*, Vol. II, 165-166.

88. Ruskin, *The Stones of Venice*, Vol. II, 166. See Sherbourne, *John Ruskin, or the Ambiguities of Abundance*, 32, for a discussion of Ruskin's attempt at consumer education.

Chapter Four

Constituting the Aesthetic Self: Medievalism, Pre-Raphaelitism and Morris's Early Education

> If you can really fill your minds with memories of great works of art, you will, I think, be able to a certain extent to look through the aforesaid ugly surroundings, and will be moved to discontent of what is careless and brutal now, and will, I hope, at least be so discontented with what is bad, that you will determine to hear no longer that short-sighted, reckless brutality of squalor that so disgraces our intricate civilization.
>
> —Morris, "The Lesser Arts"[1]

Morris's early life was spent in continual interaction with "great works of art," both as a student and a practitioner. It was a period in which he not only began to immerse himself in the history of architecture and in the exciting works of the romantic poets, but also in which he initiated his own artistic production in literature and the decorative arts. For Morris scholars, this period of his life has represented a curious hermeneutic task: if Morris began his life ensconced in a world of art, what relation did these practices and discourses have to his later political ideals and actions? What has caused the most interpretive headaches in this respect is Morris's unabashed devotion in this period to a notion of beauty for its own sake, one that does not yet have the clear Ruskinian overtones he proffered in his lectures on art beginning in 1877. This has led to a number of different readings of Morris's life. For different ideological reasons, both J. W. Mackail and Paul Meier have argued that there is a clear break between Morris's earlier aesthetic practices and ideals and his later socialist activism; while E. P. Thompson and Michael Naslas have attempted a more judicious and subtle reading of Morris's earlier aesthetic life, distinguishing between those aspects that can be linked to his later political stance, and those that presented stumbling blocks to his further politicization.[2] Yet, if the latter two have recognized the importance of Morris's earlier aesthetic ventures on his political development, both agree that Morris's attachment to the aesthetic ideals of Pre-Raphaelitism and aestheticism—both of which emphasized the creation of beauty for its own sake—was ultimately antithetical to the position that he would take in his later lectures, and, importantly, provided at most a negative step in the development of later political self-understandings.[3]

What role, if any, did Morris's attachment to a notion of beauty have for his political development? The answer I think is succinctly conveyed in the quotation with which we began. If Morris did not feel compelled to engage directly with the harsh world of Victorian society in his mature poetry and decorative art, these aesthetic practices engendered a critical and ethical notion of beauty that intensified Morris's "discontent of what is careless and brutal" in Victorian life and offered him a vision of a future society. In this respect, "beauty" became a discourse for political critique and political action. His devotion to a concept of beauty as a way of life separate from, though antagonistic to, Victorian society is not only implied in the principles of others generally associated with aestheticism (Pater, Swinburne and Wilde), but was also articulated by those intimately involved in working class struggles.

This chapter will focus on Morris's early aesthetic education, investigating the particular practices and ideas that engaged him in this important period from the 1850s to the late 1870s, a period when Morris first began to practice art in a serious way and initiate the conceptual journey that would surface in his lectures on art beginning in 1877. This conceptual and biographical narrative will consider not only the particular aesthetic notions that were connected to his aesthetic practices, but also the way in which these notions were intermingled with political discourses and/or providing a foundation for his later political development.

Morris's Early Life and Aesthetic Education

> I can't enter into politico-social subjects with any interest, for on the whole I see that things are in a muddle, and I have no power or vocation to set them right in ever so little a degree. My work is the embodiment of dreams in one form or another. . .
>
> —Morris to Cormell Price, 1856[4]

So Morris wrote to his Oxford friend Cormell Price, indicating the extent to which he felt his life to be uninvolved with political or social issues. Most Morris scholars are in agreement that at this point in life he felt more attune to the stanzas of romantic poetry, medieval architecture and ecclesiastical pursuits, than to the world of "politico-social subjects."[5] Born in 1834 to an upper-middle class family outside London, he had entered Oxford in 1853 already well versed in the existing literature on English architecture and the Gothic style, as well as the romantic tradition popularized in the novels of Sir Walter Scott. Reading Scott as a young child, Morris, like many of his contemporaries, was enamored by the life and struggles of the Middle Ages. Indeed, upon his admission to Oxford, Morris was influenced by three cultural movements intimately related to the representation and valorization of the middle ages: the High Church movement (which he had earlier appropriated through his sister Emma and his education at the public school of Marlborough, and which still held sway in Exeter

College at Oxford); the medievalist movement that was most clearly exhibited in the growth of historical literature on that period, in the more politically informed works of Carlyle and Ruskin, and in the aesthetic ideals of Pre-Raphaelitism; and, the romantic tradition in poetry. In terms of his immersion into the romantic tradition of poetry, J. W. Mackail notes that while Morris and his coterie of intimate friends—which included, in addition to Price, Edward Burne-Jones and Charles Faulkner, all of whom would remain lifelong friends—were well versed in the poetry of Shelley and Byron, it was to the poetry of Keats, Browning, and especially Tennyson, that they were drawn. Indeed, the latter represented for these intellectually precocious young men the "end of all things in poetry."[6] It is also at this time that Morris first began to write poetry, a venture that on all accounts came very naturally to him.

While he had entered Oxford with the intention of eventually taking Holy orders, Morris became more and more interested in the life of the artist. He continued to write poetry, and took his first trip to France in the summer of 1854 to get a first hand view of the Gothic architecture there. It is in the years between 1853-55, a period of intense intellectual and creative exploration for Morris, that he began reading Carlyle's *Past and Present*, the works of the Christian socialist Charles Kingsley and Ruskin's *The Stones of Venice*.[7] Indeed, the fact that Morris read such works—all of which represent heartfelt denunciations of the political and social ills of the nineteenth century—implies that his statement concerning lack of interest in "politico-social subjects" must not be taken too literally. Moreover, Morris's friends Price and Faulkner were intensely interested in the plight of the working class. The latter wrote an article on working class sanitation and housing for *The Oxford and Cambridge Magazine*, a journal established in 1856 and initially edited by Morris. Coming from the industrial area of Birmingham, Price and Faulkner had intimate knowledge of the inhuman conditions of the worker's life. They not only supported the sanitation and the Factory Acts, they also argued for the necessity of providing the workers "bare elements" of a human life.[8] Concerning his experience of the degrading existence of the worker, Price noted:

> Things were at their worst in the forties and fifties. There was no protection for the mill-hand or miner—no amusements but prize-fighting, dog-fighting, cock-fighting and drinking . . . The country was going to hell apace. At Birmingham School a considerable section of the upper boys were quite awake to the crying evils of the period; social reform was a common topic of conversation. We were nearly all day-boys, and we could not make short cuts to school without passing through slums of shocking squalor and misery, and often coming across incredible scenes of debauchery and brutality.[9]

What thus seems clear is that Morris was not unacquainted with social issues, but rather felt "in a muddle" about how to discuss and articulate them, feeling himself more easily drawn to aesthetic issues. Moreover, given Price's familiarity with these topics, Morris may have felt rightfully humble about expounding his own views on this subject. What is interesting is that his aesthetic temper

was not unaffected by such discussions, providing instead a conceptual prism for articulating questions concerning nineteenth-century labor in the guise of medievalist and romantic imagery. That is, seeing himself already as an artist, Morris reaffirmed his concern for the nineteenth-century worker in his portrayal of the craftsman of the medieval past.

While Morris's own contributions to *The Oxford and Cambridge Magazine* were all artistic in character or focus, we can see signs of the aesthetic appropriation of these social issues in a couple of the pieces.[10] Most of the prose pieces and poetry clearly show Morris's penchant for pure romance; each of them vaguely based in the milieu of the Middle Ages, full of unrequited love, death and chivalric battles, and brimming with rich descriptions of nature. Yet, in one of the first prose pieces he published, "The Story of the Unknown Church," Morris inscribes these romantic themes within the life of a "master-mason" of a church. While the tale itself quickly takes off into a somewhat mystical illumination of the protagonist's foreshadowing of the death of a loved one, it also portrays Morris's early interest in the conditions of labor of the medieval craftsman. In particular, in the course of this romantic portrayal, Morris describes in some detail the pleasure, intelligence and love that goes into the work of the medieval craftsman.

This concern becomes more pronounced in his descriptive article on Amiens Cathedral. What is initially clear in this richly detailed remembrance of Amiens is how the sheer "beauty of it"[11] had emotionally captured the young Morris, so much so that he feels he can only "tell men how much I loved them; so that, though they might laugh at me for my foolish and confused words, they might yet be moved to see what there was that made me speak my love, though I can give no reason for it."[12] Following this disclaimer, Morris transfers this "love" of the architecture to the life of the Middle Ages that spawned such wonders:

> For I will say here that I think those same churches of North France the grandest, the most beautiful, the kindest and most loving of all the buildings that the earth has ever borne; and, thinking of their past-away builders, can I see through them, very faintly, dimly, some little of mediaeval times, all else dead and gone from me fore ever,—voiceless for ever.[13]

And in following this seemingly Ruskinian thought further, Morris begins to expand upon the inscription of the character of the "builder" on the manifold intricacies of its architecture:

> And those same builders, still surely living, still real men, and capable of receiving love, I love no less than the great men, poets and painters, and such like, who are on earth now, . . . Ah! Do I not love them with just cause, who certainly loved me, thinking of me sometimes between the strokes of their chisels; and for this love of all men that they had, and moreover for the great love of God, which they certainly had too; for this, and for this work of theirs, the uprising of the great cathedral front with its beating heart of the thoughts of

men, wrought into the leaves and flowers of the fair earth; wrought into the faces of good men and true, fighters against the wrong, . . . ; wrought through the lapse of years, and years, and years, by the dint of chisel, and stroke of hammer, into stories of life and death, the second life, the second death, stories of God's sealing in love and wrath with the nations of the earth, stories of the faith and love of man that dies not: for their love, and the deeds through which it worked, I think they will not lose their reward.[14]

This first tentative step toward explaining his love of Gothic architecture, a love that seemed to spring from an instinctual source, illuminates a number of important issues: first, that Morris was clearly drawn to medieval art forms because of their beauty, which generated within him an intense emotional reaction. In true romantic fashion, Morris initially describes that experience as one beyond words, as if it were a product of some mystical, almost divine, process existing outside of human comprehension. Yet, he does not stay long on this purely romantic plane, and instead begins an archeology of that experience, moving from an experience of love for the architecture to that of the "builders" who crafted that monument. Thus, the second issue that this article illuminates is Morris's early attempt at conceiving art as a social hieroglyph whose beauty reflects the social and human conditions underlying its production. Amiens provides a window to "mediaeval times," its aesthetic form and ornamentation giving the keen observer a view of a time that in other respects is "voiceless for ever." Moreover, inscribed in the beauty of Amiens is the "love" and the "beating heart of the thoughts" of its builders. While this latter emphasis would become central to his discussions of art beginning in the late 1870s, it is the entrenchment of the notion of beauty as aesthetic ideal that characterizes Morris's early development as an artist.

Constituting Aesthetic Self-understandings, I: Medievalism and Cultural Politics

What surfaces within this first tentative analysis of architecture is Morris's attachment to a notion of beauty, as well as the peculiar way in which Morris was beginning to articulate political and social issues within the framework of these burgeoning aesthetic discourses. His clear reliance on Ruskin to help him discern the reason behind his aesthetic desire for these art forms brought him to the issue that so concerned his peers and more socially conscious contemporaries—namely, the life of the workman. But, it was not the workman who toiled in the factories in Manchester, but the craftsman who exhibited his intelligence and pleasure in every laboring gesture, and in so doing, produced beauty. In looking to the Middle Ages for aesthetic sustenance, Morris was clearly participating in the tide of the late Romantic Movement, whose most characteristic manifestation was the widespread medievalist movement. As Margaret Grennan has argued, this movement gripped all forms of intellectual and practical discourse in nineteenth-century England (economic, political and aesthetic). The rediscovery

of the social life-world of the Middle Ages provided a rich cultural reservoir not only for reinvigorating discussions in diverse intellectual fields, but also for engendering aesthetic practices as well as social reform.[15] Given the ubiquitous influence of this movement on cultural and political theory, it is important to more specifically characterize its discursive manifestations.

Importantly, the medievalist movement drew attention to the social and economic practices of that period as they related to the everyday life of the common people. William Cobbett's *A History of the Reformation in England and Ireland* (1824), Robert Southey's *Colloquies* (1829) and Thorold Roger's *History of Agriculture and Prices* (1866), portrayed a world in which the medieval worker, supplied with all the necessities of life in abundance, lived a life that was more fulfilling than his Victorian counterpart. These representative texts portray the "appropriation of history" and "the art of generalization" that characterized the nineteenth-century mind, and which especially found ample play in the Middle Ages.[16] In his first lecture, "The Lesser Arts" (1879), Morris expressed the debt that he and his contemporaries had to the flourish of historical practices associated with the medievalist revival. We live, Morris claimed,

> at a time when history has become so earnest a study amongst us as to have given us, as it were, a new sense: at a time when we so long to know the reality of all that has happened, and are to be put off no longer with the dull records of the battles and intrigues of kings and scoundrels...[17]

Yet, as may be apparent, such an historical imagination was not just directed toward the goal of elucidating "the reality of all that has happened," striving for a better historical understanding for its own sake, but was infused with a clear intention, as Morris claimed later, to "enrich the present and the future."[18] This "new sense" that Morris speaks about helped to provide ample fodder for indictments against Victorian society. This weighing of the past in light of present social and cultural problems found its most keen expression in narrative form of contrast, in which the author sets the new historical knowledge of the Middle Ages against the present social situation. While this narrative form provided the basis of both Cobbett's *A History of the Reformation* (in which the author compares pre- and post-Reformation England in its religious and social senses) and Southey's *Colloquies* (in which the author constructs a dialogue between Sir Thomas More and himself, bringing out the radical differences between working practices of the Middle Ages and the Victorian period), it had its most famous expression in Carlyle's *Past and Present*. In this work, Carlyle contrasts the social anarchy of Victorian England (characterized by the desperate cries of Chartism, the "dilettantism" of the landed aristocracy and the "Mammonism" of the modern industrialists) with the moral and social order of a twelfth-century Abbey at St. Edmundsbury. The latter is characterized by loving, hard-working monks participating in a micro-economy based on obedience to authority, exhibiting, in Carlyle's words, the "depth and opulence of social vitality."[19] Along with other historical works on the Middle Ages, the reading of

Carlyle's prophetic words helped to bolster Morris's growing sense of the reality of the Middle Ages; in particular, as E. P. Thompson notes, such literature (and we cannot leave out Ruskin here) offered Morris an image of "an organic, pre-capitalist community with values and an art of its own, sharply contrasted with those of Victorian England."[20]

If the new historical sense of the Middle Ages was infusing Victorian life with a perspective from which to attack current economic and social conditions, it was also engendering aesthetic practices that were profoundly important to the early development of Morris as an artist. We have already mentioned the importance of the medievalist movement in literature, a development that not only energized the medium with stories, but which also popularized a certain stylistic archaicism. The poetics of romance—as exhibited in the works of Browning and Tennyson—centered around a conception of the creation of beauty for its own sake, in which the terrors and ugliness of the railway age would be compensated for, and antagonized by, the creation of an aesthetically sealed world of beauty. This aesthetic distance was reinforced by the use of medieval settings and characters. We will return to the importance of this aestheticist claim for Morris's initial constitution as a political subject later within the chapter.

Another influential aesthetic movement associated with medievalism was the Gothic revival in architecture. The Gothic revival gripped the architectural imagination of England with a vengeance, driven by the renewed appreciation and earnest archaeological study of England's Gothic past. Two of the most important architects in this revival were August W. Pugin and Gilbert Scott.[21] While Scott was the more influential and prolific of the architects, Pugin was the first true theoretician of the movement. As the title suggests, Pugin's *Contrasts; or, a Parallel between the Noble Edifices of the Middle Ages and the corresponding Buildings of the Present Day; showing the Present Decay of Taste* (1836) compared the beauty of Gothic forms in their medieval settings to the architectural monstrosities that inhabited the burgeoning industrial towns of Victorian England. Importantly, Pugin saw the differences in architectural styles to be intimately related to the moral life of the period, a principle that was to provide Ruskin with such intellectual nourishment for his later studies of Gothic architecture. Pugin not only glorified the Middle Ages as a period of true Christianity, and thus one which produced noble architecture; he also felt that the construction of Gothic architecture in Victorian society would have a positive effect on its moral life.[22] While Ruskin, and later Morris, would further develop the Puginian principle that the art of a period was inexorably related to its conditions of life, they were less sanguine about the revivalist's zeal for bringing such style back in the drastically different social conditions of Victorian England. In a two part lecture, entitled, "The Gothic Revival" (1882), Morris notes that while the Gothic revival portrayed the extent to which men were becoming dissatisfied with the world around them, representing a beacon of hope for a more civilized life in the future, it can only flounder in its aims unless there is a transformation of the laboring conditions of society:

> This then is the real bar to the success of the Gothic revival which aimed at bringing back reasonable, logical beauty to the life of man in civilized countries: it is not as some supposed the difference in life otherwise, except so far as the stupid luxury of the rich and idle is founded in the oppression of the workers: it is the subjection of all labour to the necessities of the competitive market which stands in the way of the Gothic revival...[23]

In E. P. Thompson's work, *William Morris: Romantic to Revolutionary*, the author notes how the "cult of medievalism" was instrumental in

> liberating Morris's mind from the categories of bourgeois thought. In this reconstructed world, Morris found a place, not to which he could retreat, but in which he could stand and look upon his own age with the eyes of a stranger or visitor, judging his own time by standards other than its own.[24]

Thompson has insightfully keyed into one aspect of the cultural politics of medievalism which affected Morris and many of his contemporaries. In articulating a past world of communitarian values and economic livelihood, the medievalist movement was able to break through the "bourgeois" conceptions that were intimately related to the economic processes of industrial capitalism. Whether such conceptions of the Middle Ages were true representations of the period is not the issue; their pragmatic force was not derived from their historical veracity. Victorians, believing they were true, thought and acted accordingly. To portray a past that may have been better in certain respects than the present broke through the inevitable Whig tendency to see the present as a necessarily progressive moment in the development of human civilization. The present became something less desirable, associated not with human progress, but with barbarism. Medievalism thus helped to reorient the thinking of those who may have had little direct sympathy with social issues, especially those issues related to the condition of the working classes.

If, according to Thompson, medievalism helped to liberate individuals within Victorian society from the ideological categories that proclaimed the necessity of their present social order, and in so doing, provided a negative critique of economic, social and cultural practices, it also simultaneously elicited images of a future life. The fact that medievalism looked to the past for its critical political sustenance meant that it exhibited a peculiar polyvalence in terms of its politics—it provided for a wide range of political visions, both conservative and socialist. In the works of Carlyle and Ruskin, medievalism generated concern for a past age in which social anarchy was replaced by obedience to authority and Christian moral love. In this political tradition, there was a real desire to rejuvenate Victorian society by recovering these past cultural and political discourses. Yet, at the same time, the "romantic sense" of the Middle Ages was inspiring others to conceive new social conditions for the future. In "Preface to Medieval Lore by Robert Steele" (1893), Morris articulated the diverse political positionings that arose from this widespread cultural movement:

it is characteristic of the times in which we live that, whereas in the beginning of the romantic reaction, its supporters were for the most part mere *laudetores temporis acti*, at the present time those who take pleasure in studying the life of the Middle Ages are more commonly to be found in the ranks of those who are pledged to the forward movement of modern life; while those who are mainly striving to stem the progress of the world are as careless of the past as they are fearful of the future. In short, history, the new sense of modern times, the great compensation for the losses of the centuries, is now teaching us worthily, and making us feel that the past is not dead, but is living in us, and will be alive in the future which we are now helping to make.[25]

As we will see later, it is clear that at this point Morris thought that the "forward movement of history" was represented in the socialist ideal he was still actively expounding; that is, it was related to the ideal of the institution of a society of equality and the emancipation of the working classes from the drudgery and exploitation of "competitive commerce" or capitalism. Yet, even during the early part of his life, Morris never succumbed to the conservative attitude that consumed Carlyle, and to a certain extent Ruskin. For Morris, the appellation of "romantic" meant not a lover of the past, for the sake of the past, "but what romance means is the capacity for a true conception of history, a power of making the past part of the future."[26] This process of making "the past part of the future" involved the articulation of notions drawn from the Middle Ages, yet applied in political discourses directly relevant to the new conditions of nineteenth-century England. As Morris explained, a "true conception of history" implied an understanding of "perpetual change," and of the irretrievability of the past.[27]

According to Thompson, the medievalism of Ruskin and Carlyle provided the most important influence on Morris's development of his political subjectivity. They were "the two men who most influenced him in effecting this liberation" from bourgeois categories.[28] In his discussion of these two thinkers, Thompson focuses primarily on their condemnation of Victorian society; that is, their importance to Morris's political views is a consequence of the explicit "political" themes they raise, and their critiques of the "cash-nexus" of capitalism (Carlyle) or the dehumanization of the laborer (Ruskin). What receives much less attention in Thompson's discussion of Morris is the importance of the aesthetic interests that shaped Morris during the early period of his life. These interests included his fascination with Pre-Raphaelitism, his design work for the decorative art firm and his mature poetic production. For Thompson, these aesthetic interests—especially Pre-Raphaelitism and his mature poetry—are escapist and apolitical subjects, and show a quietist acceptance of "the brutal reality of life within industrial capitalism."[29]

What is implied in Thompson's dismissal of the politics of Morris's aesthetic practices is an underlying assumption concerning the irreducible specificity of aesthetic and political discourses, i. e., that knowledge or action engendered by these respective discourses is only pertinent to its particular practices. This, as we know from our discussion in Chapter One, replicates certain essentialist positions that are highly problematic, and completely ignores the more

rich and interesting analyses of cultural politics that have arisen in contemporary cultural theory. Indeed, Thompson claims that the pursuit of art is political only if it somehow engages within its narrative form the exigencies of life in Victorian society. What we find in the romantic poetry of Browning, Tennyson and especially Morris (at least up through the publication of *Love Is Enough* in 1870), Thompson claims, is a

> poetry of "romance"—of medievalism, trance, and escape, filled with nostalgia and yearning for values which capitalism had crushed, and which were projected into archaic or dream-like settings . . . The poetry of "romance"—as if emphasized by its special "poetic" attitudes and vocabulary—was always a little detached from the essential human conflicts of the time. But not withstanding this, the love of art, the cherishing of aspirations threatened by philistinism, gave rise to poems of great poignancy and beauty. And it was to this poetry of "romance" that William Morris's youthful contribution was made.[30]

While Thompson clearly articulates the antagonistic quality inherent to the poetry of romance (it exhibits a "yearning for values which capitalism has crushed" that "were projected into archaic or dream-like settings"), he does not take this assumption to heart in his interpretation of Morris's aestheticist position. For him, its emphasis on dream-like images of the past, and on the creation of beautiful effects for their own sake, renders it innocuous to the social practices of Victorian life, and shows Morris's acquiescence to his surroundings. Yet, if the problems associated with industrial capitalism engendered some poetry that realistically and directly engaged with the social conditions that so appalled reasonable men—a tradition that included the first generation of the romantic movement, in particular Byron, Shelley, Wordsworth and Blake—it also spawned the mode of art that focussed on "romance," an aesthetic discourse that favored formalistic archaicisms, medievalist themes and the representation of beauty for its own sake. As such, the latter discourse was just as related to the "harsh realities" to which Thompson refers. For Morris in particular, his immersion into this discourse provided a space in which he could articulate ideals about human existence that were thwarted by the present political and social conditions of Victorian society, without at the same time identifying them with current social and political options and discourses. Moreover, Morris's attachment to aestheticist principles helped to engender a conception of beauty that was itself historically and socially articulated in opposition to the harsh Victorian realities. Such a period of unabashed "aestheticism" was highly instrumental in the political development of Morris.

Constituting Aesthetic Self-Understandings, II: Pre-Raphaelitism, Aestheticism and Morris's Poetry of Romance

With respect to his constitution as an artist, Morris certainly owed a great debt to the personality and ideas of Dante Gabriel Rossetti. Rossetti had been an

original member of the Pre-Raphaelite Brotherhood, a name given to a group of young artists at the Royal Academy who were in revolt against the academic style proffered by Joshua Reynolds. Formed in 1848, a time seemingly ripe for both political and aesthetic revolt, the Brotherhood was a loose-knit group that included, aside from Rossetti, the talented painters, John Everett Millais and William Holman Hunt (the "founders" of the Brotherhood); Rossetti's brother, William Michael Rossetti; and Rossetti's sister, Christina, who would become a famous poet. While not formally a member of the group, Ford Madox Brown was an important associate and friend of the group. They were called "Pre-Raphaelite" for their avid devotion to the religious art of the early Italian Renaissance (they claimed to derive inspiration from painters before but including Raphael), art that for them was a personal, truthful expression of nature and life. In their eyes, art after Raphael became lifeless through convention: painting no longer expressed the creativity and individuality of the artist, but was driven by rule-bound imitation. This latter situation was especially characteristic of the academic style they were being taught at the Royal Academy.[31] As William Michael Rossetti claimed in *The Germ*, the journal set up by the Brotherhood in 1850, and which was the inspiration behind Morris's *Oxford and Cambridge Magazine*: " . . . the predominant conception of the Pre-Raphaelite Brotherhood [was], that an artist, whether painter or writer, ought to be bent upon defining and expressing his own personal thoughts, and that they ought to be based upon a direct study of Nature, and harmonised with her manifestations."[32]

The Pre-Raphaelite's injunction to resist conventional representation in painting for the individualized rendering of natural fact represented a twofold oppositional stance: first, it reiterated the romantic critique of Enlightenment thinking, specifically in terms of the rationalization and conventionalization of painting styles. They looked to the pre-Renaissance practices of painting because of their creative individuality. As William Michael Rossetti argued:

> The painters before Raphael had worked in often more than partial ignorance of the positive rules of art, and were utterly unaffected by conventional rules. These were not known of in their days; and they neither invented them or discovered them. It is to the latter fact, and not the former, that the adoption of the name of "Pre-Raphaelite" by the artists in question is to be ascribed. Pre-Raphaelite truly they are—but of the nineteenth century. Their aim is the same—truth; and their process the same—exactitude of study from nature . . .[33]

Second, the romantic critique of rationality in the arts is part of a larger opposition to the nineteenth-century industrial world. As Raymond Williams has argued, the "cultural formation" of the Pre-Raphaelite Brotherhood was essentially a revolt against the commercial bourgeoisie. Their emphasis on

> naturalism was mixed, from the beginning, with an explicit 'medievalism': an attachment to a certain romantic and decorative kind of beauty, which was also—and in the end very explicitly—a critique of the ugliness of nineteenth century commercial and industrial civilization. At this point, inevitably, they

were dissidents from their class [the commercial bourgeoisie], and in one sense rebels against it, but in a specializing way, in that they found in the arts of painting and poetry an *alternative* to the dominant social and cultural order.[34]

Also involved in their particular theory of art was an emphasis on the importance of manual labor in precisely the same way that Ruskin had elaborated in his later studies of Gothic art; for the Pre-Raphaelites, true art arose from the diligent, creative and individualized labor of the artist.

When Morris met Dante Rossetti in 1856, the original Pre-Raphaelite Brotherhood had been dissolved. If he had been nurtured already on the Gothic architecture of Amiens and the romantic poetry of Tennyson, Morris now entered the world of Pre-Raphaelite painting, one whose visual language increased his burgeoning medievalist sentiments and brought him closer to the liberating effects of nature. For the Pre-Raphaelites, nature represented a critical force that militated against the conventionalized representations they had been taught to paint. As one sympathetic commentator remarked in 1852:

> The general principle which the Pre-Raphaelites took up separately, and which became the bond of their union, was that they should go to Nature in all cases, and employ, as exactly as possible, her literal forms. If they were to paint a tree as part of a picture, then, instead of attempting to put down, according to Sir Joshua Reynolds's prescription, something that might stand as an ideal tree, the central form of a tree, the general conception of a beautiful tree derived from a previous collation of individual trees, their notion was that they should go to Nature for an actual tree, and paint *that*.[35]

This going back to nature for their subject, a (re)turning that attempts to reinvigorate one's aesthetic representations with the details and individualities of the natural world, opens up a political dimension only hinted at thus far in our analysis. As Raymond Williams seems to intimate, it vitiates against the encroaching rationalization of life associated with capitalist industrialization by representing the individuality of life unmediated by universalizing economic processes. Thus, to represent nature is not only to critique implicitly its destruction in the wake of industrial production, but also to offer a utopian projection of future social and political possibilities. As Adorno has argued, in the context of technology and capitalist industrialization the "image of nature" elicits "the possibility of a sphere beyond bourgeois work and commodity exchange."[36] Indeed, Audrey Williamson has claimed that this attachment to nature ensured that the Pre-Raphaelite revolt was not only against "convention in life and art but also against the whole pattern of ideas and society created by the industrial revolution."[37] This attention to nature represents the bedrock of Morris's aesthetic practices—be they painting, poetry or the decorative arts—and is probably the one important lesson that he gained from his apprenticeship in Pre-Raphaelitism.

Morris's career as a painter lasted only a few years, and is represented in two, maybe three, works.[38] Yet, while he never succeeded at this art form as he had hoped, his tutelage under Rossetti resulted in two important developments

that greatly affected his later life: through Rossetti Morris met Jane Burden, whom he married in 1859; and, with Rossetti and other Pre-Raphaelite notables, he set up a decorative art firm in 1861. Actually, these two developments were intimately related. Morris wished to begin his marriage in a house that would avoid the "ugliness" and "shoddiness" that characterized so much of Victorian architecture, and so he hired his friend Philip Webb to design the building. The result was the Red House in Bexleyheath, outside of London, a house built of local red bricks, with Queen Anne windows, high-pitched red-tiled roofs, and deeply recessed Gothic porches. While intimating the style of the Middle Ages, it exhibited, as Pevsner has noted, "a surprisingly independent character, solid and spacious looking and yet not in the least bit pretentious."[39] Morris, along with Burne-Jones, Rossetti and Webb, proceeded to decorate the interior of the house with floral designs, medievalist murals and eminently solid and practical furniture. And, it was the experience and success of this venture that convinced them to set up a decorative art firm. As Morris notes in a autobiographical sketch attached to a letter he sent to his socialist colleague Andreas Scheu:

> At this time the revival of Gothic architecture was making great progress in England and naturally touched the Preraphaelite movement also; I threw myself into these movements with all my heart: got a friend to build me a house very mediaeval in spirit in which I lived for 5 years, and set myself to decorating it; we found, I and my friend the architect especially, that all the minor arts were in a state of complete degradation especially in England, and accordingly in 1861 with the conceited courage of a young man I set myself to reforming all that: and started a sort of firm for producing decorative articles. D. G. Rossetti, Ford Madox Brown, Burne-Jones, and P. Webb the architect of my house were the chief members of it as far as designing went. Burne-Jones was beginning to have a reputation at that time; he did a great many designs for us for stained glass, and entered very heartily into the matter; and we made some progress before long, though we were naturally much ridiculed; I took the matter up as a business and began in the teeth of difficulties not easy to imagine to make some money in it: about ten years ago [1875] the firm broke up, leaving me the only partner, though I still receive help and designs from P. Webb and Burne-Jones.[40]

Describing themselves as "Fine Art Workmen in Painting, Carving, Furniture, and Metals," the firm of Morris, Marshall, Faulkner & Company set about to revitalize the decorative arts, applying the skill and knowledge of "Artists of reputation" to the production of "work of a genuine and beautiful character."[41] While Rossetti and Burne-Jones devoted themselves to the design of stained glass, and Webb was particularly important for the design of the furniture that the firm made, Morris set his design skills to the production of wallpaper, textiles and embroidery. Indeed, a year after its founding Morris began the wallpaper designs of the "Trellis," the "Daisy," and the "Fruit." While these earlier designs did not have the complex, flowing lines and masses, nor the intricacies of detail, that characterized his later designs, they were indicative of the naturalism that was to guide all of his design work in this art.[42] His initiation into

these arts, as he further notes in his letter to Scheu, forced him "to learn the theory and to some extent the practice of weaving, dyeing and textile printing: all of which I must admit has given me and still gives me a great deal of enjoyment."[43] As is well-known, Morris's venture in the decorative arts was to provide an important practical exemplar for the arts and crafts movement in both England the United States later in the century.[44] Importantly for our purposes here, the ideal embodied in this business venture—that decorative art could flourish only through the concerted and cooperative effort of "Artist Workmen" engaged in the multifaceted labor associated with all stages of aesthetic production—provided a practical foundation upon which Morris would developed his own conception of art in his lectures. Yet, before he could do so he would have to continue to wage "Holy Warfare against the age" through his poetry,[45] a task that at once proved to be important for his later political position, but which also elucidated to him the very limitations that literature holds in that battle.

If in 1861 Morris began his lifelong career as a decorative artist, it was also the year in which be began his monumental epic poem, *The Earthly Paradise*. The publication of this poem between 1868 and 1870 (Volume I was published in 1868, and Volumes II and III appeared in 1870) established Morris as a popular and critically acclaimed poet. While this poem marked the beginning of Morris's literary eminence, it also represents for Thompson "a poetry of despair" in which "the extinction of hope in the world around him drove Morris to abandon Keats's struggle, and the struggle of his youth, to reconcile his ideals and his everyday experience" and turn "his back on the world by telling old tales of romance."[46] Thompson is not just referring to existential despair, but to a lack of antagonism toward Victorian life that would provide a foundation for Morris's political stance in later years, a conflict that he sees clearly surfacing in the formal intricacies of Morris's earlier poetry. Thompson's argument still represents one of most interesting attempts to uncover the formal dimensions of Morris's later political stance. In general, he argues that the narrative structure of Morris's earlier poems (particularly, those poems published in *Defense of Guenevere*) continually exhibit a tension between the ideals of love and beauty and the harsh realities of human life. With *The Earthly Paradise*, we no longer see this tension in the highly refined and stylized archaicisms of his language; moreover, Morris explicitly lays out a notion of the creation of beauty for the sake of pleasure and escape that seems to abandon all conflict with Victorian society.[47] While the "extinction of hope" is clear in this latter poem, we should be wary of then making the rather unsubstantiated claim that this signaled a reconciliation of "his ideals and his everyday experience."

Morris published his first set of poems, *The Defense of Guenevere and Other Poems*, in 1858. While there were clear signs of Morris's eminence as a poet in this collection, the critics generally did not take notice; if they did, they were generally negative in their appraisal. Yet, while critics may have been critical of the archaic images and language inspired by Malory's *Morte d' Arthur* that populated this collection—H. F. Chorley had noted how "his book of Pre-Raphaelite minstrelsy" was "a curiosity which shows how far affectation

may mislead an earnest man towards the fog-land of Art"[48]—they were also aware of Morris's potential as a poet. As one unfavorable critic in the *Saturday Review* claimed, almost grudgingly: " . . . Mr. Morris's powers . . . are, in our judgment, considerable." Yet they were

> altogether spoiled and wasted by his devotion to a false principle of art. False principle, we say, because a poet's work is with the living world of men. Mr. Morris never thinks of depicting man or life later than the Crusades. With him, the function of art was at an end when people began, in decent life, to read and write. So all that he produces are pictures—pictures of queer, quaint knights, very stiff and cumbrous, apparently living all day in chain armour, and crackling about in cloth of gold . . . The trees and flowers are very pronounced in colour, and exceedingly angular and sharp in outline.[49]

The author of this review has touched upon the underlying impetus behind Morris's poetry in this collection: to present in content the trials and tribulations of the Middle Ages, and to do so in the form of archaic language. Chivalric battles between knights, unrequited love, death and hope all intermingle in this collection of vignettes to provide the reader with a literary tour of this historical period. Such historical veracity, which had irked most critics, led J. H. Shorthouse to see the collection as "the most wonderful reproduction of the tone of thought and feeling of a past age that has ever been achieved."[50]

If *The Defense of Guenevere* exhibited the deep historical sense of Morris's poetic powers, intertwining "ideal decorative beauty and brutal realism,"[51] *The Earthly Paradise* showed a quiet refinement that overcame the violence and abruptness of his earlier poems. What should be noted is that Morris did not see the difference between his earlier poetry and the *Earthly Paradise* as anything other than the perfection of his craft, a gradual unfolding of his aesthetic powers. For him, his pre-socialist poetic ventures were all a process of coming to terms with his burgeoning poetic skills.[52] A. C. Swinburne had been one of the few public admirers of Morris's *Defense*, and would become an intimate friend during the 1860s.[53] While there was much disagreement on the importance of *Defense* by the critics, Swinburne noted that

> upon no piece of work in the world was the impress of native character ever more distinctly stamped, more deeply branded. It needed no exceptional acuteness of ear or eye to see or hear that this poet held of none, stole from none, clung to none, as tenant, or as beggar, or as thief. Not yet a master, he was assuredly no longer a pupil.[54]

While not yet a "master" in his earlier poetry, many felt that he reached that stature with the publication of the *Earthly Paradise*. The poem is made up of 24 poetic narratives, of greatly varying length, from differing sources (classical, eastern, medieval and Norse). They are grouped in pairs for each month of the year, prefaced by verses for the month. The "Prologue," which incorporates Morris's only original plot of the overall work,[55] sets the context for these narra-

tives: the Wanderers, having heard of an earthly paradise, set sail for it. Along the way, they encounter many different cultures and lands, each raising their hopes that they may have finally reached their goal, only to be dashed by some grievous occurrence. Finally, as old men, the Wanderers encounter a Grecian civilization, where they spend the remaining last days of their life amongst kind folk, paying back the hospitality of their guests by telling stories they have picked up in their travels.

While the tales are wonderful in their lyricism and decorative detail, for our purposes the most important part of the poem comes in the brief "Apology" prior to the "Prologue." In these prefacing remarks, Morris touches upon the particular limitations that he feels arises from his poetry. As a rather direct statement of his conscious intentions as a poet, it is worth quoting at length:

> Of Heaven or Hell I have no power to sing,
> I cannot ease the burden of your fears,
> Or make quick-coming death a little thing,
> Or bring again the pleasure of past years,
> Nor for my words shall ye forget your tears,
> Or hope again for aught that I can say,
> The idle singer of an empty day.
>
> But Rather, when aweary of your mirth,
> From full hearts still unsatisfied ye sigh,
> And, feeling kindly unto all the earth,
> Grudge every minute as it passes by,
> Made the more mindful that the sweet days die—
> Remember me a little then I pray,
> The idle singer of an empty day.
>
> The heavy trouble, the bewildering care
> That weighs us down who live and earn our bread,
> These idle verses have no power to bear,
> So let me sing of names remembered,
> Because they, living not, can ne'er be dead,
> Or long time take their memory quite away
> From us poor singers of an empty day.
>
> Dreamer of dreams, born out of my due time,
> Why should I strive to set the crooked straight?
> Let it suffice me that my murmuring rhyme
> Beats with light wing against the ivory gate,
> Telling a tale not too importunate
> To those who in the sleepy region stay,
> Lulled by the singer of an empty day. . .
>
> So with this Earthly Paradise it is,
> If ye will read aright, and pardon me,
> Who strive to build a shadowy isle of bliss

Chapter Four

> Midmost the beating of the steely sea,
> Where tossed about all hearts of me must be;
> Whose ravening monsters mighty men shall slay,
> Not the poor singer of an empty day.[56]

As we can see from Morris's comments in the "Apology," the poet is no longer seen as the titanic force that shakes the foundations of society with his verse. If Shelley had claimed that all poets were the true "legislators" of the world, Morris now humbles the mighty bard by sizing him as an "idle singer of an empty day." As one commentator has clarified, Morris's poetic intentions clearly initiates the "Aesthetic Movement" in poetry, one that was intimated in Tennyson and Browning, but which most decisively surfaces within Morris's pre-socialist poetry, and the verse of Rossetti and Swinburne.[57] What characterizes this movement is the notion that art should concern itself only with the portrayal of beauty, and not for any other purpose than for the pleasure that representation brings. In this, the Aesthetic Movement clearly falls within the tradition of *art pour l'art*, an aesthetic ideal that was to continue to define the practices of avant garde artists up through the present century. As Swinburne had claimed:

> There are pulpits enough for all preachers in prose; the business of verse-writing is hardly to express convictions; and if some poetry, not without merit of its kind, has at times dealt in dogmatic morality, it is all the worse and all the weaker for that.[58]

While there may be merits to poetry that attempts to educate its readers in "dogmatic morality," it cannot reach the level of aesthetic worth that is implied in the poetic form. Importantly, what is breached in these impassioned words for the autonomy of art is the polemical (and as we will see, political) context behind its own genesis. Such a movement developed as a reaction to the reigning practice and ideal of "didacticism," in which poetry was seen as a medium through which a poet delivers lessons in truth, morality and personal conduct. Thus, didacticism, which held sway after the eclipse of the first generation of the Romantic Movement, promoted a conception of poetic *utility*: poetry was to provide a forum for moral and civic education. Importantly, it was intimately tied to the hegemonic project of the rising bourgeoisie by specifically relegating art to their ideal of conduct, politics, etc.[59] Thus, aestheticism was another way in which to struggle against the hegemony of bourgeois life by proclaiming the autonomy of art from the economic and social dictates that abounded in that social order.

This antagonism to Victorian life was clearly articulated by members of the Aesthetic Movement: art provides a higher ethic than normal bourgeois morality, one that was intimately related to style and beauty. This curious decoupling of moral utility and art, with a concomitant assertion of the latter's higher morality, is found in a maxim of Oscar Wilde, an artist who would become associated with the Aesthetic Movement in the 1880s:

Aesthetics are higher than ethics;
Truth is entirely and absolutely a matter of style;
To morals belong the lower and less intellectual spheres;
Wickedness is a myth invented by good people to account for the curious attractiveness of others;
In its rejection of the current notions about morality, is one with the higher ethic.[60]

Swinburne, who was the closest to Morris of all participants in the Aesthetic Movement, also claimed that art should strip itself of any connection with religion, duty or morality. In so doing, art will then display its most important feature, that of beauty. Yet, if this is the *raison d'être* of art, it will inevitably stand in opposition to the harsh exigencies of human life, providing both a critical lever and a nurturing tool:

> Beauty you see is an exception; and excellence means rebellion against a rule, infringement of a law. That is why people who go in for beauty pure and plain—poets and painters are all born aristocrats on the moral side. Nature, I do think, if she had her own way, would grow nothing but turnips; only the force that fights her . . . now and then revolts; and the dull soil here and there rebels into a rose . . . The comfort is that there will always be flowers after us to protest against the cabbage commonwealth and insult the republic of radishes.[61]

Given Morris's close association with Swinburne (their friendship lasted until Morris's death), it is reasonable to assume that he shared his belief in the critical posture of art to Victorian life. This is also confirmed by the fact that when Morris made the leap to socialist activism in 1883, he immediately assumed that this fellow artist would follow his lead into the movement. Swinburne, detesting democratic movements, declined.[62]

In Walter Pater's review of *The Earthly Paradise*, we are not only given one of most eloquent statements of the principles of the Aesthetic Movement, but also a telling interpretation of Morris's place within that movement.[63] For Pater, *The Earthly Paradise* is exemplary in its ability to "project above the realities of its time" toward a higher ideal of human life. "The secret of the enjoyment of it is that inversion of home-sickness known to some," Pater continues, "that incurable thirst for the sense of escape, which no actual form of life satisfies . . . It is this which in these poems defines the temperament or personality of the workman."[64] Importantly, this temperament is expressed throughout this poem in "the continual suggestion, pensive or passionate, of the shortness of life; this is contrasted with the bloom of the world [of poetry] and gives new seduction to it; the sense of death and the desire of beauty; the desire of beauty quickened by the sense of death."[65] At this point, Pater hears the jeers of those who would scorn such aestheticist vices:

> you say, 'here in a tangible form we have the defect of all poetry like this. The modern world is in possession of truths; what but a passing smile can it have for a kind of poetry which, assuming artistic beauty of form to be an end in it-

self, passes by those truths and the living interests which are connected with them, to spend a thousand cares in telling once more these pagan fables as if it had but to choose between a more and a less beautiful shadow?'[66]

Pater then directly confronts those critics who cannot see any role for the "poetry of romance," and its attendant idealization of beauty. What importance can such aesthetic posturing have for us? Given the passing quality of human experiences, what is most important is to grasp the passion and "ecstasy" of life:

> High passions give one this quickened sense of life, ecstasy and sorrow of love, political or religious enthusiasm, or the 'enthusiasm of humanity.' Only, be sure it is passion, that it does yield you this fruit of a quickened, multiplied consciousness. Of this wisdom, the poetic passion, the desire of beauty, the love of art for art's sake, has most . . .[67]

It is thus the "desire of beauty" that will provide an invigoration of life's fleeting moments, even laying a foundation for other activities and passions—religious, political and humanitarian. It is here that we see the important aspect to the aestheticist creed that bears upon Morris's own life: to claim the necessity of a realm of beauty beyond the present world ensures its continued critical position to those "living interests" (as Pater noted), and secures the existence of a realm of ideals that may in turn provide sustenance for its rejuvenation. This may indeed have meant an explicit "escapism" in the particulars of aesthetic portrayal, but, for Morris and other members of the Aesthetic Movement, it in no way implied an acquiescence to the troubling world around the poet.

For Morris, poetry has "no power" to alleviate "The heavy trouble, the bewildering care/That weighs us down who live and earn our bread." Rather, its task is to create a beautiful world of dreams ensconced in the confines of a "Palace of Art": "Let it suffice me that my murmuring rhyme/Beats with light wing against the ivory gates." In saying this in *The Earthly Paradise*, Morris is indeed decoupling poetry from the political function it held for his romantic predecessors. When Morris further claims that he is a "Dreamer of Dreams, born out of my due time/Why should I strive to set the crooked straight?," Thompson concludes that

> in its sum it is a confession of defeat: considered within the traditions of the romantic movement, it is a rejection of Shelley's claims for the poet, a refusal to sustain the struggles of Keats for full poetic consciousness and responsibility. The tension between the ideal and the real, between the rich aspirations of life and art and the ignoble and brutal fact, which underlies the best of Keats's poetry and (in a more complex way) Morris's own early poems, is no longer present.[68]

While Thompson is right to see the differences between Morris's conscious intentions and those of Shelley and Keats, he has too quickly overlooked the tension that the poet experiences between the autonomous world of art and Vic-

torian life. The very fact that Morris is compelled to reiterate the gap between his poetry of romance and "the heavy trouble" that exists shows a keen awareness of the conflict between "the ideal and the real." Within the aestheticist problematic, this tension is no longer articulated within the poetic world; rather, it now is inscribed in the very absence of that reality. Because poetry should only represent that which is beautiful, the poet is driven to portray only that which conforms to that ideal. Thus, when the "harsh reality" of life is excluded, it should be read as an indictment of the existing in terms of beauty. When discussing years later his immersion into Pre-Raphaelitism and aestheticism, Morris attempted to justify the avoidance of contemporary reality in artistic production by this tension between the beautiful and Victorian "sordidness":

> When an artist has really a very keen sense of beauty, I venture to think that he can not literally represent an event that takes place in modern life. He must add something or another to qualify or soften the ugliness and sordidness of the surroundings of life in our generation. That is not only the case with pictures, if you please: it is the case also in literature.[69]

What is then apparent is that Morris's gradual devotion to a notion of beauty provided a very important tool in his political development: it engendered within him a continual antagonism to the "ugliness" and "sordidness" of his surroundings. Fueled by his immersion into Pre-Raphaelitism and aestheticism, beauty represented an ideal that was not now existing, but which could be discerned in the past, in particular, in the life and art of the Middle Ages. Yet, the institution of beauty within human life could not come about, as Shelley and others had supposed, through the medium of poetry. This is the foundation of the "extinction of hope" we find in Morris's "Apology" to *The Earthly Paradise*. But the character of this pathos is radically different from what Thompson wishes us to believe: it is not a general psychological or political despair but rather a disquietude that arises from the questioning of the role of poetic practices in the struggle itself. For Morris, the individualized, aesthetic realm of poetry really could not "set the crooked straight." What Morris is then articulating is the limitation associated with the singular art work in engendering beauty in the everyday life of human beings. But, and this is important, Morris did see a hope for a beautiful everyday life within the renewal of the decorative arts, aesthetic practices that intimately intertwined with the lives of the masses of people.

What we then see in Morris's early aesthetic life is an attachment to an ethical notion of beauty, that is, a notion that proclaims the necessity of establishing beauty in the human world. What is indeed interesting is that this connection between beauty and a better social life was already being articulated by those who were intimately involved in working class struggles. In an article, aptly titled, "Poetry to Be Lived," the Chartist Bandiera claimed that "poetry *is* a thing of beauty, and a joy forever."[70] For this activist, beauty exists in the natural world; it even resides within the very intricacies of our misery. These small

moments of beauty, fleeting as they are, call forth a grander vision of human betterment:

> The commonness nature has some divine touch of poetry to it—crushed and degraded as we are, worn down by suffering and sorrow, blighted by the dryrot of slavery and the branding stamps of tyranny, there are times when we walk on the angel-side of life, and feel that our lives do not all turn in darkness—and the generous aspiration *will* be stirring in the heart, the sweet tears *will* be starting to the eyes, and we know that we might have been something better, and lived a nobler life, if the world had done justice by us. Those tears are as a telescope to the soul, through which it catches big glimpses of the infinite: and those aspirations realize unto us the highest kind of poetry—*the poetry to be lived!*[71]

Beauty, in whatever shape and form, engenders a discontent with what is ("we might have been something better"), and, at the same time, offers a vision of what might be (a "nobler life"). When the poets devote themselves to beauty, they not only show the very lack of its realization in human life, but they keep the ideal alive for the rest of mankind:

> it was in the absence of the reality that the poets have sought to win us their ideal fantasies; the actual world was cold and desolate, and they have kept Eden alive, fresh, and green, in their hearts, and from thence created a world of glorious imagination to live in. . . .And all this is meant for us, with its beauty and its plenty, its freedom and its happiness, else is the poet's song a lure of the siren, and the boundless good with which his heart gushes, mere beggary and utter starvation. There is more poetry to be *lived* than to be written![72]

The same limitations that Morris began to see with his poetry are succinctly described by Bandiera. Beauty is important as an ideal ensconced in the confines of an autonomous realm of art, but it must eventually move beyond this "earthly paradise" toward the realm of social reality. Moreover, in giving "big glimpses of the infinite," beauty calls all to struggle against the infamies that stand in its way, especially those harsh realities that block the happy existence of the working class:

> Brother working-men, let us endeavour to live this poetry in our lives! I know how the untoward circumstances will hem round, and, like hounds of hell, bay at the aspiring soul; but still struggle on. It may be ye are born where light never comes, and where birth is the very sepulchre of the soul—still hold on, for the day is breaking, and a light is coming whereby the poor man may read the many beautiful meanings that are so rudely inscribed on the chamber-walls of his life! Never give up; there are lions in the way to the gate which is called "Beautiful". . .[73]

Written in 1850, Bandiera's exuberant hopes had little chance of realization in Victorian England. Moreover, Morris himself would not see the hope that

beckoned at the gate of the "Beautiful" until much later. In the meantime, Morris—a "dreamer of dreams"—would cultivate the fertile ground of art for that day. Ernest Jones, in his poem, "The Painter of Florence," clearly saw the fruit that would come out of such husbandry of beauty. While beauty may be a dream that lies in a distant world from today's troubles,

> —dreams are but the light of clearer skies,
> Too dazzling for our naked eyes;
> And when we catch their flashing beams,
> We turn aside, and call them dreams!
> Oh, trust me!—every truth that yet
> In greatness rose and sorrow set,
> That time in ripening glory nurst,
> Was called an idle dream at first![74]

Notes

1. Morris, "The Lesser Arts" (1877), in *CW*, Vol. XXII, 16.
2. See J. W. Mackail, *The Life of William Morris* (London: Longman's Green and Co., 1922), Vol. I, 82; E. P. Thompson, *William Morris: Romantic to Revolutionary*, 22-170; Paul Meier, *William Morris: The Marxist Dreamer* (Atlantic Highlands: Humanities Press, 1978), Part I; Michael Naslas, "Medievalism in Morris's Aesthetic Theory," *The Journal of the William Morris Society* V, no.1 (Summer 1982): 16-24.
3. See Thompson, *William Morris: Romantic to Revolutionary*, 61; Naslas, "Medievalism in Morris's Aesthetic Theory," 22.
4. In *The Collected Letters of William Morris*, ed. by Norman Kelvin (Princeton: Princeton University Press, 1984), Vol. I, 28.
5. Mackail, *The Life of Willam Morris*, Vol. 1, 29-112; Peter Stansky, *William Morris* (Oxford: Oxford University Press, 1983), 10-27; Thompson, *William Morris: Romantic to Revolutionary*, 22-170; Philip Henderson, *William Morris: His Life, Work and Friends* (London: Andre Deutsch Limited, 1986), 11-38; Jack Lindsay, *William Morris: A Biography* (New York: Toplinger Publishing Co., 1979), 42-85
6. Mackail, *The Life of William Morris*, Vol. I, 48.
7. Mackail, *The Life of William Morris*, Vol. I, 48.
8. Mackail, *The Life of William Morris*, Vol. I, 66.
9. Quoted in Mackail, *The Life of William Morris*, Vol. I, 66.
10. Morris's contributions numbered sixteen in all, and included poetry ("Winter Weather"; "Riding Together"; "Hands"; "The Chapel in Lyonness"; and "Pray but One Prayer for Me." The latter four were later published in 1858 in *The Defense of Guenevere and Other Poems*, Morris's first book of poetry), prose romances ("The Story of the Unknown Church"; "A Dream"; "Frank's Sealed Letter"; "Gertha's Lovers"; "Sven and his Brethren"; Lindenburg Pool"; "The Hollow Land"; and "Golden Wings"), and articles on architecture, art and poetry ("The Churches of North France. No. I. Shadows of Amiens"; a rumination of the wood engravings of Alfred Rethel entitled, "Death the Avenger and Death the Friend"; and a review of Robert Browning's "Men and Women.").

11. Morris, "The Churches of North France," originally published in *Oxford and Cambridge Magazine*, Feb., 1856, and reprinted in *Prose and Poetry by William Morris* (Oxford: Oxford University Press, 1920), 619.
12. Morris, "The Churches of North France," 617.
13. Morris, "The Churches of North France," 617.
14. Morris, "The Churches of North France," 617-618.
15. See Margaret Grennan, *William Morris: Medievalist and Revolutionary* (Morningside Heights, New York: King's Crown Press, 1945).
16. Grennan, *William Morris*, 51.
17. Morris, "The Lesser Arts," 8.
18. Morris, "Address at the Second Annual Meeting of Anti-Scrape," June 28, 1879, in *William Morris: Artist, Writer, Socialist*, Vol. I, 121. The importance of Morris's conceptualization of the past for his vision of socialism is brought out nicely in Lawrence D. Lutchmansingh, "Archaeological Socialism: Utopia and Art in William Morris," in F. Boos and C. Silver, eds. *Socialism and the Literary Artistry of William Morris*, 7-25.
19. Carlyle, *Past and Present*, 89.
20. Thompson, *William Morris: Romantic to Revolutionary*, 28.
21. For a general discussion of the Gothic Revival in architecture, see Clark, *The Gothic Revival*.
22. While Morris is generally associated with this tradition of thought, his feelings about Pugin were rather negative, and any influence Pugin had on Morris's thinking seems more surely to have come indirectly through the writings of Ruskin. For a discussion of the relation of Pugin to Ruskin and Morris, see Williams, *Culture and Society*, 130-134.
23. Morris, "The Gothic Revival, II," in *The Unpublished Lectures of William Morris*, Eugene Lemire, ed. (Detroit: Wayne State University Press, 1969), 89. What is ironic, especially given these later comments, is that in 1856 Morris gave up all intentions of entering the church and articled himself at the offices of G. E. Street, a young architect who was to become very important in the Gothic revival. Though Morris remained in Street's employment for only 9 months, he learned a general principle that was to influence his conception of the artist, both practically and intellectually. If the Gothic revival wished to revitalize the Victorian landscape with Gothic buildings, it had to rethink the working practices of the architect. Street believed that to create a truly living Gothic style the architect must not only design the edifice but also have working knowledge of all decorative art that went inside. Morris's initiation into these ideals and skills at Street's office was not only to bear fruit when he set up his decorative art firm in 1861, but it would also provide a practical example of the artist-craftsman who frequently appeared in his discussions of art, a figure who combined both intellectual/design and manual skills in the creation of art works. For a discussion of these influences on Morris, see Stansky, *William Morris*, 15, and Clark, *The Gothic Revival*, 217.
24. Thompson, *William Morris: Romantic to Revolutionary*, 28-29.
25. Morris, "Preface to Medieval Lore by Robert Steele," in *William Morris: Artist, Writer, Socialist*, Vol. I, 287-288.
26. Morris, "Address at the Twelfth Annual Meeting of Anti-Scrape," July 3, 1889, in *William Morris: Artist, Writer, Socialist*, Vol. I, 148.
27. Morris, "Address at the Twelfth Annual Meeting of Anti-Scrape,"152. See also Morris's statement in 1879 in his "Address at the Second Annual Meeting of Anti-Scrape," in *William Morris: Artist, Writer, Socialist*, Vol. I, 121. Morris notes that the

aim of historical retrospection lay "not in striving to bring the dead to life again, but to enrich the present and future."

28. Thompson, *William Morris: Romantic to Revolutionary*, 29.
29. Thompson, *William Morris: Romantic to Revolutionary*, 20.
30. Thompson, *William Morris: Romantic to Revolutionary*, 20-21.
31. For a discussion of Pre-Raphaelitism, see Hough, *The Last Romantics*, 40-82; Thompson, *William Morris: Romantic to Revolutionary*, 40-60; as well as the collection of original pieces and critical essays in *Pre-Raphaelitism: A Collection of Critical Essays*, James Sambrook, ed. (Chicago: University of Chicago Press, 1974).
32. Quoted in Hough, *The Last Romantics*, 55.
33. William Michael Rossetti, "Pre-Raphaelitism" in *Pre-Raphaelitism: A Collection of Critical Essays*, 66.
34. Williams, *The Sociology of Culture*, 78.
35. David Masson, "Pre-Raphaelitism in Art and Literature," originally published in *The British Quarterly Review*, 16, 1852, reprinted in *Pre-Raphaelitism: A Collection of Critical Essays*, 74.
36. Adorno, *Aesthetic Theory*, 102.
37. Audrey Williamson, *Artists and Writers in Revolt: The Pre-Raphaelites* (Philadelphia: The Art Alliance Press, 1976), 7-8.
38. In *William Morris and the Middle Ages* (Manchester: Manchester University Press, 1984), 114-116, the editors note that accounts of Morris's life and work have placed two paintings that he did in the late 1850s, one of which dealt with the Tristram and Iseult story as told by Malory, the other was called at different times, *Queen Guenevere* and *La Belle Iseult*.
39. Pevsner, *Pioneers of Modern Design*, 59.
40. Letter to Andreas Scheu, September 15, 1883, in *Collected Letters of William Morris*, Vol. II, Part I, 228-229.
41. From the prospectus of the firm as cited in Henderson, *William Morris: His Life, Work and Friends*, 66-67.
42. For the best book-length analysis of Morris's work as a designer, consult Paul Thompson, *The Work of William Morris* (London: Heinemann, 1967), especially 66-145. For a good discussion of the work of Morris and the firm in its first ten years, see Henderson, *William Morris: His Life, Work and Friends*, 58-78. For a lengthy discussion of Morris's career as a designer, see May Morris's portrayal in *William Morris: Artist, Writer, Socialist*, Vol. I, 34-62. As any tour through museum bookstores will attest, Morris is today known primarily for his design work in wallpapers and textiles.
43. In *Collected Letters of William Morris*, Vol. II, Part I, 230.
44. For a discussion of Morris and the Arts and Craft Movement in England, see Stansky, *Redesigning the World*, particularly, 37-68, and for Morris's influence in the United States, see Eileen Boris, *Art and Labor: Ruskin, Morris and the Craftsman Ideal in America* (Philadelphia: Temple University Press, 1986).
45. This is the phrase that Burne-Jones used to describe the original intention of the aesthetic brotherhood that he and Morris were thinking of initiating in 1853. Quoted in Mackail, *The Life of William Morris*, Vol. I, 65.
46. Thompson, *William Morris: Romantic to Revolutionary*, 132.
47. Thompson, *William Morris: Romantic to Revolutionary*, 76-86, for his discussion of Morris's early poetry, and, 114-150, for his discussion of *The Earthly Paradise* and the aestheticist creed.

48. M. F. Chorley, unsigned review, *Athenaeum*, April 1858, reprinted in *William Morris: The Critical Heritage*, Peter Faulkner, ed. (London: Routledge Kegan and Paul, 1973), 37.

49. Unsigned review, *Saturday Review*, November 1858, reprinted in *William Morris: The Critical Heritage*, 45.

50. From *Literary Remains of J. H. Storehouse*, reprinted in *William Morris: The Critical Heritage*, 48-49.

51. Thompson, *William Morris: Romantic to Revolutionary*, 77. See also, Philip Henderson, *William Morris* (London: Longmans Green and Co., 1952), 12.

52. In Morris's letter to Scheu, he describes his poetic production in this way, making no distinction between *Defense* and *The Earthly Paradise*, except in terms of developing his artistic skills:
Meantime in 1858 I published a volume of poems, *The Defense of Guenevere*; exceedingly young also and very mediaeval; and then after a lapse of some years conceived the idea of my *Earthly Paradise*, and fell to work very hard at it. I had about this time extended my historical reading by falling in with translations from the old Norse literature, and found it a good corrective to the maundering side of Medievalism. In 1866 (I think) I published the *Life and Death of Jason*, which, originally intended for one of the tales of the *Earthly Paradise*, had got too long for the purpose. To my surprise the book was very well received both by reviewers and the public, who were kinder still to my next work, *The Earthly Paradise*, the first series of which I published in 1868 (in *Collected Letters of William Morris*, Vol. II, Part I, 229).

53. See Swinburne's discussion of *Defense* in his review of Morris's *Life and Death of Jason* in *Fortnightly Review*, July 1867, as reprinted in *William Morris: The Critical Heritage*, 57-58.

54. Quoted in Mackail, *The Life of William Morris*, Vol. I, 135.

55. See Florence S. Boos, "The Evolution of 'The Wanderers Prologue'," *PLL* 20, no. 4 (1984): 397-417.

56. Morris, *The Earthly Paradise* (London: Longmans and Green and Co., 1902), Part I, 1-2.

57. Delbert Gardner, *An "Idle Singer" and His Audience: A Study of William Morris's Poetic Reputation in England, 1858-1900* (The Hague: Mouton and Co., 1974), 4.

58. Letter to the Editor of *The Spectator*, June 7, 1862, as quoted by Gardner, *The "Idle Singer" and His Audience*, 9-10.

59. Gardner, *The "Idle Singer" and His Audience*, 4.

60. Quoted in Hilery Fraser, *Beauty and Belief: Aesthetics and Religion in Victorian Literature* (Cambridge: Cambridge University Press, 1986), 186.

61. A. C. Swinburne, *Lesbia Brandan* (London: Methuen, 1952), 119.

62. See Morris's letter to Swinburne, Nov. 17th, 1883, in the Ashley Library Manuscripts 1218, Folio 3, where he asks Swinburne to write a poem for the socialist journal, *Today*, as well as join the Democratic Federation.

63. Walter Pater, *Westminster Review*, October 1868, reprinted in *William Morris: The Critical Heritage*, 79-92. For an interesting discussion of Pater's aestheticist position, see Loesberg, *Aestheticism and Deconstruction*, 7-74.

64. Pater, *Westminster Review*, 80.

65. Pater, *Westminster Review*, 89.

66. Pater, *Westminster Review*, 89.

67. Pater, *Westminster Review*, 92.
68. Thompson, *William Morris: Romantic to Revolutionary*, 121.
69. Morris, "The English Pre-Raphaelites" (1891), in *William Morris: Artist, Writer, Socialist*, Vol. I, 304.
70. Bandiera, "Poetry to Be Lived," in *The Red Republican* 1, no. 3 (July 6, 1850): 19.
71. Bandiera, "Poetry to Be Lived," 19.
72. Bandiera, "Poetry to Be Lived," 19.
73. Bandiera, "Poetry to Be Lived," 19.
74. As quoted in a review of Jone's *Poems and Notes to the People* in *The Friend of the People*, no. 27 (June 14, 1851): 234.

Chapter Five

Aesthetic Theory and Political Subjectivities: Morris's Lectures on Art

> But in spite of all the success I have had, I have not failed to be conscious that the art I have been helping to produce would fall with the death of a few of us who really care about it, that a reform in art which is founded on individualism must perish with the individuals who have set it going. Both my historical studies and my practical conflict with the philistinism of modern society have forced on me the conviction that art cannot have a real life and growth under the present system of commercialism and profit-mongering. I have tried to develop this view, which is socialism seen through the eyes of an artist, in various lectures, the first of which I delivered in 1878.
>
> —Morris to Scheu, 1883[1]

With the formation of the Society for the Protection of Ancient Buildings ("Anti-Scrape") in 1877, Morris began his lifelong crusade against the destruction and restoration of ancient buildings. Driven by his intense love of Gothic architecture, Morris began to wage war against the "philistinism" of Victorian society that exhibited itself in the avid razing of ancient architecture, and through the pretentious attempts to restore such monuments to their original splendor. For Morris, the destruction of these aesthetic and historic monuments was directly related to the entanglement of economic concerns with issues of art, in which it is generally "assumed that any considerations of Art must yield if they stand in the way of money interests."[2] As Morris further averred to the editor of *The Athenaeum*, to have ancient buildings "pulled down simply for the value of the ground it stands on: this seems to me such a causeless loss of valuable property."[3] To an artist deeply devoted to the ideal of beauty, and painfully aware of the "value" of such an artifact as a historical beacon of human intelligence and creation, the razing of ancient buildings seemed a "causeless loss" engendered by a system of "profit-mongering."

Even when Victorian society saw the importance of these monuments, and was not overly blinded by the lure of property values, their attempts at restoration were for Morris equally as destructive. If England was gripped with a new historical sense in which periods from the past began to come to life again, supplying imagery and ideals for an invigoration of cultural and political life, it also

tended to engender a certain reconstructive hubris when it came to ancient monuments. We have already discussed how Ruskin had attacked those restoration methods that attempted to re-create ancient buildings with "mechanical exactitude." To do the latter, as Ruskin argued, would be a tragedy and a farce (though, unlike what Marx had claimed, all at the same time), for architecture is intimately tied to the social conditions of the period in which it was built, and can thus not be re-created, even restored, without those very same conditions. The clearer historical sense that defined the Victorian period had only reinforced the illusion that it was possible to produce an exact reproduction of the monument under question. Following Ruskin's lead, Morris branded such attempts as illusory in their goal, and ultimately injurious to the aesthetic quality of such monuments:

> Every stroke by which the ingenious masons of today carry out the conjecture of the learned architect on the intentions of the ancient builders will reveal the fact that they are living in the 19th, not in the 14th century: the painter who will be employed to restore the remains of fresco on the walls will surely feel ashamed that while he is obliterating what is left of the thought of his long-dead brother in the arts, he is expressing no thought of his own: when all is done, the [building] will be, as far as its surface is concerned, a modern building with the openly ridiculous pretense of being an old one . . .[4]

Such a reproductive malaise was ultimately related to the transformation of social conditions that made it impossible for the mason of the nineteenth century to reproduce his forebear's aesthetic sense (for, as Morris implies above, each period of social life had its own aesthetic sense). Moreover, the division of labor that had been intensifying since the Renaissance had actually taken away the possibility of exhibiting the intimately aesthetic qualities that had defined each working and laboring act of the medieval craftsman:

> It does indeed seem strange to me people cannot see how the times have changed, that they should insist on these lifeless pieces of reproduction. The workman of to-day is not an artist as his forefather was; it is impossible, under his circumstances that he could translate the work of the ancient handicraftsman . . . *I say the workman of to-day is no artist; it is the hope of my life that this may one day be changed.*[5]

We see in this latter statement of Morris's ideal the interesting way in which his aesthetic notions were translating into a political project, one that, as he had claimed to Scheu with the benefit of hindsight, was "socialism seen through the eyes of an artist." The staging for this theoretical and political development were his numerous lectures that he began to write on art and society in 1877. As Thompson has argued, the timing of Morris's lectures on the decorative arts and architecture with his practical activism for Anti-Scrape is not coincidental: his leadership in this organization forced him to continually define and refine his conception of art which he had developed through his initial engagement with

Ruskin, and, as I have argued, in his practices as a Pre-Raphaelite poet and decorative artist.[6] In this chapter, I will examine the contours of Morris's aesthetic theory, especially as expressed in his lectures between 1877 and 1883, showing how the ideal of making the workman an artist is an important foundation for the development of Morris's socialism.

This task is important for two reasons: first, these lectures provided an important theoretical space in which Morris began to elaborate his political theory in the context of aesthetic discussions. Given this constitutive process, it is not surprising that he first publicly declared himself a socialist within his lecture, "Art Under Plutocracy" (1883), ending it with a call for all lovers of art to support the socialist cause by joining the Democratic Federation, one of the first political bodies in England to openly declare itself socialist. Thus, these earlier lectures provide an insight into the constitution of Morris as a political theorist, clarifying the theoretical and conceptual bridge between his Pre-Raphaelite and aestheticist artistic practices and his socialist activism. By focussing on this period it should not be assumed that Morris stopped writing on questions of art after 1883; they still provided an important topic in his lectures, especially to middle class audiences who were becoming swayed by the arts and crafts movement in which Morris was a leader. Not only is this period important because it illuminates the particular way in which aesthetic concerns transformed into political issues for Morris, but it is also important because his later lectures on art developed these earlier insights. These lectures established the basic constellation of ideals and notions crucial to Morris's later treatment of art.[7]

The second reason for focussing upon Morris's aesthetic theory is that Morris scholars have paid too little attention to the systematic features of his aesthetic theory.[8] One reason for this gap in Morris scholarship is that Morris's style eschewed analytic distinctions for the presentation of "constructive" ideas motivated by the particular topic at hand.[9] Years later, Morris reflected upon his particular style of thought as a socialist; his remarks apply equally to his approach to art:

> There are, in fact, two groups of mind with whom Social Revolutionists like other people have to deal, the analytical and the constructive. Belonging to the latter group myself, I am fully conscious of the dangers which we incur, and still more perhaps of the pleasures which we lose, and am, I hope, duly grateful to the more analytical minds for their setting of us straight when our yearning for action leads us astray . . .[10]

If Morris's brand of "constructive" theorizing has confounded commentators, there are other formal aspects of his theory that have vitiated against a systematic appraisal of his oeuvre. Indeed, Morris never developed a systematic treatise on art, but elaborated his ideas in a series of disparate lectures given to diverse audiences. Thus, his lectures are at times repetitious, and presume a certain familiarity with his aesthetic assumptions. Given these and other factors,[11] scholars have tended to downplay the importance of Morris as a theorist:

while being struck by the incisiveness of his insights, they ultimately relegate him to a secondary status as a theorist. Expressing this general sentiment, Thompson claims: "As a theorist of the arts—despite all his profound insight—he failed to construct a consistent system, and muddled his way around some central problems."[12] What is implied in Thompson's critique is a certain assumption concerning the nature of "good" theory: logical consistency and analytic rigor are the traits that define a worthy theoretical enterprise. Yet, such a "philosophical" definition of theory closes off the more tantalizing issue of the relation of theory to ideology and political action.[13] As Morris seems keenly aware, his brand of "constructive" theory, while lacking the "pleasures" of analytic rigor, is intimately connected to a "yearning for action." What this implies, at least on the metatheoretical level, is that his theory is intimately involved in the process of negotiating the political world around him, supplying concepts for political self-definition, and providing provisional tools for political action. In particular, his aesthetic theory was important and necessary for the development of his political self-understanding as a socialist, and can be seen to be eminently consistent on that level.

Aesthetic Theory and the Constitution of the Political Subject: The Social and Political Meaning of Art

> [I]t is impossible to exclude socio-political questions from the considerations of aesthetics.
>
> —Morris, "The Revival of Handicrafts"[14]

After *The Earthly Paradise*, Morris continued to write poetry. In 1872, he published *Love Is Enough*, and then in 1875, *Sigurd the Volsung*, his epic poem based on the Icelandic sagas. The latter work—which G. B. Shaw claimed was "the greatest epic since Homer"[15]—was the last original poetry Morris would publish until he turned his bard's gifts toward the socialist cause in *The Pilgrims of Hope* (1885-86). Meanwhile, Morris continued his design work for his decorative art firm.

When Morris reflected on the nature of art and beauty in his lectures beginning in 1877, he shied away from discussing the "high art" of literature, and instead devoted his intellectual energies to discussing the decorative arts. Morris not only avoided discussing poetry and literature because he felt himself to be only a practitioner of the craft, and thus not well suited to literary criticism,[16] but also because he attached his growing social ideals to those arts which were integrated with the lives of everyday people. For, unlike literature, the decorative arts seemed to offer hope for the rejuvenation of beauty in Victorian everyday life.

Between 1877 and 1883, Morris delivered fourteen public lectures on the decorative arts and architecture.[17] Drawing upon the critical insights of his mentor, John Ruskin, Morris would in lecture after lecture call the faithful to see

the conditions and character of the present destruction of beauty, make heartfelt pleas for the necessity of revitalizing art in civilization, and point to possible reforms and/or socio-political transformations needed to bring about its rebirth. The emotional tenor and constructive yearning that underpin these lectures do not detract from the force and originality of the ideas he was beginning to develop concerning the relationship of art to human life. Yet, what is important about this period between 1877 and 1883 is the way in which Morris is gradually and tentatively coming to political and social understandings through his aesthetic theory.

Defining Art: Aesthetic Decay and the Necessity of Art

In "The Lesser Arts" (1877), Morris begins by delimiting the scope of his particular analysis. He claims that he will not be discussing "the great arts commonly called Sculpture and Painting."[18] Yet, to discuss those "lesser so-called Decorative Arts" separately should not imply that their character and life are dissociated from those of the higher or "intellectual" arts. As Morris notes, intimating the historical vision he will later fill out in more detail,

> it is only in latter times, and under the most intricate conditions of life, that they have fallen apart from one another; and I hold that, when they are so parted, it is ill for the Arts altogether: the lesser ones become trivial, mechanical, unintelligent, incapable of resisting the changes pressed upon them by fashion or dishonesty; while the greater, however they may be practiced for a while by men of great minds and wonder-working hands, unhelped by the lesser, unhelped by each other, are sure to lose their dignity of popular arts, and become nothing but dull adjuncts to unmeaning pomp, or ingenious toys for a few rich and idle men.[19]

As Morris noted, the lesser arts were at one time part and parcel of the higher arts: they were inextricably connected in that those who were deeply involved in making things for use were also expressing the creativity, intelligence and pleasure that now seems to define the artist, and in so doing creating beauty. For Morris, the critical period in history that marks the decline of art is the Renaissance. "From the first dawn of history," Morris claimed,

> till quite modern times, Art, which Nature meant to solace all, fulfilled its purpose; all men shared in it: that was what made life romantic, as people called it, in those days—that and not robber-barons and inaccessible kings with their hierarchy of serving-nobles and other such rubbish . . . Then came . . . a time of so much and such varied hope that people call it the time of the New Birth: as far as the arts are concerned I deny it that title; rather it seems to me that the great men who lived and glorified the practice of art in those days, were the fruit of the old, not the seed of the new order of things . . . and it is strange and perplexing that from those days forward the lapse of time, which, through plenteous confusion and failure, has on the whole been steadily destroying

privilege and exclusiveness in other matters, has delivered up art to be the exclusive privilege of a few, and has taken from the people their birthright . . .[20]

We can excavate from the above quotations a number of notions that make up the primary assumptions of Morris's aesthetic theory. First, the most obvious assumption that surfaces in this statement is the perception of the decline of art in the modern period. Though Morris sees the symptoms of its decline in the sequestering of art in the hands of a few gifted artists, and in the general ignorance of art in the masses of working people, he locates its social cause in the increase in the division of labor that became apparent during the Renaissance. As he observed in "Making the Best of It" (1879):

> The division of labour, which has played so great a part in furthering competitive commerce, till it has become a machine with powers both reproductive and destructive, which few dare to resist, and none can control or foresee the result of, has pressed specially hard on that part of the field of human culture in which I was born to labour. That field of the arts, whose harvest should be the chief part of human joy, hope, and consolation, has been, I say, dealt hardly with by the division of labour, once the servant, and now the master of competitive commerce, itself once the servant, and now the master of civilization . . .[21]

To think that we can save art by keeping it within the preserve of art museums (the "amusements of the rich"),[22] is to ignore the fact that art can only flourish once it has become part of the daily life of all people, rich or poor. In saying this, Morris is not only critiquing well-meaning middle-class attempts at educating the working classes in art, but also all those artists (and undoubtedly he is including his previous aesthetic self here) who think that they can create a viable Palace of Art in the context of art-destroying *social* conditions. Indeed, the very existence of the aesthetic ideology of "art for art's sake" is a telling dialectical image of the loss of art by the masses of people: the fact that art is now confined in the hands of a few individuals cloistered within their bohemian hovels generates the ideological and discursive rendering of art as something separate from the travails of the everyday world. Without the sympathy of the masses of people, art is something now done purely for the enjoyment of the artist. Given this development, art is then generalized as an artifact whose goal is not to affect all men's lives, but to generate pleasurable sensations. While Morris sees that those few who have "caught up the golden chain" of past art must continue to persevere in their practices to keep the hope of beauty going, it will come to naught unless all share in its benefits. For, "the truth is," Morris claimed, "in art, and in other things besides, the laboured education of a few will not raise even those few above the reach of the evil that beset the ignorance of the great mass of population."[23] No corner of English society can escape the degradation of the aesthetic sense, no matter how much money or cultivation they may have. "The lack of art," Morris noted,

or rather the murder of art, that curses our streets from the sordidness of the surroundings of the lower classes, has its exact counterpart in the dullness and vulgarity of those of the middle classes, and the double-distilled dullness, and scarcely less vulgarity of those of the upper classes.[24]

Second, Morris is claiming a necessary and important position for art in human life in general. Art brings "solace" as well as "joy, hope, and consolation" to human life. In arguing for the development of human qualities *arte magistra*, Morris is making what seems to be an anthropological claim about the necessity of beauty and art. In "The Beauty of Life" (1880), Morris directly confronts all those middle-class individuals who argue either that art has a life as a consequence of the luxury spawned by competitive commerce, or, that it really does not matter, for art and beauty are themselves dispensable. Morris rejects the first argument, claiming "that men in struggling towards the complete attainment of all the luxuries of life for the strongest portion of their race . . . deprive their whole race of all the beauty of life . . ."[25] While the middle class has seen the accumulation of luxuries as the pinnacle of natural "progress," they are ignorant of the way in which it has also destroyed the beauty of life. Morris then proceeds to claim that in losing art and beauty, we are also destroying that which ultimately distinguishes us from other animals. "The beauty of life," Morris argued,

> is a thing of no moment, I suppose few people would venture to assert, and yet most civilised people act as if it were of none, and in so doing are wronging both themselves and those that are to come after them; for that beauty, which is what is meant by *art*, using the word in its widest sense, is, I contend, no mere accident to human life, which people can take and leave as they choose, but a *positive necessity of life*, if we are to live as nature meant us to do; that is, unless we are content to be less than men.[26]

To let art die, as it is doing under competitive commerce, is not to forego a pretty picture or a well-designed piece of furniture, but to deny oneself a human life. For,

> these arts . . . are part of a great system invented for the expression of man's delight in beauty: all peoples and all times have used them; they have been the joy of free nations, and the solace of oppressed nations; religion has used and elevated them, has abused and degraded them; they are connected with all history, and are clear teachers of it; and, best of all, they are the sweeteners of human labour, both to the handicraftsman, whose life is spent in working in them, and to people in general who are influenced by the sight of them at every turn of the day's work: they make our toil happy, our rest fruitful.[27]

Art and beauty are thus given a primary place in the hierarchy of human needs, and represents that life force necessary for a truly human life. In this respect, Morris was drawing upon the lessons he learned from his aestheticist background. Moreover, he seems to be echoing the words of the young Marx

when he perceives the distinction between animals and man to rest ultimately in the latter's ability to create aesthetically, a conscious ability not limited by physical needs. Animals produce, Marx argued in a famous passage,

> only under the dominion of immediate physical needs, while man produces when he is free from physical need and only truly produces in freedom therefrom ... An animal forms things in accordance with the measure and the need of the species to which it belongs, while man knows how to produce in accordance with the measure of every species and knows how to apply everywhere the inherent measure to the object. Man, therefore, also forms things in accordance with the laws of beauty.[28]

With Marx, Morris also delineates the importance of the inherent, species-specific, potentialities of human labor that is best exemplified in the creation of beauty and art. The relationship of Morris's thinking to that of Marx's is an interesting topic, one which we will deal with at greater length in the following chapter.[29] At this point, we can note that while the young Marx seems to be elaborating an anthropological conception of human labor, Morris was always keenly aware of the historical nature of human creative practices. In particular, Morris's conception of the human meaning of art was formulated primarily in terms of the conditions of life that prevailed in the Middle Ages.

Yet, another important difference is evident. Marx viewed the inherent potentialities of human labor as exhibited in the creation of beauty in relation to an analysis of economic exploitation and alienated labor. Morris reached the same conclusion through a thorough excavation of the foundations of art. One of the most important concepts in his aesthetic theory is that of the "art of the people." This concept reflects Morris's growing realization that art's future is inextricably intertwined with that of the mass of people who labor, i. e., the working classes.

Representing Labor in Aesthetic Theory, I: "Art of the People" and Pleasurable Labor

In his lecture, "Some Hints on Pattern-Designing" (1881), Morris interrupted his discussion concerning the principles of good ornamentation with a telling confession:

> I have a compact with myself that I will never address my countrymen on the subject of art without speaking as briefly, but also as plainly as I can, on the degradation of labour which I believe to be the great danger of civilization, as it has proved itself to be the very bane of art.[30]

In "The Art of the People" (1879), Morris declared: "That thing which I understand by real art is the expression by man of his pleasure in labour."[31] In his lectures, Morris could never discuss architecture or the decorative arts as if they were autonomous, self-regulating practices; their strength and vitality, or their

weakness and exhaustion, were inextricably tied up with the material practices of human life. Moreover, "it is not possible to dissociate art from morality [and] politics . . . Truth in these great matters of principle is of one, and it is only in formal treatises that it can be split up diversely."[32]

The interweaving of politics with art was present in Morris's lectures from the beginning—either explicitly in the discussion of social conditions and the necessity of their transformation for the good of art, or implicitly in the focus upon labor as a key category in his understanding of art. In his earliest lectures, the rudiments of a conscious political discourse are contained in brief asides to his general discussions of aesthetic reform. In "The Lesser Arts," he reminds his audience that the aesthetic reforms (which included the simplification of needs, well-made handicrafts and the protection of ancient buildings) he wishes to implement are bound up with "stupendous difficulties, social or economic."[33] At this stage in his thinking, Morris gives more space to the practical actions that can keep the ideal of art going within the profit-grinding teeth of commerce or the "greed of money,"[34] than to discussions of wider social transformations implied in his analysis. Yet, toward the end of this lecture, Morris ventures tentatively onto the terrain of a political discourse concerning wide-scale social transformations, iterating the ideal that will become important in his later socialist activism:

> I believe that as we have even now partly achieved LIBERTY, so we shall one day achieve EQUALITY, which, and which only, means FRATERNITY, and so have leisure from poverty and all its griping, sordid cares . . . for surely then we shall be happy in [labour], each in his place, no man grudging at another; no one bidden to be any man's *servant*, every one scorning to be any man's *master*: men will then assuredly be happy in their work, and that happiness will assuredly bring forth decorative, noble, *popular* art.[35]

The political triptych of liberty, equality and fraternity is ultimately submerged to, or captivated by, the overarching concern for the regeneration of art. The realization of such goals is not strictly for the sake of the poor, but rather as a means toward creating a "decorative, noble, *popular* art." As is well-known, this tripartite constellation of ideals was to be a cornerstone of socialist theory,[36] and its elaboration within the context of an aesthetic discourse is what Morris ultimately meant when he claimed he was propounding "socialism as seen through the eyes of an artist." In a letter to Thomas Coglan Horsfall in February 1883, Morris clarified his position during the writing of those lectures collected in *Hopes and Fears of Art* (1882):

> You see it was not necessary in lectures to tell people that I am in principle a Socialist, and would be so in practice if there should ever in my lifetime turn up an occasion for action: add to this fact that I have a religious hatred to all war and violence, and you have the reason for my speaking and writing on subjects of art. I mean that I have done it as seed for the goodwill and justice that *may* make it possible for the next great revolution, which will be a social one . . . [37]

If Morris felt himself to be "in principle a Socialist" during the writing of these early lectures, his commitment to the political project of the working class in English society was still rather undefined. While he recognized the necessity of eradicating the mechanical toil that characterized the factory system, and promoted the institution of pleasurable labor, Morris did not directly link the hopes and fears of art with the struggles of the working class. At this stage, Morris's representation of labor in his aesthetic theory took the form of pictures of the robust figure of the medieval craftsman, vague calls for social transformation (as in the call for liberty, equality and fraternity) and the elaboration of the ideal of the "art of the people."

At the end of "The Lesser Arts," Morris notes that while art is dying there are remnants of "peasant art" that "clung fast to the life of the people."[38] While not as majestic as that of the rulers,

> it [was] never oppressive, never a slave's nightmare nor an insolent boast: and at its best it had an inventiveness, and individuality that grander styles have never overpassed: its best too, and that was in its very heart, was given as freely to the yeoman's house, and the humble village church, as to the lord's palace or the mighty cathedral: never course, though often rude enough, sweet, natural and unaffected, an art of peasants rather than of merchant-princes or courtiers, it must be a hard heart, I think, that does not love it . . .[39]

It was Morris's hatred of all the sham art in the nineteenth century (and he specifically included "art manufactures," like those that populated the Great Exhibition, under this rubric), and his corresponding "love" of the everyday decorative art that he claimed blossomed all over the human landscape of the Middle Ages, that moved him to sympathize with the common laborer. His aesthetic longing for beauty led him to scan the past of art and note "that down to very recent days everything that the hand of man touched was more or less beautiful: so that in those days all people who make anything shared in art, as well as all people who used the things so made: that is, *all* people shared in art."[40] This widespread condition of aesthetic production, and the ideal it engenders for him, is what Morris meant by "art of the people." If we were to look to our museums for ancient art, and study the historical period of their life, we would see that

> wonderful as these works are, they were made by 'common fellows,' as the phrase goes, in the common course of their daily labour. Such were the men we honour in honouring those works. And their labour—do you think it was irksome to them? Those of you who are artists know very well that is was not; that it could not be . . . No it is impossible. I have seen as most of us have, work done by such men in some out-of-the-way hamlet . . . in such places, I say, I have seen work so delicate, so careful, and so inventive, that nothing in its way could go further. And I assert, without fear of contradiction, that no human ingenuity can produce work such as this without pleasure being a third party to the brain that conceived and the hand that fashioned it.[41]

Like Ruskin before him, Morris moves in his narrative from the observation and worship of beauty to the actual conditions of its production; namely, the intelligence, dexterity and pleasure of the labor that went into its production. In this conceptual move, Morris attaches his aesthetic desires to the life of the craftsman. Morris is representing labor in his aesthetic theory; literally, he is a spokesman for their life, pleasures, and above all, their art. The art history that Morris wishes to write is thus not that of the few great artists—the Michelangelos, the Van Eycks—but of the "countless multitude of happy workers whose work did express, and could not choose but express, some original thought, and was consequently both interesting and beautiful."[42] For Morris, then, art history becomes social history in the contemporary sense: a history of the common people. In engaging in such historical practices, Morris was making a very important contribution to the rethinking of the discipline of history in general.[43] As Morris noted concerning the limitations of nineteenth-century historical practices:

> It seems there were others than those of whom history (so called) has left us the names and deeds. These, the raw material for the treasury and the slave-market, we now call 'the people,' and we know that they were working all that while. Yes, and that their work was not merely slaves' work, the meal-trough before them and the whips behind them; for though history (so called) has forgotten them, yet their work has not been forgotten, but has made another history—the history of Art. . .History (so called) has remembered the kings and warriors, because they destroyed; art has remembered the people, because they created.[44]

Drawing sustenance from other historical findings in the wake of the medievalist movement, Morris claims not only that the medieval craftsman was better off economically than his Victorian counterpart (as Roger, Southey and Cobbett had argued, and which Morris would come back to in greater detail as a socialist),[45] but more importantly, at least for his immediate interests, that they could also produce art, a human activity not allowed the Victorian worker caught up in the mind-numbing toil associated with industrial capitalism. For Morris, art is the expression of pleasurable labor, and while in the Middle Ages "life was often rough and evil enough, beset by violence, superstition, ignorance, slavery," he cannot "help thinking that surely as poor folks needed a solace, they did not altogether lack one, and that solace was pleasure in their work."[46] Art could thus flourish because of this freedom of mind and hand that characterized the everyday labor of the workman, a condition that Morris grants was encircled by political oppression. Yet, if the Victorian workman was beginning to gain political freedoms (the Second Reform Bill of 1867 gave a significant section of urban workers the vote), its economic servitude was more onerous, at least with respect to art. Given that competitive commerce and the division of labor created an "enormous amount of pleasureless work. . .work which everybody who has to do with tries to shuffle off in the speediest way that dread of starvation or ruin will allow him,"[47] art will never be a part of their productive lives. While agreeing with Ruskin about the art-destroying properties of

machines ("I believe that machines can do everything—except make works of art"),[48] Morris was more sanguine about their possible use to alleviate the most toilsome labor necessary for human life. "As to machines, the reasonable thing to say of them is that they are like fire, bad masters, good servants."[49]

Marx located economic exploitation in the internal mechanisms of capitalist production, in which surplus value was appropriated in the production of profit, but Morris located exploitation in the very act of production, i. e., in the condition of pleasureless toil. This condition meant that economic life had lost the human dimension it once had, and was being driven by profit or greed. The labor theory of art that Morris gained from Ruskin provided a very useful means for discerning exploitation within nineteenth-century society. If the assumption, derived from history, is that beauty is a consequence of pleasure of labor, then the lack of beauty in human life alerts the critic to the presence of conditions of degradation and exploitation for the purposes of "greed" or "profit." And, this implied not an individualized relation of power, but a societal one. Morris referred to the kind of labor produced by the "tyrannous organization of labour which was a necessity of competitive commerce" as "Mechanical Toil."[50] Not only did such labor lie at the heart of art's death, but it was also destroying the life of the worker.

> The workmen who do purely mechanical work do as a rule become mere machines as far as their work is concerned. Now as I am sure that no art, not even the feeblest, rudest, or least intelligent, can come of such work, so also I am sure that such work makes the workman less than a man and degrades him grievously and unjustly, and that nothing can compensate him or us for such degradation . . .[51]

How, then, are we to rid society of "such degradation"? Still ensconced in the aura of aestheticism, and indeed arguing in a somewhat circular fashion, Morris claimed that the redemption of present social ills rested in giving all people a share in art. That labor "which now makes things good and necessary in themselves, merely as counters of the commercial war," Morris argued,

> needs regulating and reforming. Nor can this reform be brought about save by art; and if we were only come to our right minds, and could see the necessity for making labour sweet to all men, as it is now to very few—the necessity, I repeat; lest discontent, unrest, and despair should at last swallow up all society—If we, then, with our eyes cleared, could but make some sacrifice of things which do us no good, since we unjustly and uneasily possess them, then indeed I believe we should sow the seeds of a happiness which the world has not yet known, of a rest and content which would make it what I cannot help thinking it was meant to be: and with that seed would be sown also the seed of real art, the expression of man's happiness in his labour—an art made by the people, and for the people, as a happiness to the maker and user.[52]

What we then see are a number of important and related issues that arise in this early period of his aesthetic thought. First, that Morris's study of the history

of art has alerted him to the existence of the "art of the people," a condition in which all craftsman and laborers participated. This concept works on two interrelated levels: it is at once an empirical concept, related to the supposed historical facts of the Middle Ages, and a politico-aesthetic ideal that is a goal for future action. Methodologically, the veracity of the empirical statements become less important than their effect on the constitution of Morris as a political actor. Whether or not these pictures of the Middle Ages are true is ultimately a secondary issue, for they gradually lead Morris to attach his aesthetic desires to the worker, albeit a romanticized, idealized image of the medieval craftsman. If the nineteenth-century worker appears at all in this aesthetic discourse, it is as a disfigured and deformed character, hopelessly chained to machinery and engaging in "mechanical toil," engendering from its hands not art but an icon of its servitude. Yet, whatever the details of this representation of labor in his aesthetic thought, what is important is that he increasingly ties the aims of art to the conditions of the working class, past and present. And with the mediating, highly politicized, concept of "pleasurable labour," Morris can critique the conditions and organization of labor in Victorian society, while at the same time entering into the discourses of wider social struggles of the working class. In a recent interview, Raymond Williams has noted the way in which Morris's concept of pleasurable labor practically and conceptually implies a notion of economic democracy and worker's control. For the worker, pleasurable and creative labor implies, as Williams notes,

> in some way expressing some part of his skill and of himself. Now this is where the argument connects not just with what can be said about hand labour as distinct from machine labour, but with the argument about capitalism; about who *decides* what is to be produced. Once you get to that point you see that you can only get autonomy in your labour, control over what you are making, if you have an altered relation to the decisions about production, the key decisions about what is to be produced.[53]

While Williams rightly notes that Morris's concept on a pragmatic level implies other discourses about economic control and worker's democracy, what is more important is that Morris was beginning to make connections with the working class struggle on a conscious level. This becomes particularly clear in the lectures on art he delivered after 1881. If Morris began his conceptual journey by representing labor in the form of a imagined craftsman, he now begins to reformulate the image of the nineteenth-century worker.[54]

Representing Labor in Aesthetic Theory, II: Working Class Struggles and Socialist Ideals

Morris's lectures during and after 1881 reflected a growing awareness of the relation of his aesthetic aims to those of the political struggles of his contemporaries. In his lecture, "Art and the Beauty of the Earth" (1881), Morris

interrupts his discussion of those practical things that artists and the middle class can do to stem the disastrous tide of civilization (e.g., use the right materials, etc.) with a blistering and eloquent call for the bettering of the conditions of the working class. "As I sit at my work at home," Morris confided in a famous statement,

> which is at Hammersmith, close to the river, I often hear go past my window some of that ruffianism of which a good deal has been said in the papers as of late . . . As I hear the yells and shrieks and all the degradation cast on the glorious tongue of Shakespeare and Milton, as I see the brutal reckless faces and figures go past me, it rouses the recklessness and brutality in me also, and fierce wrath takes possession of me, till I remember, as I hope I mostly do, that it was my good luck only of being born respectable and rich that has put me on this side of the window among delightful books and lovely works of art, and not on the other side, in the empty street, the drink-steeped liquourshops, the foul and degraded lodgings. What words can say what all that means? Do not think, I beg of you, that I am speaking rhetorically in saying that when I think of all this, I feel that the one great thing I desire is that this great country . . . turn that mighty force of her respectable people, the greatest power the world has ever seen, to giving the children of these poor folks the pleasures and hopes of men. Is that really impossible?[55]

Shortly after this irruption into his aesthetic discourse of political matters, Morris relates these to the original aesthetic concerns of the lecture. From his own "feelings and desires" as an artist he recognizes that what these men need is art, for "in my mind it means the properly organized labour of all men who make anything."[56] Morris's conception of art is moving toward making the terms "art" and "socialism" synonymous. In a letter to Georgiana Burne-Jones (1881), Morris for the first time talks about his political desires for transforming class society:

> Though to me, as I suppose to you, everyday begins and ends a year, I was fain to catch hold of ancient custom; nor perhaps will you think it ceremonious or superstitious if I try to join thought with you to-day in writing a word of hope for the new year, that it may do a good turn of work toward the abasement of the rich and raising up of the poor, which is of all things most to be longed for, till people can at last rub out from their dictionaries altogether those dreadful words rich and poor . . .[57]

Morris had always recognized that the division of society into "'cultivated' and 'uncultivated, i.e., degraded classes'" meant that the "foundation of real art, the desire of the whole people to have it . . . cannot exist . . ."[58] The eradication of these distinctions thus became important in light of his aesthetic ideals. From this initial realization, Morris developed the central notion that defines his socialism, namely, "equality of condition."[59]

Chapter Five 115

In his lecture, "The Prospects of Architecture in Civilization" (1881), Morris begins his discussion of architecture by again chastising the cultivated classes for not caring about art. If the rich feel "that as labour is now organized art can go indefinitely as *it* is now organized, practiced by a few for a few, adding a little interest, a little refinement to the lives of those who have come to look upon intellectual interest and spiritual refinement as their birthright," they are mistaken; for real art cannot survive in the class system in which it is "the slave of the rich, and token of the enduring slavery of the poor."[60] While this is perfectly consistent with Morris's earlier ideas, what is new is the sense of hope that he has for art's future development. If in earlier lectures Morris evidenced a melancholy realization that artists already engaged in aesthetic production were the only hope for the future of a living art (a despair that was consonant with Morris's earlier words in *The Earthly Paradise*), he has now located the social agent of its rebirth. As Morris observed:

> if of late there has been a change for the better in the prospects of the arts; if there has been a struggle both to throw off the chains of dead and powerless tradition, and to understand the thoughts and aspirations of those among whom those traditions were once alive powerful and beneficent; if there has been abroad any spirit of resistance to the flood of sordid ugliness that modern civilization has created to make modern civilization miserable: in a word, if any of us have had the courage to be discontented that art seems dying. . .it is because others have been discontented and hopeful in other matters than the arts; I believe most sincerely that the steady progress of those whom. . .we call the lower classes in material, political and social conditions, has been our real help in all that we have been able to do or to hope . . .[61]

This awareness on Morris's part concerning the linkages between the struggles of the "lower classes" and his own aesthetic ideals was a result not only of his earlier aesthetic ideas, but also of his experience with the organization and strength of the working class during the years of political activism in the Eastern Question Association.[62] Also, Morris had for a brief period after 1880 joined the National Liberal League (with Henry Burrows as Secretary) "to stir up some opposition to the course of the Liberal Government and party were taking in the early days of this parliament."[63] While the NLL quickly fell to pieces, it undoubtedly offered Morris more contacts with trade union leaders and Radical elements of the working class. Moreover, the 1870s had witnessed an increase of the stature of the trade union movement in general, with successful strikes (e. g., the five month strike of engineering and shipbuilding workers in the Northeast for the Nine Hour Day), the organization of previously unorganized sections of the working class (e. g., the organization of agricultural workers in Southern England), the further consolidation and representativeness of the Trade Union Council, and the repeal of the Master and Servant act in 1875.[64] These developments undoubtedly affected Morris's thinking about the political and social conditions of a future revival in the arts. Morris paid homage to these working class developments, noting that if competitive commerce has destroyed much, it has

"unwittingly" created a positive development: the increasing class consciousness of the working class. "The determination which this power has bred in it to raise their class as a class," Morris claimed,

> will, I doubt not, make way and prosper with our good will, or even in spite of it . . . The time of unreasonable and blind outcry against the Trades Unions is, I am happy to think, gone by, and has given place to the hope of a time when these great Associations, well organized, well served, and earnestly supported, as I *know* them to be, will find other work before them than the temporary support of their members and the adjustment of their wages for their crafts; when that hope begins to be realized, and they find they can make use of the help of us scattered units of cultivated classes, I feel sure that the claims of art, as we and they will then understand the word, will by no means be disregarded by them.[65]

This is probably the most positive statement Morris wrote about the trade union movement, and undoubtedly reflects the experiences he had as a Radical in the EQA and NLL. When Morris's political ideals began to solidify as a revolutionary socialist, he became increasingly distrustful of parliamentary politics, which he felt included trade union leaders involved in party political activities. While Morris may have thought at this point that the trade unions would not disregard "the claims of art" (which were really to become the claims of his socialism), their continued attachment to "the adjustment of their wages for their crafts," tied to their reformist policies that accepted competitive commerce, later forced Morris to disregard their potentiality for social transformation. Two years later in his lecture, "Art Under Plutocracy" (1883), Morris expressed this disillusionment with existing working class organizations: ". . . the very combinations, the Trades Unions, founded for the advancement of the working class as a class, have already become conservative and obstructive bodies, wielded by the middle-class politicians for party purposes . . ."[66] It was Morris's turning away from parliamentary politics and existing working class organizations, a move precipitated by his own experience as a Radical and the "claims of art" he perceived were necessary, that represents for some commentators the very Achilles' heel of his socialism, a weak point that limited the practical import and influence of his socialist theory and tactics.[67]

Historically, the condition of the working class was increasingly tied to questions of art through the well-meaning middle class attempts to create an art affordable to the worker, as well as through attempts at art education that spawned the numerous openings of pubic galleries around the country. In terms of the first option, Morris was adamant about the futility of creating an art work cheap enough for all to share, and thus assuming that one was creating the conditions of a living art. No one really shares in art "unless it touches everything that man makes," and "'tis only here and there that art touches the matters of our daily life."[68] As Morris observed:

> we shall at least make up our minds to one thing: not to try to make a poor man's art while we keep a rich man's art for ourselves: not to say, there, that suits your condition, I wouldn't have it myself but 'tis good enough for you. . . palliation is no use when evils are great, and when people have not begun *to strike at the root*.
> Educate your workmen into general discontent: that is the only remedy.[69]

Written in 1881, this comment shows the extent to which Morris saw the importance of working class struggles for the creation and spread of the arts. Yet, there is also another important marker here that we should heed. Morris's claim that all that does not "*strike at the root*" of the matter is "palliation" is an indication of Morris's realization that art, or the pleasure and beauty of life, could not come about unless there is a complete transformation of social conditions. If the "tyrannous organization of labour" and the class system of competitive commerce has been the deathblow to real art, then the latter can only flourish once competitive commerce has been eradicated and overcome. It is Morris's realization that the systemic quality of competitive commerce is what is at the root of the present "barbarism," that foretells of his *revolutionary* socialist perspective. It is an all or nothing proposition for Morris—art is either alive, a creation of everyone's pleasure in labor, or it is dead, ground under the wheels of economic oppression and machine-slavery. Reform within those confines was only a smooth varnish over a rotten apple, whose decay would be apparent to all discerning eyes, or an imaginary act of goodwill that only assuaged the conscience of the middle class.

The concern of some individuals about the lack of an art sense in the working classes was evidenced in the numerous attempts to provide them with art education, including classes in art—such as those which Ruskin and Rossetti taught at the Working Men's College during the 1860s—and the opening of art galleries to the working class. While well-meaning, these middle-class attempts were, in Morris's view, misdirected. To assume that all that was needed for the flowering of the aesthetic sense was an introduction to great works of art was to ignore the social foundations of that activity. Ultimately, without attending to those social conditions, and promoting the transformations necessary for changing the lives of the working class so they could have a real aesthetic sense, the middle class was only adding insult to injury:

> though public libraries, and museums, and picture exhibitions are good, and very good yet, if you are tempted to look upon them as substitutes for decent life in the workshops and the home, if they are to be mere tubs thrown to the whole of poverty, they may become dangerous snares to well-meaning middle class philanthropists . . .[70]

The educational value and intent of these art shows should then not rest in making the life of the workman more cultured within the degrading confines of competitive commerce, but in persuading them to transform their present conditions of life. "If we have that intention," Morris noted,

we can give a different kind of invitation indeed: . . . they are works of men who were not gentlemen but workmen like yourselves: the instincts that enabled them to produce these works are latent in your hands and minds if only you had the opportunities to develop them: these works of wonder should be present . . . in your own daily work and have their influence upon your home life, making it orderly, beautiful, in a word human: come here often . . . and let the sight of these wonders stimulate you to trying to win a worthy life for yourselves and your fellows, a life of men and not of 'operatives'.[71]

By the end of 1881, the various elements of Morris's socialism[72]—the emphasis on the exploitation of the working classes; the discussion of the disastrous effects of the class system upon the cultural life of society; the linking of art with a complete social transformation of the life of the working class; and an identification of the ultimate goal of equality with the activity of pleasurable labor—were in place. All that is really missing at this point is the word, "socialism." All of these ideals and critiques are at this point expressed under the rubric of redefining "art." At the beginning of 1883, driven by his own thinking on the hopes and fears of art, Morris joined the Democratic Federation, whose commitment to socialist principles the following year offered Morris a practical avenue for action. With the aid of art, Morris had become a "practical" socialist.[73]

Notes

1. In *Collected Letters of William Morris*, Vol. II, Part I, 230.
2. Morris, "Report of the Society for the Protection of Ancient Buildings" (1878), in *William Morris: Artist, Writer, Socialist*, Vol. I, 117.
3. In *Collected Letters of William Morris*, Vol. II, Part I, 87.
4. Morris, Letter to the Prefect of Florence, 1881, in *Collected Letters of William Morris*, Vol. II, Part I, 6.
5. Morris, "Address at the Second Annual Meeting of Anti-Scrape" (1879), in *William Morris: Artist, Writer, Socialist*, Vol. I, 123.
6. Thompson, *William Morris: Romantic to Revolutionary*, 23. While Thompson rightly sees this practical engagement with the antagonism between property rights and art, at least as they surfaced within the context of restoration, as an important educational principle leading to his later conception of communism, he is a little too easily drawn into the traditional conception of political education that this experience seems to afford. As we have already pointed out in Chapter Four, Morris was working through his politics in his early career as an artist, an experience that at least set the parameters of his later activism in the name of ancient architecture.
7. For a list lectures he wrote on art after this date, consult Eugene Lemire's list of speeches and lectures in *The Unpublished Lectures of William Morris*, Appendix II, 291-322.
8. For secondary texts that discuss Morris's aesthetic theory at some length, each differing in their assessment and in their emphasis, see Thompson, *William Morris: Romantic to Revolutionary*, 641-666; Hough, *The Last Romantics*, 83-102; Anna Helmholtz-Phelan, *The Social Philosophy of William Morris* (Durham: Duke University Press,

1927), 30-49; Henderson, *William Morris: His Life, Work and Friends*, 194-213; Williams, *Culture and Society*, 148-158; the diverse articles under the Architecture and Art sections in *William Morris Today*, 43-121; Boris, *Art and Labor*, 7-12; Alice Chandler, *Dream of Order: The Medieval Ideal in Nineteenth Century English Literature* (Lincoln: University of Nebraska Press, 1970), especially Chapter 6, "Art and Society: Ruskin and Morris," 209-230; and Jessie Kocmanova, "The Aesthetic Opinions of William Morris," *Comparative Literature Studies* IV, no. 4 (1967): 409-424.

9. A. L. Morton in his "Introduction" to *The Political Writings of William Morris* (New York: International Publishers, 1973), 11, notes that in his aesthetic and political thinking Morris's "mind was constructive rather than analytical."

10. Morris, "The Society of the Future" (1888), in *William Morris: Artist, Writer, Socialist*, Vol. II, 455.

11. The clear indebtedness of Morris's thought to Ruskin's (a debt that Morris acknowledged on many occasions) has led some scholars to see Morris's ruminations on art as only a weak echo of his master's more trenchant and illuminating discussions. See Hough, *The Last Romantics*, 83-133. As will become clearer later in this chapter, Morris did draw upon Ruskin's ideas, but took them to different and original levels, showing him to be an accomplished and insightful theorist on his own.

12. Thompson, *William Morris: Romantic to Revolutionary*, 717.

13. See Richard Ashcraft, "Political Theory and the Problem of Ideology," *The Journal of Politics* 42 (1980): 687-705, for a critique of philosophical definitions of theory, and a discussion of the importance of conceiving theory as intimately related to ideology and political action.

14. "The Revival of Handicrafts" (1888), in *CW*, Vol. XXII, 332.

15. Shaw, "William Morris As I Knew Him," xxxvii.

16. In a letter Morris wrote to James Richard Thursfield, Feb. 16, 1877, in *Collected Letters of William Morris*, Vol. I, 347, he turned down an offer to hold a chair of poetry at Oxford because he felt himself to be a better practitioner than theorist of poetry:

> It seems to me that the *practice* of any art rather narrows the artist in regard to the *theory* of it; and I think I come more than most men under this condemnation, so that though I have read a good deal & have a good memory my knowledge is so limited & so ill-arranged that I can scarce call myself a man of letters...

17. These lectures included "The Lesser Arts" (1877), "The Art of the People" (1879), "Making the Best of It" (1879), "The History of Pattern Design" (1879), "The Beauty of Life" (1880), "The Prospects of Architecture in Civilization" (1881), "Art and the Beauty of the Earth" (1881), "Some Hints on Pattern Designing" (1881), "The Lesser Arts of Life" (1882), "The Progress of Decorative Art in England" (1882), "Art: A Serious Thing" (1882), "Art, Wealth, and Riches" (1883), "Art under Plutocracy" (1883), and "Art and the People: A Socialist's Protest against Capitalist Brutality; Addressed to the Working Classes" (1883). The first five lectures (disregarding "The History of Pattern Design") were subsequently published in his first collection of essays, *Hopes and Fears of Art* (1882). The latter two lectures were written when Morris had joined the Democratic Federation, and are the crowning statements of his aesthetic thought, as well as the first claims of his conscious socialist theory.

18. Morris, "The Lesser Arts," 3.

19. Morris, "The Lesser Arts," 3-4.

20. Morris, "The Beauty of Life," in *CW*, Vol. XXII, 56-57.

21. Morris, "Making the Best of It," in *CW*, Vol. XXII, 82.
22. Morris, "The Prospects of Art in Civilization," in *CW*, Vol. XXII, 138.
23. Morris, "The Beauty of Life," 62.
24. Morris, "The Beauty of Life," 62-63.
25. Morris, "The Beauty of Life," 52.
26. Morris, "The Beauty of Life," 53.
27. Morris, "The Lesser Arts," 8.
28. Marx, "Economic and Philosophical Manuscripts" (1844), in *Karl Marx: Early Writings*, Rodney Livingston and Gregor Benton, trans. (London: Penguin Books, 1975), 329.
29. The connections between Marx and Morris have been dealt with before, most notably, R. Page Arnot, *William Morris: The Man and The Myth* (London: Lawrence Wishart, 1964); Thompson, *William Morris: Romantic to Revolutionary*, specifically, 741-762; and, Paul Meier, *William Morris: The Marxist Dreamer*. It should be noted that these discussions were initiated to dispel the widespread notion that Morris's socialism was a muddled utopianism. All of the authors rightly note the influence of Marx on Morris's writings, which came to him not only in reading the French translation of *Capital* in 1883 but also in discussions with his socialist colleagues. For a discussion of Morris's socialism, see Chapter Six.
30. Morris, "Some Hints on Pattern-Designing," in *CW*, Vol. XXII, 202.
31. Morris, "The Art of the People," in *CW*, Vol. XXII, 42.
32. Morris, "The Art of the People," 47.
33. Morris, "The Lesser Arts," 14.
34. Morris, "The Lesser Arts," 14.
35. Morris, "The Lesser Arts," 26-27.
36. Indeed, these words would adorn, alongside naturalist decoration, the membership card that Morris would design for the Democratic Federation in 1883.
37. From *Collected Letters of William Morris*, Vol. II, Part I, 157.
38. Morris, "The Lesser Arts," 18.
39. Morris, "The Lesser Arts," 18.
40. Morris, "The Beauty of Life," 54.
41. Morris, "The Art of the People," 40-41.
42. Morris, "The Beauty of Life," 55.
43. For a good discussion of Morris's contribution to the rethinking of history by British Marxists, see Ralph Samuel, "British Marxist Historians, 1880-1980: Part One," *New Left Review*, # 120, 1980, 21-96. Samuel focuses on Morris's later, socialist years, and tends to ignore the importance of his earlier art historical practices, which were equally as important for the development of social history.
44. Morris, "The Art of the People," 32.
45. See Morris, "Architecture and History" (1884), in *CW*, Vol. XXII, for an example of the breadth and insightfulness of Morris's economic interpretation of the Middle Ages, and its relation to the production of art.
46. Morris, "Art and Beauty of the Earth," in *CW*, Vol. XXII, 163.
47. Morris, "The Art of the People," 45.
48. Morris, "Art and the Beauty of the Earth," 166.
49. In *Collected Letters of William Morris*, Vol. II, Part I, 126.
50. Morris, "Prospects of Art in Civilization," 150.
51. Morris, "Prospects of Art in Civilization," 144.

52. Morris, "The Art of the People," 46.

53. "William Morris, Questions of Work & Democracy: Interview with Raymond Williams," in *William Morris Today*, 122.

54. I have been using the term "representation" in a number of different, though related, ways. There are two meanings that are particularly important for our purposes, and have been used in this work. First, there is the more common meaning of representation as "reflection" and "resemblance." At this semantic level, we argue that category of labor was important because it was a category in social use. Thus, with our discussion of Ruskin we argued that his labor theory of art was a "reflection" or "resemblance" of these larger social struggles. Especially in cultural studies, this is a contested meaning, given its reductionist overtones and its tendency in its Marxist guises to fall into the rigid base/superstructure model. Yet, it still has an important purpose.

The second meaning is a little more complex. Drawing more on poststructuralist tendencies, "representation" is used to signify, in the words of Derrida, "a theatrical representation. . .which is not necessarily or uniquely reproductive or repetitive but. . .a presentation (*Darstellung*), an exhibition, a performance" ["Sending: On Representation," *Social Research* 49, no. 2 (Summer 1982): 301]. In this sense of the term, "to represent" does not mean to present again an already existing entity (e. g., social forces, class languages), but rather "to constitute," "to set before oneself" something. The performance of a play is always something different, outside, even originary, no matter the details of the script. Importantly, the process of representation on this level entails the constitution of both a subject (the actor as character) and a world of objects. From this angle, we might claim that Morris was not only constituting labor in this aesthetic theory, that is, engendering an image of workers and labor, but also that he was constituting himself as a political subject.

55. Morris, "Art and the Beauty of the Earth," 171-172.

56. Morris, "Art and the Beauty of the Earth," 172.

57. In *Collected Letters of William Morris*, Vol. II, Part I, 3.

58. Letter to Thomas Coglan Horsfall, December 31, 1882, in *Collected Letters of William Morris*, Vol. II, Part I, 145.

59. See Morris, "Communism" (1893), in *Political Writings of William Morris*, 226-239, for a mature statement of his notion of socialism.

60. Morris, "The Prospects of Architecture in Civilization," 123.

61. Morris, "The Prospects of Architecture in Civilization," 124.

62. See Thompson, *William Morris: Romantic to Revolutionary*, 202-225. For Thompson, Morris's involvement in the EQA provided the initial political education of the limits of liberal politics and the strength of working class struggles.

63. Letter to Scheu, 1883, in *Collected Letters of William Morris*, Vol. II, Part I, 230.

64. Disreali introduced two bills that abolished imprisonment for breach of contract, excluded trade disputes from the law of conspiracy, and underwrote the right of peaceful picketing. This represented a parliamentary move that finally settled the trade unions' legal status. For a discussion of these developments, see James Hinton, *Labour and Socialism: A History of the British Labour Movement, 1867-1974* (Sussex: Wheatsheaf Books, 1983), 1-23.

65. Morris, "The Prospects of Architecture in Civilization," 139.

66. Morris, "Art Under Plutocracy," in *CW*, Vol. XXIII, 188.

67. This is essentially Thompson's argument, though he is fully aware that Morris's position after 1890 changed dramatically, to the point where he somewhat grudgingly saw the importance of multiple strategies (e. g., trade union activities, parliamentary politics). See *William Morris: Romantic to Revolutionary*, 331-639, for a lengthy discussion of these issues.

68. Letter to Thomas Coglan Horsfall, February 1881, in *Collected Letters of William Morris*, Vol. II, Part I,16.

69. Letter to Thomas Coglan Horsfall,17.

70. Morris, "The True Lesson of Picture Shows," delivered in Manchester, September 17, 1884, in British Museum Additional Manuscripts 45331, May Morris Bequest, 189.

71. Morris, "The True Lesson of Picture Shows," 188-189.

72. Through references and claims in Morris's writings, Thompson has argued that he became a socialist in 1882. See *William Morris: Romantic to Revolutionary*, 268, 306-307. Thompson is primarily referring to the comment to Horsfall concerning his lectures in *Hopes and Fears of Art* we quoted earlier in the chapter. As I have shown, there is ample evidence (let alone the very statements he made in that letter) to argue that his conscious socialist perspective may have developed earlier.

73. This is how Morris refers to his activity beginning in 1883. See "How I Became a Socialist."

Chapter Six

The Political Theory of William Morris: Revolutionary Socialism, Utopian Practicalities, and the Beauty of Life

> The art of Modern Europe, whose roots lie in the remotest past, undiscoverable by any research, is doomed, and is passing away; that is serious, nay an awful thought; nor do I wonder that all artists, even the most thoughtful, refuse to face the fact. I cannot conceive of anyone who loves beauty, that is to say, the crown of a full and noble life, being able to face it, unless he has full faith in the religion of Socialism.
>
> —Morris, 1884[1]

As Morris explained to Scheu, by 1882 he was ready "to join any body who distinctly called themselves Socialists."[2] Upon the invitation of H. M. Hyndman, Morris joined the Democratic Federation in January 1883, quickly becoming a member of the executive committee (as Treasurer), and thereupon embarking on a very active career as one of England's most famous socialists during the period of ideological and political development known as "the revival of socialism."[3] From this point onward, Morris "preached" socialism as an ideal to middle class and working class audiences throughout England and Scotland until his death in 1896. While the preparation for this activism lay within his aesthetic practices and discourses, Morris now came into contact with ideas and texts that supplied him with more theoretical substance in socialist doctrine, allowing him to broaden and strengthen his already burgeoning political stance. Morris read Mill's posthumously published chapters on socialism in 1882 (which were, as Morris noted, a critique of "Socialism in its Fourierist guise," the ironic consequence being that Mill's writings put "the finishing touch to my conversion to Socialism").[4] Still, Morris had not read any other important economic texts. In March 1883, Morris read a French translation of Volume One of Marx's *Capital* which began his theoretical journey into "scientific" socialism. As Morris noted about his theoretical education at this time:

> Well, having joined a Socialist body (for the Federation soon became definitely Socialist), I put some conscience into trying to learn the economical side of Socialism, and even tackled Marx, though I must confess that, whereas I thor-

oughly enjoyed the historical part of *Capital*, I suffered agonies of confusion of the brain over reading the pure economics of that great work. Anyhow, I read what I could, and will hope that some information stuck to me from my reading; but more, I must think, from continuous conversation with such friends as Bax and Hyndman and Scheu, and the brisk course of propaganda meetings which were going on at the time, and in which I took my share. Such finish to what of education in practical Socialism as I am capable of I received afterwards from some of my Anarchist friends, from whom I learned, quite against their intention, that Anarchism was impossible, much as I learned from Mill against *his* intention that Socialism was necessary.[5]

While initiated within the conceptual journey of his aesthetic theory, Morris's conversion to "practical Socialism" was consummated by the socialist literature he began reading, as well as through the discussions and experiences he had within the movement itself.[6] Once he devoted himself to the task of spreading the ideal of socialism, Morris pursued it with the earnestness he had shown in his previous ventures. This included not only learning more about the ideals and hopes of socialism, but also intense propaganda work, delivering lectures to various audiences and preaching on street corners.

The character of Morris's political theory has been an exceedingly contested issue. In general, we can locate at least two important arenas of disagreement. First, there is the area of contention related to the relative importance and significance of Morris's differing activities as an artist and socialist, with commentators generally seeing these two activities as being incompatible. Where they differ is in the characterization of which activity truly defines Morris's greatness. Initially, beginning with Mackail's biography, commentators recognized Morris's turn to socialism (a fact that obviously could not be avoided), but saw the latter as a degradation or turning away from his true calling. Thus, we find Mackail noting that one of the "disturbing forces" in Morris's life related to the "patient revenge of the modern or scientific spirit, so long fought against, first by his aristocratic, and then by his artistic instincts, when it took hold of him against his will and made him a dogmatic socialist."[7] Leaving aside for the moment his characterization of Morris's socialism as "dogmatic," what is important is that there is assumed an unbridgeable gap between the "idle singer of an empty day" and the fiery revolutionary socialist of the 1880s. With Morris's turning away from the day-to-day currents of the socialist movement in 1890 (after the loss of the Socialist League to the Anarchists), and his immersion into more aesthetic pursuits associated with the Kelmscott Press and prose romances after that date—the latter included the seemingly apolitical fantasies *The Wood Beyond the World*, *The Well at the World's End*, *The Water of the Wondrous Isles*, and *The Sundering Flood*—commentators like Mackail saw a welcome return from the trenches of ideological dogmatism to Morris's aesthetic calling.[8] This Manichean characterization of Morris was reinforced in the process of rectifying these earlier commentators' denial of the importance of Morris's socialist activism, and can be seen most clearly in the work of Paul Meier.[9]

Chapter Six

The second area of contention has to do with how one is to characterize Morris's socialism: is it "dogmatic," "utopian," or "Marxist"? Mackail's assertion of Morris's "dogmatic" socialism was a prevalent interpretation from admirers and friends who had felt dismay over Morris's turn toward socialism. Obviously coming from a more "conservative" position, and thus seeing any commitment to socialist principles as "dogmatic," such a response ignores how dialectical and subtle Morris's socialist theory actually was, especially when compared to the mechanistic rigidities of other socialists during this time.[10]

Other commentators have seen Morris's socialism as "utopian," orientated toward the portrayal of the future society without regard to the practical dimensions of its attainment. This appellation initially was concomitant with a denial of Morris's Marxist leanings in his political theory, and represented what R. Page Arnot has called one of the central "Morris-Myths."[11] More recently, this interpretation has been expounded by Stanley Pierson when he notes how "Morris, working out of a romantic tradition, reverted to the utopianism from which Marx believed he had rescued Socialists."[12] In this, Pierson is undoubtedly attempting to articulate the connection between Morris's aesthetic heritage and his socialist theory, and, in the process, elucidating the uniqueness of Morris's socialism. Yet, in so doing, he has, as Thompson has argued, unwittingly set up a reductionist distinction between Romanticism (as an idealist "utopianism") and Marxism.[13]

Starting with Arnot's pathbreaking study published in 1934, there has been the important attempt by scholars to show the Marxist roots of Morris's socialism.[14] Instrumental in this reinterpretation has been the recent work of both Thompson and Meier, both of whom have provided a much needed rectification of earlier interpretations of Morris's political theory, conclusively showing the centrality of Marx's ideas to Morris's thinking upon his entering the socialist movement in the 1880s.[15] Yet, in their zeal to bring Morris within the tradition of Marxism, both theorists have in differing degrees overly stated the discursive break between Morris's aesthetic understandings and his socialism, with Meier going so far as to claim that most, if not all, of the "Marxian" reflections in Morris's theory could not have come about through his own aesthetic reflections, but only through knowledge of Marx's unpublished writings.[16]

This chapter will make two closely related arguments. First, that Morris's socialism, while drawing upon different sources than his earlier writings, is still clearly informed by these insights, and is thus still linked to his aesthetic discourses and theory. What has confused commentators in this respect is that from 1883, Morris began to express his political theory in two types of writing: those that referred to aesthetic issues, and those that dealt with more clearly political topics. Indeed, while previously his political thinking lay within the general confines of his thinking on art, it now assumed the distinct form of a *political* discourse. That is, while previously Morris's aesthetic theory *was* his political theory, he now devoted his theoretical energies to essays discussing socialist theory and socialist tactics, referring to intellectual traditions that were part of the political theories at the time (for example, the thought of Owen, Fourier and

Marx), and dealing with issues and events that were related to his political activity as a socialist. Indeed, if his activity within Anti-Scrape forced him to put to paper his ideas on art, his socialist practice engendered a theoretical outpouring in political reflections. Aside from his first lectures written after joining the DF, and the poetry and prose romances he wrote for the cause (all of which were intimately related to glorifying the existing socialist movement and/or its ideal),[17] Morris now differentiated his writing into those which were on political topics and those which were on questions of art. The latter writings were directed primarily towards middle-class audiences, who were the recipients of almost all of his previous lectures on art. Yet, this did not mean that the lectures on art he did write ignored his political cause; indeed, they always drew the connection between the possible life of art and socialism, in so doing providing an important rhetorical way in which to persuade middle-class art lovers of the necessity of the socialist cause. Unlike other socialist activists, Morris always felt the importance of propaganda directed towards the middle class, and, given his reputation with respect to the middle-class pursuits of fine decorative arts and literature, he seemed the perfect person to promote such an endeavor.[18]

Nor, were his political writings completely devoid of discussions of art. As if to pay homage to his earlier aesthetic education and continued aesthetic interests, Morris many times discussed art in the context of his portrayal of socialist society. Yet, art no longer represented the primary discursive terrain for his elaboration of politics; rather, aesthetic issues now were an adjunct to larger social and political ideals, notions which themselves had germinated, *arte magistra*. Moreover, if there now seemed to be a division of theoretical labor in his discussions of art and politics, his discussion of political ideals were articulated within the very aesthetic and literary discourses that he had nurtured over the years. This can be seen in the socialist prose romances and poetry he wrote while in the movement, the most famous being his socialist utopia, *News From Nowhere* (1890).

What this signifies, and which will be the second argument of this chapter, is that Morris's main contribution to socialism lay in what he had called the "constructive" nature of his thought that imaginatively portrayed a future socialist society. While this means that Morris's socialism was "utopian" in the sense of being orientated toward rendering a picture of future society, such a vision was not rendered with ignorance of the historical and practical dimensions of its realization. Indeed, Morris's socialism was clearly elaborated with the intention of creating the possibility for political action, or, to put it in the words Morris used, his theory was intimately related to a "yearning for action."[19] Moreover, the "utopian" quality of Morris's theory was explicitly premised upon his analysis of what was necessary for the development of socialism as a political movement. To emphasize the "constructive" aspect of Morris's socialism does not a priori exclude the importance of Marx's ideas within Morris's socialism. Marx's ideas were instrumental in forming central notions in Morris's thought, but not in the ways that previous commentators have suggested. Marx's ideas were not necessarily integrated on the level of theory per se

(which previous attempts at construing Morris's socialism have assumed), but were appropriated in a pragmatic way for rendering the political world meaningful, and for engendering political action.

Art and Socialism: Morris's Initial Characterizations of Socialist Ideals and Tactics

The first three lectures he delivered after joining the Federation were all on art—"Art, Wealth and Riches," "Art Under Plutocracy," and "Art and the People: A Socialist's Protest against Capitalist Brutality; Addressed to the Working Classes." Of particular interest are the latter two lectures. In "Art Under Plutocracy" (1883), Morris provides a concise statement of his aesthetic ideas, while also publicly declaring himself to be a socialist for the first time. "Art and the People" (1883) was Morris's first lecture to a working class audience. In it, Morris attempted to show the importance of the ideal of art (which he explicitly labels, "Art of the People") for the working class. Both of these lectures are seminal to Morris's political development, representing an intermediary discursive surface—at once a closure and an opening—between his aesthetic theory of the previous five years, and the socialist theory he developed in the last years of his life. While "Art and the People" is important in its rendering of the significance of art for the immediate concerns of the working class audience to which it was directed, signaling his heartfelt intent to engage with the working class, it does not break any new substantive ground. It is in "Art Under Plutocracy" that Morris first presents his political conception of socialism, and the tactics he thought were necessary for its realization.

Delivered in November of 1883, in the hall of University College at his alma mater, with his mentor John Ruskin sitting in the chair, "Art Under Plutocracy" announces Morris's conversion to "practical Socialism." The irony of the situation is interesting: the lecture was delivered in the very institution which he felt had given him an education in spite of itself—"I took very ill to the studies of the place,"[20] he claimed to Scheu—with the piercing eyes of Ruskin upon him, who had been "the first comer, the inventor"[21] of his particular emphasis in aesthetic theory. Morris was confronting the past with one bold sweep. The ideas that Morris developed concerning the state of art are not new, but they are condensed into a single text: art is not flourishing, and its decay can be seen in the clear distinction between the "Intellectual" and "Decorative" arts. While there has always been a distinction between the two in the history of art—the former serves our "mental needs," while the latter is involved in the "service of the body"[22]—they were, "when art flourished most," mutually inclusive practices and discourses, to such an extent that "the best artist was a workman still, the humblest workman was an artist."[23] Morris then reaffirms the claim from his earlier lectures that this bifurcation has created a class system in aesthetic terms—a few artists, and a mass of people totally ignorant of art. Yet, instead of rendering the redemption of art in terms of its very life—a circular move we previously noted, and one related to Morris's earlier self-conception as a poet

and an aesthetic reformer—Morris now conceives of its future hope in the spread of "the religion of socialism."

While in his earlier lectures Morris had described the social conditions that underlie this withering of popular art in terms of the division of labor, he now identifies the particular characteristic of the social system as "competition in the production and exchange [of] the means of life."[24] What Morris wishes the audience to realize, though, is that this system is not immutable. Instead, it is one stage in the dialectical movement of history, one that extends from the chattel slavery of Ancient times to the "system of so-called free contract now existing."[25] "That all things since the beginning of the world have been tending to the development of this system," Morris continued,

> I willingly admit, since it exists; that all the events of history have taken place for the purpose of making it eternal, the very evolution of those events forbids me to believe.
>
> For I am 'one of the people called Socialists'; therefore I am certain that evolution in the economical conditions will go on, whatever shadowy barriers may be drawn across its path by men whose apparent self-interest binds them, consciously or unconsciously, to the present, and who are therefore hopeless for the future. . . .I think that the change from the undeveloped competition of the Middle Ages, trammeled as it was by the personal relations of feudality, and the attempts at associations of the gild-craftsmen into the full-blown *laissez-faire* competition of the nineteenth century, is bringing to birth out of its own anarchy, and by the very means by which it seeks to perpetuate that anarchy, a spirit of association founded on that antagonism, which has produced all former changes in the condition of men, and which will one day abolish all classes and take definite and practical form, and substitute association for competition in all that relates to the production and exchange of the means of life. I further believe that as that change will be beneficent in many ways, so especially will it give an opportunity for the new birth of art . . .[26]

At the end of the lecture Morris makes a plea to those who share his concern for the life of art to "help us [the Federation] actively with your time and your talents if you can, but if not, at least with your money."[27] The lecture clearly shows that Morris read history as the progressive liberation of mankind, from the "personal relations of feudality" to the extreme development of "competition" to that of "association." Now engaged in the practical struggle for socialism, Morris saw hope for the future of mankind in history's inevitable movement toward socialism.

While Morris's lecture ostensibly focussed upon the question of art, it is clear that he made the development of "association" in the "means of life" the primary issue of his lecture, the happy consequence being that it also will revive the aesthetic sense. Moreover, the key elements of Morris's socialist theory are formulated in terms of a characterization of the present system of "competition" and the goal of "association." As Thompson has noted, Morris's preoccupation in these lectures was with the dialectic of "discontent" with the present conditions and their effect on human life and "hope" of the transformation of these

conditions into socialism.[28] This is reflected in the titles of some his most important lectures in 1884: "Useful Work versus Useless Toil"; "Misery and the Way Out"; and "How We live and How We Might Live." In all of these lectures, Morris begins by attacking the complacency of Whig common sense about present conditions of life, clarifying the exploitation and dehumanization that are constitutive of competitive commerce or capitalism, and then providing a sense of how socialism represents the overcoming of these particular evils.

If "Art Under Plutocracy" is important in that it represents Morris's first attempt at developing a political narrative of socialism, it is also important for the elaboration in nascent form of the direction Morris's thinking will take in terms of socialist strategy. What is interesting is Morris's articulation of the necessary tactics artists and other lovers of art should take under these circumstances. Given the loss of the popular aesthetic sense, "artists are obliged to express themselves, as it were, in a language not [understood by] the people."[29] While this situation may call for an attempt to move one's aesthetic practices and discourses closer to the "ignorant" populace, Morris thinks that this type of translation can only do a disservice to the "cause of art":

> If they were to try, as some think they should, to meet the public half-way and work in such a manner as to satisfy at any cost those vague prepossessions of men ignorant of art, they would be casting aside their special gifts, they would be traitors to the cause of art, which it is their duty and glory to serve. They have no choice save to do their own personal individual work unhelped by the present, stimulated by the past, but shamed by it, and even in a way hampered by it; they must stand apart as possessors of some sacred mystery which, whatever happens, they must at least do their best to guard. It is not to be doubted that both their own lives and their works are informed by this isolation. But the loss of the people; how are we to measure that?[30]

What is readily apparent in this statement is an argument for aesthetic autonomy and purism, one that clearly shows the influence of the aestheticist beliefs: the goals of art are such that there should not be any attempt to water down one's aesthetic practices just to be closer to the unknowing masses. As with later neo-Marxist theories on art, Morris is implying that art's transformative quality—rectifying the "loss of the people"—lies precisely in its elitist stance from the very people it will help.[31] This is for Morris necessary in a period in which art is dead—"unhelped by the present"—for it at least allows for the continuation of the ideals of the past for the future. As Morris noted to a correspondent in 1882:

> we must do our best to keep everything alive that contrasts with the squalor you speak of; those who in any way engage in creating beauty of any sort, must understand that their occupation is no longer a frivolous one, but most serious: those who have any responsibility as regards relics of the times of art must remember that they are the guardians not merely of a public building, so much Stones and Mortar and Timber, but that they hold in their power the very seeds of Civilization to come.[32]

For Morris, then, all attempts at making an art for the masses under present conditions would only add insult to injury, mystifying the fact that a true art of the people must "*strike at the root.*" That is, it would substitute an art *for* the people, based upon social conditions that denied them a human life, for an art *of* the people that would arise from the rebirth of their life under radically transformed conditions. It is because Morris insists that art is either alive or dead, helped or hindered by social conditions, that he could see no middle ground for reforms within the present society. "Palliation is no use when evils are great." He declared, "Educate your workmen into general discontent; that is the only remedy."

This aesthetic purism parallels Morris's supposed "sectarian" stance when it came to socialist strategy. As with his feeling about those few who can produce art, those who have the knowledge of socialism must do no more than try to educate the people as to the ideals and possibility of socialism. If one were to attempt to translate socialism into pragmatic and palliative measures (trade union activity, parliamentary action, etc.), the ideal itself would be mystified and rendered obsolete, losing the clear utopian and transformative quality of the doctrine. While eschewing reformist measures creates an initial isolationism, Morris seems to be saying, it will ultimately be more beneficial in creating a more humane life in the future by ensuring the sanctity of ideals upon which a new social order can arise.

In arguing for this purism of doctrine, Morris is not claiming that socialists know the best means for reaching that goal; on the contrary, they should have no preconceived doctrine on that issue. Their only strength lies in their utopian vision. As Morris argued years later in the pages of *Commonweal* in response to the different tactics proposed by parliamentary factions and the anarchists:

> Our business, I repeat, is the making of Socialists, i.e., convincing people that Socialism is good for them and is possible. When we have enough people of that way of thinking, *they* will find out what action is necessary for putting their principles in practice. Until we have that mass of opinion, action for a general change that will benefit the whole people is *impossible*. Have we that body of opinion or anything like it? Surely not. If we look outside that glamour, that charmed atmosphere of party warfare in which we necessarily move, we shall see this clearly: that though there are a great many who believe it possible to compel their masters by some means or another to behave better to them . . . all but a very small minority are not prepared *to do without masters*. When they are so prepared, then Socialism will be realized; but nothing can push it on a day in advance of that time.
>
> Therefore, I say, make Socialists. We Socialists can do nothing else that is useful, and preaching and teaching is not out of date for that purpose; but rather for those who, like myself, do not believe in State Socialism, it is the only rational means of attaining to the New Order of Things.[33]

As Thompson has noted, this purist strategy, which Morris had called a "policy of abstention,"[34] would ensure that Morris would never receive the real

practical benefits derived from supporting more reformist measures, in particular, increased membership in his socialist organization not to mention wider political influence among working class reformers.[35] This did not mean that Morris did not come to terms with the importance of these political developments at the end of his life. He notes in a lecture in 1894 that parliamentary politics may be "the shortest or perhaps the only road to the change which we can follow," with the proviso that one must be clear that such political action is to "be looked on as the means and not the end of the struggle."[36] This is undoubtedly a grudging response to the increasingly prevalent practice of sending independent Labour candidates to Parliament since 1888, a practice spearheaded by the candidacy of Keir Hardie in 1888, which eventually lead to the formation of the Independent Labour Party in the 1890s.[37]

Nevertheless, even during his purist days, Morris never completely denounced parliamentary methods. He recognized the necessity for a diverse strategy in the socialist movement. Morris left the Democratic Federation in 1885 not only in reaction to the dictatorial methods employed by Hyndman, but also because of his disapproval of the parliamentary overtures by Hyndman and his supporters. With Edward Aveling, Eleanor Marx-Aveling, Joseph Lane, Belfort Bax, John Mahon and others, Morris set up the Socialist League to promote "complete Revolutionary Socialism," in which the main purpose was to do "all in its power towards the education of the people in the principles of this great cause."[38] In 1887, when branches of the Socialist League began to clamor for accepting the strategy of parliamentary action (in the form of the "Croyden Resolution"), Morris argued against such tactics, threatening to leave the League if they were passed. While Morris won this struggle, he lost the support of those in the growing parliamentary faction, a loss that set the stage for the dominance of the Anarchist wing.[39] In the process of this conflict over the "Croyden Resolution," Morris wrote to John Glasse clarifying his position:

> I believe that the Socialists will certainly send members to Parliament when they are strong enough to do so: in itself I see no harm in that, so long as it is understood that they go there as rebels, and not as members of the governing body prepared by passing palliative measures to keep 'Society' alive. . .; and I think it will be necessary to keep alive a body of Socialists of principle who will refuse responsibility for the action of the parliamentary portion of party. Such a body now exists in the shape of the League, [and] while germs of the parliamentary side exist in the S. D. F., Fabian, & Union. Now why should we try to confound the policy of these bodies?[40]

As we can see from this passage, Morris felt the necessity of keeping a purist stance in relation to other tactical positions within the socialist movement in general. In this way, Morris was not necessarily elaborating a restrictive strategic position, but only clarifying what he felt was the necessary division of labor that could ensure the overall success of the socialist movement. What this claim then raises is the necessity of looking at the wider context of the socialist movement in order to clarify the meaning of Morris's own position.

Morris and "The Revival of Socialism": Historical Precedents and New Directions in the 1880s

As already intimated, Morris's comments concerning socialist ideals and strategy were not elaborated within a political vacuum, but were polemical engagements with other socialists. Morris's brand of revolutionary socialism represented only one important current within the overall political developments that have been termed by historians the "revival of socialism." While coming to his own socialist conclusions through the prism of aesthetic discourses, Morris quickly linked up with the two hundred individuals who were fervently revitalizing the tradition of socialism within England in the early 1880s. Their backgrounds could not have been more dissimilar—as Morris noted, they were a "little band of oddities" made up of intellectuals, working class activists, foreign émigrés, and artists[41]—yet their perseverance in pushing the ideal of socialism began to engender not only recognition from the general public, but also active political participation from more and more individuals (especially of the working classes) who were experiencing the pains of the present economic order.

As M. Beer has argued, the history of socialism in Britain is a long and interesting one, its seeds planted during the Middle Ages in the thought and actions of John Wycliffe and John Ball (the latter would be the inspiration behind one of Morris's more famous socialist prose pieces, *A Dream of John Ball*), coming to its first clear fruition in Sir Thomas More's *Utopia*.[42] Morris had noted in 1885 the importance of More during that period of "young commercialism," arguing that he represented a lone beacon of the "prophetic hopes of times yet to come when that commercialism itself should have given place to the society which we hope will be the next transform[ation] of civilization into something else: into a new social life."[43]

With the continued growth of capitalism, the next outgrowth of socialist thought can be found in tracts and ideas of the Levellers during the seventeenth century, especially those associated with the Digger movement, who Morris claimed were the "pioneers of Socialism in that day."[44] This latter movement, though small and short-lived, proclaimed that the earth and the fruits produced thereof were given to men in common, and their enclosure into the private hands of the nobility and gentry "was tantamount to the impoverishment and enslavement of his fellow-men."[45] The purpose of the movement, as noted in a famous Digger tract, was "to lay the foundation of making the earth a common treasury for all, rich and poor, that everyone that is born in the land may be fed by the earth his mother that brought him forth, according to the Reason that rules in the Creation."[46]

Between 1760 and 1825, English socialist thought took a number of different forms and characteristics. Yet, while there was a variety of different perspectives on the crisis confronting the working people, as well as a number of different proposed remedies, they all drew sustenance from the natural rights theory of John Locke as expounded in the *Second Treatise on Government*.[47]

Chapter Six

With the turn of the nineteenth century, English socialist thought took two important directions: one was closely related to the thought and actions of Robert Owen, while the other grew out of the mounting Chartist movement. Owen premised his political theory on the Benthamite idea that happiness was the goal and object of human society, and claimed that this goal can only be attained through the creation of the right social conditions. Such right conditions must include the abundance of wealth, given that poverty is one of the leading causes of misery. Ultimately, Owen fought for the implementation of Factory Legislation and unemployment relief (a propaganda effort that helped to bring about the Factory Acts of 1819), and later, when convinced that evil conditions were intrinsic to an economic system based on private property, to establishing "Villages of Unity and Co-operation" that would create wealth for all of its members while uniting them in brotherhood and fellowship.[48] Owen's followers set up the London Co-operative Society in 1824, an organization which explicitly proposed to set up "a community on the principles of mutual co-operation" while also returning the fruits of labor to the laborer.[49] Moreover, it was in the pages of *The Co-operative Magazine*, the main organ for the orthodox Owenite movement, that the term "socialist" first appeared to describe those who subscribed to common ownership of property.[50] It should be noted that Owenite socialism was one of the only active forms of socialist thought between the end of the Chartist agitations and the 1880s.

In his lecture, "The Hopes of Civilization" (1885), Morris comments upon the importance of Owen's ideas in keeping the ideals of a better life alive. Yet, for Morris at least, Owen's ideal of "brotherhood and co-operation" could not go far given that it wished to establish such communities within an overall system of exploitation and political privilege. "The Socialism of Robert Owen," Morris argued, "fell short of its object because it did not understand that, as long as there is a privileged class in possession of executive power, they will take good care that their economical position, which enables them to live on the unpaid labour of the people, is not tampered with. . ."[51] Moreover, as Morris noted in 1886, while Owenite communities are "founded on absolute conditions of equality as amongst themselves," they "do not pretend to meddle with society at large," and are thus "destined. . .to failure and extinction after having played their part of experiment of association more or less valuable."[52] For Morris, one had to strike at the root of society, completely transform economic and political conditions in order for there to be the possibility of a new human life.

Later in "The Hopes of Civilization," Morris observes that while the Chartist Movement "was thoroughly a working-class movement," and was fundamentally more progressive than Radicalism because of this class character, still, "its aim was after all political rather than social."[53] Thus, while Owen had erred for Morris because he overlooked the importance of ruling class political power and the necessity of revolutionary change, the Chartists overlooked

> that true political freedom is impossible to people who are economically enslaved: there is no first and second in these matters, the two must go hand in

hand together: we cannot live as we will, and as we should, as long as we allow people to *govern* us whose interest it is that we should live as *they* will, and by no means as we should; neither is it any use claiming the right to manage our own business unless we are prepared to have some business of our own: these two aims united mean the furthering of the class struggle till all classes are abolished—the divorce of one from the other is fatal to any hope of social advancement.[54]

The history of the Chartist movement has been discussed and interpreted by many commentators, and there is thus no need to go over the particular historical events and intellectual ideas associated with its development.[55] What is important for our purposes here is that Morris expressed what seems to have been a widely held view amongst revolutionary socialists in the 1880s that Chartism was ultimately a political movement that wished to keep intact the social arrangements of society, and in this respect it was not comparable to the ideological advancement of the socialists in the 1880s. As Morris further noted in this same lecture:

Chartism, therefore, though a genuine popular movement, was incomplete in its aims and knowledge; the time was not yet come and it could not triumph openly; but it would be a mistake to say that it failed utterly: at least it kept alive the holy flame of discontent; it made it possible for us to attain to the political goal of democracy, and thereby to advance the cause of the people . . .[56]

As Morris's comments indicate, Chartism seemed to later Socialists an important yet infantile form of socialism, one that ultimately failed due to its limited "aims and knowledge." What is most interesting is that this view shows the extent to which the period between 1850 and 1880 had wiped away aspects of the Chartist tradition for later socialists; for it is clear that many Chartists believed that political reforms were only the first stage of a complete social transformation in which laborers would be able to gain the fruits of their industry. Moreover, in later years a few of the more prominent Chartists like Ernest Jones and G. Julian Harney became explicitly socialist in their ideas, seeing the necessity of both political and social transformation, or, as Harney put it in *The Red Republican*, "The Charter and Something More."[57] It was also in Harney's journal that there appeared the first English translation of *The Communist Manifesto* by Marx and Engels, a consequence of Harney's relationship to Marx since 1847.[58] Even with these historical precedents, socialists in the 1880s felt they were starting afresh on more sure theoretical ground, and, bolstered by the spread of the ideas of Marx, they now felt they had a vantage point unknown to previous English socialists.

Thus, one factor that did distinguish the "revival of socialism" in the 1880s was the importance of European ideas and theories, in particular those of Marx.[59] Most of the individuals associated with the first group of socialists in the 1880s were well-versed in Marx's theory, and a few of them had had direct contacts with Marx before his death, as well as a continuing relationship with

Engels.⁶⁰ What Marx's theory brought to the English Socialist tradition was a more elaborate and "scientific" analysis of the exploitative conditions of capitalist production, as well as the "uncovering" of the laws of economic development that pointed toward the inevitable transformation toward socialism. In one of his many references in his socialist lectures to Marx, Morris identifies this latter aspect as the most important feature of Marx's thought:

> To Germany we owe the school of economists, at whose head stands the name of Karl Marx, who have made modern Socialism what it is: the earlier Socialist writers and preachers based their hopes on man being taught to see the desirableness of cooperation taking the place of competition, and adopting the change voluntarily and consciously, and they trusted to schemes more or less artificial being tried and accepted, although such schemes were necessarily constructed out of the materials which capitalistic society offered: but the new school, starting with an historical view of what had been, and seeing that a law of evolution swayed all events in it, was able to point out to us that the evolution was still going on, and that, whether Socialism be desirable or not, it is at least inevitable.⁶¹

Morris had already gained from his thinking on art the realization that his ideals could only come about through a complete transformation of social conditions; he had also recognized that capitalism was made up of two classes, whose interests were mutually exclusive. Through his appropriation of Ruskin's labor theory of art and his own excavations of the history of art, Morris had also come to the conclusion that labor was the creator of all worth and value. What Marx's theory did was to strengthen these insights, and provide detailed economic and historical reasons for these earlier conclusions. In this way, Marx helped to deepen his political stance, not supplant it. But, one important ingredient that Marx added to Morris's conception of socialism was that his ideal was "at least inevitable." Marx had shown Morris that "a law of evolution swayed all events," and that it was already preparing present social and economic conditions for the transition toward a classless society. In a lecture entitled, "Socialism" (1885), Morris was clear about this historical determinism: "We Socialists . . . believe that we know why these classes exist and how they have grown into what they are, a growth inevitable indeed, but so far from being eternal that it will itself destroy itself and give place to something else, a society in which there will be no rich and no poor."⁶² Moreover, because of these evolutionary processes socialists can now become more useful than previously. "[A] little band of people preaching certain utopian doctrines," Morris argued,

> cannot bring about such a stupendous revolution as this. Well, no set of people knows that better than Socialists: at no time can a part of existing society change the basis of that society unhelped by those of past ages: but we Socialists claim that the progress of mankind has really been steadily in this direction, and that all we have to do is to help in developing the obvious and conscious outcome of this progress . . .⁶³

Morris was not alone in this assumption concerning the inevitable movement of history toward socialism; this, at times apocalyptic, sense of coming transformation pervaded the thought of the first socialists in the early 1880s, and was a direct consequence of their reading and discussing of Marx's economic theory.[64] But, unlike socialist cohorts with a less trained imaginative faculty, this assumption not only inflamed Morris's political activism, but also set his aesthetic sights toward envisioning the contours of a future society. What is important to reiterate here is that Morris's attachment to socialism as an ideal came through his analysis of art, and it was then that he began to clarify his position with Marx's and other socialist's characterization of capitalism. In a lecture entitled, "How Shall We Live Then?" (1889), Morris again returns to characterizing his development as a socialist, noting how his thinking as an artist began his movement toward socialism. "My Socialism began where that of some others ended," Morris continued,

> with an intense desire for complete equality of condition for all men; for I saw and am still seeing that without equality, whatever else the human race might gain it would at all events have to relinquish art and imaginative literature, and that to my temperament did and does imply the real death of mankind—the second death. Of course with the longing for equality went the perception of the necessity of the abolition of private property; so that I became a communist before I knew anything about the history of Socialism or its immediate aims. And I had to set to work to read books decidedly distasteful to me . . . and get myself into absurd messes and quarrel like a schoolboy with people I liked in order to become a practical Socialist—which rank I have no doubt some of you don't think I have gained yet. But all that did not matter because I had once again fitted a hope to my work and could take more than all the old pleasure in it; my bitterness disappeared and—in short I was born again.[65]

What is clear from the above statement is that Morris's reading of Marx (and other works that were "decidedly distasteful") allowed him to become a "practical Socialist," in the process engendering "hope" for the realization of his "intense desire for complete equality of condition for all men." In this way, Marx allowed Morris a way to continue his artistic work (which he thought was hopeless in the grinding teeth of capitalism), and provided a meaningful interpretation of the social world for political action. What is also important to note is Morris's aside that his claim about becoming a *practical* socialist may not have been agreed to by his audience. Morris first delivered this lecture to the Fabian Society, whose members were decidedly orientated towards bringing about socialism through parliamentary action, and through securing control of local communities. Some socialists had thus applied the term "municipal socialism" to Fabianism. Morris had disparagingly referred to it as "Gas and Water Socialism."[66] Ultimately, the Fabians thought the state would become the means through which to reform society toward socialism.[67] Morris realized that his revolutionary socialist position seemed impractical to those who wished to work within the existing parliamentary and electoral arenas. If he disagreed about the

means the Fabians and other parliamentary factions promoted, he also felt the Fabian goal of "state socialism" to be equally distasteful, even if it were a probable stage in the coming transformation toward communism:

> I neither believe in State Socialism as desirable in itself, or, indeed, as a complete scheme do I think it possible. Nevertheless, some approach to it is sure to be tried, and to my mind this will precede any complete enlightenment on the new order of things. The success of Mr. Bellamy's Utopian book, deadly dull as it is, is a straw to show which way the wind blows. The general attention paid to our clever friends, the Fabian lecturers and pamphleteers, is not altogether due to their literary ability; people have really got their heads turned more or less in their direction.[68]

In the context of the debate over the ends and means of socialist struggle, Morris claimed that his position was eminently "practical." This may seem strange for one who labeled all parliamentary and trade union activity as "palliation," and who consistently put his mind to rendering the outlines of future communist society. To understand how this could be the case, we need to explore more fully Morris's socialist theory.

Morris's Constructive Socialism, I: Capitalist Degradation, Communism and Utopian Practicalities

As has been noted previously, the character of Morris's socialism has been much debated. One reason for this proliferation of interpretative perspectives has to do with the very "constructive" character of his thought. Orientated toward motivating political action, it was not necessarily analytically consistent nor systematic as a political discourse. Rather, propelled by a "profound discontent with the whole of modern life" gained through his confrontations as an artist,[69] which engendered an avid longing for equality of condition, Morris drew upon various sources to provide a form and structure to his political desires, in the process hoping to galvanize other people to his cause. Indeed, what underpinned Morris's socialism was a heartfelt moral outrage at the effects of capitalism on human life. In asking why people join the socialist movement at such an early stage, Morris queried:

> Is intellectual conviction deduced from the study of philosophy or from that of politics or economics in the abstract? I suppose that there are many people who think that this has been the means of their conversion; but on reflection they will surely find that this was only its second stage: the first stage must have been the observation that there is a great deal of suffering in the world that might be done away with.[70]

The moral outrage Morris had felt toward that "great deal of suffering in the world that might be done away with" surfaced in the way he characterized capitalism. He struck at the root of this system of production with the use of a highly

charged vocabulary: "makeshift," "useless toil," "misery," "plutocracy," "commercial war," "false society." Each of these appeared in the titles of lectures Morris gave as a socialist, and each of these terms contributed toward a unifying theme underlying his attacks upon the exploitation, degradation and dehumanization that capitalism engendered not only for the working class, but for artists as well. It is this incisive quality of his thought to which G. B. Shaw referred, observing that:

> He was on the side of Karl Marx *contra mundum*, but he had none of the intellectual pretentiousness and pride of education that made Lassalle boast of being equipped with all the culture of his age, and Marx elaborated a patent philosophic dialectic and an economic theory of bourgeois exploitation and surplus value . . . Going straight to the root of communism he held that people who do not do their fair share of social work are 'damned thieves,' and that neither a stable society, a happy life, nor a healthy art can come from honoring such thieving as a mainspring of industrial society. To him the notion that a British workman cannot arrive at this simple fundamental conclusion except through the strait gate of the Marxian dialectic, or that the dialectic can be anything to such a one but a most superfluous botheration, was folly.[71]

While Shaw's characterization of the importance of Marx for Morris may seem contradictory, it is, in part, a reflection of Shaw's distaste for Marx's economic theory.[72]

When Morris characterized the evils of capitalism in his pre-socialist writings he primarily focussed upon those factors that related to the destruction of art: the division of labor, and the "Mechanical Toil" associated with the prevalence of machinery in the factories. These factors destroyed the intelligence and creativity necessary for producing a living art. After 1883, while retaining these earlier critiques, Morris utilized socialist critiques that focussed upon the internal mechanisms of exploitation intrinsic to the capitalist system of production, namely, the appropriation of the worker's value in the form of capitalist profits, i.e., "surplus value."[73] In his lecture, "The Ends and the Means" (1886), Morris utilized the notion of "robbery" to signify this systemic quality of exploitation in which "the possessing or monopolizing class make it their business to live without producing [on the produce of the working class]."[74] Morris had already seen the importance of labor in human life through his study and practice of art: not only was it a necessary thing for humans to do (as Morris claimed, "the race of man must either labour or parish"),[75] but he also had noted that, if properly organized and practiced, it would be a "blessing, a lightening of life."[76] So, when he noted that there was a group of individuals who were living without laboring, it engendered outrage: ". . .Nature bids all men to work in order to live, and that command can only be evaded by a man or a class forcing others to work for it in its stead; and, as a matter of fact, it is the few that compel and the many that are compelled."[77]

For Morris, the capitalist class could compel others to work for that class's livelihood because of their monopoly of the means of production. As Morris explained in his lecture, "Socialism":

> the commercial period [has] resolved into two great classes, those who possess all the means of production save one, and those who possess nothing except that one, the *power of labour*. The first class the rich therefore can compel the latter, or the poor, to sell that power of labour to them on terms which ensure the continuance of the rich class.[78]

Moreover, such a situation of exploitation implied a fundamental antagonism of class interests, for "it is the object of the employing class to get as much as it can out of the privilege, the possession of the means of production, and all it makes can only be made at the expense of the workers. . .what one gains the other loses, there is therefore constant war between them."[79] Later in the same lecture, Morris briefly summarizes his argument about the exploitative nature of capitalism, one that he would in one form or another repeat many times throughout his lecturing career:

> Let me recapitulate before I go further: there are two classes, a useful and a useless class: the useless class is the upper, the useful the lower class: the one class having the monopoly of all the means of production except the power of labour can and does compel the other to work for its advantage so that no man of the workers receives more than a portion, the lesser portion too of the wealth he creates; nor will the upper class allow the lower to work on by other terms.[80]

We can see in the latter part of this statement that Morris has articulated in his own way the Marxian notion of surplus value, as well as the fact that this process of appropriating part of the wealth the worker creates is intrinsic to the system of production itself. In this, we can see the importance that Marx's ideas held for Morris: they provided reassurance of his revolutionary project by reaffirming the necessity of a complete transformation of social conditions in order to reach a better life. Indeed, Morris claimed that Marx's notions were only really theoretical articulations of the "facts" of economic life. In response to a correspondent's inquiry concerning the validity of Marx's notion of surplus value, Morris points out that making a theoretical case against it does not dismantle the project of socialism, for

> Socialism does not rest on the Marxian theory; many complete Socialists do not agree with him in this point; and of course disproving of a theory which professes to account for the facts, no more gets rid of the facts than the mediaeval theory of astronomy destroyed the sun. What people really want to know is why they cannot get at the raw material & instruments of labour without being taxed for the maintenance of a proprietary class; and why labour is so disorganized that all the inventions of modern times leave us rather worse off than before.[81]

What is interesting is that Morris's constructive socialism never sufficiently responds to the questions he raises; rather, his primary preoccupation is with establishing the "fact" of degradation, dehumanization, etc. For, while the former may provide us with a surer grounding theoretically, it is not necessary for motivating people to take political action to achieve a better life. For Morris, what is most important in order to bring people to socialism is the "observation that there is a great deal of suffering in the world that might be done away with." And, this is what he attempted to do in most of his lectures, i. e., provide a clarification of the "fact" of suffering along with a vivid portrayal of a future world.

When Morris attempted to articulate the principles of a future society he resolutely labeled himself a "Communist."[82] In the most concise fashion, this meant not only the necessity of transferring private ownership of the means of production to the community, but also of establishing *equality of condition*, or the "communization of the products of labour."[83] In relation to the other socialist positions Morris was contending with during the late 1880s (State Socialist, Social-Democratic, or Anarchist), this term took on an increasing polemical tinge. For Morris, the only viable goal was complete equality of condition; everything before that point, while possibly bringing about an alleviation of the worker's condition, was "merely a compromise with the present condition of society,"[84] and a dimming of the possibility of a truly better life. Thus, Morris's use of the term meant to signify not only a particular vision of socialism (which articulated a position concerning the broad outlines of a classless society, and the important values it would portray), but also the particular revolutionary means he saw were fundamentally necessary for its attainment. In terms of the latter, though, he in no way accepted the means proposed by the Anarchists:

> As to the attempt of a small minority to terrify a vast majority into accepting something which they do not understand, by spasmodic acts of violence, mostly involving the death or mutilation of non-combatants, I can call that nothing else than sheer madness.[85]

On the other hand, while he was less disagreeable to their means, he ultimately felt that any attempt at putting Socialist candidates in Parliament would only force concessions on their part, thereby helping to promote the very system they were supposedly there to change.[86] For Morris, the important task for "complete Socialists" or "communists" is "*to make socialists.*"[87] This meant undertaking the tasks of clarifying the exploitation of present capitalist society and of presenting a vision of a future society.

Morris's penchant for always straining his imaginative faculty toward the future—a characteristic most clearly seen in his lectures "The Society of the Future" (1887) and "How Shall We Live Then?" (1889), and which comes to its fruition in the literary utopia, *News From Nowhere* (1890)—was premised upon what he thought were "practical" considerations for two reasons: first, in terms of what means may be most successful in bringing about a complete transformation of human life, Morris was adamant about the important role of specula-

tion. "We need not be afraid of scaring our audiences with too brilliant pictures of the future of society," Morris argued,

> nor think ourselves unpractical and utopian for telling them the bare truth, that in destroying monopoly we shall destroy our present civilization. On the contrary, it is utopian to put forward a scheme of gradual logical reconstruction of society which is liable to be overturned at the first historical hitch it comes to; and if you tell your audiences that you are going to change so little that they will scarcely feel the change, whether you scare anyone or not, you will certainly not interest those who have nothing to hope for in the present society, and whom the hope of a change has attracted towards Socialism.[88]

Second, Morris felt that, with the splintering of the socialist movement along different tactical lines, the only way to ensure the continued viability of a unified movement was to continually keep within sight the goal for which all socialists strive. In his lecture, "How Shall We Live Then?," Morris notes that his "personal view of the Promised Land of Socialism" should not "be altogether a matter of controversy amongst Socialists."[89] Indeed, as Morris continues,

> to come sometimes out of the hedge of party formulas and show each other our real desires and hopes ought to be something of a safeguard against the danger of pedantry which besets the intellectual side of the Socialist movement and the danger of machine politics which besets its practical and work-a-day side.[90]

Morris's "utopian" side, then, was not just a reflection of his "Romantic" heritage; it was also based upon a consideration of the practical necessities of the socialist movement, and the best political action he thought one should take to reach the professed goal of socialists. In his most famous literary work, *News From Nowhere*, Morris found a literary genre whose formal convention is the rendering of a no place (u-topia)/good place (eu-topia). In this work, one finds all of the imaginative qualities that were somewhat constrained in his socialist lectures put to the use of actually rendering in tone, character, feeling, and beauty all of the principles he had previously expressed.[91] William Guest, a nineteenth-century socialist, wakes up 100 years later to a future society in which all are pleasantly engaged in their work for the community, in which the architectural monstrosities of the nineteenth century are now tokens of beauty, in which all individuals are now in pursuit of a *human* life. As he comes to know these people, and understand the reasons behind their fulfilling lives (which relate to the eradication of private property, and the institution of "pure communism"), he finds that he cannot stay there. As the novel ends, the protagonist begins to disappear from this new world, slipping back to his own troubled time. In this, Morris seems to be clearly recognizing that while this vision may not be attainable in his own time, it is important to keep in mind for the hard road of struggle ahead. As William Guest leaves, he hears his new friends say:

> Go back again, now you have seen us, and you outward eyes have learned that in spite of all the infallible maxims of your day there is yet a time of rest in store for the world, when mastery has changed into fellowship—but not before. Go back again, then, and while you live you will see all around you people engaged in making others live lives which are not their own, while they themselves care nothing for their own real lives—men who hate life though they fear death. Go back and be happier for having seen us, for having added a little hope to your struggle. Go on living while you may, striving, with whatsoever pain and labour needs be, to build up little by little the new day of fellowship, and rest, and happiness.[92]

Morris's Constructive Socialism, II: Art, Pleasure and Natural Beauty

Closing a self-reflection on his political development published toward the end of his life, Morris explicitly returned to the importance of the ideal of art for a socialist future:

> We want by means of Social Democracy to win a decent livelihood, we want in some sort to live, and that at once. Surely any one who professes to think that the question of art and cultivation must go before that of the knife and fork (and there are some who do propose that) does not understand what art means, or how that its roots must have a soil of a thriving and unanxious life. Yet it must be remembered that civilization has reduced the workman to such a skinny and pitiful existence, that he scarcely knows how to frame a desire for any life much better than that which he now endures perforce. It is the province of art to set the true ideal of a full and reasonable life before him, a life to which the perception and creation of beauty, the enjoyment of real pleasure that is, shall be felt to be as necessary to man as his daily bread, and that no man, and no set of men, can be deprived of this except by mere opposition, which should be resisted to the utmost.[93]

What is clear from this statement is that Morris sees the political potential of works of art under the present system of capitalist degradation to lie in their ability to evoke visions of "a full and reasonable life." Moreover, as an aside to his artist compatriots (not to mention his earlier aesthetic self), Morris notes that questions related to art must not come before the real brass tack issues of social equality. In one discursive breath, then, Morris seems to exalt *and* decimate the role of art for the coming of socialism. How are we to understand this seemingly contradictory claim about the politics of art?

As opposed to the postmodern version of the aestheticist position we discussed in Chapter One, Morris's conception of cultural politics clearly recognizes the very limitations of art as well as its relative necessity. Art can provide an important arena within which political knowledge can be grasped (i.e., knowledge of present historical limitations and future possibilities), but its very individualized existence under present conditions (which reflects the social fact that a few people are "artists" while the mass of those which labor are not) elic-

its the very denial of a truly human life. In this respect, art must transcend its very specialized practices to become a defining feature of society as a whole.

As we know, Morris is able to argue this conception of cultural politics by metonymically equating art to particular conditions of labor, to the full flowering of pleasure and desire, and to what he noted in an earlier lecture as the "beauty of life." All of these practices are intimately social in character, reflecting a condition shared by all members of society. It is thus, as we also know, a society that is no longer defined by private property, but reflects the principles of "pure communism." What this means is that Morris reiterates the call of the Chartist Bandiera that "Poetry must be lived!": escaping its aesthetic representational status, poetry/beauty becomes a defining feature of human life itself.

The dual way in which beauty is articulated politically comes out nicely in Morris's crowning literary achievement devoted to the socialist cause, *News From Nowhere*. Written in installments in *Commonweal*, this work exhibits not only the role that aesthetic beauty will play in engendering glimpses of a better world, but also the way that beauty is to be lived by inhabitants of this socialist life-world itself. After the protagonist, William Guest, leaves a nineteenth-century socialist meeting (in which there were six sections of the party proposing different conceptions of "what would happen on the Morrow of the Revolution"),[94] he slowly makes his way home. At the very outset in Chapter I, Morris sets up a dialectical conflict between the ugliness and sordidness of capitalist society and the vision of a better world that arises from a brief epiphany of natural beauty. After traveling in "that vapour-bath of hurried and discontented humanity," and chancing upon "an ugly suspension bridge," Guest pauses before his home on the Thames:

> It was a beautiful night of early winter, the air just sharp enough to be refreshing after the hot room and the stinking railway carriage. The wind, which had lately turned a point or two north of west, had blown the sky clear of all cloud save a light fleck or two which went swiftly down the heavens. There was a young moon halfway up the sky, and as the home-farer caught sight of it, tangled in the branches of a tall old elm, he could scarce bring to his mind the shabby London suburb where he was, and felt as if he were in a pleasant country place—pleasanter, indeed, than the deep country as he had known it.[95]

In the context of what is to follow as of Chapter II, such a vision of natural beauty (a vision that could easily have been written by the early Morris still ensconced in the self-conceptions of Pre-Raphaelitism and aestheticism) foretells of the revitalization of art, human pleasure and natural beauty that will define his vision of a socialist life-world. Indeed, for the protagonist, such an experience gave rise to "a vague hope, that was now become a pleasure, for days of peace and rest, and cleanness and smiling goodwill."[96]

Upon waking after the "Morrow of the Revolution," Guest confronts details of the new world that slowly elicit the immense social transformations that have occurred. The first clue is the change of seasons—while it was winter when he went to sleep, it is now summer. Driven by the cognitive dissonance of such an

experience, Guest ventures out to the Thames for a morning swim, thereupon encountering ecological regeneration in the form of clean water, smokeless skies and the flourishing of salmon. Moreover, the "ugly suspension bridge" that the protagonist bemoaned earlier no longer exists; rather, there now exists a beautiful stone bridge. It is only after such glimpses of everyday beauty that Guest understands, through an encounter with a boatman, the radically different economic practices that exist in this society—his attempt to pay the boatman for his rowing services are confronted by a cheerful confusion concerning the use and place of these "tokens of friendship" Guest wishes to give to him. All in all, the socialist life-world for Morris is one in which the intricacies of one's everyday life are filled with beauty, hope, and ultimately pleasure. The protagonist continually confronts such "beauty of life"—in the form of architecture, human dress and ornament, wild nature, and human nature—and later learns that such a noble existence is intimately premised upon the eradication of private property and the institution of pure communism.[97]

As we noted earlier, Morris continued to discuss art in lectures to middle class audiences, ensuring to always make the connection between the longed for revitalized practices of aesthetic life (which were the concerns of these classes) and the institution of socialism. In the process, he adamantly argued that if individuals are truly concerned with the life of art they will have to be concerned with life and toil of the working classes. Moreover, rarely did he discuss art at great length in those lectures delivered to working class audiences. Yet, in "The Worker's Share of Art" (1885), Morris directly discusses the place and necessity of art for the working class audiences and socialist contemporaries who would be reading *Commonweal*. Morris begins this essay by noting clearly how his audience might be taken aback by the topic of the essay:

> I can imagine some of our comrades smiling bitterly at the above title, and wondering what a Socialist journal can have to do with art; so I begin by saying that I understand only too thoroughly how 'unpractical' the subject is while the present system of capital and wages last. Indeed, that is my text.[98]

But, for Morris at least, art is "man's embodied expression of interest in the life of man; it springs from man's pleasure in his life," particularly as it relates to "work."[99] In this respect, the travails of the working class under the grinding teeth of capitalism are directly related to "hope and fears" of art itself:

> the workers, by means of whose hands the mass of art must be made, are forced by the commercial system to live, even at the best, in places so squalid and hideous that no one could live in them and keep his sanity without losing all sense of beauty and enjoyment of life. The advance of the industrial army under its 'captains of industry' (save the mark!) is traced, like the advance of other armies, in the ruin of the peace and loveliness of earth's surface, and nature. . . . Men living amidst such ugliness cannot conceive of beauty, and, therefore, cannot express it.[100]

In the context of this metonymic convergence of art, pleasure, natural beauty, and socialism, Morris could not but assume that his present activism for social revolution would help to give life to his aesthetic desires and goals he had been nurturing and promoting his whole life:

> the leisure which Socialism above all things aims for obtaining for the worker is also the very thing that breeds desire—desire for beauty, for knowledge, for more abundant life, in short. Once more, that leisure and desire are sure to produce art, and without them nothing but sham art, void of life or reason for existence, can be produced: therefore not only the worker, but the world in general, will have no share in art till our present commercial society gives place to real society—to Socialism.[101]

Notes

1. Morris, "The Exhibition of the Royal Academy," *To-Day*, July 1884, reprinted in *William Morris: Artist, Writer, Socialist*, Vol. I, 240.

2. Morris, letter to Scheu, 1883, in *Collected Letters of William Morris*, Vol. II, Part I, 231.

3. See Cole and Postgate, *The British Common People*, 414-425; A. L. Morton and George Tate, *The British Labour Movement* (London: Lawrence and Wishart, 1956), 155-184; M. Beer, *A History of British Socialism*, 246-314; and, Brougham Villiers, *The Socialist Movement in England* (London: T. Fishcher Unwin, 1908), 85-100.

For a general history of the Social Democratic Federation (the later name of the D. F.), see Martin Crick, *The History of the Social-Democratic Federation* (Staffordshire: Ryburn Publishing, 1994).

4. Morris, "How I Became a Socialist."

5. Morris, "How I Became a Socialist."

6. For a thorough discussion of the multiple sources of Morris's socialism, consult Meier, *William Morris: The Marxist Dreamer*, especially Vol. I. While Meier has definitely provided an important service to Morris scholarship by painstakingly uncovering the various sources of Morris's political theory (from medievalism to radicalism to Marx), he has overly emphasized the connection between Marx and Engel's thought and Morris's. Meier makes the somewhat reductionist claim that some of Morris's most important socialist ideas were drawn from works of Marx that were not available (he conjectures that Engels was the conduit of these ideas). For criticism of Meier's thesis, see Thompson, *William Morris: Romantic to Revolutionary*, 779-791; and, Adam Buick, "William Morris and Incomplete Communism: A Critique of Paul Meier's Thesis," *The Journal of the William Morris Society* III, no. 2 (Summer 1976): 16-32. For a more judicious discussion of Morris's relationship to Marx and Engels, see A. L. Morton, "Morris, Marx and Engels," *The Journal of the William Morris Society* VII, no. 1 (Autumn 1986): 45-54.

7. Mackail, *The Life of William Morris*, Vol. I, 82. R. Page Arnot, one of the first champions of Morris's Marxist heritage, notes that this is one of the major "Morris-myths" that have populated Morris scholarship up until the 1950s: this myth extolled "Morris as poet, artist, typographer, master-craftsman of the lesser arts and crafts, and

treated his socialist activity as an unfortunate aberration." See his "William Morris, Communist," *Marxist Quarterly Review* 2, no. 4 (Oct. 1955): 237.

8. Mackail, *The Life of William Morris*, Vol. II, 242-367.

9. Meier, *William Morris: The Marxist Dreamer*, 96, where the author notes that it was only with the activism of Antiscrape and the E. Q. A. that Morris was "snatched away from the lures of pure art."

10. Many commentators have noted the non-dogmatic character of Morris's socialism, especially when compared to the rigid mechanism of an H. M. Hyndman. See, for instance, Thompson, *William Morris: Romantic to Revolutionary*, 294; Hinton, *Labour and Socialism*, 41-42; Villiers, *The Socialist Movement in England*, 108-112; and Pierson, *Marxism and the Origins of British Socialism*, 81-84.

11. Arnot, "William Morris, Communist," 237.

12. Pierson, *Marxism and the Origins of British Socialism*, 84.

13. Thompson, *William Morris: Romantic to Revolutionary*, "Postscript: 1976," 784.

14. See Arnot, *William Morris: A Vindication* (London: Wishart, 1934) for the first attempt to uncover the Marxist roots in Morris's thought.

15. See Thompson, *William Morris: Romantic to Revolutionary*, especially Appendix II, "William Morris, Bruce Glasier and Marxism," 741-762; Meier, *William Morris: The Marxist Dreamer*, Vol. I.

16. See Meier, *William Morris: The Marxist Dreamer*, Vol. II. For critiques of Meier's thesis, see footnote 6.

17. His poetry expressly written for the cause included *Chants for Socialists* (1883-1886), written for publication in *Justice* and *Commonweal*, and, *The Pilgrims of Hope* (1885), written in installments in *Commonweal*. His prose romances that were also politically motivated were *A Dream of John Ball* (1886), and *News From Nowhere* (1890), both written in installments for *Commonweal*.

18. See Thompson, *William Morris: Romantic to Revolutionary*, 322. Indeed, Morris's attachment to promoting socialism within his lectures on art to the middle class audiences was so strong that he would prefer to not deliver a lecture if he was asked to leave out his creed. For instance, Henry Bowie, director of the Edinburgh Philosophical Institution, requested a lecture from Morris on "Household Aesthetics" in 1884. Morris replied that he would deliver "Art and Labour," in which "Socialism will be the real subject. . .only looked on from the point of view of its bearing on the fine arts." Bowie replied that he should deliver the lecture "leaving out socialism," the result being that Morris never delivered the lecture (in *The Collected Letters of William Morris*, Vol. II, Part I, 312-313, 314f).

19. Morris, "The Society of the Future," in *Political Writings of William Morris*, 190.

20. Morris, Letter to Scheu, 1883, *Collected Letters of William Morris*, Vol. II, Part I, 230.

21. Morris, Letter of September 1882, in *Collected Letters of William Morris*, Vol. II, Part I, 126.

22. Morris, "Art Under Plutocracy," 165-166.

23. Morris, "Art Under Plutocracy," 166.

24. Morris, "Art Under Plutocracy," 172.

25. Morris, "Art Under Plutocracy," 172.

26. Morris, "Art Under Plutocracy," 172-173.

27. Morris, "Art Under Plutocracy," 191.
28. Thompson, *William Morris: Romantic to Revolutionary*, 310.
29. Morris, "Art Under Plutocracy," 167.
30. Morris, "Art Under Plutocracy," 168.
31. See Marcuse, *The Aesthetic Dimension*, for an elaboration of this type of position concerning art's political potential. In relation to Brecht's claim that art should speak the language of the people, Marcuse argues for the necessity of aesthetic autonomy and elitism. As Marcuse claims:

> Writers must rather first create this place, and this is a process which may require them to stand against the people, which may prevent them from speaking their language. In this sense 'elitism' today may well have a radical content. To work for the radicalization of consciousness means to make explicit and conscious the material and ideological discrepancy between the writer and 'the people' rather than to obscure and camouflage it. Revolutionary art may well become 'The Enemy of the People' (35).

32. Morris, Letter to Recipient Unknown, September 1882, in *Collected Letters of William Morris*, Vol. II, Part I, 126.
33. Morris, "Where Are We Now?," *Commonweal*, Nov. 15, 1890, in *William Morris: Artist, Writer, Socialist*, Vol. II, 518.
34. See Morris, "The Policy of Abstention" (1887), in *William Morris: Artist, Writer, Socialist*, Vol. II, 434-453.
35. Thompson, *William Morris: Romantic to Revolutionary*, 455-464.
36. Morris, "Makeshift," in *William Morris: Artist, Writer, Socialist*, Vol. II, 481.
37. See Thompson, *William Morris: Romantic to Revolutionary*, 597-639 for a discussion of Morris's rejection of purism in response to the ILP. For a thorough study of the ILP, consult, David Howell, *British Workers and the Independent Labour Party, 1888-1906* (Manchester: Manchester University Press, 1983). Howell notes (352) that although Morris may not have always shared the gradualist stance of the ILP, he was quite influential on a number of its most important members (e. g., J. Bruce Glasier).
38. From "The Manifesto of the Socialist League" (1885), Appendix I in Thompson, *William Morris: Romantic to Revolutionary*, 736-737.
39. This would finally occur in 1890, forcing Morris to set up the Hammersmith Socialist Society.
40. Morris, Letter to John Glasse, May 23, 1887, in *Collected Letters of William Morris*, Vol. II, 658.
41. See Morris's description in "Where Are We Now?" (1890) in *Political Writings of William Morris*, 220-221.
42. Beer, *A History of British Socialism*, 19-44.
43. Morris, "The Hopes of Civilization," in *CW*, Vol. XXIII, 63.
44. Morris, "The Hopes of Civilization," 64.
45. From the Digger tract, *Light Shining on Buckinghamshire* (1648), as quoted by Beer, *A History of British Socialism*, 61.
46. From *The True Levellers' Standard Advanced* (1649), as quoted by Beer, *A History of British Socialism*, 63.
47. Beer, *A History of British Socialism*, 101, 106-111. As Beer argues, Locke provided an important theoretical justification for social transformation and communist ideals, influencing the differing perspectives of Agrarian reformers in the late eighteenth century (e.g., Spence, Ogilvie and Paine). With the rise of the industrial revolution,

Locke's theory was also instrumental in the critiques of the Chartists. For a discussion of the relation of Locke's theory to the Chartists, consult, Richard Ashcraft, "A Victorian Working Class View of Liberalism and the Moral Life."

48. See Beer, *A History of English Socialism*, 160-181, for a discussion of Owen's ideas.

49. As quoted in Beer, *A History of English Socialism*, 185.

50. Beer, *A History of English Socialism*, 187.

51. Morris, "The Hopes of Civilization," 71. For a discussion of Morris's relation to Owen, consult, Meier, *William Morris: The Marxist Dreamer*, Vol. I, 187-190.

52. Morris, "The Political Outlook," in *William Morris: Artist, Writer, Socialist*, Vol. II, 279.

53. Morris, "The Hopes of Civilization," 71.

54. Morris, "The Hopes of Civilization," 71-72.

55. See, for instance, Beer, *A History of British Socialism*, Vol. I, 280-347, and Vol. II, 3-174; Theodore Rothstein, *From Chartism to Labourism* (London: Lawrence and Wishart, 1983), 7-181; Morton and Tate, *The British Labour Movement*, 49-128; and Cole and Postgate, *The British Common People*, 272-327.

56. Morris, "The Hopes of Civilization," 72.

57. See Saville, "Introduction" to *The Red Republican and The Friend of the People*, xi-xv, for a discussion of the socialist tendencies of these latter Chartists. For a representative presentation of Harney's views on this issue, see "The 'Little Charter' versus 'The Charter and Something More'," *The Red Republican*, no. 19 (October 26, 1850): 145-146.

58. Harney, "The 'Little Charter' versus 'The Charter and Something More'," ix. *The Communist Manifesto* was serialized in *The Red Republican*, nos. 21-23 (November 9-23, 1850).

59. See Villiers, *The Socialist Movement in England*, 85-88, 107.

60. See Thompson, *William Morris: Romantic to Revolutionary*, 288.

61. Morris, "The Hopes of Civilization," 74-75.

62. Morris, "Socialism," British Additional Manuscripts 45333, May Morris Bequest, 14.

63. Morris, "Socialism," 25.

64. See Thompson, *William Morris: Romantic to Revolutionary*, 294-296, for a discussion of this aspect in Hyndman's thought.

65. Morris, "How Shall We Live Then?," ed. by Paul Meier, *International Review of Social History* XVI, Pt. 2 (1971): 226.

66. As quoted by May Morris in *William Morris: Artist, Writer, Socialist*, Vol. II, 333.

67. For a discussion of Fabian socialism, consult Beer, *A History of English Socialism*, Vol. II, 274-298; and Pierson, *Marxism and the Origins of British Socialism*, 106-139.

68. Morris, "Where Are We Now?," 517.

69. Morris, "How Shall We Live Then?," 226.

70. Morris, "How Shall We Live Then?," 224.

71. Shaw, "Morris As I Knew Him," ix.

72. Later in "Morris As I Knew Him," Shaw berates Marx's labor theory of value, and concomitant notion of surplus value, as "academic blunders" (x). Shaw had become convinced of the correctness of Jevon's critique of Marx's labor theory of value.

73. Morris rarely, if ever, actually used the term "surplus value," even though it was a much debated notion in socialist circles. Not only were the Fabians actively criticizing Marx's labor theory of value, and the issue was thus in the air for all socialists, but at Morris's Hammersmith branch of the Socialist League there was a lecture by Edward Aveling entitled, "Capital and Surplus Value" in 1885. See British Museum Additional Manuscripts 45891, Hammersmith Socialist Society Papers, 27.

74. Morris, "The Ends and the Means," in *William Morris: Artist, Writer, Socialist*, Vol. II, 431.

75. Morris, "Useful Work Versus Useless Toil," in *CW*, Vol. XXIII, 98.

76. Morris, "Useful Work Versus Useless Toil," 99.

77. Morris, "Monopoly: or, How Labour is Robbed" (1887), in *CW*, Vol. XXIII, 245.

78. Morris, "Socialism," 17.

79. Morris, "Socialism," 21.

80. Morris, "Socialism," 23.

81. Morris, Letter to E. J. Collings in *Collected Letters of William Morris*, Vol. II, Part II, 729.

82. See Morris, "The Policy of Abstention," 437.

83. Morris, "The Policy of Abstention," 437.

84. Morris, "Socialism and Anarchism" (1889) in *Political Writings of William Morris*, 209.

85. Morris, "Communism," in *William Morris: Artist, Writer, Socialist*, Vol. II, 351.

86. This position is developed by Morris in a number of different lectures, but is most concisely presented in "The Policy of Abstention."

87. Morris, "Where Are We Now?," 224.

88. Morris, "On Some 'Practical' Socialists," *Commonweal* (Feb. 18, 1888).

89. Morris, "How Shall We Live Then?," 222.

90. Morris, "How Shall We Live Then?," 223.

91. A number of commentators have seen the importance of this work in Morris's oeuvre. Paul Meier, who provides the most detailed discussion of *News From Nowhere*, argues that this work represents the clear Marxian influences in Morris's vision of socialism. See his *William Morris: The Marxist Dreamer*, 53-65, and Volume II, which is devoted to *News From Nowhere*. See also, Thompson, *William Morris: Romantic to Revolutionary*, 692-698, where the author argues that it signifies a "scientific utopia," that most readily shows Morris's "mastery of the historical process," as well as his integration of Romantic dream and harsh reality. Perry Anderson in *Arguments Within English Marxism* (London: Verso, 1980), 177-179, notes how *News From Nowhere* shows the important strategic insights that Morris had as a socialist. For a discussion of how Morris initiates a "renewal" of the utopian genre, see Krishan Komar, "News From Nowhere: The Renewal of Utopia," in *History of Political Thought* XIV, no. 1 (Spring 1993): 133-143.

92. Morris, *News From Nowhere*, in *Three Works by William Morris* (New York: International Publishers, 1968), 401.

93. Morris, "How I Became a Socialist."

94. Morris, *News From Nowhere*, 181.

95. Morris, *News From Nowhere*, 182.

96. Morris, *News From Nowhere*, 182.

97. Like all good literary utopias, *News From Nowhere* spends less time in laying out the institutions and principles associated with socialism (though there are ample discussion of these throughout the text) and more time on rendering the "feel" of this new order of things through the means of vivid imaginative description and discursive constructions of central characters. In this sense, it attempts to engender the lived experience of a socialist world. Undoubtedly the politics of such a literary form are interesting: the literary mode of description draws the reader into the world, and helps to persuade her to listen to the lectures later on. Thus, the very use of aesthetic devices allows the author to potentially gain more adherents to the cause, in turn engendering more political action. For a very interesting discussion of literary utopias that gets to some of these issues, see Bertrand De Jouvenel, "Utopia for Practical Purposes," in Frank E. Manuel, ed. *Utopias and Utopian Thought: A Timely Appraisal* (Boston: Beacon Press, 1967), 219-235.

98. Morris, "The Worker's Share of Art" (1885), originally published in *Commonweal*, April 1885, reprinted in *William Morris: Selected Writings and Designs*, Asa Briggs, ed. (Middlesex: Penguin Books, 1962), 140.

99. Morris, "The Worker's Share of Art," 140.

100. Morris, "The Worker's Share of Art," 141.

101. Morris, "The Worker's Share of Art," 143.

Conclusion

Morris and Western Marxism

If we have established the importance of Morris's life and theory as an indicator of the important ways in which aesthetic discourses can bring about the constitution of political subjectivities and political actions, we have only hinted so far at what substantive issues Morris's cultural and political theory offers contemporary theorists. Unfortunately, many Morris commentators—no matter whether they are attached to Morris's aesthetic practices and writings (Mackail), or Morris's later socialist position (Meier), or to the multifarious totality of Morris's oeuvre (Thompson)—are easily led astray from a sustained analysis of the substantive theoretical and conceptual themes that Morris initiates. For those who establish a Manichean bifurcation of Morris (e.g., Mackail and Meier), such an inability relates directly to their distaste for part of Morris's diverse talents—to ignore the intimate interconnections between Morris's aesthetic life and his revolutionary socialism means that one cannot perceive the theoretical fruits that arise from such a dialectical conceptual constellation.

On the other hand, for those with a more judicious understanding of the interconnections between Morris the artist and Morris the socialist, we confront altogether other barriers to a sustained treatment of Morris's theoretical stature. For example, there seem to be three stumbling blocks in Thompson's treatment of Morris in this respect: first, Thompson's overly biographical approach to Morris makes his life, not necessarily his theory, the central focus (leading him to argue that his stature is related to the overall quality of "moral realism"); second, Thompson's disdain for the intricate *theoretical* debates that have been circulating within the Marxist tradition in the late twentieth century blinds him to a sense of Morris's potential importance;[1] and, third, as we noted earlier, Thompson seems to assume a certain definition of "good theory" that militates against taking Morris seriously as a theorist. What does Morris offer us as a theorist? More specifically, what substantive issues and themes does he initiate within the tradition of Western Marxism that show him to be of interest for contemporary theorists?

Of course, to ask the latter question is to beg the exceedingly contested issue of whether we can include Morris in the tradition of Western Marxism at all. As I have shown, Morris not only read Marx and learned of his ideas from socialist compatriots, but he also appropriated Marx's ideas into his constructive socialist position. Yet, in so doing we must be aware of the continuities and dis-

continuities that are present between Marx's and Morris's theoretical positions—even if Morris read and studied Marx's ideas, he incorporated them in a pragmatic way into his revolutionary socialist position, a position whose outlines (not to mention important specifics) were already constituted through aesthetic discourses. It is very clear that when Morris articulated his notion of socialism in his writings that he saw it in line with Marx's position in two ways: first, Morris's conception of exploitation and his principle of equality of condition were bolstered by Marx's ideas in this respect;[2] and, second, he clearly felt that Marx's historical understanding of social evolution (a conception that, in the words of Morris, "made Modern Socialism what it is") provided an important and necessary political tool in convincing activists that socialism "is at least inevitable."[3]

At the same time, though, it is just as clear that Morris's specific theoretical position has important differences from that which Marx took. Indeed, Morris's continual attempt at rendering the future socialist life-world in which pleasure, beauty and art flourish would have clearly troubled Marx (who, as we know, disdained people whom he felt were working within the "cookshops of the future"), and did raise concerns for those wedded to a particular conception of Marxism. But, such a disjuncture should not necessarily concern us in terms of placing Morris within the tradition of Western Marxism. What ultimately makes Western Marxism a *living tradition* is the way in which participants establish a lineage and legacy (e.g., the enactment of concepts used by Marx and other "Marxists" within the tradition; the confirmation of current understandings by locating and finding their originary meanings in Marx's writings) while also engaging in differential play and conceptual agonistics. That is, a living tradition is ultimately one that is constituted by both continuities and discontinuities.[4] Moreover, there is a curious way in which Morris's thought is part of the Western Marxist tradition because of the way in which contemporary articulations of this tradition have played out. That is, Morris's place within this tradition comes to the forefront with the recognition of similarities between his ideas and those of later participants within the tradition.

Given these metatheoretical comments, I want to briefly look at the theoretical innovations that Morris has introduced, important issues that I think allow him to be considered a living presence within the contemporary theoretical scene. While I cannot be as detailed as I would like in the space of this concluding chapter, I do hope to at least initiate a discussion that can be expanded by others. In particular, I want to briefly look at three important issues: Morris's articulation of what we may call a *"materialist" aestheticist position*; his discussion of *pleasure and desire* as both a political ideal and a crowning condition of a future socialist life-world; and, his initiation of an *eco-socialist position*. As may seem apparent, these three issues are intimately related to one another.

As we have already noted, Morris's conception of art is premised upon two interwoven conceptualizations that he gathered from his earlier aesthetic education and discourses, and from Ruskin's prescient analyses of aesthetic life: first, that beauty must be lived, and thus become an intimate part of the everyday life

of individuals; and, second, that the life of beauty is intimately associated with the social conditions of individuals. What this constellation of claims did for Morris is make him realize very early on that the ideal of beauty can never be realized within a specific artwork. Rather, for beauty to be politically realized it must transcend its very specialized spectacular status and integrate within the everyday life of human beings. In this respect, the relation between art and politics is never direct: if one is to translate aesthetic ideals and notions into everyday life one has to transform their content and form, ensuring that they are relevant to collective political and social action. This conceptual understanding was established by Morris's metonymic association of beauty with both pleasure and wider social conditions.

Such a conception of cultural politics—which I would call a *materialist aestheticist position*—can be traced from Morris's premonitory discussions in this respect to very important later positions within the tradition of Western Marxism: we see similar theoretical understandings in the ideals of the Soviet constructivists, the theory and practice of the situationists, and even the brief remarks by Jürgen Habermas in his provocative riposte to postmodern positions.[5] What all of these positions share is a realization that beauty and art must become relevant to everyday life. Thus, what is important is not necessarily to create another great work of art; rather, one should attempt to infuse everyday life with the pleasure, creativity and revitalization of desires that is intimated by all good art. As Mustapha Khayati, a prominent situationist, noted: "The realization of art—poetry in the situationist sense—means one cannot realize oneself in a 'work,' but rather realize oneself period."[6] Moreover, in reflecting upon the modernist strategies of the Dadaists and surrealists, Habermas critiques their assumption that opening one cultural sphere will inevitably transform a "reified everyday praxis." Following a suggestion from Albrecht Wellmer, Habermas argues that art can have a transformative political effect only if it somehow engages the everyday experiences of the individuals involved. As Habermas continues:

> The aesthetic experience not only renews the interpretation of our needs in whose light we perceive the world. It permeates as well our cognitive significations and our normative expectations and changes the manner in which all of these moments refer to one another.[7]

What the situationists would add to this particular conception proffered by Habermas is that the aestheticization of aspects of everyday life entails *a flourishing of desire and pleasure*: indeed, that is what beauty means in terms of everyday life. Moreover, in this context desire and pleasure are not only conceived in terms of their individuated expression within subjects but are understood as intimately involved in larger social and political practices and dynamics. Undoubtedly, this is a conceptualization that Morris would agree with wholeheartedly. What then Morris also initiates is a conceptualization of a politics of desire and pleasure within the Western Marxist tradition.

As opposed to anarchist and contemporary postmodern positions on the politics of desire,[8] Morris's understanding of the connections between desire and material conditions is exceedingly relevant for those within the Marxist tradition wishing to engage in this arena of contention. For Morris, what socialism offered was a way of creating the material conditions in which desire and pleasure could flourish and multiply (as he noted, "the leisure which Socialism above all things aims for obtaining for the worker is also the very thing that breeds desire").[9] Moreover, the ideals of pleasure and desire themselves (tied as they are to the life of art) represent an important discourse for engendering political struggle itself. Obviously, this makes it understandable why Morris would see the future socialist life-world to be premised upon desire and pleasure in all facets of human relationships (personal as well as productive).

What I think Morris offers contemporary discussions of the politics of desire and pleasure are important cautionary provisos that all good materialist positions raise. First, that desire and pleasure are never anything more than their particular material investment, which implies that they do not have a life beyond history. That is, for the materialist desire is historically imminent. It is in this respect that Morris could easily understand that capitalist society engenders an unusual plethora of desires and pleasures all tied to the profit motive, and thus desire and pleasure can be intimately linked to human exploitation.[10] Given its connections to real material and social conditions, then, desire may not necessarily be revolutionary. This helps to overcome some of more simplistic naturalistic assumptions associated with the postmodern position (particularly, the early Lyotard) that assume that the free-flowing of desire in all of its forms is politically progressive.

Yet, if desire and pleasure are intimately wedded to the historical vicissitudes of material conditions they have a particular dynamic and logic that raises concerns beyond the strictly economic issues associated with human needs. That is, a materialist concept of desire points to issues associated with diverse struggles for human plenitude and singularity. In this respect, we need to realize that Morris initiates a discussion that offers Western Marxism a way of entering into current discussions concerning the politics of desire and pleasure.[11] As we know, such discussions did arise within the work of Freudo-Marxists (particularly, in the work of Wilhelm Reich and Herbert Marcuse). Indeed, Marcuse very early on realized the limitations that the Marxist tradition had when it came to issues of pleasure and desire. In his essay, "On Hedonism" (orig. 1938), Marcuse argued that Marxists needed to accept the political importance of the tradition of "hedonism," which he claimed had often been misread by classical Marxism as a subjectivist discourse. Seeing Marxism as part of the tradition of the "philosophy of reason," Marcuse argued that hedonism provides a counterweight to the necessary, though one-sided, universalist, materialist and rationalist aspirations of this tradition: in raising the ideal of happiness and enjoyment, hedonism promotes "the comprehensive unfolding of human wants and needs, emancipation from an inhuman labor process, and liberation of the world for the purposes of enjoyment."[12] If anything, Morris's importance within Western Marxism relates

directly to his espousal of a form of hedonism that paints socialism as the flourishing of these diverse practices of desire and pleasure.[13]

In turning to the last substantive issue that Morris's theory raises within the Western Marxist tradition, we may have hit upon the most important innovation, at least as it relates to contemporary political issues and concerns. Given Morris's romantic attachment to nature (seen clearly in his early espousal of Pre-Raphaelitism, his design work, and his life-long literary production), and his overall concern with the "beauty of life," Morris's critique of capitalism, not to mention his ideal of socialism, were always intimately *ecological*.[14] For Morris, not only was capitalism destroying human beings and eradicating the possibility of art, it was destroying nature itself. In this respect, Morris's theory may be an important intervention into current debates within radical ecology.[15]

While scholars do look to Morris as an important ecological thinker, they are generally torn as to where to place him in the pantheon of radical ecology positions. For example, we find Robyn Eckersley squarely placing Morris in the "eco-anarchism" camp,[16] while David Pepper points to Morris's centrality as an eco-socialist thinker.[17] Undoubtedly, part of the problem here is related to the way in which both anarchism and socialism were articulated in late nineteenth-century England: not only were anarchists and socialists working together in the same political organizations, but, related to this practical propinquity, their theoretical positions were very close in terms of their critique of capitalism and their espousal of some form of communism.[18] What maybe is of more importance in terms of Morris's relevance for contemporary debates is that Morris's ecological theory, given its seeming conceptual and political ambivalence, may be an important way of bridging some of these very politico-theoretical chasms within current radical ecology debates. As a socialist, Morris clearly realized that ecological destruction was intimately related to the external diseconomies associated with a system based upon the profit motive, and he assumed, like eco-socialists afterward, that the institution of socialism would ensure the creation of an ecologically sustainable world. Moreover, his vision of socialism entails the eradication of "false needs" engendered in the wake of capitalist production, and thereby a simplification of one's desires and pleasures. Given such developments, pollution-creating machinery will become less of a necessity (though Morris is clear that machinery will exist to deal with the most necessary work that humans do not wish to do themselves); individuals will begin to disperse into decentralized communities, in the process living closer to nature; and, wild nature will revivify, in the process beautifying the everyday life of human beings.

If anything divides radical ecological thinking today it is the supposed choice between an "anthropocentric" position (which sees the human value of emancipation as the primary ideal, though linked intimately to ecological regeneration—this position is exhibited in social ecology, eco-socialism, and forms of eco-feminism) and an "ecocentric" position (which assumes that nature or "ecosystems" have some intrinsic worth, irrespective of its relation to human needs and desires—this position is exhibited in deep ecology, forms of environmental

ethical philosophy, and forms of eco-feminism).[19] Morris's radical ecological position works between these two overall positions—given the aesthetic genesis of his ecological vision, Morris is equally concerned about human liberation (which he realized could only be brought about with the institution of a pleasurable life through socialism) and the intrinsic worth of nature. For, what Morris deeply felt is that only with such a dual commitment to the important goal of human happiness and to the inherent worth of nature could there be beauty and art. And, as an aestheticist *and* revolutionary socialist, such a goal was more important than theoretical disagreements and conceptual quandaries.

Notes

1. See Thompson, "The Poverty of Theory or an Orrery of Errors," in *The Poverty of Theory and Other Essays* (New York: Monthly Review Press, 1978), 1-210. While ultimately a sustained attack on the Althusserian position, it is also clear that Thompson has little patience for the diverse theoretical positions and debates that have arisen within the tradition of Western Marxism.
2. For a discussion of Morris's understanding of exploitation, particularly as it relates to Marx's notion of surplus value, see Chapter Six. In terms of his notion of equality [see his lecture, "Equality" (1888), British Museum Additional Manuscripts 45335, May Morris Bequest, 219], Morris reiterates the famous Blancian principle of communism that Marx also drew upon: "*To* everyone according to his needs, *from* everyone according to his capacities" (Morris's rendering). But, even here, we need to be careful with making the further assumption that Morris developed his principle of equality of condition from Marx. As we noted earlier, Morris claimed that his notion of equality developed in his thinking of how to regenerate a world in which beauty and art flourish (See Morris, "How Shall We Live Then?," 226).
3. Morris, "The Hopes of Civilization," 74-75.
4. In talking about "tradition" in this way, I am relying upon the interesting comments made by Ernesto Laclau and Chantal Mouffe about the placement of their post-Marxist position. Drawing eclectically on the work of Heidegger, Gadamer and Foucault, they argue that one must establish a "dialogue which is organized around continuities and discontinuities, identifications and ruptures. It is in this way, by making the past a transient and contingent reality rather than an absolute origin, that a *tradition* is given form" ["Post-Marxism Without Apologies," in E. Laclau, ed. *New Reflections on the Revolution of Our Time* (London: Verso Press, 1990), 98].

While the authors are clearly referring to the diachronic dimension to traditions (the way in which temporally they are negotiated), we can also argue that this holds as well in a synchronic fashion. That is, at any given moment a tradition becomes a living tradition when it establishes linkages and differential relationships, and is therefore an arena for conceptual agonistics. How such a conception makes sense in terms of the tradition that Marx initiates is that those differential relations are intimately premised upon differing material practices (be they cultural, theoretical or economic) in existence at that moment of time. This I think is implied in the famous metatheoretical position Marx lays out in the *Theses on Feuerbach*: "All mysteries which mislead theory into mysticism find their

rational solution in human practice and in the comprehension of this practice" (in R. Tucker, *The Marx-Engels Reader*, 145).

5. For a critical discussion of situationist theory and practice that focuses primarily on their notion of cultural politics, see Bradley J. Macdonald, "From the Spectacle to Unitary Urbanism: Reassessing Situationist Theory," *Rethinking Marxism* 8, no. 2 (Summer 1995): 89-111. See Habermas, "Modernity Versus Postmodernity," *New German Critique*, no. 22 (Winter 1981): 12.

6. Khayati, "Captive Words: Preface to a Situationist Dictionary," in K. Knabb, ed. *The Situationist International Anthology* (Berkeley: Bureau of Public Secrets, 1981), 172. When Guy Debord—the most prominent situationist theorist—reflected on their relationship to the earlier movements of Dadaism and surrealism he raised the same issue: "Dadaism wanted *to suppress art without realizing it*, surrealism wanted *to realize art without suppressing it*, the critical position later elaborated by the *Situationists* has shown that the suppression and the realization of art are inseparable aspects of a single *supersession of art*" [*Society of the Spectacle* (Detroit: Red and Black, 1983), Chapter 8, # 191]. For Debord at least, such a "supersession of art" implied the institution of council communism and radical democracy.

7. Habermas, "Modernity Versus Postmodernity," 12.

8. For a representative anarchist position on desire, particularly in relation to supposed shortcomings within Marxism, see Murray Bookchin, "Desire and Need," in *Post-Scarcity Anarchism* (San Francisco: Ramparts Press, 1971), 273-286. Of course, when it comes to postmodern positions, we should be aware of the early work of Lyotard, particularly *The Libidinal Economy*, and the work (separately and together) of Gilles Deleuze and Felix Guattari, particularly, *Anti-Oedipus: Capitalism and Schizophrenia*, trans. by R. Hurley, M. Seem, and H. Lane (Minneapolis: University of Minnesota Press, 1983). For critiques of Lyotard's notion see Best and Kellner, *Postmodern Theory*, 147-160, and Dews, *Logics of Disintegration*, 128-143. For a critique of Deleuze and Guattari's position, consult, Best and Kellner, *Postmodern Theory*, 85-109.

9. Morris, "The Worker's Share of Art," 143.

10. Morris called superfluous commodities that were solely engendered by the profit motive "luxury" and "waste." For Morris, capitalists had to actively engender desires for such products: ". . .capitalists know well that there is no genuine healthy demand for them, and they are compelled to foist them off on the public by stirring up a strange feverish desire for petty excitement, the outward token of which is known by the conventional name of fashion—a strange monster born of the vacancy of the lives of the rich people, and the eagerness of competitive Commerce to make the most of the huge crowd of workmen whom it breeds as unregarded instruments for what is called the making of money" ("Art and Socialism," in *Political Writings of William Morris*, 113-114).

11. I realize that there is a lot of disagreement concerning whether the Marxist tradition should engage in such a conceptualization [see, for instance, Eagleton's latest critique of "body-talk" in *The Illusions of Postmodernism* (Oxford: Basil Blackwell, 1996), 25]. I would argue that the reason that there is so much discussion of desire and pleasure within contemporary postmodern discourses is not just because it provides an ideological cover for commodity production (though any valid materialist position must take a reflective stance in this respect). Rather, discussions of desire, bodies, pleasure, etc., persist because they reflect increasingly important arenas of political, social and cultural struggle. What is then important is to not dismiss these new forms of struggle, but rather to articulate them within a materialist framework. In this respect, Morris's position may

provide a suggestive conceptual tool for rendering such struggles intelligible in their specificity while at the same time ensuring an analysis of their embeddedness within political economic practices. For a critical reconstruction of a concept of desire within Marx's writings, see Bradley J. Macdonald, "Marx and the Figure of Desire," *Rethinking Marxism* (forthcoming).

12. Marcuse, "On Hedonism," in *Negations: Essays in Critical Theory* (Boston: Beacon Press, 1968), 167.

13. Morris puts his overall goal related to desire and pleasure this way: "I am bound to suppose that the realization of Socialism will tend to make men happy. What is it then that makes people happy? Free and full life and the consciousness of life. Or, if you will, the pleasurable exercise of our energies, and the enjoyment of the rest which that expenditure of energy makes necessary to us. I think that is happiness for all, and covers all difference of capacity and temperament from the most energetic to the laziest" ("The Society of the Future," 191).

14. Again, such a position is related to Morris's conceptualization of beauty we previously discussed. For Morris, we must extend the notion of art and beauty beyond "those matters which are consciously works of art" to include "all the externals of our life" ("Art Under Plutocracy," 58).

15. For sure, "radical ecology" as a term covers a number of rather diverse traditions of environmental thinking, in particular, those theories associated with deep ecology, social ecology, eco-feminism, eco-socialism, eco-Marxism, and ecological thinking inspired by postmodern theory. What designates each of these positions as "radical" is the way in which they assume wide-ranging structural practices (be they cultural, economic, political and/or social) to be behind the ecological crisis confronting the world, and they correspondingly assume the necessity of radical transformations to bring about an ecologically sustainable society. For important recent overviews of this tradition, see Robyn Eckersley, *Environmentalism and Political Theory: Toward an Ecocentric Approach* (Albany: State University of New York Press, 1992), and Carolyn Merchant, *Radical Ecology: The Search for a Livable World* (New York: Routledge, 1992). For a discussion of radical ecology and postmodernism, see Michael Zimmerman, *Contesting Earth's Future: Radical Ecology and Postmodernity* (Berkeley: University of California Press, 1994), and Arran Gare, *Postmodernism and the Environmental Crisis* (New York: Routledge, 1995).

16. Eckersley, *Environmentalism and Political Theory*, 163-164.

17. Pepper, *Eco-socialism: From Deep Ecology to Social Justice* (London: Routledge, 1993), 62-63. Yet, even here, we find a certain ambivalence on the part of Pepper. For while he squarely argues that Morris is an important exponent of eco-socialism (even of eco-Marxism), he also uses Morris's *News From Nowhere* as an important example of an "anarcho-communist utopia" (176-185).

18. This is brought out nicely in John Quail, *The Slow Burning Fuse: The Lost History of the British Anarchists* (London: Paladin Books, 1978).

19. For a discussion of this divide, see Eckersley, *Environmentalism and Political Theory*, 49-71.

Bibliography

Adorno, Theodor, and Max Horkheimer. *Dialectic of Enlightenment*. New York: Continuum Publishing, 1972.
———. *Minima Moralia: Reflections from Damaged Life*. Trans. by E. F. N. Jephcott. London: Verso, 1974.
———. "Commitment." *The Essential Frankfurt School Reader*. Ed. by Andrew Arato and Eike Gebhardt. New York: Urizen Books, 1978.
———. *Aesthetic Theory*. Trans. by C. Lendhardt. London: Routledge and Kegan Paul, 1986.
Aho, Gary. *William Morris: A Reference Guide*. Boston: G. K. Hall and Co., 1985.
Allen, P. R. "F. D. Maurice and J. N. Ludlow: A Reassessment of the Leaders of Christian Socialism." *Victorian Studies* XI (June 1968).
Althusser, Louis. *Lenin and Philosophy*. New York: Monthly Review Press, 1971.
Altick, Richard. *Victorian People and Ideas*. New York: W. W. Norton, 1972.
Anderson, Perry. *Considerations on Western Marxism*. London: Verso, 1976.
———. *Arguments Within English Marxism*. London: Verso, 1980.
Arnot, R. Page. *William Morris: A Vindication*. London: Lawrence Wishart, 1934.
———. "William Morris, Communist." *Marxist Quarterly Review* 2, no. 4 (October 1955).
———. *William Morris: The Man and The Myth*. London: Lawrence and Wishart, 1964.
Ashcraft, Richard. "Political Theory and the Problem of Ideology." *The Journal of Politics* 42 (1980).
———. *Revolutionary Politics and Locke's Two Treatises on Government*. Princeton: Princeton University Press, 1986.
———. "A Victorian Working Class View of Liberalism and the Moral Life," unpublished paper presented to the Conference for the Study of Political Thought, New York, 1988.
Banham, Joanna, and Jennifer Harris (eds). *William Morris and the Middle Ages*. Manchester: Manchester University Press, 1984.
Barrett, Michele. *The Politics of Truth: From Marx to Foucault*. Stanford: Stanford University Press, 1991.
Barthes, Roland. *Mythologies*. Trans. by Annette Lover. New York: Hill and Wang, 1985.

Baudrillard, Jean. *For a Critique of the Political Economy of the Sign.* St. Louis: Telos Press, 1981.
Beer, Max. *A History of English Socialism* (2 Vols.). New York: Humanities Press, 1948.
Benjamin, Andrew (ed). *The Lyotard Reader.* Oxford: Basil Blackwell, 1989.
Benjamin, Walter. *Reflections.* Trans. by Edmund Jephcott. New York: Harcourt Brace Jovanovich, 1978.
Bennett, Tony. *Formalism and Marxism.* London: Routledge, 1979.
Best, Stephen, and Douglas Kellner. *Postmodern Theory: Critical Interrogations.* New York: Guilford Press, 1992.
Boime, Albert. "Ford Madox Brown, Thomas Carlyle, and Karl Marx: Meaning and Mystification of Work in the Nineteenth Century." *Arts Magazine* 56, no. 1 (September 1981).
Bookchin, Murray. *Post-Scarcity Anarchism.* San Francisco: Ramparts Press, 1971.
Boos, Florence. "The Evolution of 'The Wanderers Prologue'." *PLL* 20, no. 4 (1984).
Boos, Florence, and William Boos. "The Utopian Communism of William Morris." *History of Political Thought* VII, no. 3 (Winter 1986): 489-510.
Boos, Florence, and Carol Silver (eds). *Socialism and the Literary Artistry of William Morris.* Columbia, MO: University of Missouri Press, 1990.
Boris, Eileen. *Art and Labor: Ruskin, Morris and the Craftsman Ideal in America.* Philadelphia: Temple University Press, 1986.
Bourdieu, Pierre. *Distinctions: A Social Critique of the Judgements of Taste.* Cambridge, MA: Harvard University Press, 1984.
Bourdieu, Pierre, and Loic Wacquant. *An Invitation to Reflexive Sociology.* Chicago: University of Chicago Press, 1992.
Briggs, Asa. *Victorian People: A Reassessment of Persons and Themes, 1851-67.* New York: Harper and Row, 1963.
———. "The Language of 'Class' in Early Nineteenth-Century England." In *History and Class: Essential Readings in Theory and Interpretation.* Ed. by R. S. Neal. Oxford: Oxford University Press, 1983.
Brinton, Crane. *The Political Ideas of the English Romanticists.* Ann Arbor: University of Michigan Press, 1966.
Buick, Adam. "William Morris and Incomplete Communism: A Critique of Paul Meier's Thesis." *The Journal of the William Morris Society* III, no. 2 (Summer 1976).
Bulluck, Chris, and David Peck (eds). *Guide to Marxist Literary Criticism.* Bloomington: Indiana University Press, 1980).
Callari, Antonio, and David Ruccio (eds). *Postmodern Materialism and the Future of Marxist Theory: Essays in the Althusserian Tradition.* Hanover: Wesleyan University Press, 1996.
Carlyle, Thomas. *Sartor Resartus.* New York: The Odyssey Press, 1930.
———. *Past and Present.* New York: New York University Press, 1965.
Carpenter, Edward. "William Morris." *Freedom* X, no. 111 (Dec. 1896).

Casement, William. "Morris on Labor and Pleasure." *Social Theory and Practice* 12, no. 3 (Fall 1986).
Chandler, Alice. *Dream of Order: The Medieval Ideal in Nineteenth Century English Literature*. Lincoln: University of Nebraska Press, 1970.
Clark, Kenneth. *The Gothic Revival: An Essay in the History of Taste*. London: John Murray, 1962.
Cole, G. D. H., and Richard Postgate. *The British Common People: 1746-1946*. London: Metheun, 1961.
Cole, Henry. *Fifty Years of Public Work* (2 Vols.). London: George Bell and Sons, 1884.
Commonweal, 1884-90.
Crouzet, Francois. *The Victorian Economy*. New York: Columbia University Press, 1982.
Daily News, London, 1850-51.
Debord, Guy. *The Society of the Spectacle*. Detroit: Red and Black, 1983.
Deleuze, Gilles and Félix Guattari. *Anti-Oedipus*. Minneapolis: University of Minnesota Press, 1983.
Derrida, Jacques. "Sending: On Representation." *Social Research* 49, no. 2 (Summer 1982).
Dews, Peter. *Logics of Disintegration: Post-Structuralist Thought and the Claims of Critical Theory*. London: Verso, 1987.
Dinwiddy, J. R. *From Luddism to the First Reform Bill: Reform in England, 1810-1832*. London: Basil Blackwell, 1986.
Eagleton, Terry. *Criticism and Ideology*. London: New Left Books, 1976.
———. *Marxism and Literary Criticism*. Berkeley: University of California Press, 1976.
———. *The Function of Criticism: From the Spectator to Post-structuralism*. London: Verso, 1984.
———. *The Illusions of Postmodernism*. Oxford: Blackwell Publishers, 1996.
Eckersley, Robyn. *Environmentalism and Political Theory: Toward an Ecocentric Approach*. Albany: State University of New York Press, 1992.
Eclectic Review, 1850-51.
Egbert, Donald Drew. *Social Radicalism and the Arts: Western Europe*. New York: Alfred A. Knopf, 1970.
Engels, Friedrich. *The Condition of the Working-class in England*. Moscow: Progress Publishers, 1973.
Ensor, R. C. K. *England: 1870-1914*. Oxford: Clarendon Press, 1987.
Faulkner, Peter (ed.). *William Morris: The Critical Heritage*. London: Routledge and Kegan Paul, 1973.
Fay, C. R. *Palace of Industry, 1851: A Study of the Great Exhibition and it Fruits*. Cambridge: Cambridge University Press, 1951.
Ffrench, Yvonne. *The Great Exhibition: 1851*. London: Harvill Press, 1950.
Foucault, Michel. *Language, Counter-memory, Practice: Selected Essays and Interviews*. Trans. by Donald Bouchard and Sherry Simon. Ithaca, NY: Cornell University Press, 1977.

———. *Power/Knowledge: Selected Interviews and Other Writings, 1972-1977.* Trans. by Colin Gordon. New York: Pantheon Books, 1980.
———. *History of Sexuality, Volume One: An Introduction.* Trans. by Robert Hurley. New York: Vintage Books, 1980.
Fraser, Hilery. *Beauty and Belief: Aesthetics and Religion in Victorian Literature.* Cambridge: Cambridge University Press, 1986.
Gadamer, Hans-Georg. *Dialogue and Dialectic: Eight Hermeneutical Studies on Plato.* Trans. by P. Christopher Smith. New Haven: Yale University Press, 1980.
Gardner, Delbert. *An "Idle Singer" and His Audience: A Study of William Morris's Poetic Reputation in England, 1858-1900.* The Hague: Mouton and Co., 1974.
Gare, Arran. *Postmodernism and the Environmental Crisis.* New York: Routledge, 1995.
Graff, Gerald. *Literature Against Itself: Literary Ideals in Modern Society.* Chicago: University of Chicago Press, 1979.
Grennan, Margaret. *William Morris: Medievalist and Revolutionary.* Morningside Heights, NY: King's Crown Press, 1945.
Guinn, John Pollard. *Shelley's Political Thought.* The Hague: Mouton and Co., 1969.
Gunnell, John. *Between Philosophy and Politics: The Alienation of Political Theory.* Amherst: University of Massachusetts Press, 1986.
Habermas, Jürgen. "Modernity Versus Postmodernity." *New German Critique*, no. 22 (Winter 1981).
Hall, Stuart. "The Problem of Ideology—Marxism Without Guarantees." *Journal of Communication Inquiry* 10, no. 2 (Summer 1986).
Hauser, Arnold. *The Social History of Art* (4 Vols.). New York: Vintage Books, 1951.
———. *The Philosophy of Art History.* Evanston: Northwestern University Press, 1985.
Heidegger, Martin. *Poetry, Language, Thought.* Trans. by Alfred Hofstadter. New York: Harper and Row, 1971.
———. *The Question Concerning Technology and Other Essays.* Trans. by William Lovitt. New York: Harper and Row, 1977.
Helmhotz-Phelan, Anna. *The Social Philosophy of William Morris.* Durham: Duke University Press, 1927.
Henderson, Philip. *William Morris.* London: Longman and Green and Co., 1952.
———. *William Morris: His Life, Work and Friends.* London: Andre Deutch Limited, 1986.
Hinton, James. *Labour and Socialism: A History of the British Labour Movement, 1867-1974.* Sussex: Wheatsheaf Books, 1983.
Hobsbawm, E. J. *Industry and Empire.* London: Penguin Books, 1968.
———. *The Age of Capital: 1848-1875.* New York: New American Library, 1975.
Hobson, J. A. *John Ruskin: Social Reformer.* Boston: Dana Estes and Co., 1898.

Bibliography

Horkheimer, Max. *The Eclipse of Reason*. New York: Continuum Publishing, 1974.
Hough, Graham. *The Late Romantics*. London: Methuen, 1947.
Houghton, Walter. *The Victorian Frame of Mind, 1830-1870*. New Haven: Yale University Press, 1957.
Howell, David. *British Workers and the Independent Labour Party, 1888-1906*. Manchester: Manchester University Press, 1983.
Hunt, Lynn. *Politics, Culture, and Class in the French Revolution*. Berkeley: University of California Press, 1984.
Jakubowski, Franz. *Ideology and Superstructure*. London: Allison Busby, 1976.
Jameson, Fredric. *Marxism and Form: Twentieth-century Dialectical Theories of Literature*. Princeton: Princeton University Press, 1971.
―――. *The Political Unconscious: Narrative as a Socially Symbolic Act*. Ithaca, NY: Cornell University Press, 1981.
Kaplan, Alice Yaeger. *Reproductions of Banality: Fascism, Literature and French Intellectual Life*. Minneapolis: University of Minnesota Press, 1986.
Knabb, Ken (ed). *The Situationist International Anthology*. Berkeley: Bureau of Public Secrets, 1981.
Kocmanova, Jessie. "The Aesthetic Opinions of William Morris." *Comparative Literature Studies* IV, no. 4 (1967).
Kumar, Krishan. "News From Nowhere: The Renewal of Utopia." *History of Political Thought* XIV, no. 1 (Spring 1993): 133-143.
Laclau, Ernesto. *New Reflections on the Revolution of Our Time*. London: Verso, 1990.
Laclau, Ernesto, and Chantal Mouffe. *Hegemony and Socialist Strategy: Towards a Radical Democratic Politics*. London: Verso, 1985.
Lang, Berel, and Forrest Williams (eds). *Marxism and Art: Writings in Aesthetics and Criticism*. New York: David McKay Co., 1972.
Lentricchia, Frank. *After the New Criticism*. Chicago: University of Chicago Press, 1980.
Lindsay, Jack. *William Morris: A Biography*. New York: Toplinger Publishing Co., 1979.
Loesberg, Jonathan. *Aestheticism and Deconstruction: Pater, Derrida, and De Man*. Princeton: Princeton University Press, 1991.
Lovett, William. *Life and Struggles of William Lovett*. London: Macmillan & Kee, 1967.
Lyotard, Jean-Francois. *The Postmodern Condition: A Report on Knowledge*. Minneapolis: University of Minnesota Press, 1984.
―――. *Driftworks*. Trans. by Roger Mckeon. New York: Semiotext(e), 1984.
―――. *The Differend: Phrases in Dispute*. Trans. By Georges Van Den Abbeele. Minneapolis: University of Minnesota Press, 1988.
―――. *The Libidinal Economy*. Trans. by I. Hamilton Grant. Bloomington: Indiana University Press, 1993.
Lyotard, Jean-Francois, and J. Thebaud. *Just Gaming*. Minneapolis: University of Minnesota Press, 1985.

MacCarthy, Fiona. *William Morris: A Life of Our Time.* New York: Alfred A. Knopf, 1995.
Macdonald, Bradley. "Political Theory and Cultural Criticism: Towards a Theory of Cultural Politics." *History of Political Thought* XI, no. 3 (Autumn 1990).
———. "From the Spectacle to Unitary Urbanism: Reassessing Situationist Theory." *Rethinking Marxism* 8, no. 2 (Summer 1995).
———. "Marx and the Figure of Desire." *Rethinking Marxism* (forthcoming).
Macharey, Pierre, and Etienne Balibar. "Literature as an Ideological Practice: Some Marxist Propositions." *Praxis: A Journal of Cultural Criticism*, no. 5 (1981).
Mackail, J. W. *The Life of William Morris* (2 Vols.). London: Longman and Green and Co., 1922.
Marcuse, Herbert. *One-Dimensional Man: Studies in the Ideology of Advanced Industrial Society.* Boston: Beacon Press, 1964.
———. *Negations: Essays in Critical Theory.* Boston: Beacon Press, 1968.
———. *The Aesthetic Dimension: Towards a Critique of Marxist Aesthetics.* Boston: Beacon Press, 1977.
Marx, Karl. *Early Writings.* Trans. by Rodney Livingston and Gregor Benton. London: Penguin Books, 1975.
———. *Capital: Volume One.* Trans. by Ben Fowkes. New York: Random House, 1977.
———. *Marx: Later Political Writings.* Trans. by T. Carver. Cambridge: Cambridge University Press, 1996.
Marx, Karl, and Friedrich Engels. *The Marx-Engels Reader.* Ed. by R. Tucker. New York: W. W. Norton, 1978.
Megill, Allan. *Prophets of Extremity: Nietzsche, Heidegger, Foucault, Derrida.* Berkeley: University of California Press, 1985.
Meier, Paul. *William Morris: The Marxist Dreamer* (2 Vols.). Atlantic Highlands: Humanities Press, 1978.
Mepham, John, and David Ruben (eds). *Issues in Marxist Philosophy, Volume III: Epistemology, Science, Ideology.* London: Harvester Press, 1979.
Merchant, Carolyn. *Radical Ecology: The Search for a Livable World.* New York: Routledge, 1992.
Millman, Richard. *Britain and the Eastern Question, 1875-1878.* Oxford: Clarendon Press, 1979.
Morris, R. J. *Class and Class Consciusness in the Industrial Revolution, 1780-1850.* London: Macmillan Publishers, 1979.
Morris, William. British Museum Additional Manuscripts 45331-4, May Morris Bequest.
———. British Museum Additional Manuscripts 45891, Hammersmith Socialist Society Papers.
———. The Ashley Library Manuscripts 1218, Folios 1-4.
———. "How I Became a Socialist." *Justice*, June 16, 1894.

———. *The Earthly Paradise* (4 Vols.). London: Longman and Green and Co., 1902.
———. *Collected Works of William Morris* (23 Vols.). Ed. by May Morris. London: Longman and Green and Co., 1914.
———. *Prose and Poetry by William Morris*. Oxford: Oxford University Press, 1920.
———. *William Morris: Artist, Writer, Socialist* (2 Vols.). Ed. by May Morris. London: Basil Blackwell, 1936.
———. *William Morris: Selected Writings and Designs*. Ed. by Asa Briggs. Middlesex: Penguin Books, 1962.
———. *Three Works by William Morris*. Ed. by A. L. Morton. New York: International Publishers, 1968.
———. *The Unpublished Lectures of William Morris*. Ed. by Eugene Lemire. Detroit: Wayne State University Press, 1969.
———. "How Shall We Live Then?" Ed. by Paul Meier. *International Review of Social History* XVI (1971).
———. *The Political Writings of William Morris*. Ed. by A. L. Morton. New York: International Publishers, 1973.
———. *The Collected Letters of William Morris* (Vol. I). Ed. by Norman Kelvin. Princeton: Princeton University Press, 1984.
———. *The Collected Letters of William Morris* (Vol. II). Ed. by Norman Kelvin. Princeton: Princeton University Press, 1987.
William Morris Today. London: Institute For Contemporary Art, 1984.
Morton, A. L. "Morris, Marx and Engels." *The Journal of the William Morris Society* VII, no. 1 (Autumn 1986).
Morton, A. L., and George Tate. *The British Labour Movement.* London: Lawrence and Wishart, 1956.
Naslas, Michael. "Mediaevalism in Morris's Aesthetic Theory." *The Journal of the William Morris Society* V, no. 1 (Summer 1982).
Pepper, David. *Eco-socialism: From Deep Ecology to Social Justice.* London: Routledge, 1993.
Pevsner, Nikolaus. *Pioneers of Modern Design: From William Morris to Walter Gropius.* London: Penguin Books, 1960.
———. *Studies In Art, Architecture and Design: Victorian and After.* Princeton: Princeton University Press, 1968.
Pierson, Stanley. *Marxism and the Origins of British Socialism: The Struggle for a New Consciousness.* Ithaca, NY: Cornell University Press, 1973.
Pocock, J. G. A. *Virtue, Commerce, and History: Essays on Political Thought and History, Chiefly in the Eighteenth Century.* Cambridge: Cambridge University Press, 1985.
Punch, 1850-51.
Quail, John. *The Slow Burning Fuse: The Lost History of the British Anarchists.* London: Paladin Books, 1978.
The Red Republican & The Friend of the People. Intro. by John Saville. London: Merlin Press, 1966.

Reynold's Political Instructor, 1849-1851.
Rose, Gillian. *The Melancholy Science: An Introduction to the Thought of Theodor Adorno*. New York: Columbia University Press, 1978.
Rothstein, Theodore. *From Chartism to Labourism*. London: Lawrence and Wishart, 1983.
Ruskin, John. *Modern Painters* (Vol. II). New York: John Wiley and Sons, 1872.
———. *Fors Clavigera* (4 Vols.). London: George Allen, 1896.
———. *The Works of John Ruskin*, Vol. XII. London: George Allen, 1904.
———. *The Stones of Venice* (2 Vols.). Boston: The Colonial Press, 1912.
———. *The Political Economy of Art, Unto This Last, and Essay on Political Economy*. New York: J. M. Dent and Sons, Ltd., 1968.
———. *The Genius of John Ruskin*. Ed. by John D. Rosenberg. London: Routledge and Kegan Paul, 1979.
———. *The Seven Lamps of Architecture*. New York: Farrar, Straus and Giroux, 1986.
Sambrook, James (ed.). *Pre-Raphaelitism: A Collection of Critical Essays*. Chicago: University of Chicago Press, 1974.
Samuel, Ralph. "British Marxist Historians, 1880-1980: Part One." *New Left Review*, no. 120 (1980).
Shapiro, Michael. "Literary Production as a Politicizing Practice." *Political Theory* 12, no. 3 (August 1984).
Shelley's Prose. Ed. by David Lee Clark. London: Fourth Estate, 1988.
Sherbourne, John Clark. *John Ruskin, or the Ambiguities of Abundance: A Study in Social and Economic Criticism*. Cambridge, MA: Harvard University Press, 1972.
Short, Audrey. "The Great Exhibition of 1851." Doctoral Dissertation in History, University of Cincinnati, 1968.
Skinner, Quentin. *The Foundations of Modern Political Thought, Volume One: The Renaissance*. Cambridge: Cambridge University Press, 1978.
Solomon, Maynard (ed.). *Marxism and Art: Essays Classic and Contemporary*. Detroit: Wayne State University Press, 1979.
Spear, Jeffrey L. *Dreams of an English Eden: Ruskin and his Tradition in Social Criticism*. New York: Columbia University Press, 1984.
Sprinker, Michael. *Imaginary Relations: Aesthetics and Ideology in the Theory of Historical Materialism*. London: Verso Press, 1987.
Stansky, Peter. *William Morris*. Oxford: Oxford University Press, 1983.
———. *Redesigning the World: William Morris, the 1880s, and the Arts and Crafts*. Princeton: Princeton University Press, 1985.
Swinburne, A. C. *Lesbia Brandan*. London: Methuen, 1952.
Thomson, David. *England in the Nineteenth Century*. Middlesex: Penguin Books, 1985.
Thompson, E. P. *The Making of the English Working Class*. New York: Vintage Books, 1966.

———. *William Morris: Romantic to Revolutionary.* New York: Pantheon, 1976.

———. *The Poverty of Theory and Other Essays.* New York: Monthly Review Press, 1978.

The Times, London, 1850-51.

Villiers, Brougham, *The Socialist Movement in England.* London: T. Fishcher Unwin, 1908.

Williams, Raymond, *Marxism and Literature.* Oxford: Oxford University Press, 1977.

———. *Politics and Letters.* London: Verso, 1979.

———. *Problems in Materialism and Culture.* London: Verso, 1980.

———. *The Sociology of Culture.* New York: Schocken Books, 1981.

———. *Culture and Society: 1780-1950.* New York: Columbia University Press, 1983.

Williamson, Audrey, *Artists and Writers in Revolt: The Pre-Raphaelites.* Philadelphia: The Art Alliance Press, 1976.

Wolff, Janet, *The Social Production of Art.* New York: New York University Press, 1984.

Zimmerman, Michael. *Contesting Earth's Future: Radical Ecology and Postmodernity.* Berkeley: University of California Press, 1994.

Index

Abbott, Mr., 36
Addison, Joseph, 46; *The Spectator*, 46
Adorno, Theodor, 9-11, 13, 14, 15, 17, 86
Aesthetic Movement, xvii, 90-92, 93
aestheticism, xi, xvii, 18, 75, 76, 84, 91, 94, 112, 129, 143
aestheticist position, xv, 2, 3, 12, 14-17, 84, 93, 94, 142, 152, 153
Althusser, Louis, 7-9
Amiens Cathedral, 78, 79, 86
anarchisim, 124, 131, 140, 154, 155
Anderson, Perry, xiv, 9
Anti-Scrape, 101, 102, 126. *See also* Society for the Protection of Ancient Buildings
Aquinas, St. Thomas. xv
Aristocracy, 28, 29, 45, 46, 50, 80
Aristotle, 5
Arnot, R. Page, 125
arts and crafts movement, xi, 88
"Art and the Beauty of the Earth" (Morris), 113
"Art and the People: A Socialist's Protest against Capitalism Brutality, Addressed to the Working Classes" (Morris), 127
"The Art of the People" (Morris), 108
"Art Under Plutocracy" (Morris), 103, 116, 127
"Art, Wealth and Riches" (Morris), 127
Ashcraft, Richard, 16
The Athenaeum, 101
Aveling, Edward, 131
Aveling-Marx, Eleanor, 131

Balibar, Etienne, 8
Ball, John, 132
Bandiera, 94-95; "Poetry to Be Lived," 94
Baudelaire, Charles, 10
Baudrillard, Jean, 34
Bauhaus movement, 32
beauty, xii, xiv, xvi, xvii, xviii, 18, 35, 38, 44, 46, 49, 50, 59, 63, 66, 67, 75, 76, 78, 79, 81, 82, 84, 85, 88, 89, 91, 92, 93, 94, 95, 96, 101, 104, 105, 106, 107, 108, 110, 111, 112, 113, 117, 123, 129, 141, 142, 143, 144, 145, 152, 153, 155, 156; of gothic architecture, 65; of gothic forms, 60; Typical, 56; Vital, 53-58, 60, 61-62
"The Beauty of Life" (Morris), 107
Beer, M., 132
Beckett, Samuel, 13
Bellamy, Edward, 137
Benjamin, Walter, 33, 34, 37
Bishop of Oxford, 36
Blake, William, 84
Bourdieu, Pierre, aesthetic production, 8; attempt to overcome dualisms, 7; *Distinctions: A Social Critique of the Judgements of Taste*, 8; habitus, 8; field, 7
bourgeoisie, 26, 27, 28, 29, 39, 45, 46, 49, 50, 85, 86, 91. *See also* middle class
Brecht, Bertolt, 10
Briggs, Asa, 27, 29
Brown, Ford Maddox, 50, 85, 87; "Work," 50
Browning, Robert, 77, 81, 84, 91
Burke, Edmund, 48
Burne-Jones, Edward, 77, 87
Burne-Jones, Georgiana, 114
Burrows, Henry, 115
Byron, Lord, 77, 84

Capital (Marx), 123, 124
capitalism, 9, 11, 15, 25, 26, 27, 29, 34, 37, 38, 43, 44, 48, 50, 57, 64, 67, 82, 83, 84, 111, 113, 129, 132, 135, 136, 137, 138, 139, 144, 155
Carlyle, Thomas, 28, 29, 44, 49-50, 77, 80-81, 82, 83; *Past and Present*, 77, 80
Carpenter, Edward, xi-xii
Casement, William, xiii
Catalogue of the Great Exhibition, 31
"The Charter and Something More" (Harney), 134
Chartism, 26, 27, 28, 31, 35, 36, 58, 80, 133, 134
Chorley, H. F., 88
Christian socialism, 50
Christianity, 62, 81
Cobbett, William, 46, 80, 111; *A History of the Reformation in England and Ireland, 80; Political Register*, 46
Cobden, Richard, 27

Cole, Henry, 25, 30-31
Colloquies (Southey), 80
Commonweal, 130, 143, 144
The Communist Manifesto (Marx and Engels), 134
conservatism, 54, 55
Contrasts; or, a Parallel between the Noble Edifices of the Middle Ages and the corresponding Buildings of the Present Day, showing the Present Decay of Taste (Pugin), 81
The Co-operative Magazine, 133
Cooperative Movement, 27
Corn Laws, 27, 29, 30
Corresponding Societies, 46
Crystal Palace, 25, 30-35, 39, 43, 44
Crystal Palace Company, 32
Croyden Resolution, 131
cultural criticism, 5, 8, 17, 45-48, 49, 58
cultural politics, xiii, xv, xvii, 2, 3, 4, 5, 6, 10, 12, 13, 14, 16, 17, 18, 25, 79, 82, 84, 142, 143, 153
Culture and Society: 1750-1950 (Williams), 47-48

Dadaists, 153
decorative arts, xi, xvii, 25, 34, 39, 76, 83, 87, 88, 94, 102, 103, 104, 105, 108, 109, 110, 126
deep ecology, 155
The Defense of Guenevere (Morris), 25, 88, 89
Democratic Federation, xvii, 103, 118, 123, 126, 131
Derrida, Jacques, 2, 14
DF. *See* Democratic Federation
desire, xii, xvi, xvii, 3, 28, 29, 60, 79, 82, 92, 93, 111, 113, 114, 136, 137, 141, 142, 143, 145, 152, 153, 154, 155
Dickens, Charles, 36
Diggers Movement, 132
dignity of labor, 29, 36, 37, 38, 39
discourse on labor, 26, 29, 37, 38
Distinctions: A Social Critique of the Judgements of Taste (Bourdieu), 8
A Dream of John Ball (Morris), 132

Eagleton, Terry, 15, 45-49; *The Function of Criticism: From The Spectator to Post-Structuralism*, 45
The Earthly Paradise (Morris), 88, 89, 90, 92-93, 104, 115
Eastern Question Association, 116
Eckersley, Robyn, 155
The Eclectic Review, 36
eco-anarchism, 155
eco-feminism, 155, 156
eco-Marxism, xvii

eco-socialism, xvii, 152, 155
"The Ends and the Means" (Morris), 138
Engels, Friedrich,134, 135; *The Communist Manifesto*, 134
enjoyment, 35, 38, 39, 47, 50, 56, 58, 60, 62, 88, 92, 106, 142, 144, 154
EQA. *See* Eastern Question Association
equality, 52, 54, 57, 58, 64, 66, 67, 83, 109, 110, 114, 118, 133, 136, 137, 140, 142, 152
Enlightenment, 12, 85
exploitation, 33, 38, 51, 58, 59, 66, 108, 112, 118, 129, 133, 138, 139, 140, 152, 154
Eyck, Van, 111

Fabian Society, 136-137
Fabianism, 136-137
Factory Acts, 77, 133
Faulkner, Charles, 77
feminism, 46
feudalism, 34
Feuerbach, Ludwig, 7
First Reform Bill of 1832, 26, 27
Fors Clavigera (Ruskin), 59
Foucault, Michel, 2, 12, 13
Fourier, Charles, 52, 53, 125
Frankfurt School, 9, 11, 13, 14, 44
freedom, 8, 9, 11, 31, 51, 57, 60, 62, 64, 65, 66, 95, 108, 111, 133
French Revolution, 34
Freudo-Marxists, 154
The Function of Criticism: from The Spectator to Post-Structuralism (Eagleton), 45

The Germ, 85
Glasse, John, 131
Gospel of Work, 28, 29, 50
Gothic architecture, 53, 62, 65, 77, 79, 81, 86, 87, 101
"The Gothic Revival" (Morris), 81
Gothic revival, 81, 82, 87
Gothic Style, 63, 64, 76
Graff, Gerald, 15
Great Exhibition of 1851, xvi, 18, 25, 26, 29, 30-39, 43, 44, 45, 47, 50, 110
Grennan, Margaret, 79
Gropius, Walter, 32

Habermas, Jürgen, 153
Harney, G. Julian, 37-39, 47, 50, 134; "The Charter and Something More," 134
Hauser, Arnold, 7
Hegel, G. W., 16
Heidegger, Martin, 2, 12, 44
High Church Movement, 76

Index

History of Agriculture and Prices (Roger), 80
history of English socialism, 132-135
A History of the Reformation in England and Ireland (Cobbett), 80
Hobson, J. A., 53-54; *John Ruskin: Social Reformer*, 53
Homer, 104
Honour To Labour (Wortley), 36
Hood, Thomas, 35
Hopes and Fears of Art (Morris), 109
"The Hopes of Civilization" (Morris), 133
Horsfall, Thomas, 109
"How I Became a Socialist" (Morris), xii
"How Shall We Live Then?" (Morris), 136, 140, 141
"How We Live and How We Might Live" (Morris), 129
Hunt, Lynn, 34
Hunt, William Holman, 85
Hyndman, H. M., 123, 124, 131

ideology, 6, 7, 9, 15, 33, 38, 46, 47, 104, 106
Independent Labour Party, 131
International Peace Conference, 31

Jameson, Fredric, 5, 15
John Ruskin: Social Reformer (Hobson), 53
Jones, Ernest, 96, 134; "The Painter of Florence," 95
Just Gaming (Lyotard), 3
justice, 3, 4, 16, 51, 95

Kant, Immanuel, 3
Keats, John, 77, 88, 93
Kelmscott Press, 44, 124
Khayati, Mustapha, 153
Kingsley, Charles, 50, 77

labor, 28, 29, 47, 49, 50, 51, 52, 54, 59, 60, 62, 63, 66, 67, 78, 86, 88, 102, 106, 108, 109, 110, 111, 112, 113, 117, 118, 126, 128, 131, 133, 135, 138, 142, 143, 154
labor theory of art, 39, 58, 59, 112, 135
Laing, Samuel, 32
Lane, Joseph, 131
language of class, 27, 38, 39
Lansdowne Association, 36
"The Lesser Arts" (Morris), 75, 80, 105, 109, 110
Levellers, 132
The Life of William Morris (Mackail), xii
"Literary Production as a Politicizing Practice" (Shapiro), 12-14
Locke, John, 47, 132; *Second Treatise on Government*, 132
London Co-operative Society, 133

Love Is Enough (Morris), 84 104
Lovett, William, 36
Ludlow, J. M. 50
Lyotard, Jean-Francois, 13, 18; aesthetic rendering of the nature of justice, 4; emphasis on separate quality of discourses related to art and politics, 3; *Just Gaming*, 3; and language-games, 4, and politics of desire,154

MacCarthy, Fiona, xiii
Macherey, Pierre, 8
Mackail, J. W., xii-xiii, 75, 77, 124-125, 151; *The Life of William Morris*, xii
Mahon, John, 131
The Making of the English Working Class (Thompson), 46
"Making the Best of It" (Morris), 106
Malory, 88; *Morte d' Arthur*, 88
Mann, Thomas, 13
Mapplethorpe, Robert, 1
Marcuse, Herbert, 9-11, 13, 14, 15, 154; "On Hedonism", 154
Marx, Karl, 33, 51, 66, 112, 125, 126, 135, 138, 152; analysis of the factory system and machinery, 51; *Capital*, 123; *The Communist Manifesto*, 134; on differences between animals and humans, 107-108; on division of labor, 102; economic theory of, 136; and Idealism, 7; influence on Morris, 139, 151; on inherent potentialities of human labor, 108; "Preface" to *A Contribution to the Critique of Political Economy*, 6; relation of art to ideology, 6; *Theses on Feuerbach*, 7, 11; understanding of art as ideology, 7
Marxism, 47, 152; classical Marxism, 154; cultural criticism of, 5, 6, 129; as living tradition, xv, xiv, 5, 152-154; neo-romantic approach, 6; Western Marxism, xvii, 6, 9, 151-155
The Master and Servant Act, 115
Maurice, F. D., 50
medievalism, 66, 67, 75, 79, 81, 82, 83, 84, 85
medievalist movement, 77, 79, 80, 81, 82, 111
Megill, Alan, 2, 3
Meier, Paul, 75, 124, 125, 151
Michelangelo, 111
Middle Ages, 76, 78, 79, 80, 81, 82, 83, 87, 89, 94, 108, 110, 111, 113, 128, 132
middle class, 27, 28, 29, 35, 76, 103, 107, 114, 116, 117, 123, 126, 144. *See also* bourgeoisie
Mill, J. S., 123
Millais, John, 85

Milton, John, 114
"Misery and the Way Out" (Morris), 128
Modern Painters (Ruskin), 53-57, 60, 62
More, Sir Thomas, 132; *Utopia*, 132
Morris, William, xi, 39, 44, 45, 47, 53, 66; aesthetic education of, xii, xvi, 76-79, 126; and the Aesthetic Movement, xvii, 91, 92, 93; aesthetic purism of, 130; aesthetic theory of, 35, 38, 103-118; and aestheticism, xi, xvii, 18, 75, 76, 84, 91, 94, 107, 112, 129, 143; aestheticist position of, 18, 93, 94, 103, 142, 152, 153, 155; and anarchism, 124, 131, 140, 155; and Anti-Scrape, xii, 101, 102, 126; "Apology," 90-91; and architecture, xi, 79, 101, 102; on art and everyday life, 106, 107, 111, 143, 152, 153; on art and labor, 108, 114, 115, 117, 118, 138, 143, 144; on art and socialism, 126, 127-132, 136, 142-145; "Art and the Beauty of the Earth," 113; "Art and the People: A Socialist's Protest against Capitalism Brutality, Addressed to the Working Classes," 127; "The Art of the People," 108; "Art Under Plutocracy," 103, 116, 127; "Art, Wealth and Riches," 127; and arts and crafts movement, 108; "The Beauty of Life," 107; and Carlyle, 77, 81; on character of capitalism, 137-139; and *Commonweal*, 130, 143, 144; concept of pleasurable labour, 38, 112-113; conception of socialist life-world, 142-144, 152; contribution to the rethinking of the discipline of history, 111; and cultural politics, xv, 18, 142, 143; on decline of art, 106, 107, 127; and decorative art, xi xvii, 25, 76, 83, 87, 88, 94, 102, 103, 104, 105, 109, 110, 126, 127; *The Defense of Guenevere*, 25, 88, 89; and Democratic Federation, 103, 123, 126, 128, 131; *A Dream of John Ball*, 132; early life of, 75-79; *The Earthly Paradise*, 88, 89, 90, 92-93, 94, 104, 115; and Eastern Question Association, 115, 116; and eco-anarchism, 155; and eco-socialism, 152, 155, 156; "The Ends and the Means," 138; and Gothic architecture, 101; and Gothic revival, 82; "The Gothic Revival," 81; and Great Exhibition of 1851, 25; *Hopes and Fears of Art*, 109; "The Hopes of Civilization," 133; "How I Became a Socialist," xii; "How Shall We Live Then?," 136, 140, 141; "How We Live and How We Might Live," 129; on importance of art in human life, 107; on labor and pleasure, xiii, 38, 110, 111, 112, 113, 118; and labor theory of art, 112; "The Lesser Arts," 75, 80, 105, 109, 110; *Love Is Enough*, 84 104; on machines, 112, 155; "Making the Best of It," 106; and Marx, 107, 108, 112, 123, 124, 125, 126, 134, 136, 138, 139, 151, 152; and Marxism, xiv, xv, xvii, 125, 151, 152, 154; and medievalism, 79-84; and the medievalist movement, 77, 79-84; and Middle Ages, 76, 78, 83, 89, 94, 108, 111; "Misery and the Way Out," 129; and National Liberal League, 115, 116; *News From Nowhere*, 126, 140, 141-143; notion of beauty, xvi, xvii, 18, 75, 76, 79, 84, 88, 93, 94, 95, 101, 104, 110, 112, 143, 144, 152, 153, 155, 156; *The Oxford and Cambridge Magazine*, 77, 78, 85; and Pater, 76, 92, 93; *The Pilgrims of Hope*, 104; on political limitations of poetry, 91; and politics of desire, 154; position on history of English socialism, 132-135; "Preface to Medieval Lore by Robert Steele," 82; and Pre-Raphaelitism, xi, 75, 77, 83, 86, 94, 103, 143; "The Prospects of Architecture in Civilization," 115; "The Revival of Handcrafts," 104; role of aesthetic discourses in developing political position of, xii, xvi, xvii, 75, 103, 104, 109, 113, 125, 126, 132,136, 151, 152; and romanticism, xiv, 75, 79, 83, 93, 141; and Rossetti, 84, 86, 87; and Ruskin, xvi, 44, 52, 77, 78, 79, 81, 102, 111, 112, 127, 134, 152; *Sigurd the Volsung*, 104; "Socialism," 135, 139; and Socialist League, 124, 131; socialist position of, xi, xii, xiii, xvii, xvii, 18, 25, 44, 103, 114, 116, 117, 118, 123-145, 151, 155, 156; socialist strategy of, 130, 131, 137, 140; "The Society of the Future," 140; "Some Hints on Pattern-Designing," 108; "The Story of the Unknown Church," 78; *The Sundering Flood*, 124; and Swinburne, 76, 89, 92; theoretical stature of, 151; Thompson's position on, xi xiii-xiv, 46, 75, 82-84, 88, 93, 104, 125, 128, 130, 151; "Useful Work versus Useless Toil," 129; utopian dimension to, 126, 140, 141; wallpaper designs of, 87; *The Water of the Wondrous Isles*, 124; *The Well at the World's End*, 124; *The Wood Beyond the World*, 124; "The Worker's Share

of Art," 144; and working class, 18, 76, 110, 115, 116, 117, 127, 144
Morris, Marshall, Faulkner, and Company, 87
Morte d'Arthur (Malory), 88

Naslas, Michael, 75
National Endowment for the Arts, 1, 2
National Liberal League, 115, 116
"The Nature of Gothic" (Ruskin), 44, 52, 64
Navigation Acts, 30
NEA. *See* National Endowments for the Arts
Newman, John Henry, 49
News From Nowhere (Morris), 126, 140, 141-143
Nietzsche, Friedrich, 2
NLL. *See* National Liberal League

O'Brien, Bronterre, 28, 58
"On Hedonism" (Marcuse), 154
Owen, Robert, 52, 125, 133
Owenism, 27, 46, 47, 53, 133
The Oxford and Cambridge Magazine, 77, 78, 85

Paine, Thomas, 46; *The Rights of Man*, 46
"The Painter of Florence" (Jones), 96
Past and Present (Carlyle), 77, 80
Pater, Walter, 76, 92-93
Paxton, Joseph, 31, 30, 32
Pepper, David, 155
Pevsner, Nikolaus, 32, 34, 87
Pierson, Stanley, 125
The Pilgrims of Hope (Morris), 104
Place, Francis, 36
Plato, xv, 1, 5; *The Republic*, 1, 5
pleasurable labor, 51, 53, 66, 67, 108, 110, 111, 113, 118
pleasure, xii, xvii, 43, 50, 52, 53, 58, 62, 63, 66, 67, 78, 79, 83, 88, 90, 91, 103, 104, 105, 108, 110, 111, 114, 117, 136, 142, 143, 144, 145, 152, 153, 154, 155
Pocock, J. G. A., 15
"Poetry to Be Lived" (Bandiera), 94
The Political Economy of Art (Ruskin), 60
Political Register, 46
political science, 5, 17
political theory, 5, 15, 16, 17, 45, 60, 63, 124, 125, 133, 151
Poor Man's Guardian, 28
postmodern theory, xv, 2, 3, 5, 6, 12, 142, 153, 154
poststructuralism, 12, 13, 14, 15
"Preface" to *A Contribution to the Critique of Political Economy* (Marx), 6
"Preface to Medieval Lore by Robert Steele" (Morris), 82
Pre-Raphaelite Brotherhood, 85-87
Pre-Raphaelitism, xi, 75, 77, 83, 94, 103, 143, 155
Price, Cornell, 76, 77
Prince Albert, 30. *See also* Prince Consort
Prince Consort, 30, 36. *See also* Price Albert
"The Prospects of Architecture in Civilization" (Morris), 115
Pugin, Augustus, 33, 48, 81; *Contrasts; or, a Parallel between the Noble Edifices of the Middle Ages and the corresponding Buildings of the Present Day, showing the Present Decay of Taste*, 81
Punch, 37

"The Quarry" (Ruskin), 63

radical ecology 155, 156
Radicalism, 133
Raphael, 85
The Red Republican, 51, 134
Reich, Wilhelm, 154
Renaissance, 62, 63, 64, 85, 102, 105, 106
The Republic (Plato), 1, 5
The Rights of Man (Paine), 46
"The Revival of Handcrafts" (Morris), 104
revival of socialism, 27, 123, 132, 134. *See also* socialist revival of 1880s
Reynold's Political Instructor, 51-52
Reynolds, Sir Joshua, 55, 85
Rimbaud, Arthur, 10
Roger, Thorold, 80, 111; *History of Agriculture and Prices*, 80
Romantic Movement, 79, 91, 93
romanticism, xi, xiii, xiv, 1, 2, 47, 75, 124
Rossetti, Christina, 85
Rossetti, Dante Gabirel, 84, 85, 86-87, 91, 117
Rossetti, William Michael, 85
Royal Academy, 55, 85
Ruskin, John, xvi, 33, 35, 43-67, 77, 78, 79, 81, 82, 86, 102, 103, 104, 111, 112, 117, 127; aesthetic issues binding with those of politics, 45; aesthetic theory of, 53-67, 135; and conservativism, 39, 54, 57, 67, 83; contradictory political moments of, 54, 56-57; and the Crystal Palace, 43, 44; *Fors Clavigera*, 59; idea of enjoyable labor, xvii, 50, 53; importance of his cultural criticism, 45; labor theory of art, 39, 58, 59, 112, 135; *Modern Painters*, 53-57, 60, 62; "The Nature of Gothic," 44, 52, 64; *The Political Economy of Art*, 60; "The Quarry," 63; *The Seven Lamps of Architecture*, 43, 55, 58-62, 67; *The Stones of Venice*, 43, 44, 55, 60, 62-67, 77; on strict hierarchy of classes, 53;

on Typical Beauty, 56; *Unto This Last*, 66; on Vital Beauty, 53-58, 60, 61-62

The Saturday Review, 89
Saussure, Ferdinand, 12
Scheu, Andreas, 87, 88, 102, 124, 127
Scott, Gilbert, 81
Scott, Sir Walter, 76
Second Reform Bill of 1867, 26, 111
Second Treatise on Government (Locke), 132
Serrano, Andres, 1
The Seven Lamps of Architecture (Ruskin), 43, 55, 58-62, 67
Shakespeare, William, 114
Shapiro, Michael, 12-13
Shaw, G. B., 1, 104, 138
Shelley, Percy, 77, 84, 91, 93, 94
Sherbourne, John, 57
Sigurd the Volsung (Morris), 104
situationists, 153
Skinner, Quentin, 15, 16
Smiles, Samuel, 50
social ecology, 155
"Socialism" (Morris), 135, 139
Socialist League, 124, 131
socialist revival of 1880s, xi. *See also* revival of socialism
Society for the Protection of Ancient Buildings, 101. *See also* Anti-Scrape
"The Society of the Future" (Morris), 140
"Some Hints on Pattern-Designing" (Morris), 108
Southey, Robert, 80, 111; *Colloquies*, 80
Soviet constructivists, 153
The Spectator, 46
Stansky, Peter, xiii
Steele, Richard, 46; *Tatler*, 46
The Stones of Venice (Ruskin), 43, 44, 55, 60, 62-67, 77
"The Story of the Unknown Church" (Morris), 78
The Sundering Flood (Morris), 124
surplus value, 51, 66, 112, 138, 139
surrealists, 153
Swinburne, A. C. 76, 89, 91, 92

Tatler, 46
Ten Hours Movement, 27
Tennyson, Lord Alfred, 77, 81, 84, 86, 91
Thackerey, William, 36

Theses on Feuerbach (Marx), 7
The Times, 32
Thompson, E. P., xi-xiv. xvii, 46, 75, 81, 82, 83, 84, 88, 93, 104, 125, 128, 130, 151; *The Making of the English Working Class*, 46; *William Morris: Romantic to Revolutionary*, xii, 82
Trade Union Council, 115
Turner, J. W, 49, 55

Unto This Last (Ruskin), 66
"Useful Work versus Useless Toil" (Morris), 129
Utopia (More), 132

Victoria Regia Lily House, 33
Vincent, Henry, 36

The Water of the Wondrous Isles (Morris), 124
Webb, Philip, 87
The Well at the World's End (Morris), 124
Wellmer, Albrecht, 153
Wilde, Oscar, 76, 91
William Morris: Romantic to Revolutionary (Thompson), xii, 82
William Morris Today, xii
Williams, Raymond, 47-48, 55, 85, 86, 113; *Culture and Society: 1750-1950*, 47-48, 53
Williamson, Audrey, 86
Wolff, Janet, 5
The Wood Beyond the World (Morris), 124
Wordsworth, William, 84
"Work" (Brown), 50
work, 28, 29, 50, 52, 58, 59, 60, 63, 64, 76, 78, 80, 82, 83, 86, 87, 89, 102, 104, 107, 109, 110, 111, 112, 116, 118, 124, 129, 136, 138, 139, 141, 144, 153, 155
"The Worker's Share of Art" (Morris), 144
working class, 25, 26, 27, 28, 29, 31, 34, 35, 36, 37, 38, 39, 46, 47, 49, 50, 51, 52, 53, 54, 56, 58, 59, 62, 66, 67, 76, 77, 82, 83, 94, 95, 106, 108, 110, 113, 114, 115, 116, 117, 118, 123, 127, 131, 132, 138, 144
working class aesthetics, 39
Working Classes Central Committee, 36
Working Men's College, 50, 58, 117
Wortley, Lady Emmeline Stuart, 36
Wycliffe, John, 132

About the Author

Bradley J. Macdonald is Assistant Professor of Political Science at Colorado State University. He received his B.A. in Political Science from the University of North Carolina at Chapel Hill, and his M.A. and Ph.D. in Political Science from the University of California at Los Angeles. He has published essays on cultural politics, the tradition of Western Marxism, and contemporary political theory in scholarly journals and edited books, and he is a co-founder/co-editor of the interdisciplinary journal, *Strategies: Journal of Theory, Culture, and Politics*.